# MOROCCO

PHOTOGRAPHS CÉCILE TRÉAL AND JEAN-MICHEL RUIZ
TEXT MARIE-PASCALE RAUZIER

# MOROCCO

## A CULTURAL JOURNEY

© PUTUMAYO WORLD CULTURE

www.putumayo.com

Putumayo World Culture • 1924 Magazine Street • New Orleans, LA 70130

THE COLOURS OF MOROCCO 6

IN THE MEDINA 36

IN THE HEAT OF THE SOUKS 64

THE CALL OF THE MUEZZIN 88

THE GOLD OF THE DESERT 116

FLAVOURS & FRAGRANCES 140

# CONTENTS

THE BLUE OF THE SEAS 166

PALACES, GARDENS & RIADS 192

JEWELS OF THE EARTH 220

MOROCCO CELEBRATES 246

WORKS QUOTED 270

MAP 271

# THE COLOURS OF MOROCCO

Morocco, a vast colour chart that changes with the hours and seasons, offers a sumptuous palette of colours.

Moroccan landscapes are steeped in limitless shades of blue, red, ochre, green, yellow, orange and pink, enlivened by the play of light and shadows. In the souks there is a feast of colours: bobbins of silk yarns, multicoloured cotton hats, leather or silk oriental slippers, woven rugs, glazed pottery, brightly coloured brocades, skeins of dyed wool . . . An artistic display of colours which is mirrored in the architectural decoration; set behind austere doorways and anonymous walls, palaces are embellished with walls covered by multi-coloured zellig mosaics (small, unusually decorative pieces of earthenware of various shapes, the colours and motifs of which are skilfully laid out and combined); carved, brown cedar ceilings; white stucco panels. There is a burst of brilliant colours at festivals and moussems when women wear brightly coloured dresses, decorated with a floral pattern or embroidered with all kinds of motifs, and put on colourful scarves with silky fringes.

A blue mauve on the walls of Essaouira or Chefchaouen to keep evil spirits at bay; indigo blue, the noble colour of the Sahara and of the turbans worn by the Tuaregs, the 'blue men' of the desert, to protect them against the desert wind and the burning hot sun; cobalt blue for the earthenware of Fès; Majorelle blue, a unique blue, veering to violet, used by the painter Jacques Majorelle to decorate his studio, set in a luxuriant garden in Marrakesh.

The white which splashes the façades of the ancient Andalusian houses with light, which envelops the veiled women of the Rif, which distinguishes men on days of mourning and riders during 'fantasias' (equestrian performances), which creates stucco lace on the walls of palaces and madrasas, the Islamic religious schools.

The poppy red of the skeins of dyed wool drying in the open air in the souk of the Marrakesh dyers, skilfully shaded tones of bright red or cochineal used to dye rugs and heavy fabrics. Red, the colour that protects against the evil eye. In markets throughout the kingdom, all kind of spices in a vast range of warm hues are displayed in powdery

pyramids. The women with their smouldering eyes pass by, adding flashes of red, blue or black with their veils.

Ochre ramparts and brown kasbahs stand out haughtily against the skyline; the earth colours that light up as the sun invades the adobe architecture of the houses of the Atlas region and the south, the labyrinth of the medinas, the tall Berber earthenware jars. The brown of the nomad tents or of dates, symbols of hospitality.

Green, the colour of Islam, the Muslim paradise, the miracle of water in a desert land. Green bathes the oases and invades the coolness of the palaces. In spring, Morocco explodes in a thousand and one shades of soft greens, emeralds, blues and greys. The palm groves echo with a symphony that is barely troubled by the babbling of water. Green also adds a sparkle to the glazed tiles of royal and religious buildings and of sumptuous private houses. And every day throughout the year, the green leaves of mint tea, flavoured with marjoram or saffron, quench the thirst of parched travellers.

Orange like the burning sand of the dunes of Merzouga, like the leaves of the Atlas walnut tree in autumn, like the fire that warms the skins of the *bendir* drums on nights of celebration. Orange like the spices sold on the markets, dominated by the golden tones of saffron, turmeric and cumin. Orange like the pastries oozing with honey, consumed on the nights of Ramadan. The magic of henna, the brown or green paste that creates beautiful orange motifs on the skin when it has dried.

The golden yellow of ears of barley and wheat crushed by the mules during threshing in the Moroccan countryside. The mimosa yellow of the traditional local slippers in supple, hard-wearing leather. Yellow like the small bananas of Sous, near Agadir and the preserved lemons that accompany the best tagines. The sparkling yellow of the gold that adorns the women in the cities, the belts that they wear on special occasions or the embroidery on their kaftans. Pale and shiny, the yellow copper engraved with delicate motifs lightens the brass-workers' souk.

Black like the wrought-iron grilles, reminiscent of calligraphy with downstrokes and upstrokes, or like the kohl eye make-up of the women. Silver like Berber jewelry, so treasured by women.

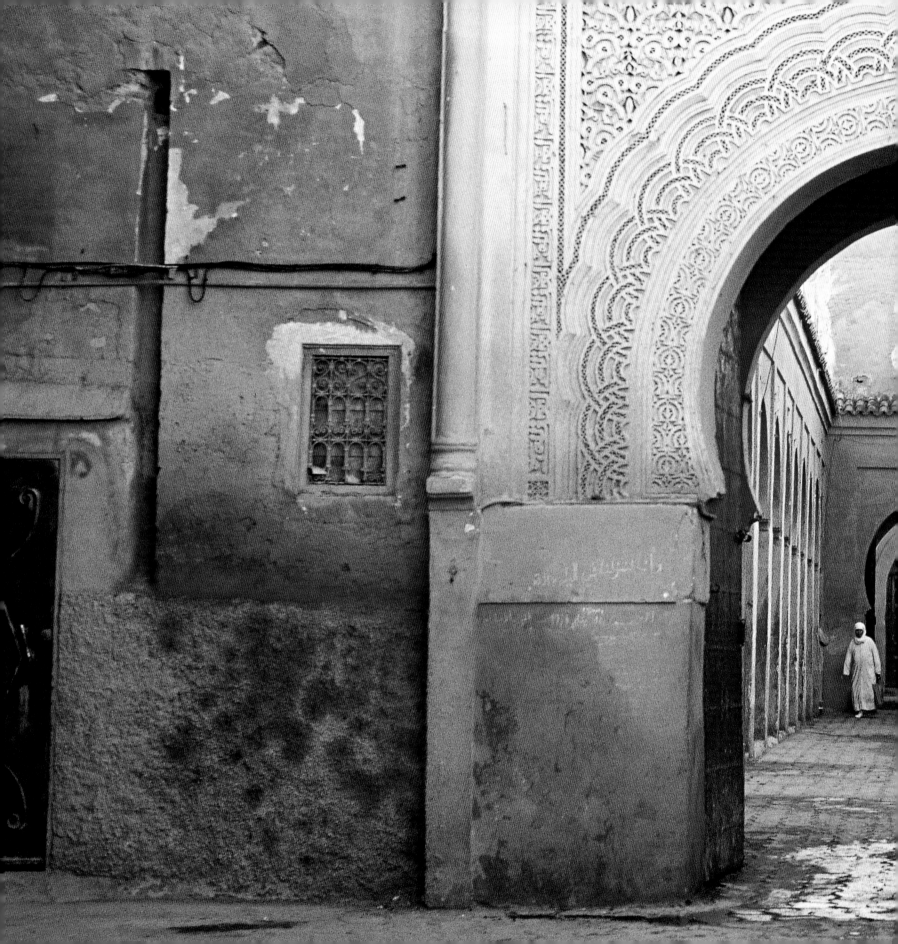

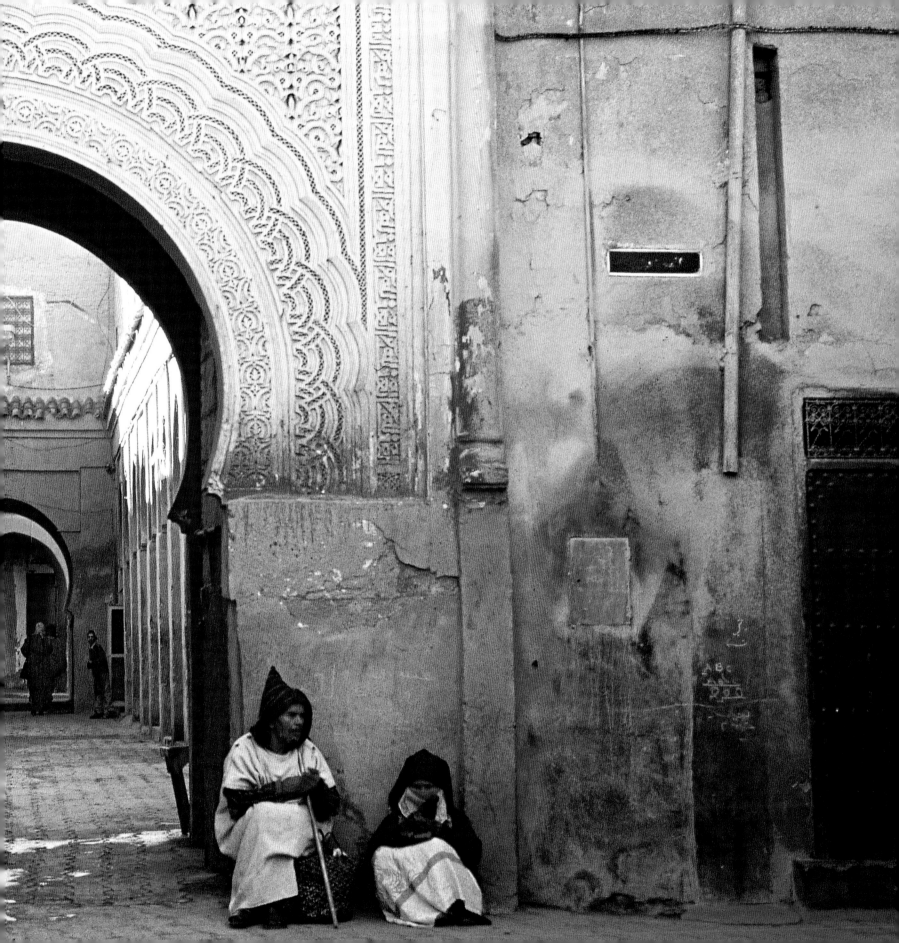

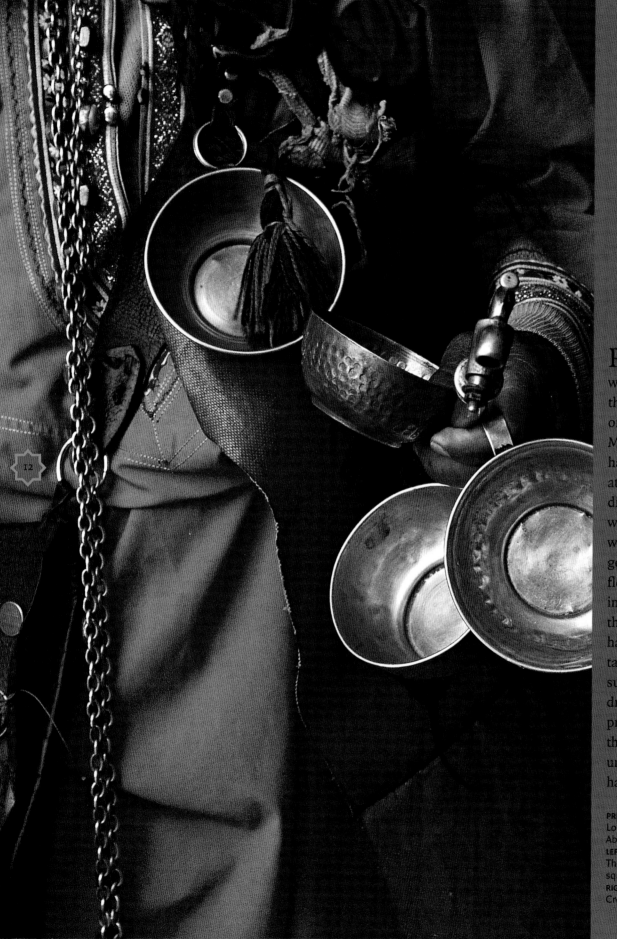

Red like the tunic of the
water-carrier, the *garrab*,
the emblematic character
on Djemaa el-Fna square in
Marrakesh. Copper goblets
hang round his neck, clinking
at every movement. For a few
dirhams he gives passers-by
water from his goatskin
which they drink from the
goblets. Mauve like the crocus
flowers that are in full bloom
in the autumn. This is when
the delicate operation of
harvesting the orange stigmas
takes place, at dawn before the
sun warms the earth. They are
dried as whole filaments and
provide the precious saffron
that gives tagines their
unrivalled taste or dyes the
hair of a young bride.

**PRECEDING PAGES**
Looking towards the Zaouïa of Sidi Bel
Abbès in Marrakesh.
**LEFT**
The water-carrier of Djemaa el-Fna
square in Marrakesh.
**RIGHT**
Crocus flowers in the Talioune region.

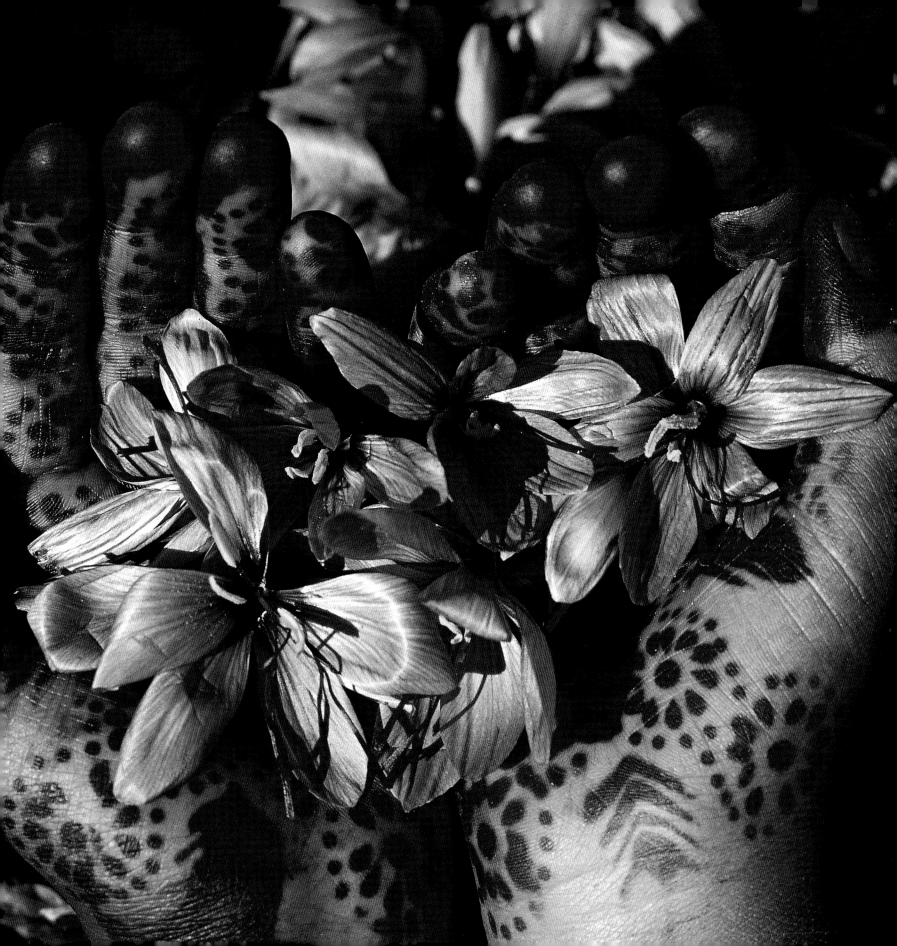

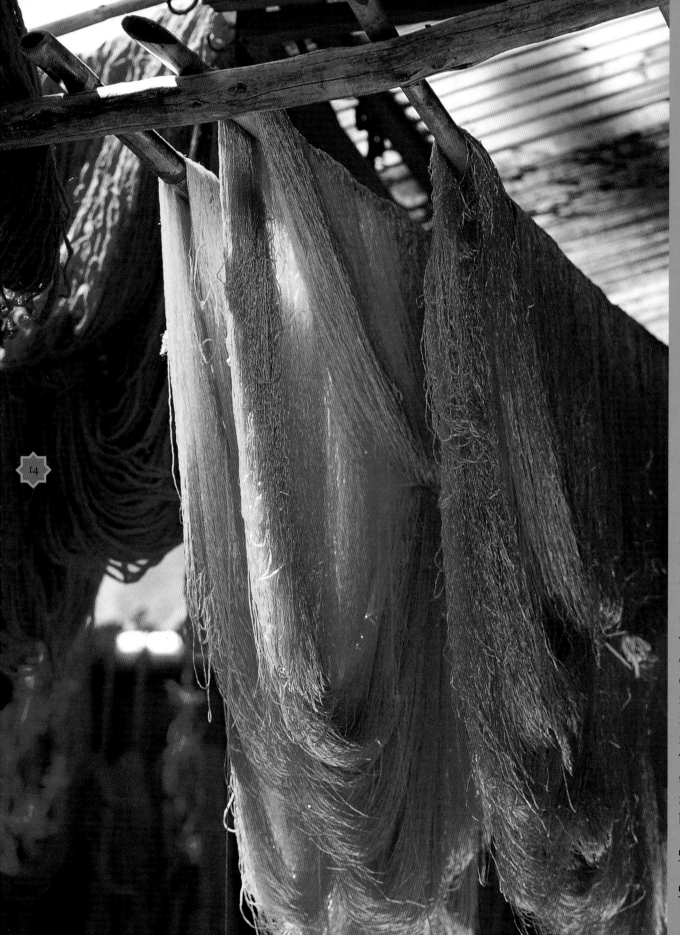

14

Orange, red, pink . . .
In the workshops of Fès and
Marrakesh, the wool and
cotton yarns are immersed
in large steaming vats of dye
and stirred for hours on end
by the men. Today the pigment-
based dyes have been replaced
by chemical colouring agents.
After dying, the skeins are
hung to dry on long bamboo
rods in the streets.

In the tanners' district,
terraces covered with large
vats form open-air honey-
combs, making a rich palette
of warm colours. In the vats
filled with lime salts and dyes,
men immersed to the waist
rinse and stamp on the skins.
These undergo various
treatments, including the
removal of hair and flesh,
before they are tanned.

**LEFT**
The dyers' souk in Marrakesh.

**RIGHT**
The tanners' souk in Fès.

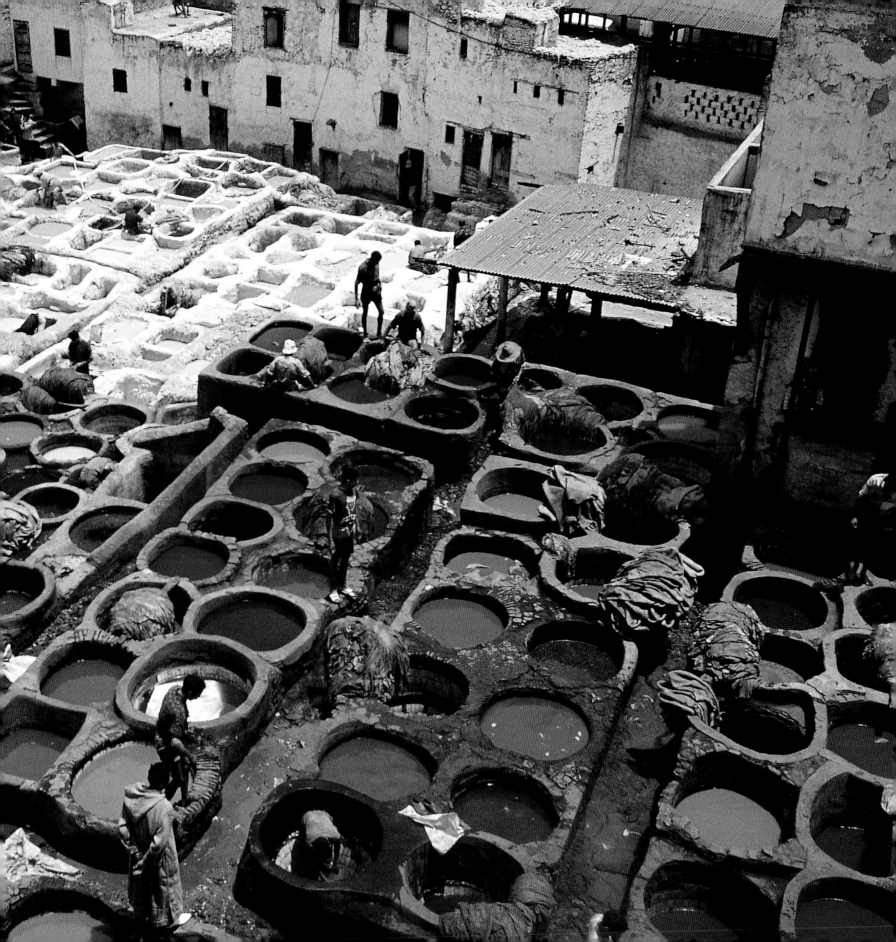

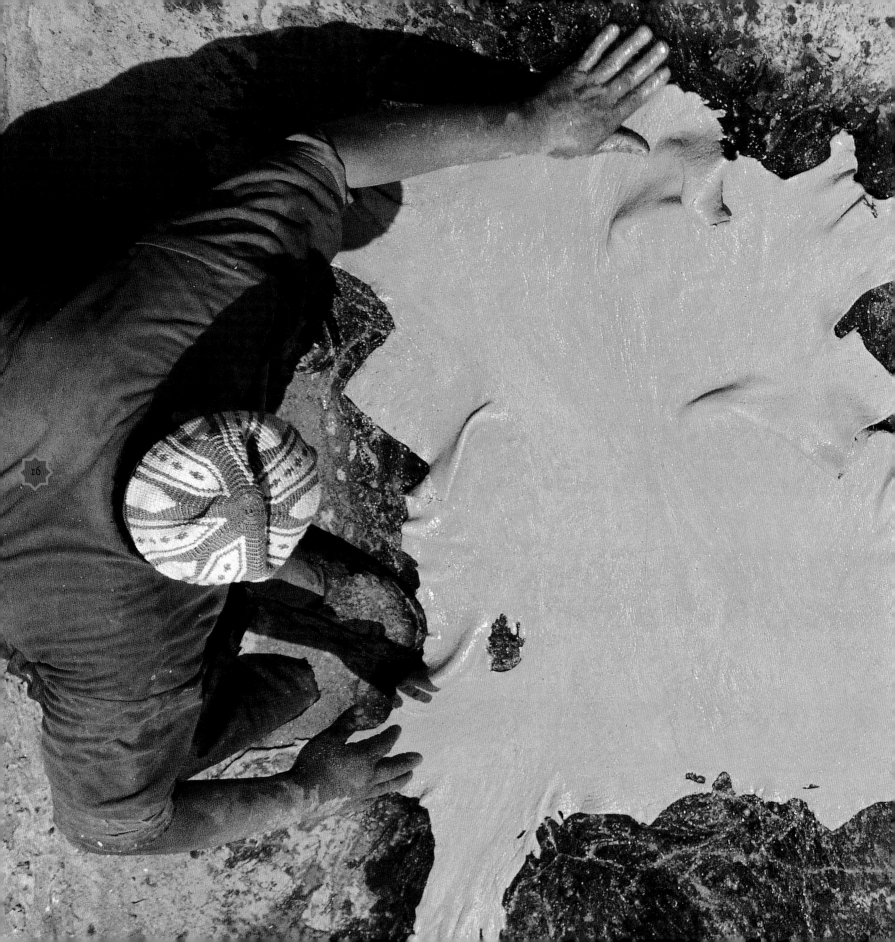

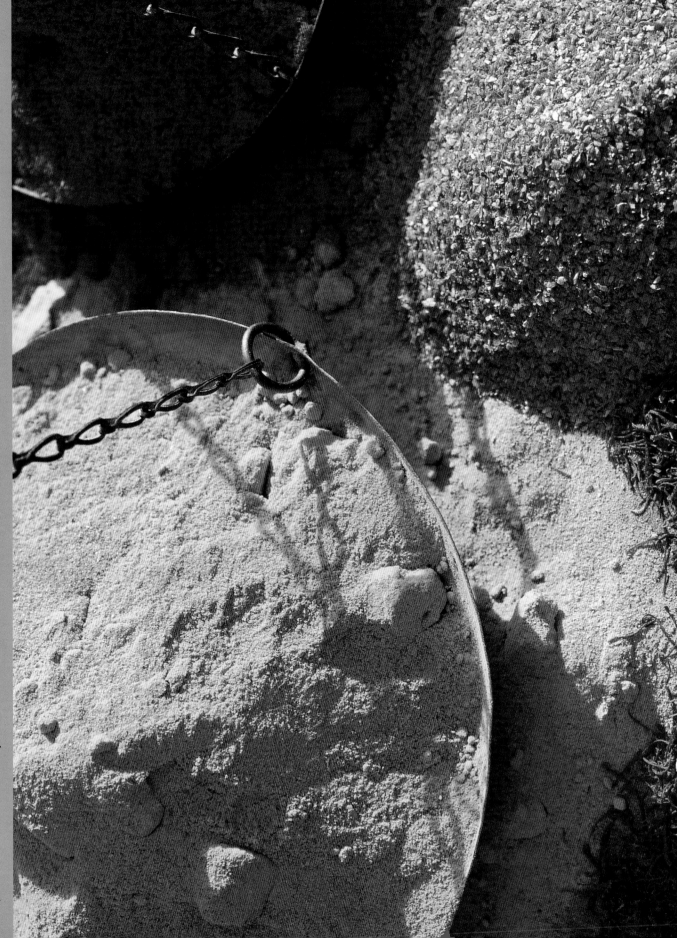

Once dyed and tanned, following techniques handed down through the generations, the sheep skins are put out to dry on the terraces of the medina or on the hills surrounding the town. Transformed into supple leather that will not rot, they will be worked by fine leather craftsmen to make pouffes, slippers and cushions.

Displayed loose and presented in conical heaps or in woven baskets, spices form brilliant splashes of colour on market stalls, exuding their sweet or piquant aromas. Ochre-coloured cinnamon, red paprika, orange saffron, cream-coloured ginger, cumin, nutmeg . . . This colour chart with its bewitching fragrances has for centuries contributed to the reputation of Moroccan gastronomy.

**LEFT**
A tanner in Fès.
**RIGHT**
In the markets, spices are sold by weight.

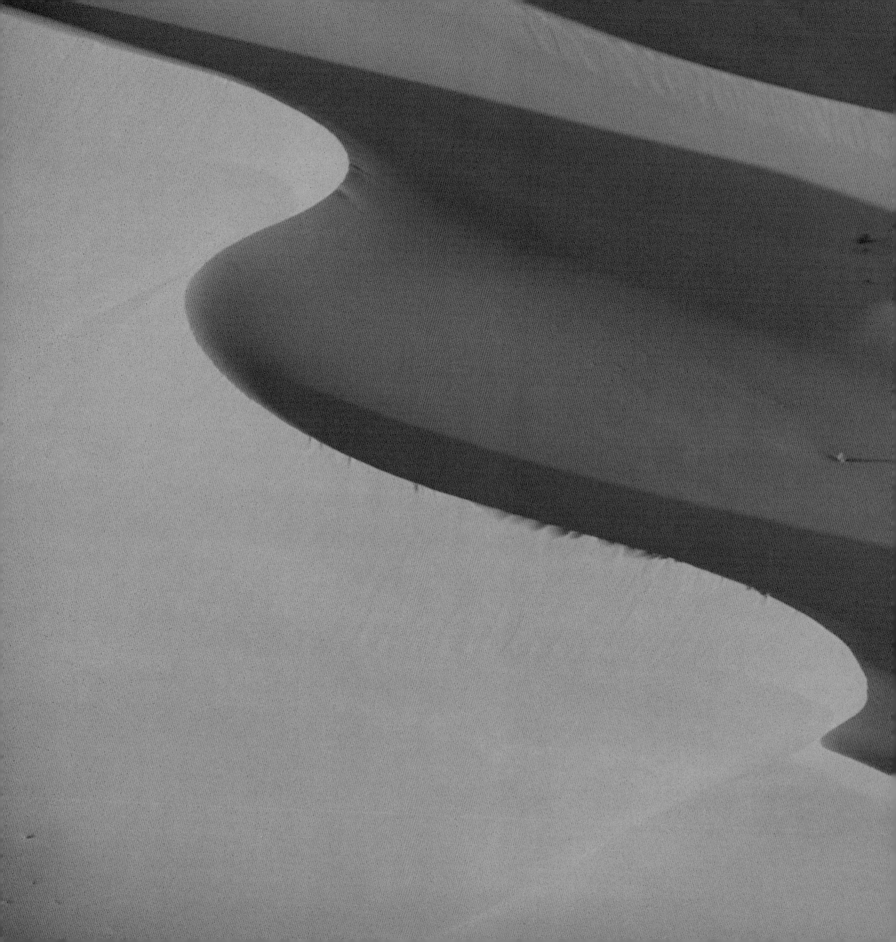

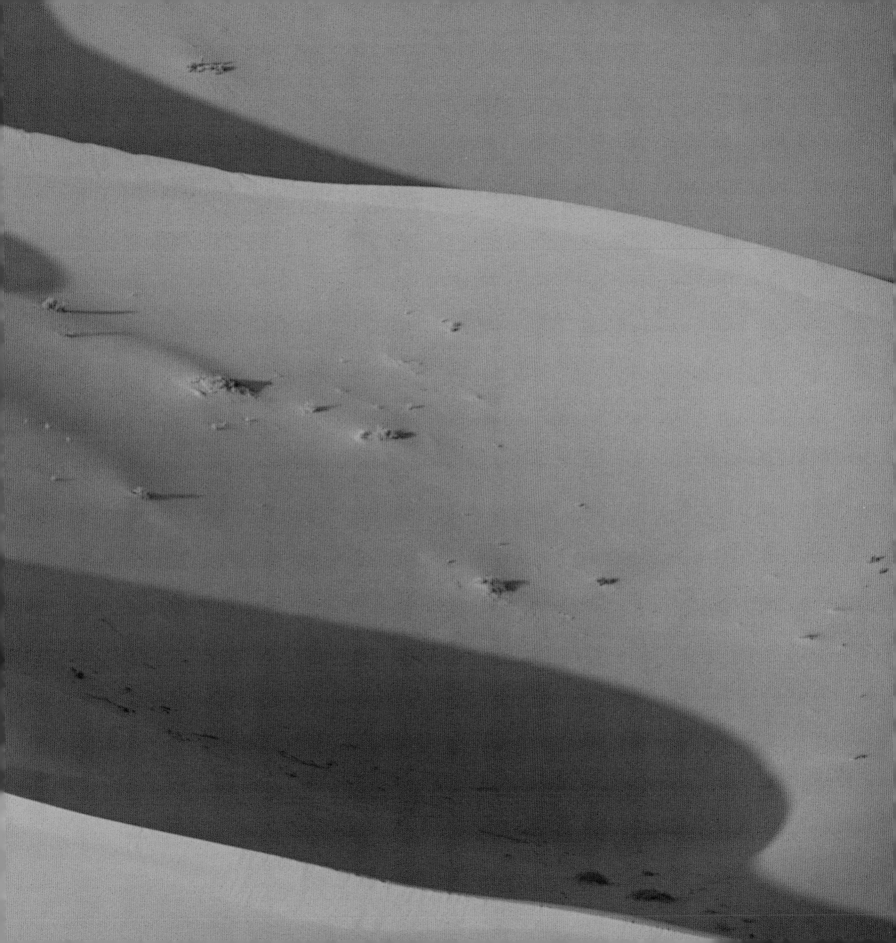

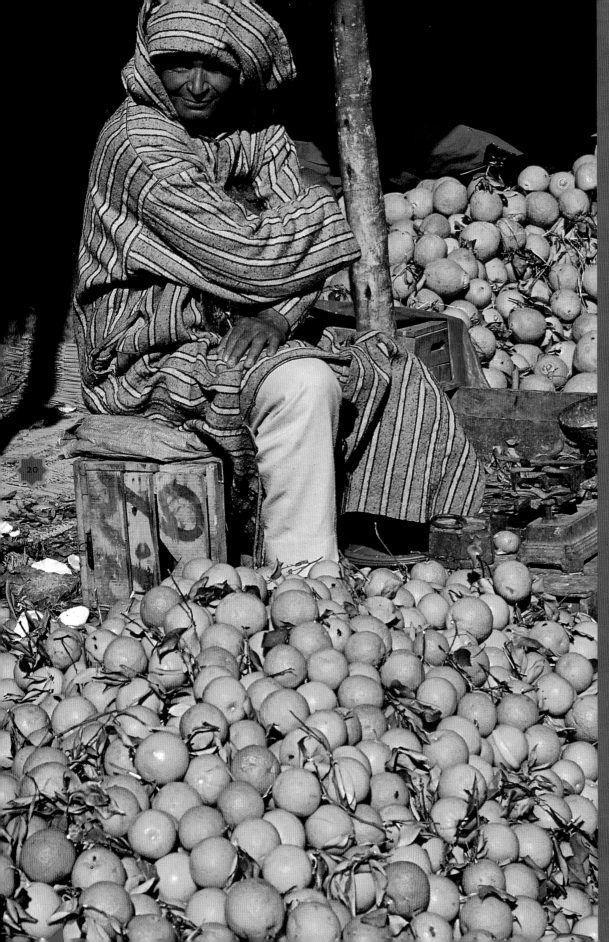

Bursting with juice and sunshine, the oranges of Morocco are famous for their sweetness. In the countryside near Agadir, the orange trees are sheltered from winds by the eastern slopes of the Anti-Atlas Mountains. Navel oranges, blood oranges, bitter or Seville oranges . . . no fewer than five varieties of oranges grow there and ripen one after the other. The gardens are fragrant with the sweet scent of orange flowers.

Thousands of babouche slippers, pointed or round-toed, line the cobblers' stalls. Originally made from leather, today they are often made of raffia, with 'rug' stitches, snake skin . . . and in a wide range of colours.

PRECEDING PAGES
The dunes of Merzouga.
LEFT
An orange seller in Marrakesh.
RIGHT
The colourful leaves of a Croton plant; traditional babouche slippers brighten a cobbler's stall.

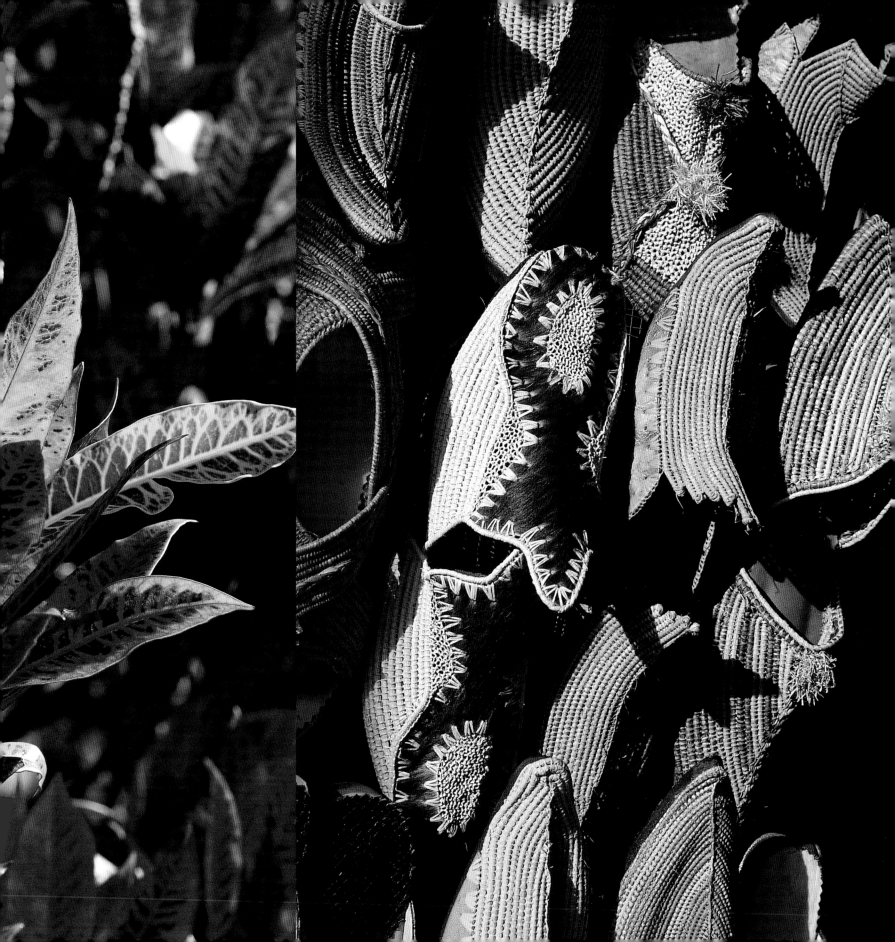

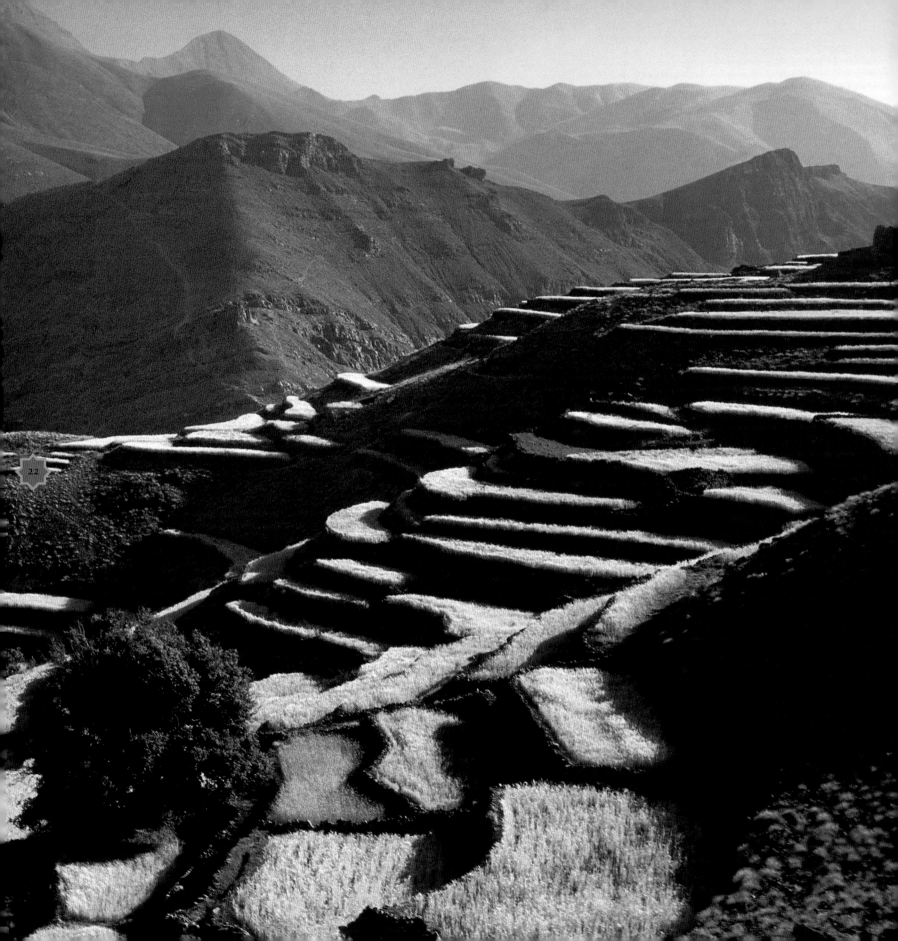

From the pass, you have a view over the valley of Aït Bou Gmez, a patch of green set in the hollow of the arid mountain; this is the most striking feature of the Berber valleys that punctuate the High Atlas mountains. They appear like oases to the traveller who has crossed barren plateaux, passed through canyons and dead forests, and climbed giant rocky ridges that are home to birds of prey and jackals and, in summer, to sheep, goats, camels and shepherds. Walking down the rocky slope, one can begin to make out the meticulous mosaic of cultivation, miniature fields set among irrigation channels, and terraces shaded by the leaves of walnut trees.

Karin Huet and Titouan Lamazou, *Sous les toits de terre du Haut Atlas (Under the Earth Roofs of the High Atlas)*

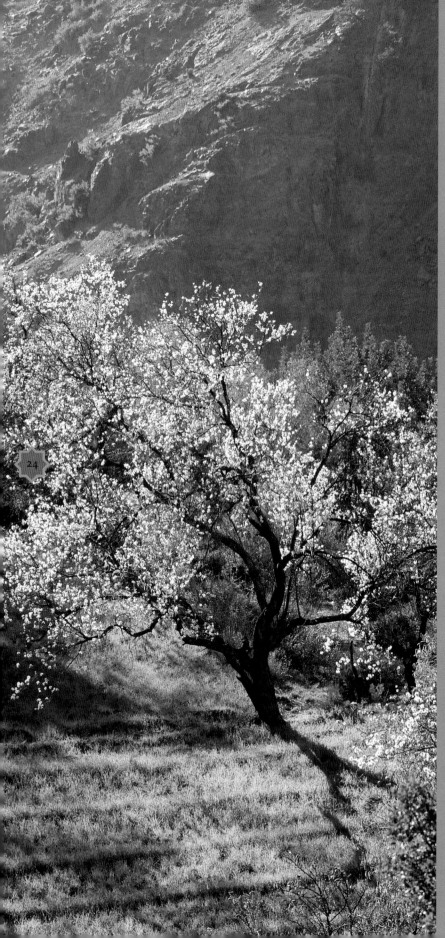

In February, in the Tafraoute region, the ephemeral whiteness of almond-tree blossoms stands out against the green of the palm trees and the pink of the houses built at the foot of these amazingly shaped rock walls. An early herald of spring, this sudden blooming is celebrated with the festival of almond trees, an event that attracts dancers, musicians and storytellers.

In Morocco, the almond, the king of dried fruit, is the food offered to guests and is the traditional way of honouring them. The almond is eaten fresh at the beginning of the summer; consumed on feast days; drunk in the form of almond milk; used to flavour pastries; or it is simply toasted. The almond is also used in the pigeon dish pastilla, in some sweet and savoury tajines, in the almond-filled pastries known as gazelle's horns and in stuffed dates.

After the olive tree, the almond tree is the most cultivated species in Morocco.

**LEFT**
Almond trees in bloom.
**RIGHT**
Sacks of ghassoul clay and powdered henna in a souk in Marrakesh. · Green tiles adorn palaces, mosques and madrasas.
The old photographs show, clockwise from top left, the entrance gate into Tiznit; a Moroccan postcard entitled 'Teatime'; and a marabout tomb in Tiznit.

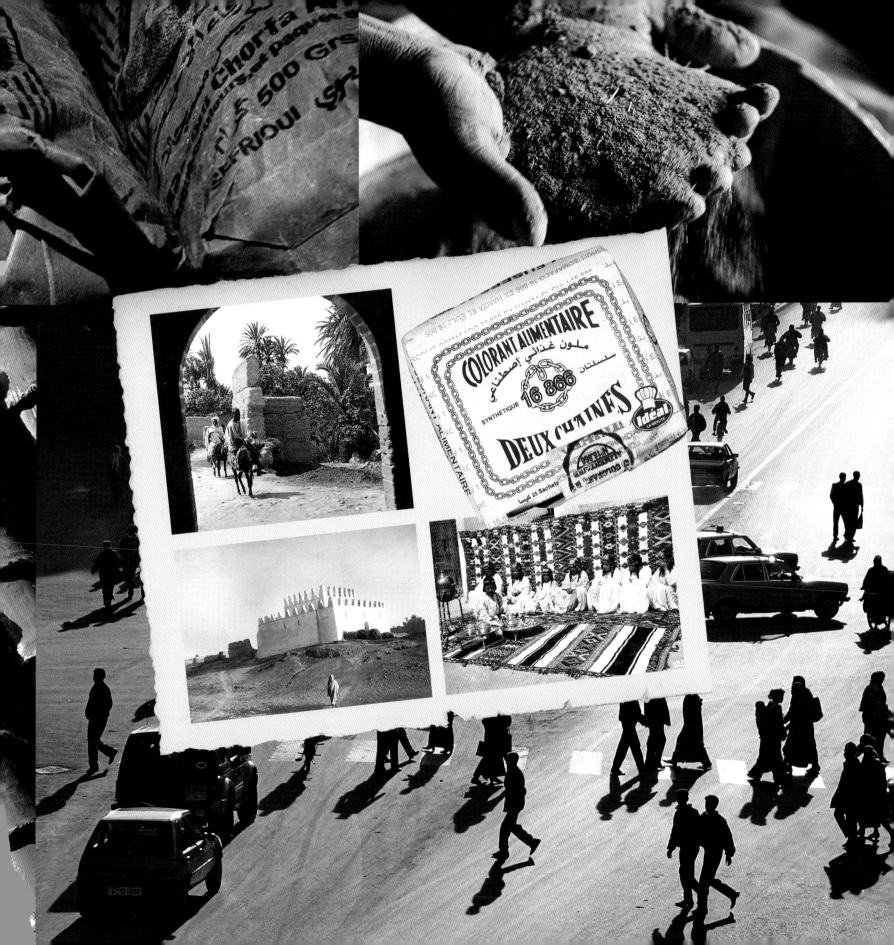

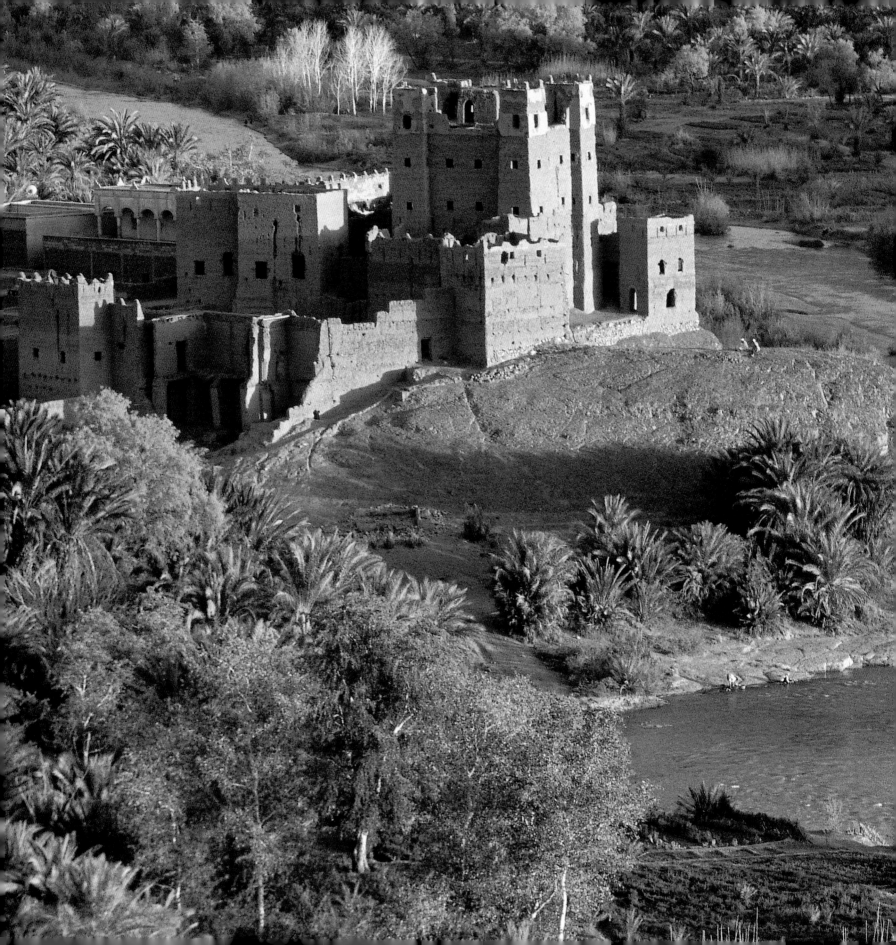

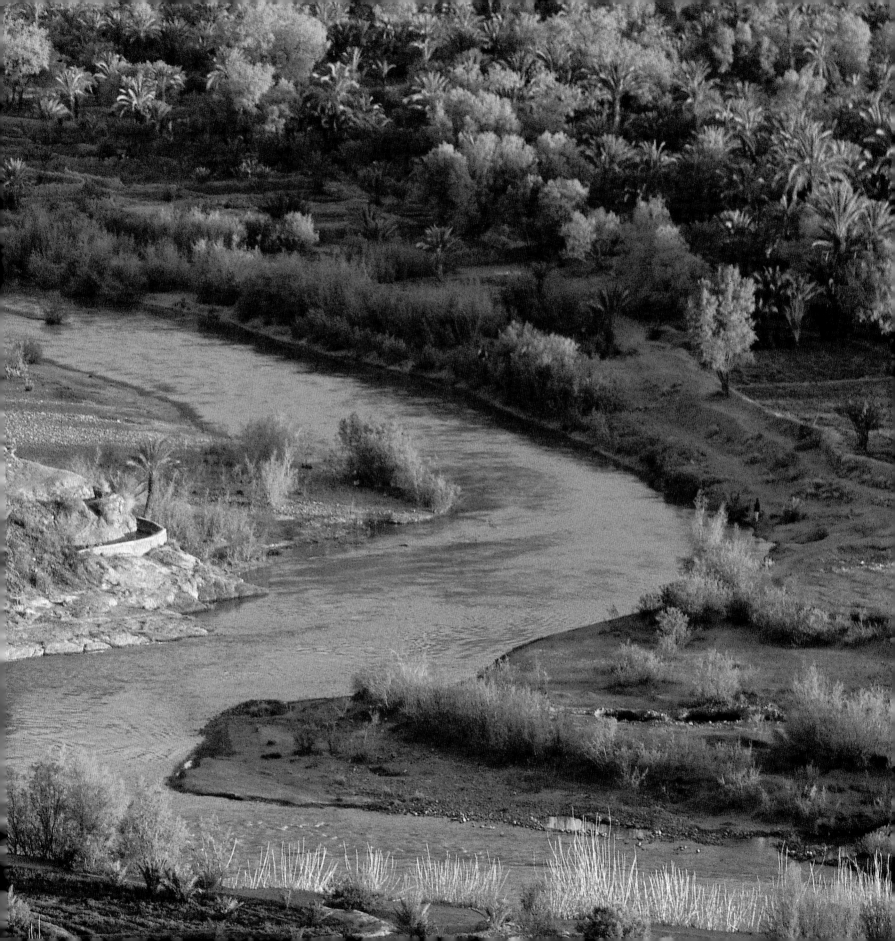

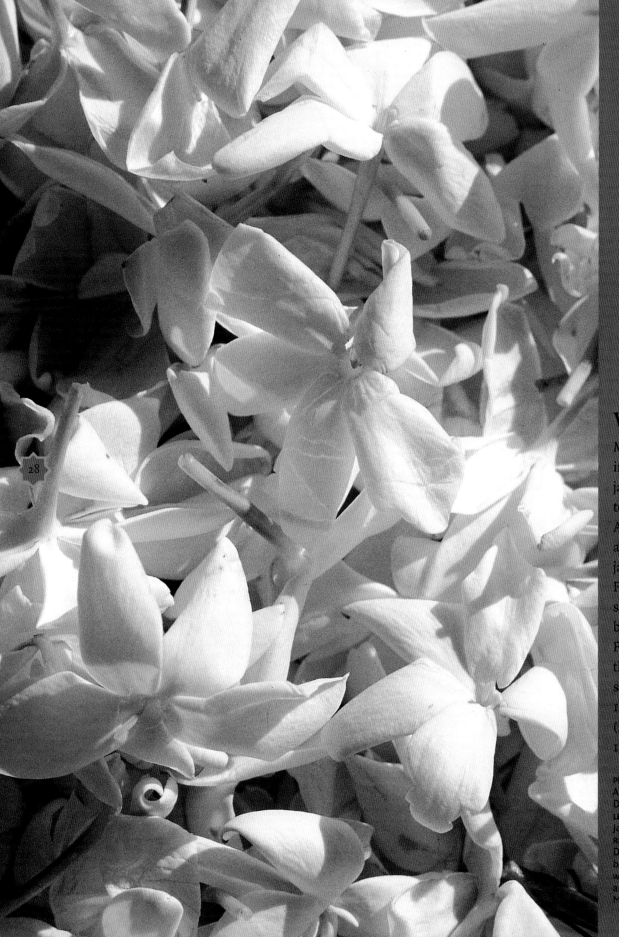

White is a sacred colour in Morocco and is triumphant in the fragrant flowers of the jasmine plant, which is native to central Asia and Persia. Although India and Egypt are the largest producers of jasmine, Morocco, Italy and France are also significant suppliers. Jasmine flowers between June and October. For making a jasmine extract, the flowers are picked before sunrise: 8,000 flowers weigh 1 kg (2.2 lb.), and 750 kg (1,650 lb.) of flowers yield 1 kg of pure jasmine extract.

**PRECEDING PAGES**
A ksar or fortified village in the Draa valley.
**LEFT**
Jasmine flowers.
**RIGHT**
Dried vegetables (including chickpeas, beans and haricot beans), sold by weight. • The white of the fine stucco arabesques of the Bou Inaniya in Meknes sparkles in the sun.

28

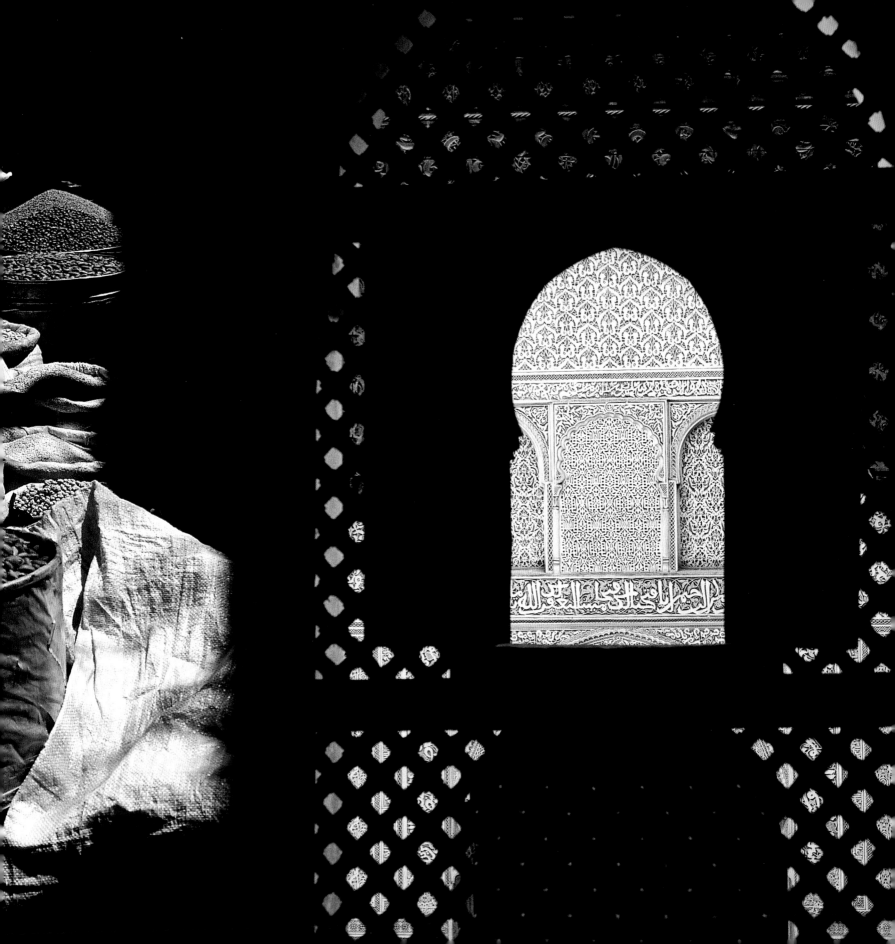

The whole town is indigo and salmon. No other colour. The walls of the houses have been painted salmon pink, all the doors and windows are painted blue. The result is a charming uniformity. In this dazzling light, these colours are in perfect harmony with each other.

Jacques Chegaray, *Au Maroc à l'aventure (Adventure in Marocco)*

30

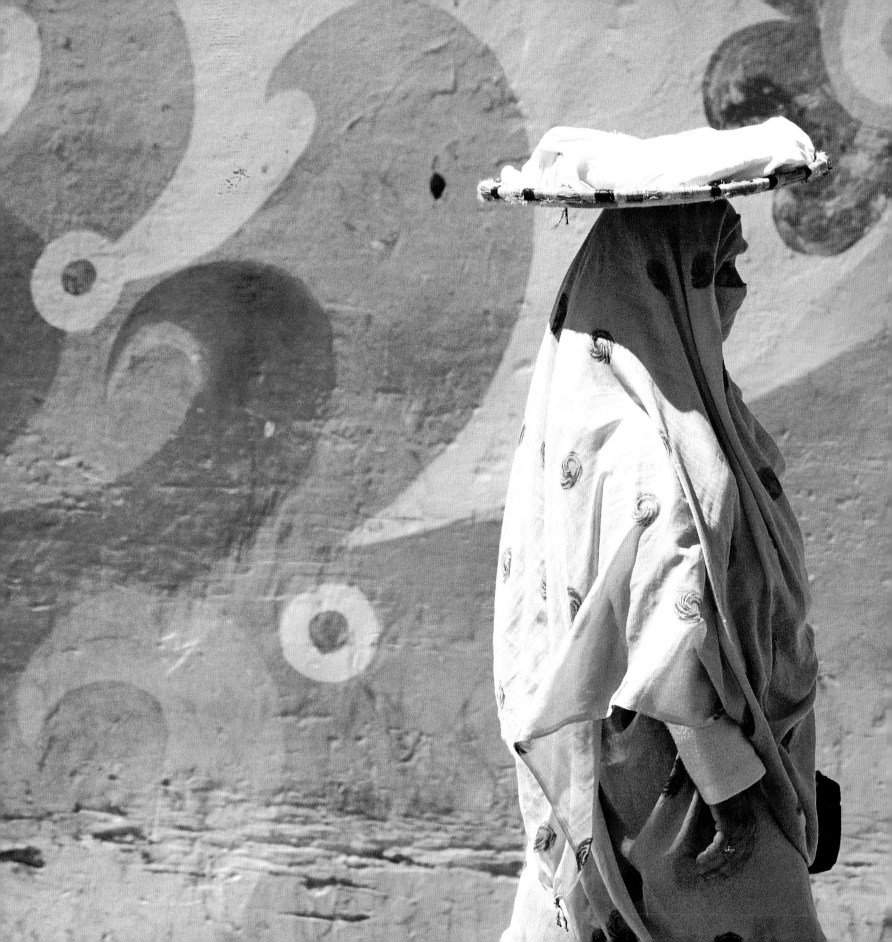

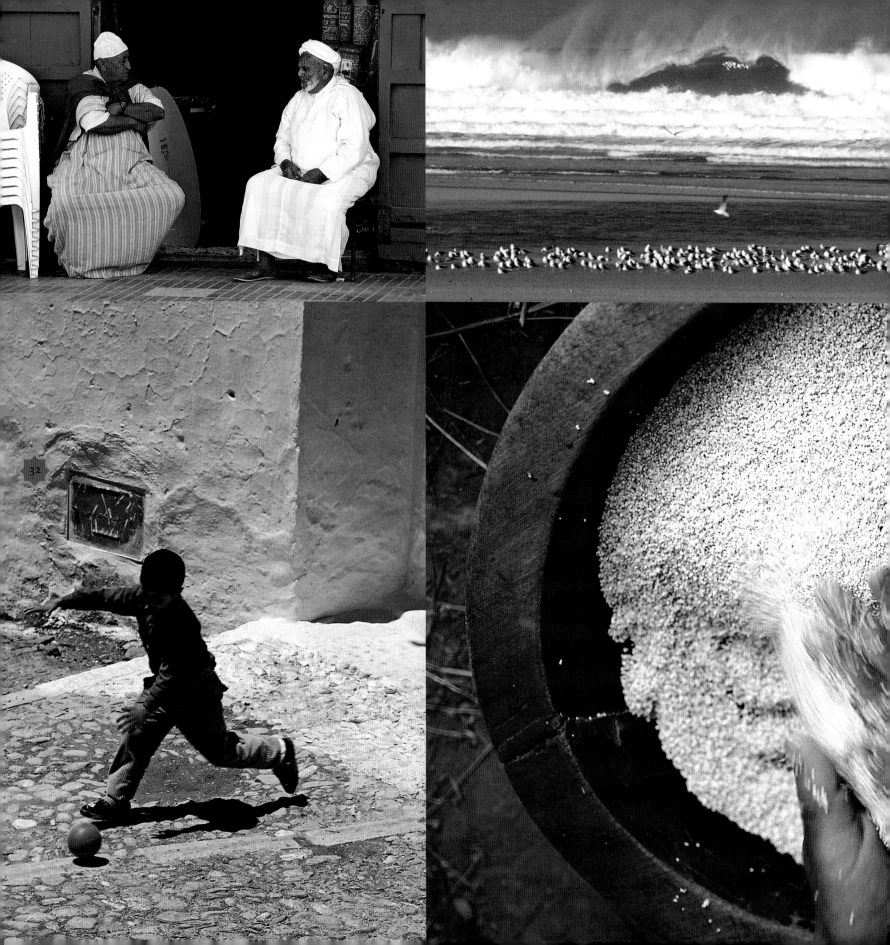

Blue and white like the waters of the Atlantic, wild and foaming at the foot of cliffs or in weakening waves approaching the sandy shore. The blue and white of the towns along the coast, blue like the fishing boats, peacefully lined up in the port of Essaouira. Blue and white like the Fès ceramics decorated with elegant motifs, the finest and most sophisticated of Moroccan pottery. White like the traditional clothes and whitewashed walls, white like the grains of wheat semolina or pearl barley, coated in a little flour and water, the basis of couscous.

**LEFT**
Two men talking in Essaouira. • The sea shore in the Essaouira region. • A child playing on the streets of Chefchaouen. • Couscous.
**RIGHT**
Boats in Essaouira. • Women at the Sidi Ben Aïssa mausoleum in Meknès. • Fès ceramic pots.

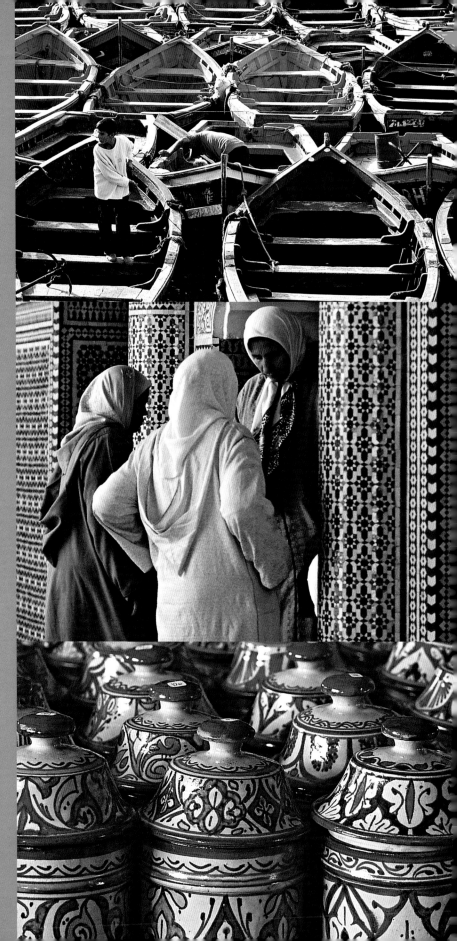

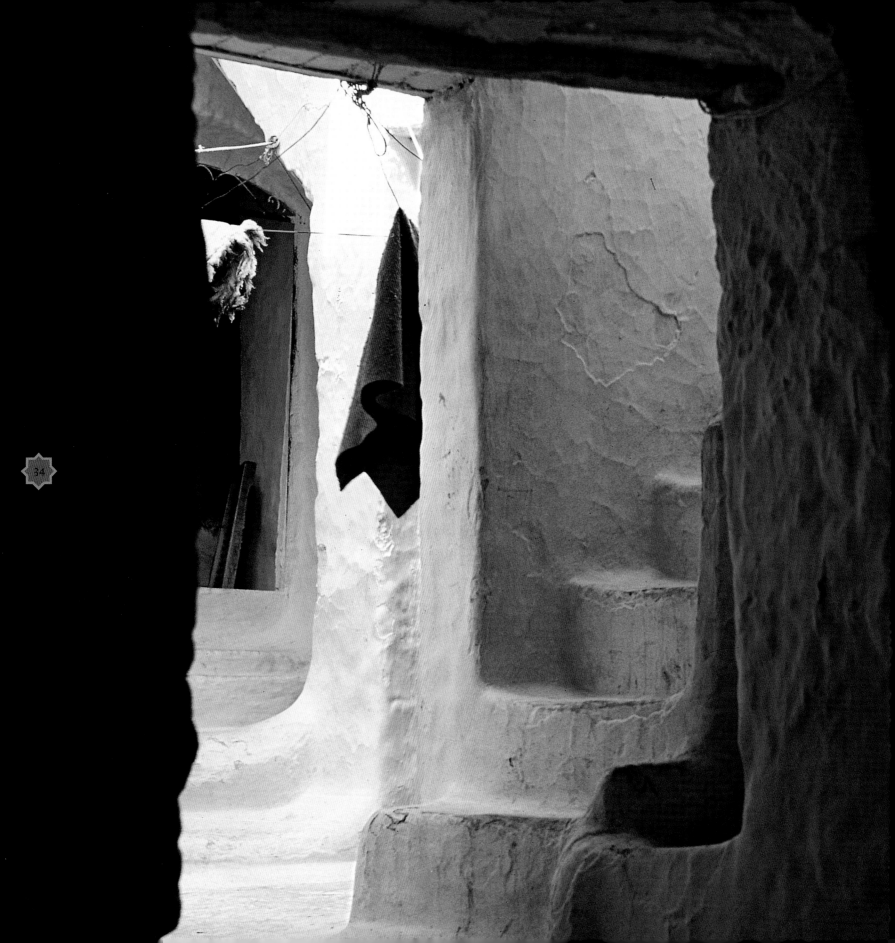

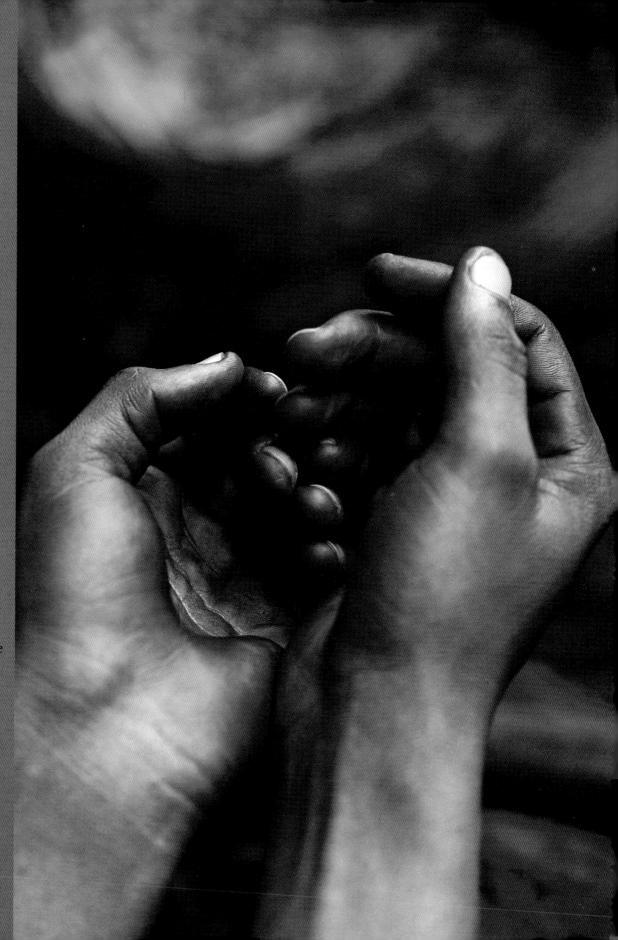

Chefchaouen encourages strolling. In this charming little town in the Rif, whitewash mixed with blue pigments creates a feeling of coolness and deters insects. The narrow back streets play with the light as they dive below the arches that link the houses to each other, while the whitish reflection simulates the cold colour of a glacier. You climb a couple of steps, turn off to the right and come out onto a little square.

**LEFT**
All the cobblestones, courtyards and steps in Chefchaouen are covered in thick layers of whitewash.

**RIGHT**
The hands and arms of dyers have been indelibly stained by the pigments, which are powerful colouring agents. Cochineal red, indigo blue, antimony black . . . dyers jealously guard the secret of the composition of their dyes.

# IN THE MEDINA

The traditional Arab town or medina has preserved its twelfth-century topography: a town looking inward to protect itself against enemy incursions and tribal conflicts, common events in the past. Seen from above, the medina looks like a labyrinth, a mosaic of ochre, cream, brown or pinkish honeycombs linked together, punctuated by elegant minarets and domes covered with green tiles. For Muslims, any fortified town with a population that has remained faithful to Islam is known as a medina, in honour of the prophet Muhammad who, fleeing Mecca, sought refuge in 622 in the Arab town of Medina.

The medina is surrounded by sandy-coloured walls, interrupted by monumental gates and punctuated by massive, crenellated towers. In Marrakesh, 200 square towers punctuate the 19 kilometres (12 miles) of the surrounding town walls. In the seventeenth century the medina in Meknès, which also contained the numerous palaces of Sultan Moulay Ismail, was surrounded by a triple wall 40 kilometres (25 miles) long with a path round the battlements, platforms for the cannons, and twenty gates leading into the town.

The disorderly appearance of the medina with its narrow streets, cul-de-sacs, covered passages and steps conceals a structure with its own logic. Structured round the religious centre – the Great Mosque, known as the Friday Mosque from the day on which the faithful are called to pray together – and the souks, the medina separates private and social life. There are no houses near the Great Mosque and the commercial centre. This is the location of the madrasas (religious foundations and residences for foreigners), mausoleums, hammams and fondouks.

The residential districts form a separate centre. A few main roads link the gates in the town walls from north to south and east to west, cutting across narrow roads which then divide further into alleyways and cul-de-sacs where the inhabitants live. The medina is divided into districts, based on social groups, brotherhoods or guilds.

The silence which hangs over these residential districts is in strong contrast with the loud hustle

and bustle of the souks. Each district has its own autonomy and its own collective facilities: its own mosque; a public oven where early in the morning every family comes to have their bread baked; a hammam (bathing establishment) where men and women have their day every week; a grocer's shop where you can buy the basic necessities (such as oil, coal, sugar and spices); a Koranic school; and a fountain where water can be obtained. Both in more modest houses and in prosperous residences, the privacy of the family is protected by austere, windowless façades, interrupted by heavy wooden doors decorated with wrought-iron nails and bronze hands – the only external decorative element – which are always firmly closed. The few windows are concealed behind spiral-shaped iron grilles or behind screens known as moucharabiehs.

The Moroccan house is a closed universe, inaccessible to the outside world, where luxury and comfort are not visible from the exterior. In contrast, the interior reflects the prestige of the master of the house: the number of outbuildings and loggias, the size of the riad (the internal garden courtyard) and the elaborateness of the décor depend on the prosperity and social rank of the owner. Modest or prosperous, the *dar* ('house' in Arabic) is the commonest type of residence in the medina. It is entered through a narrow, winding corridor that does not immediately reveal the secrets of the house. The building encloses a square, open-air courtyard that allows fresh air to circulate inside and which is surrounded by high walls and flanked by long, narrow rooms. The first floor – if there is one – consists of a gallery overlooking the courtyard and living rooms. The riad, originally an enclosed garden inspired by those in Andalusia, has by extension given its name to the town house surrounding this enclosed garden.

In the past the fondouks in the large medinas were inns and warehouses where travelling merchants and their mounts could stay. Today they house artisans' workshops. Although in the course of time their inhabitants have opted for the modern comfort of houses in the European style built during the French Protectorate, the medinas remain the soul of Moroccan towns.

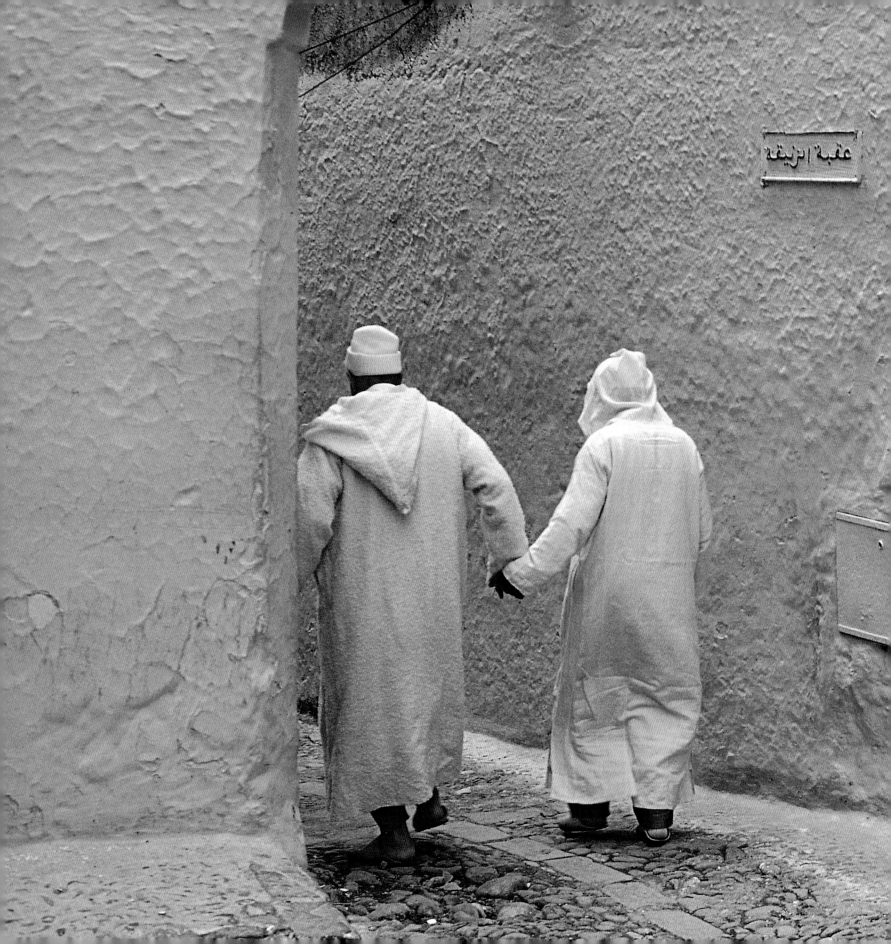

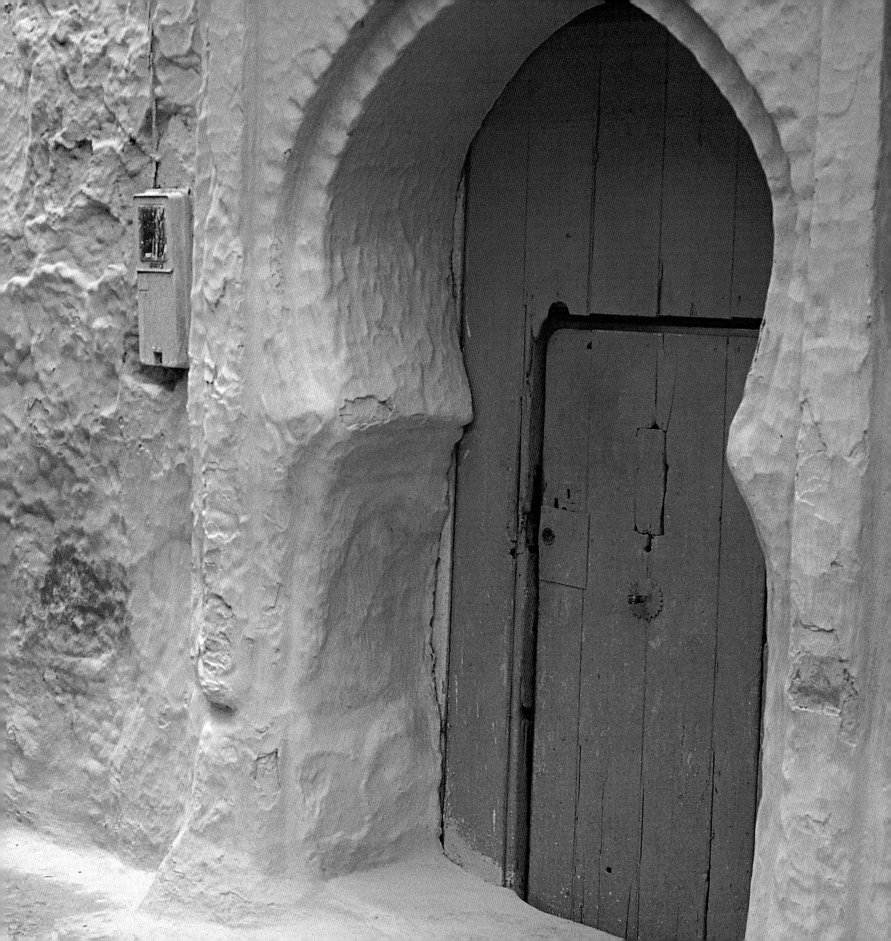

Outside the medina, the modern town developed during the French Protectorate, which was established in 1912. The traffic and noise in the modern town contrast sharply with the tranquillity of the narrow streets of the medina. In the young country that is Morocco, which looks forward enthusiastically to the future, the gap between the young, urban generation and the older generation has grown wider. The young, who have grown up with the Internet, are keen on all things modern and look to the West, while the old turbaned men, supporters of patriarchy, finger their prayer beads as they enjoy mint tea at tables outside the cafés.

**PRECEDING PAGES**
In Chefchaouen in the Rif, the narrow streets are paved with cobbles and the walls are painted with whitewash mixed with blue pigments.
**LEFT**
Young women on scooters in the streets of Marrakesh.
**RIGHT**
The driver of a horse-drawn carriage.

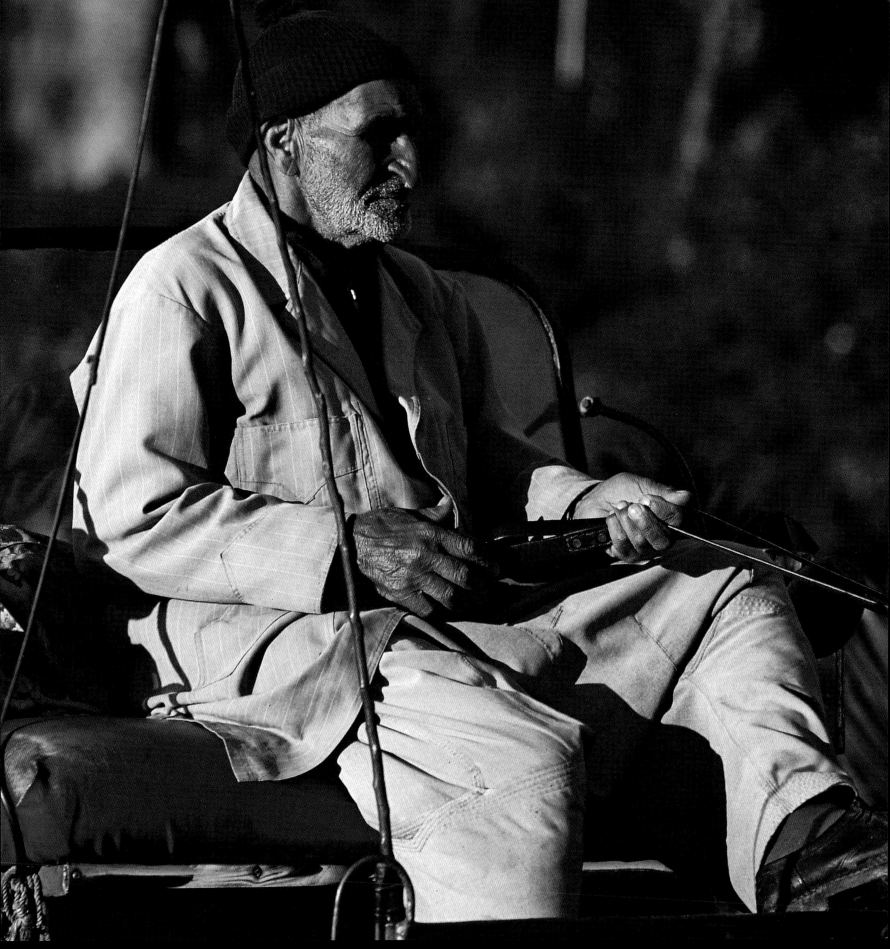

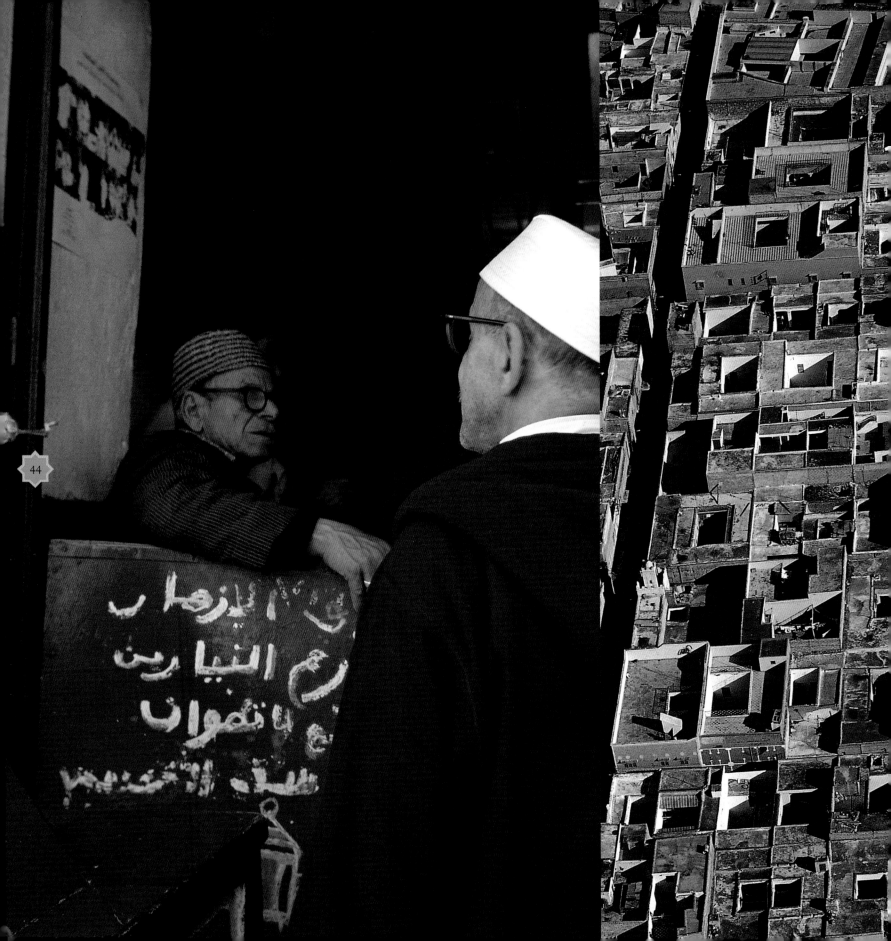

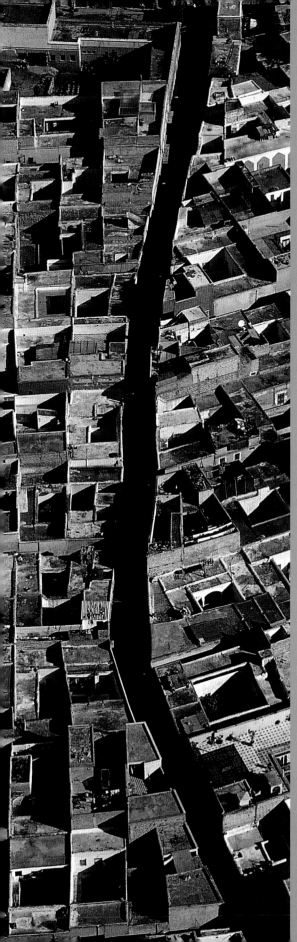

The vast maze of the medina is crossed by a few main thoroughfares. The buildings are constructed to appear like a single edifice, so from the outside it is difficult to see where one house starts and another one ends. The only identifiable 'presence' is the minaret of the mosque.

In this tortuous labyrinth, where public areas and private places are clearly defined, the only transport is a bicycle or a donkey. The continuous hustle and bustle that punctuates the days in the medina is regulated by unchanging rituals: the daily work of craftsmen that has remained unchanged for centuries, the hours of prayer and the sales patter of the merchants.

**LEFT**
A hand-painted shop sign in the medina of Tetouan. • The medina of Marrakesh seen from above.
**RIGHT**
One of the numerous minarets standing out from the compact mass of houses in the medina in Fès.

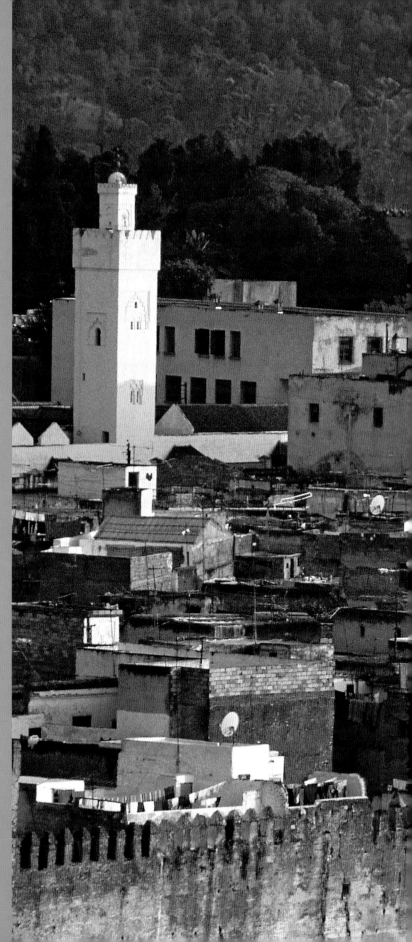

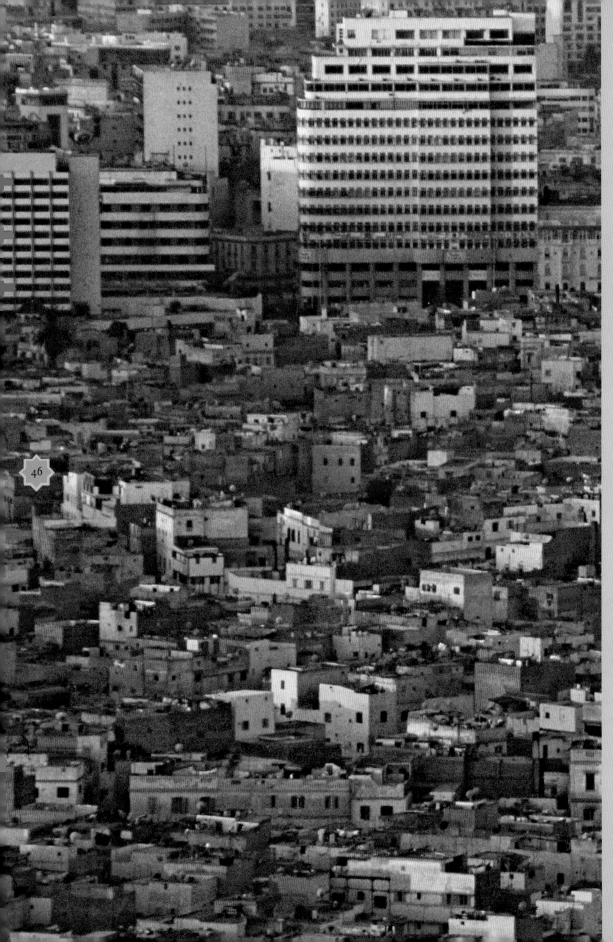

Of Berber origin, the Moroccan people have been subjected to various influences throughout their history. The Arab invasions in the seventh century drove the Berbers, the native population of Morocco, into the Rif and Atlas Mountains. After the fall of the Córdoba caliphate in 1492, Fès welcomed the Andalusians, expelled from Spain, who gave the region a distinct cultural character. The population of the big cities along the coast was affected by the arrival of Europeans: Portuguese, Spanish and later French. Finally, the Jews who fled from Spain at the end of the fifteenth century played an important part in Moroccan trade until the 1960s, when many of them left the country.

**LEFT**
Casablanca, the business capital.
**RIGHT**
The medina in Marrakesh. • The white walls of Chefchaouen.

46

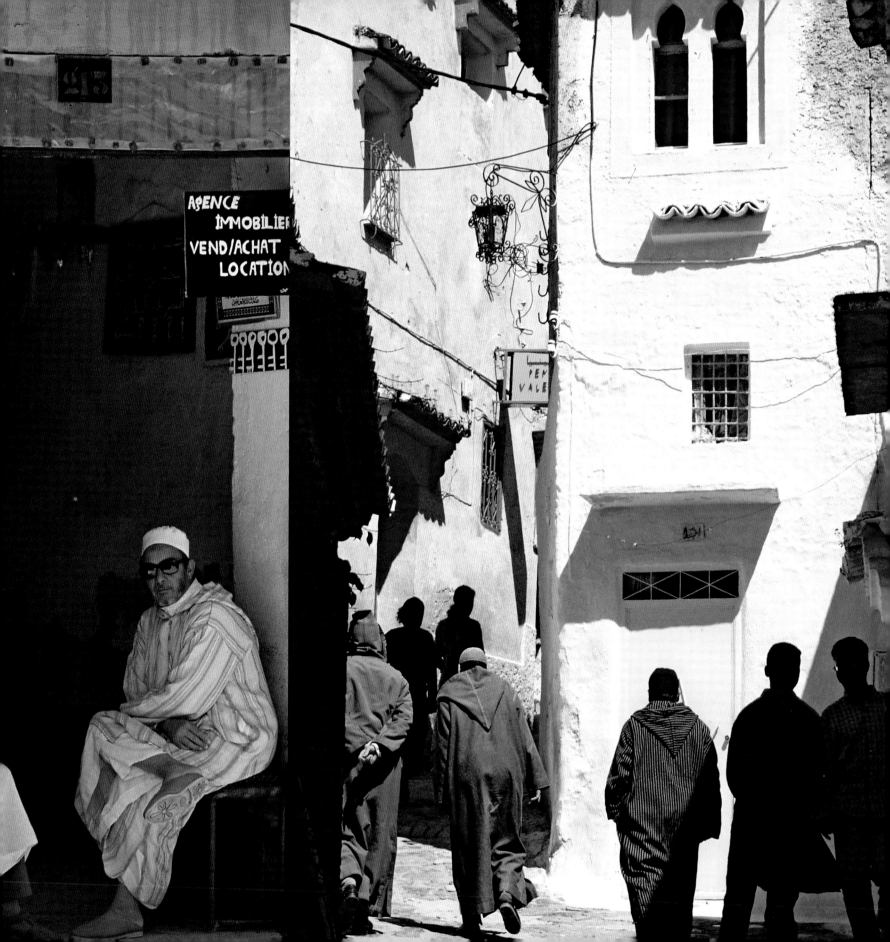

All traditional Arab towns look alike, not because of the style of their buildings but because their houses are pressed against each other and so form a smooth uniform canvas, while at the same time each house preserves its uniqueness and hides itself from the curiosity of passers-by. The interior remains concealed behind high walls so that the private life of the inhabitants can be discovered only from above, on the terrace, which is the way the house breathes and its opening to the sky.

Amjad Nasser, *Impressions du Maroc (Impressions of Morocco)*

You can find something to eat at any time of the day or night in the medina. Cumin-flavoured kebabs are sizzling on red-hot iron braziers and then stuffed in half a *kesra*, the Moroccan bread, so as to lose none of the taste of the spicy meat. The tajines cooking on kanouns or clay hearths combine their fragrances with that of mint. Sheep's heads, calves' feet, hard-boiled eggs with salt and cumin . . . The food cooked on the streets is always fresh because Moroccans are very exacting in this matter. Handcarts sell fruit, vegetables, sweet things or snails cooked in spicy, herb-flavoured stock. The man selling fritters produces mouth-watering gold rings in no time by dipping balls of white dough in boiling oil while women make irresistible *beghir*, the pancakes 'with a thousand holes'.

**LEFT**
Cinema posters in the medina of Tiznit.
**RIGHT**
The fish market in Tiznit.

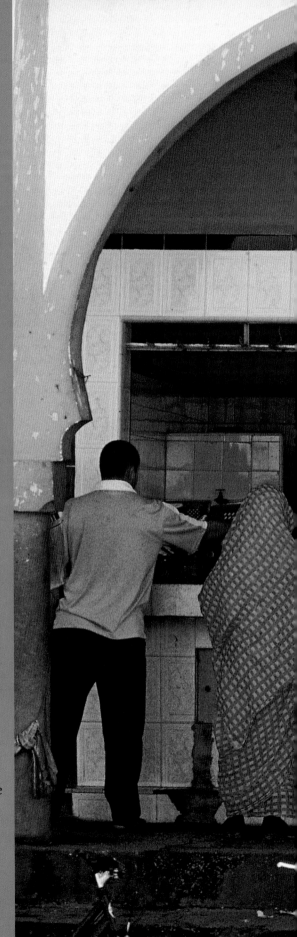

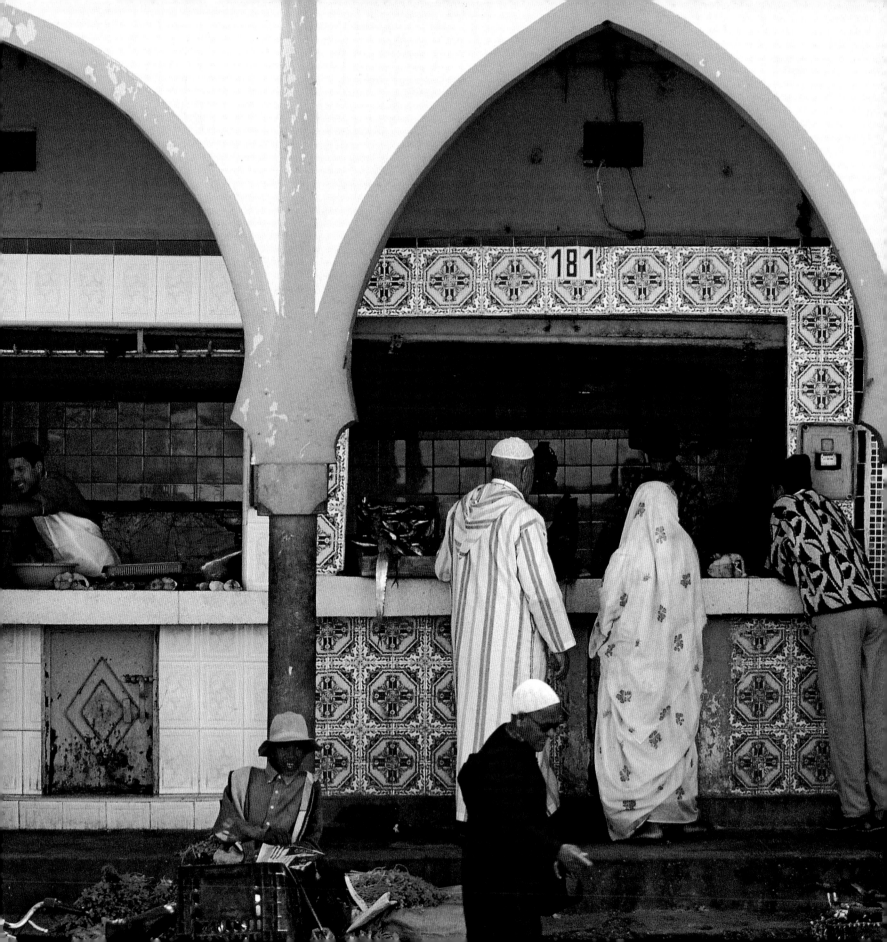

مدينة الريصاني محطة
وقوف السيارات و الشاحنات
PARKING 2.00 DH

Municipalité My ALI CHERIF    بلدية مولاي علي الشريف
N° 0    MARCHES    أسواق

1,00 DH
N° 169281    1 درهم
Un Dirhams.

52

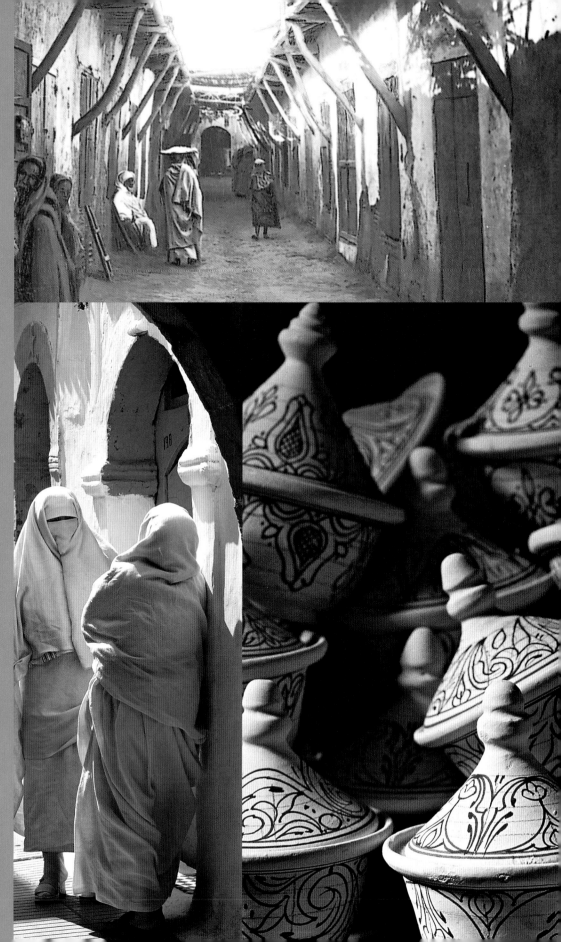

The world of the souk is the extrovert face of the medina. A convivial place of exchanges and contacts, it is where both inhabitants and strangers meet. In contrast, the family's private life is protected behind high, windowless walls and heavy doors. The numbering of the houses in the medina is confusing for those who do not know how it works. Like the Arab script, it goes from right to left and follows all the twists and turns of the street.

**LEFT**
In Fès, skeins of silk yarn dry on a terrace before being spun, then woven. • The door of a house in Chefchaouen. • A grocer's shop in Taroudannt.
The old photographs show, clockwise from top left, a street in Marrakesh at the beginning of the twentieth century; a Moroccan woman in regional costume on a rampart in Rabat in about 1919; and the Andalusian district in Fès.

**RIGHT**
A street in Taroudannt at the beginning of the twentieth century. • Women in the medina of Essaouira. • Small earthenware pots with a cone-shaped top, medina of Fès.

**OVERLEAF**
When dusk falls on Djemaa el-Fna square in Marrakesh, itinerant restaurateurs set up their stalls lit by paraffin lamps. In this open air restaurant, people gather round the welcoming tables where they enjoy couscous, kebabs, fried aubergines, hot harira and omelettes flavoured with coriander.

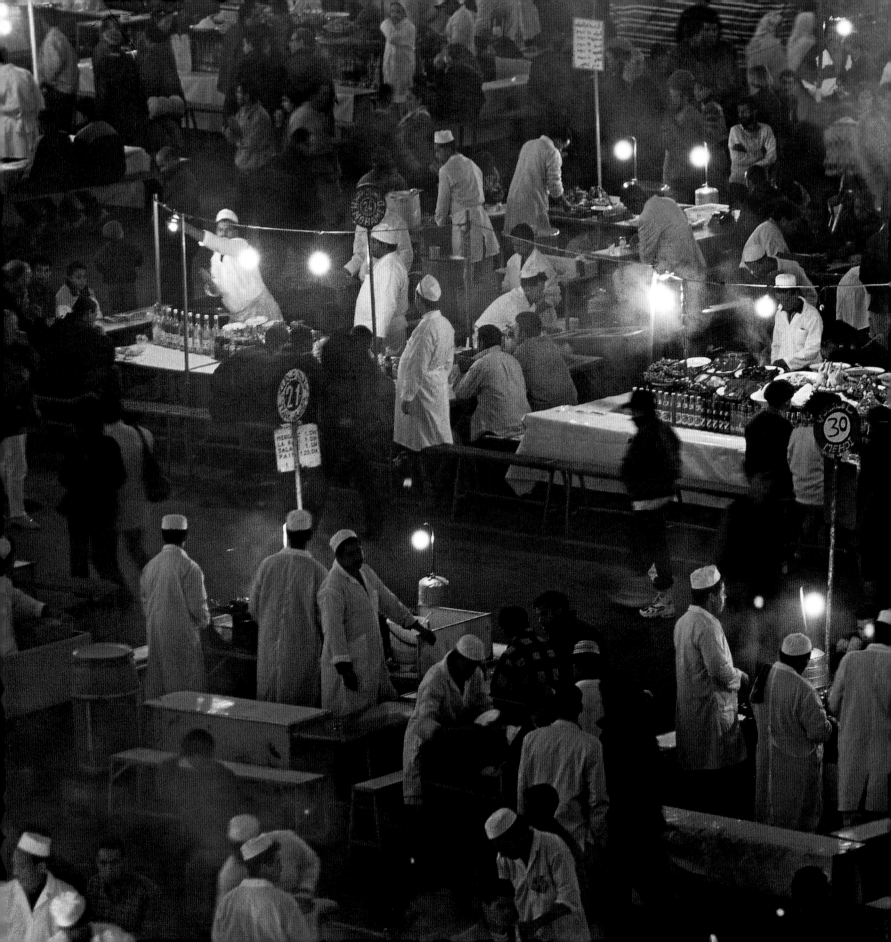

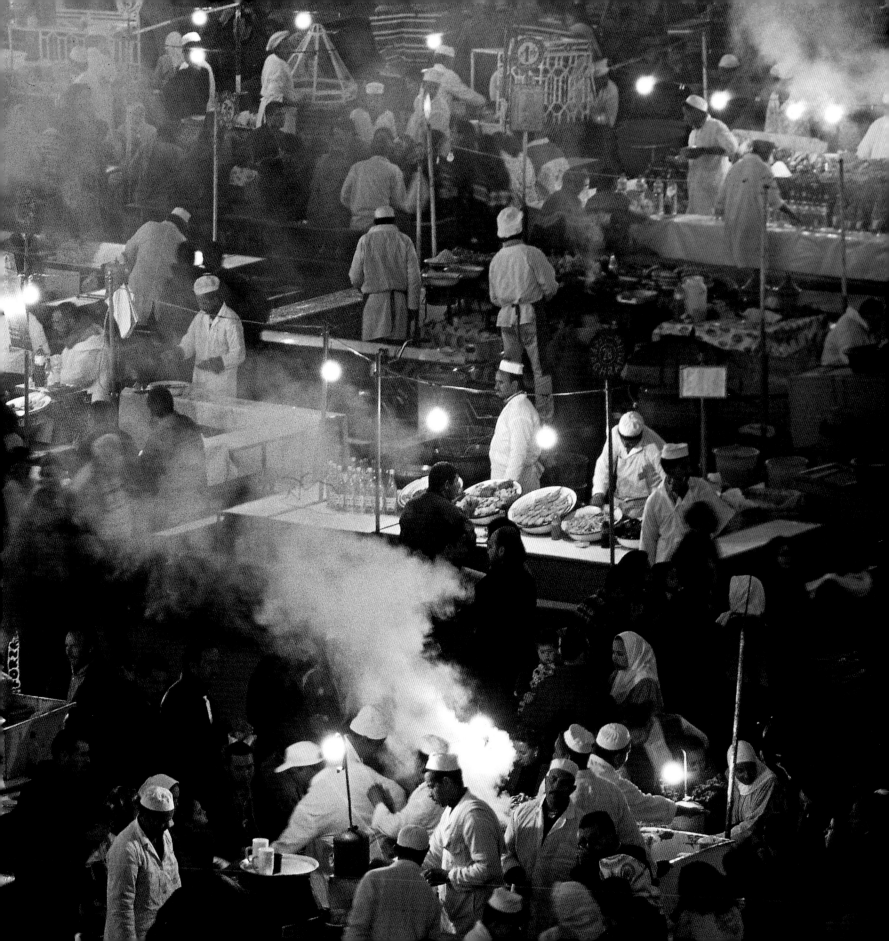

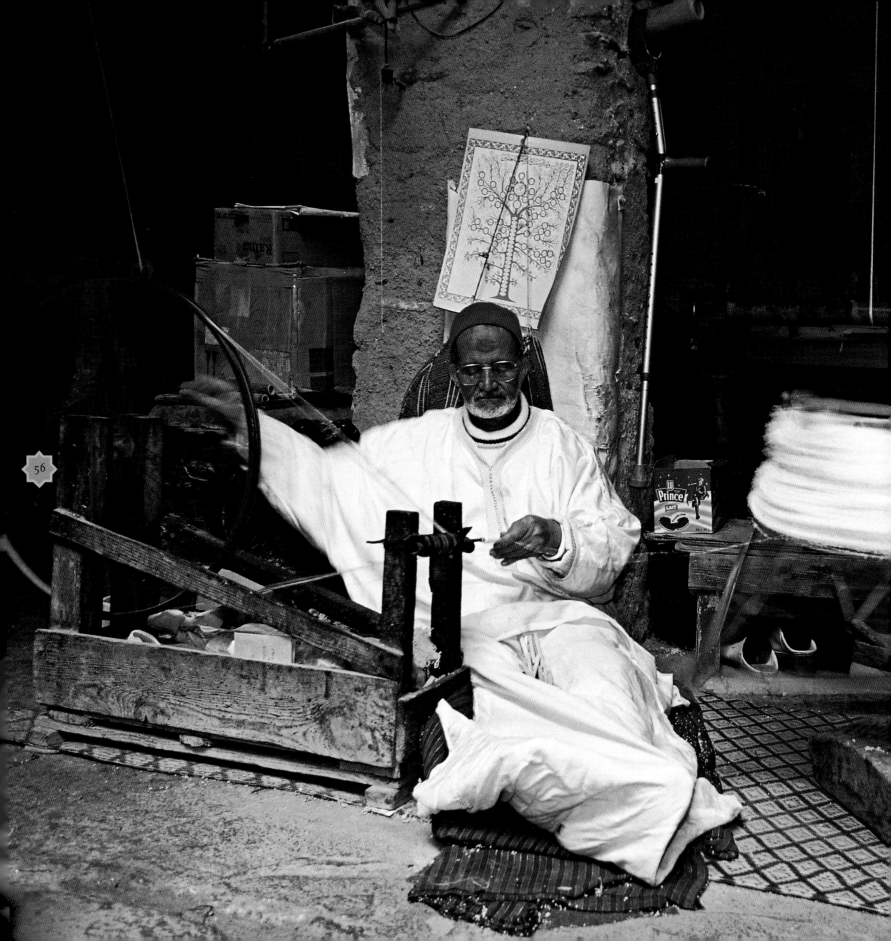

The silk winders turn the large wheels amidst their skeins the colour of exotic birds; the dyers hang their wools and silks, still steaming from the vats, above the streets. For centuries, the stallholder selling dates, nuts, almonds and henna has sat above his goods, like some ancient idol, a wooden spoon at hand to serve his customers from afar.

Jérôme and Jean Tharaud, *Marrakech ou les Seigneurs de l'Atlas (Marrakesh or the Masters of the Atlas)*

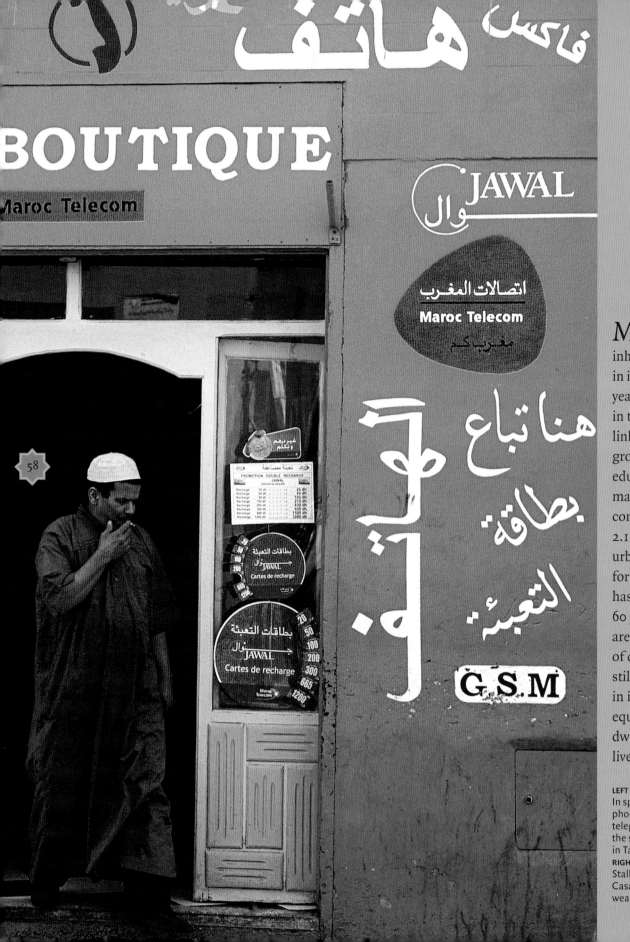

فاكس) هاتف

BOUTIQUE

Maroc Telecom

JAWAL

اتصالات المغرب
**Maroc Telecom**

58

هنا تباع بطاقة التعبئة

G.S.M

Morocco, with 30 million inhabitants, has seen a decline in its growth rate in the last ten years. The downward trend in the size of the population, linked to the country's growing urbanization, the education of women and marriages later in life, is confirmed by a birth rate of 2.1 children per woman in urban areas. A rural society for centuries, Morocco now has a population that is nearly 60 per cent urban and there are sharp contrasts in levels of development. There are still significant differences in income and access to basic equipment between town dwellers and and those who live in the country.

**LEFT**
In spite of the spread of the mobile phone in recent years in Morocco, little telephone shops still play a useful role in the social life of a town or village, here in Taroudannt.
**RIGHT**
Stalls selling spices in the souk at Casablanca. • A shopkeeper in Essaouira wearing the traditional Moroccan dress.

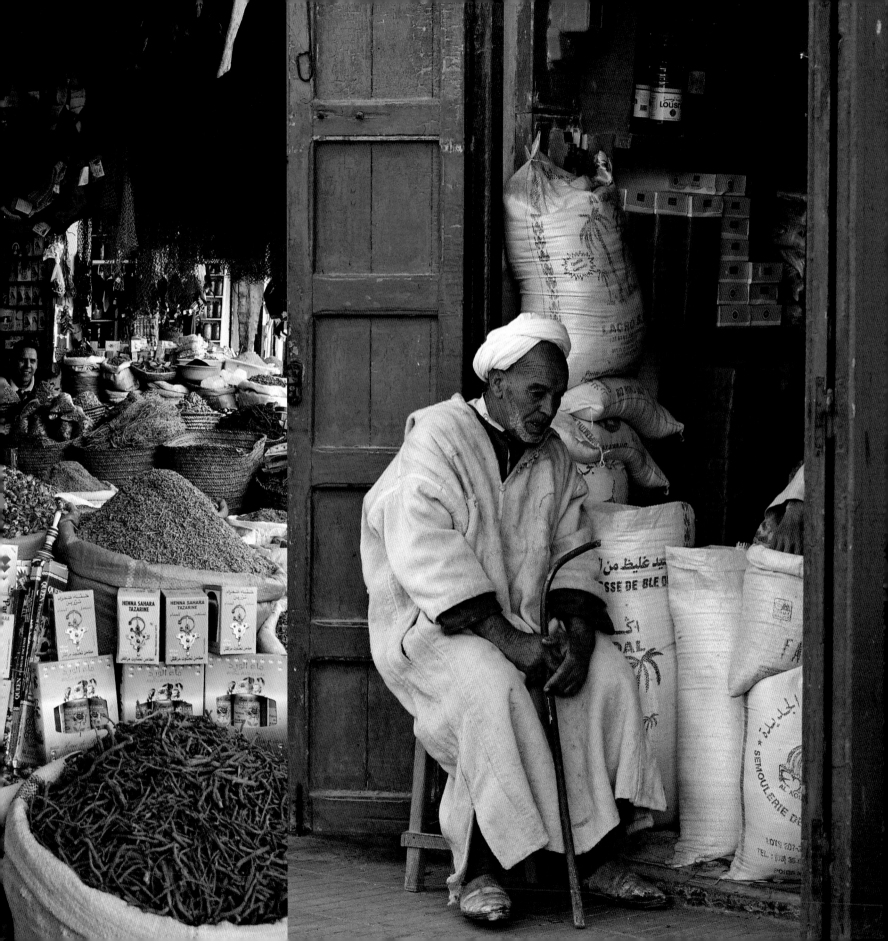

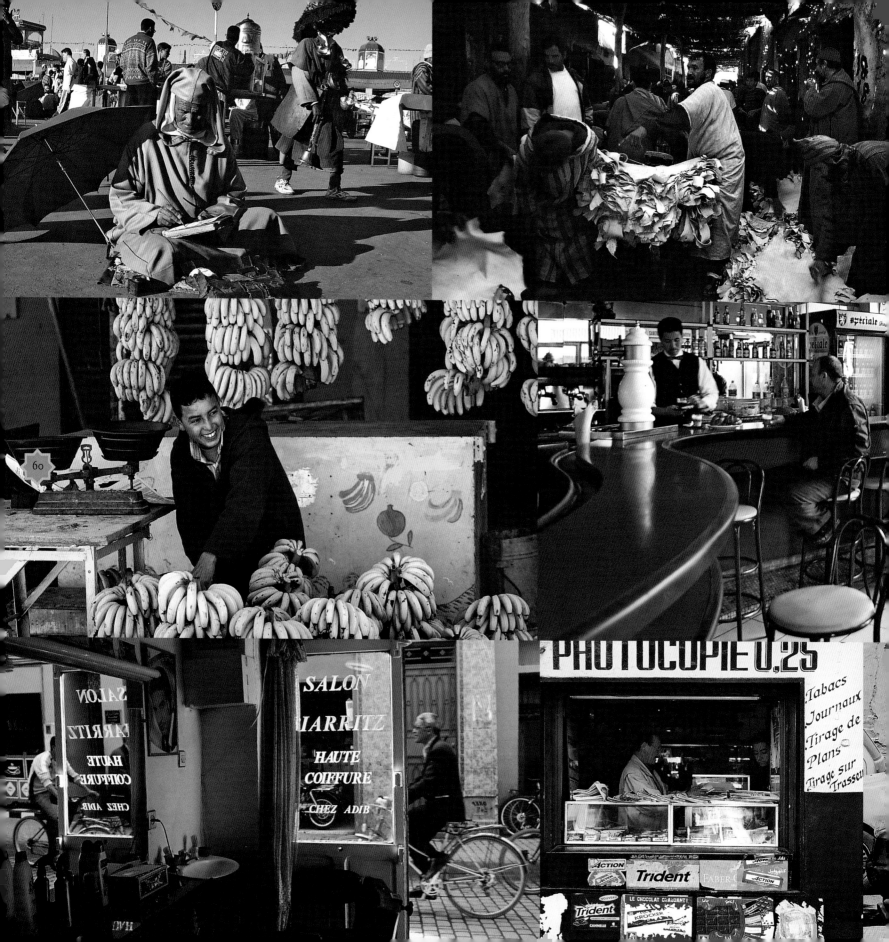

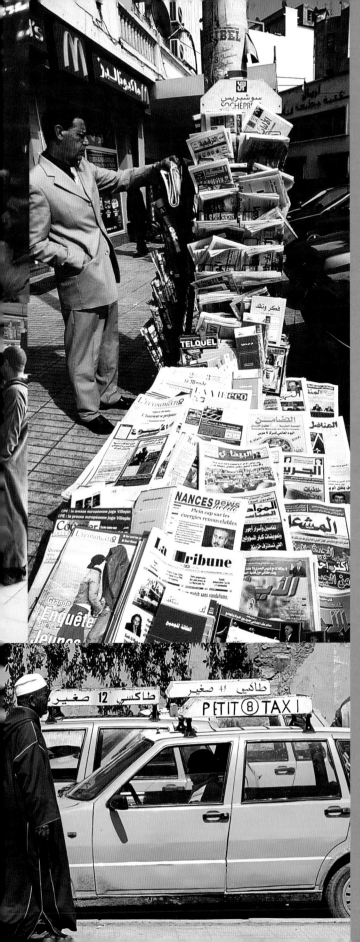

Morocco has a flourishing small-scale economy, visible but not easily quantifiable, especially as far as the craft industry and trade are concerned. Apart from the hypermarkets to be found at Casablanca, Rabat and Marrakesh, most people still shop in small boutiques and at markets. Well integrated in the social fabric of the medina, these small shops, supplied by local workshops, offer all kinds of products at unbeatable prices. From hawkers to cigarette sellers and the small shopkeeper selling contraband goods, the range of activities defined as 'parallel' is endless. This phenomenon has its roots in the traditions of bartering and the desire to avoid any attempt at registration and census.

**LEFT**
Djemaa el-Fna square in Marrakesh. • The leatherworkers' souk in Marrakesh. • A stall selling newspapers and magazines in Casablanca. • A merchant selling bananas from Sous in Tamri, to the north of Agadir. • The Petit Poucet café in Casablanca. • Barber in Taroudannt. • A tobacco and newspaper seller in Casablanca. • The 'litle taxis' of Taroudannt.
**RIGHT**
Drinking mint tea in Taroudannt. • The medina.

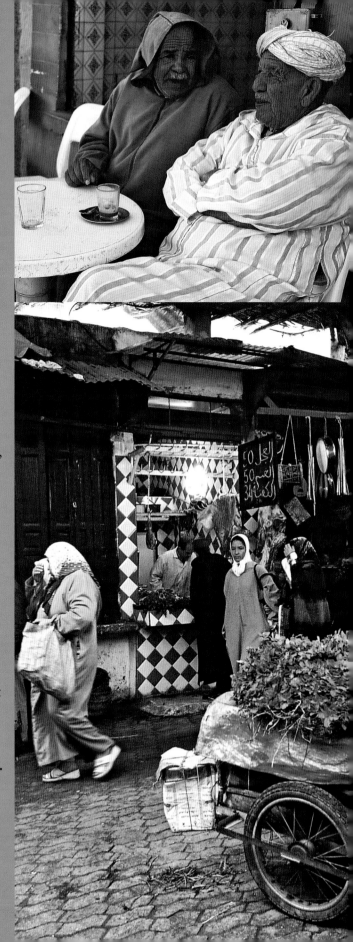

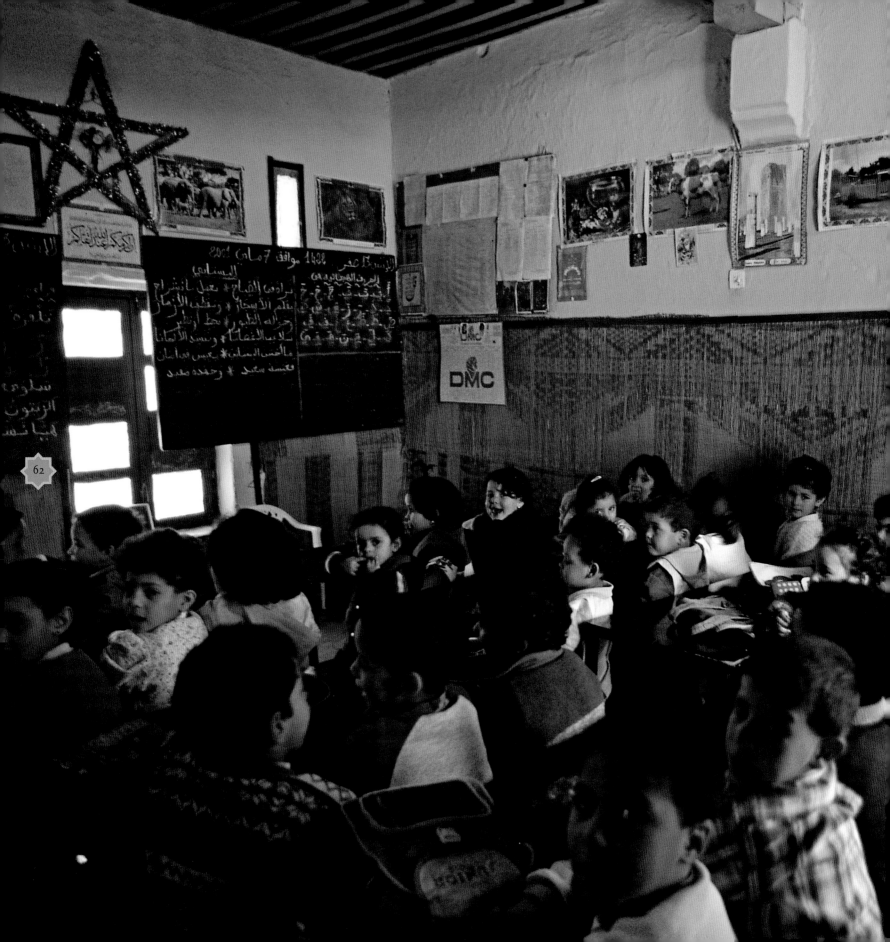

62

In Morocco over 30 per cent of the population is under the age of fifteen. As a result, education is a major investment for the country. Close to 97 per cent of children attend school at primary level and almost 68 per cent are in secondary education. The education system has greatly improved, trying hard to reduce the educational backwardness in rural areas. Similarly, the gaps in attainment that existed between boys and girls have been considerably reduced. Nonetheless, more than 50 per cent of adults are still illiterate and many problems remain to be resolved. Arabized in a rush in the 1970s, the education system is finding it difficult to meet the requirements of modern life; the command of the French language, the language used in business and technology, is the preserve of the more privileged members of society.

**LEFT**
A classroom of children in the medina of Meknès.
**RIGHT**
Sweets in a small shop in the Mellah district of Marrakesh.

# IN THE HEAT OF
# THE SOUKS

Enveloped by a sea of colours and smells, the visitor who ventures into the souk is faced with a wonderful, magical world where the light is subdued as it filters through the bamboo trellises or the wooden latticework shielding the alleyways from the heat of the sun. The range of goods on display in the tiny shops lining the narrow streets is breathtaking. Every corner is filled with goods for sale and all the stalls overflow with tempting products. Earthenware pots are skilfully piled on top of each other, walls are lined with colourful ceramic dishes, the babouches stand two by two waiting for buyers and the carefully polished copper vessels sparkle in the background.

The trading heart of the big medinas, the souk is organized in a hierarchic fashion around the Great Mosque. Near the Mosque itself are the traders in more luxury goods, such as goldsmiths, bookbinders, booksellers and moneychangers. Further away, the products become more commonplace. The tanneries and blacksmiths, the most polluting and noisiest activities, are concentrated near the ramparts. The practitioners of each trade – brassworkers, weavers, carpenters, cobblers – have their own street, lined with tiny stalls that are closed at night with two shutters. Craftsmen have preserved their skills by tirelessly repeating the same movements, passed down from father to son or under the benevolent eye of a *mâalem*, the master craftsman.

Occupying a central position and criss-crossed by alleyways intersecting at right angles, this district where precious fabrics and silk yarns rub shoulders with embroidered caftans and the oriental slippers known as babouches is closed every evening by heavy wooden doors. In the workshops of the dyers' district, men stir the wool, cotton or silk in large vats filled with dye. Outside, the sky is obscured by fabrics and skeins of dyed wool that, hung out to dry on bamboo rods straddling the street, drip on the glistening paving stones below. The souk specializing in rugs comes to life every afternoon at an auction where dealers sell rugs made by Berber tribes. In the brassworkers' district, men work copper, brass and bronze amid the regular sound of

hammering as they create lamps, platters for festive occasions and kettles for tea. In the basketmakers' quarter, men weave baskets using *doum* – palm leaves – or reeds cut into thin strips. In the babouche-makers' area, slippers are no longer just yellow and white as they were in the past. Real works of art, they are now embroidered with gold or silver thread, silk yarn, or woven in raffia or in the same way as rugs.

The spice district is an intoxicating place where cumin, saffron, cinnamon and turmeric are sold by weight. In the henna souk, traditional medicinal herbs are next to beauty products, kohl or ghassoul soap. Another fragrant souk is that of the carpenters, dominated by the heady fragrance of cedar wood. Cut up in sawmills outside the medina, here the wood is transformed into low tables, chests, chessboards and other decorative objects. Elsewhere, craftsmen cut up small squares of enamelled terracotta, using a chisel, which when assembled will create the colourful zellig mosaics.

Dominated by persistent acrid smells, the tanners' souk is like a painting. Men immersed up to the waist tread the skins of lambs, sheep and cows in round pits filled with tanning agents.

Throughout Morocco, the weekly country souks held in the open or under canvas tents attract people from the surrounding villages. People flock to them in small groups on foot, by mule, riding sidesaddle, by bike or by motorbike. The souk is a centre of attraction, a meeting place where transactions take place and the necessary supplies are bought. It is in the souk that debts are settled and marriages take place. The merchants are grouped together according to their speciality. The farmers sell their produce, grown on their small plots of land, fresh from the ground, weighing the fruit and vegetables on small traditional scales. The impromptu café-restaurants are welcoming places where people quench their thirst with mint-flavoured green tea while enjoying the delicious aromas of the tagines kept warm on braziers.

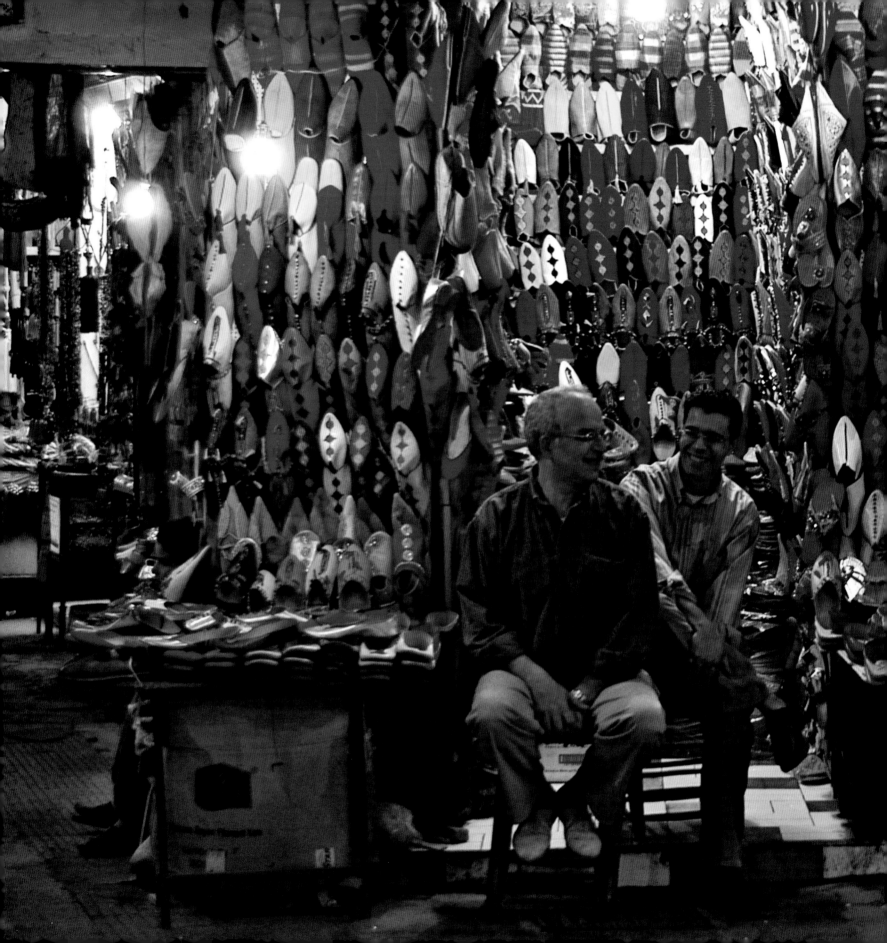

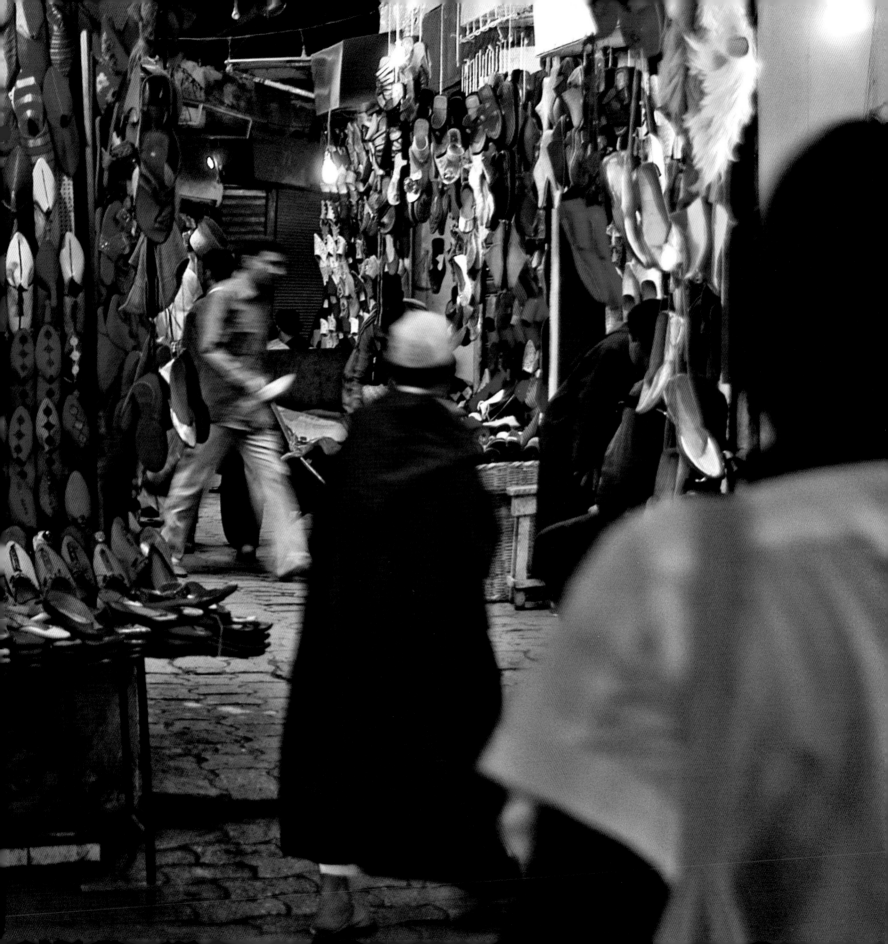

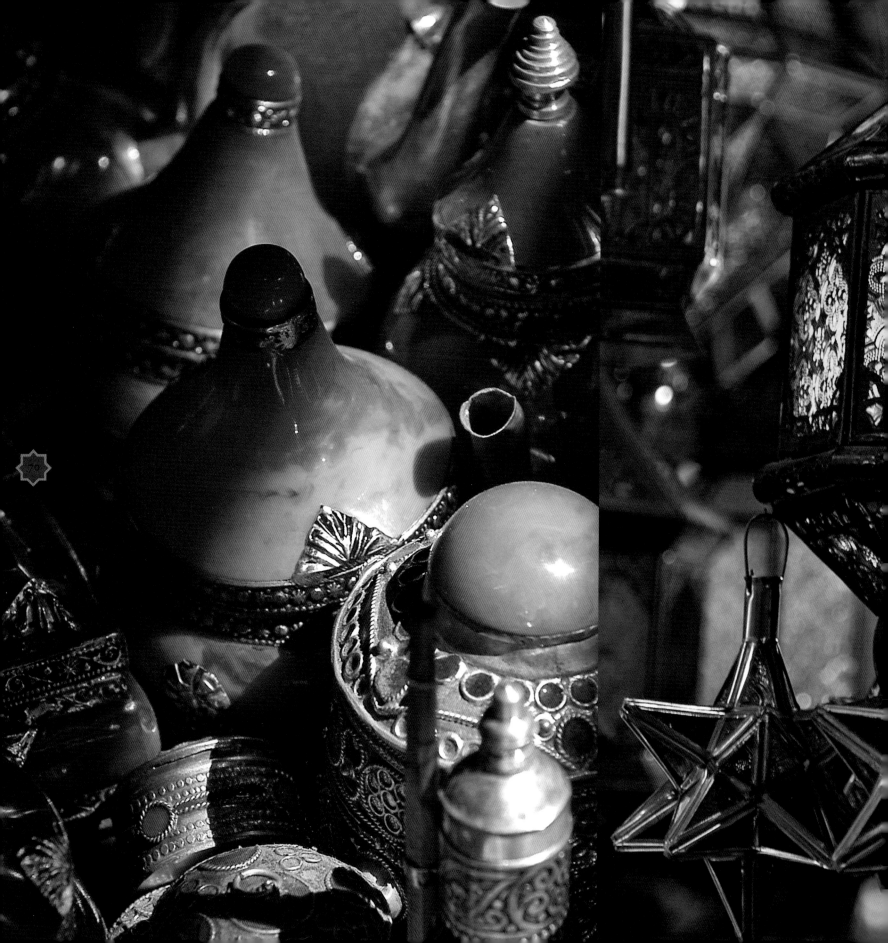

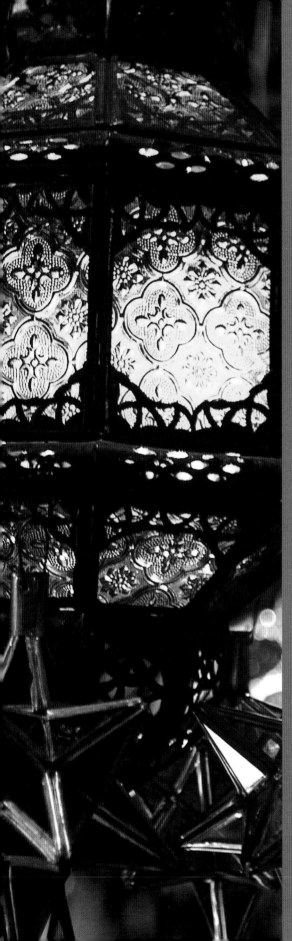

The brassworkers' district is immediately identifiable by the continuous sound of hammering metal. Copper, tin and silver are worked and transformed – beaten, shaped with a hammer, polished and then assembled. Platters, pot-bellied teapots, double-bottomed hand basins with matching ewer, perfume burners and braziers with scalloped sides – all these come to life in the hands of these craftsmen. Engraved with a chased design and sometimes made of openwork, these metal objects add a touch of elegance to coloured glass lanterns or ceramic items.

**PRECEDING PAGES**
Slippers of all colours fill the souk dedicated to them in Marrakesh.
**LEFT AND RIGHT**
Decorative pottery, lamps and necklaces in the souks of Marrakesh.

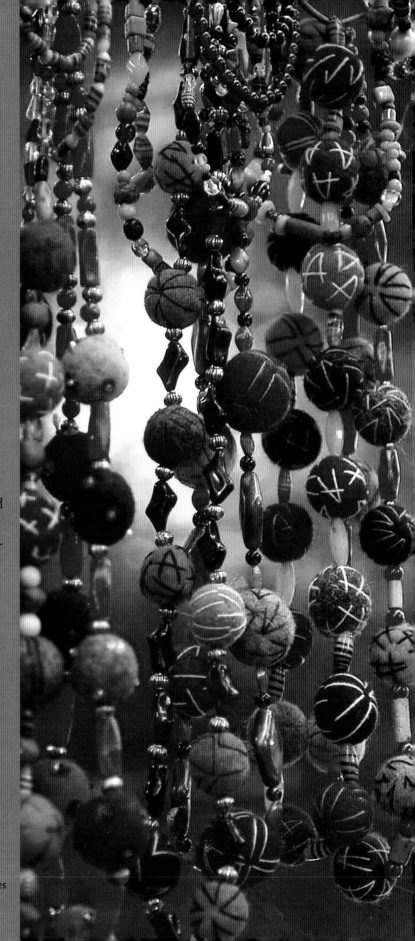

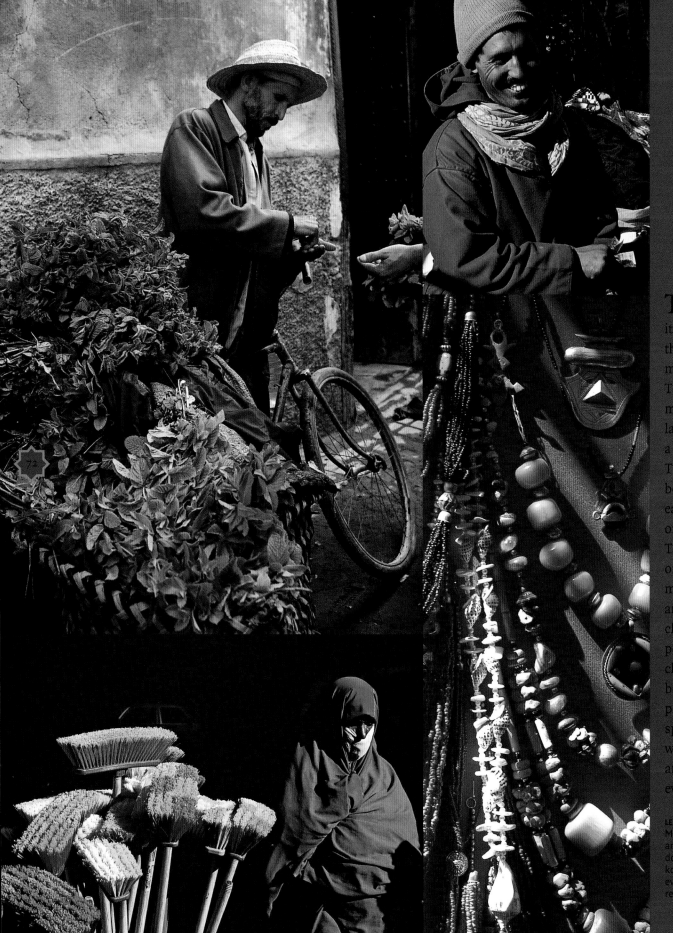

Tradesmen, craftsmen, itinerant sellers, *maâlem* ... the dramatis personae of the medina bring the souk to life. They start working early in the morning and continue until late at night. They only need a tiny place to sell their goods. The itinerant sellers of mint, boiled snails or oranges give each street the appearance of an impromptu market. The herbalists' souk is one of the most picturesque in the medina. There you can buy amulets in bulk, live or dried chameleons, necklaces or powdered coral good-luck charms, flutes made of wood, bone or horn with magical powers, henna that alleviates sprains, musk, amber, kohl which emphasizes the eyes and protects against the evil eye . . .

**LEFT AND RIGHT**
Mint sellers in Marrakesh, orange and broom sellers in Taroudannt, doll and basket sellers in Marrakesh, kohl and spice sellers in Fès . . . all crafts, even the less significant ones, are represented in the souks.

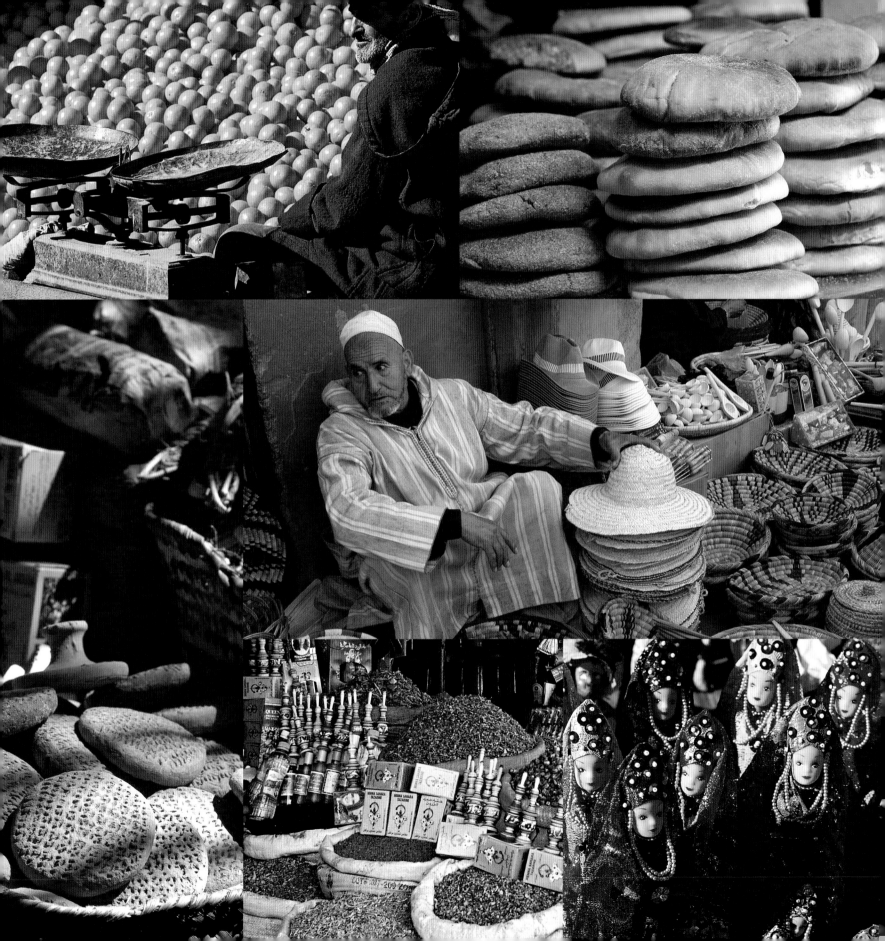

Here and there, shopkeepers and stallholders hold court, surrounded by pyramids of oranges. In the background you can hear the sound of a popular singer's tambourine and the little bell of the water-seller . . . The stalls and trays of sweets attract my attention. There are decorative cockerels and chicks made from yellow sugar, pink filaments, transparent teapots, tiny slippers and bellows. These magnificent objects reminded me of my "Boîte à merveilles".

Ahmed Sefrioui, *La Boîte à merveilles*

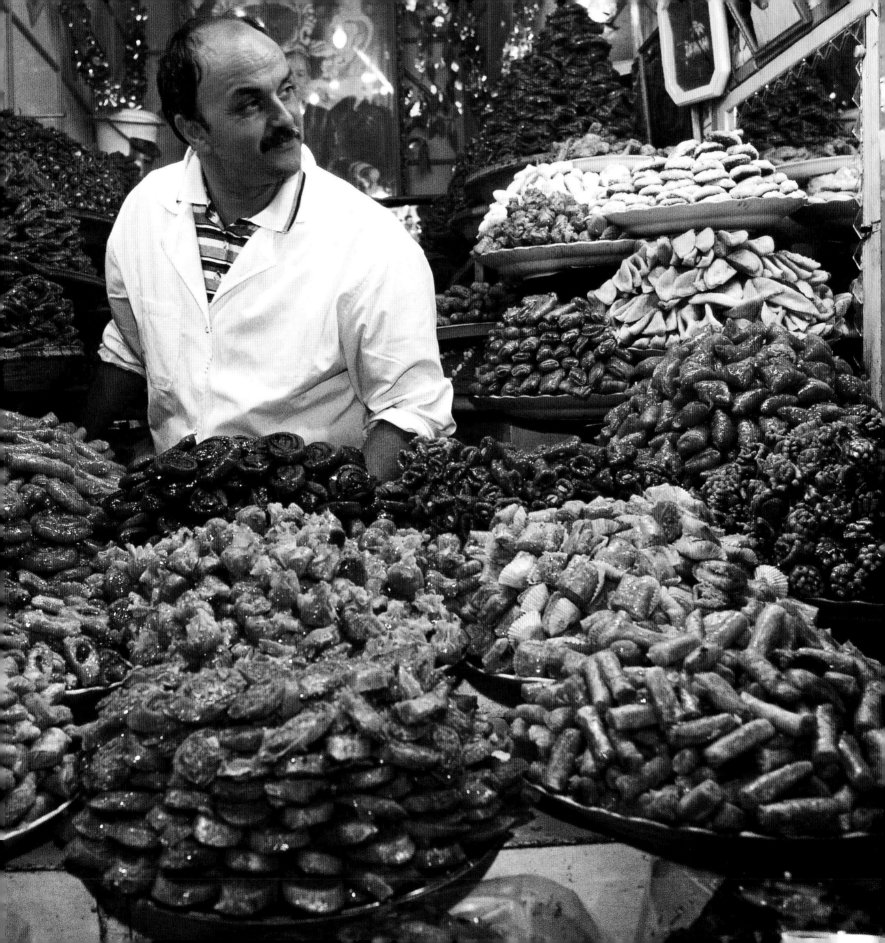

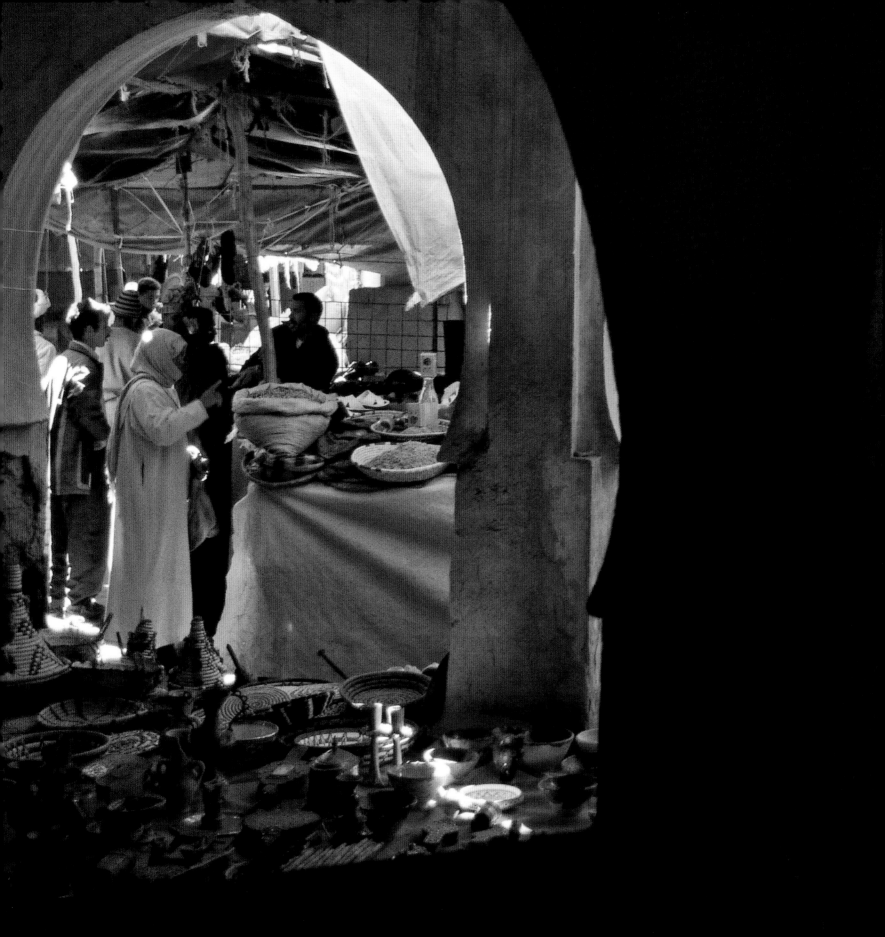

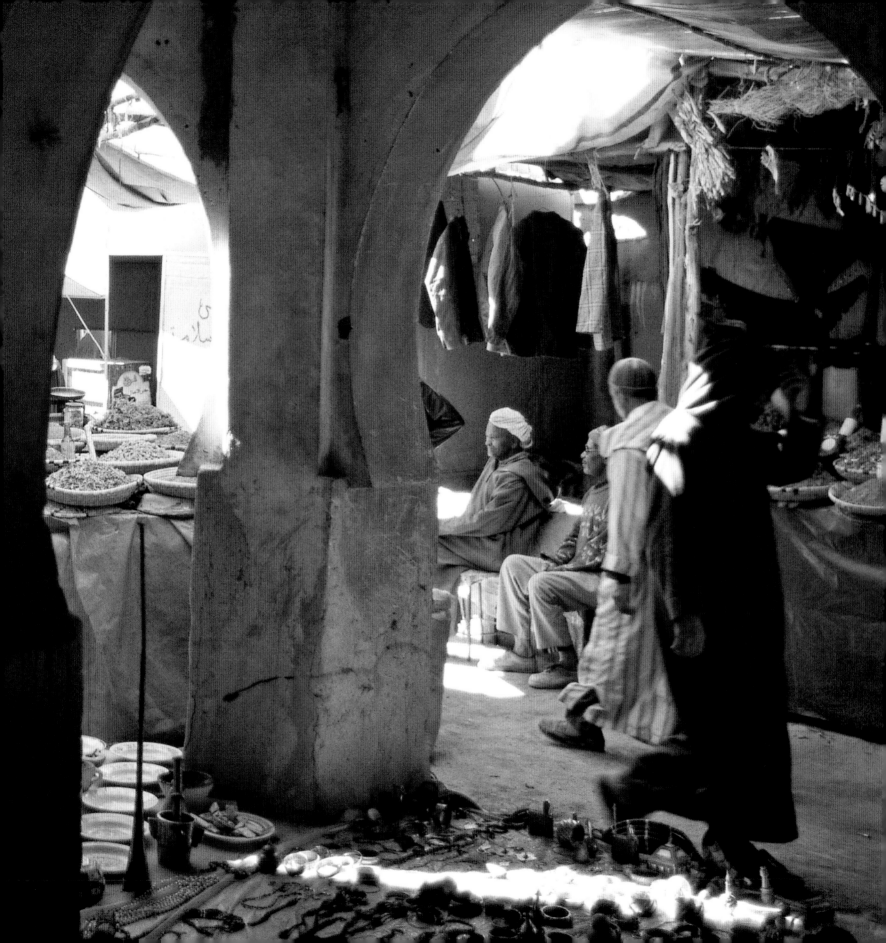

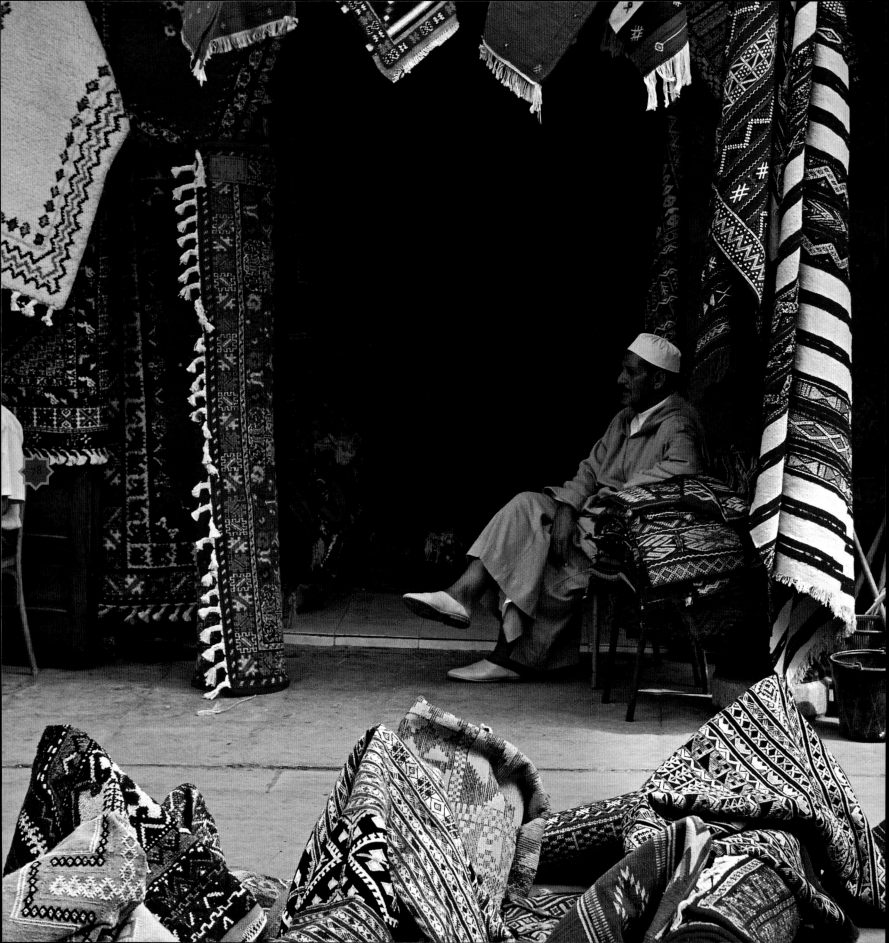

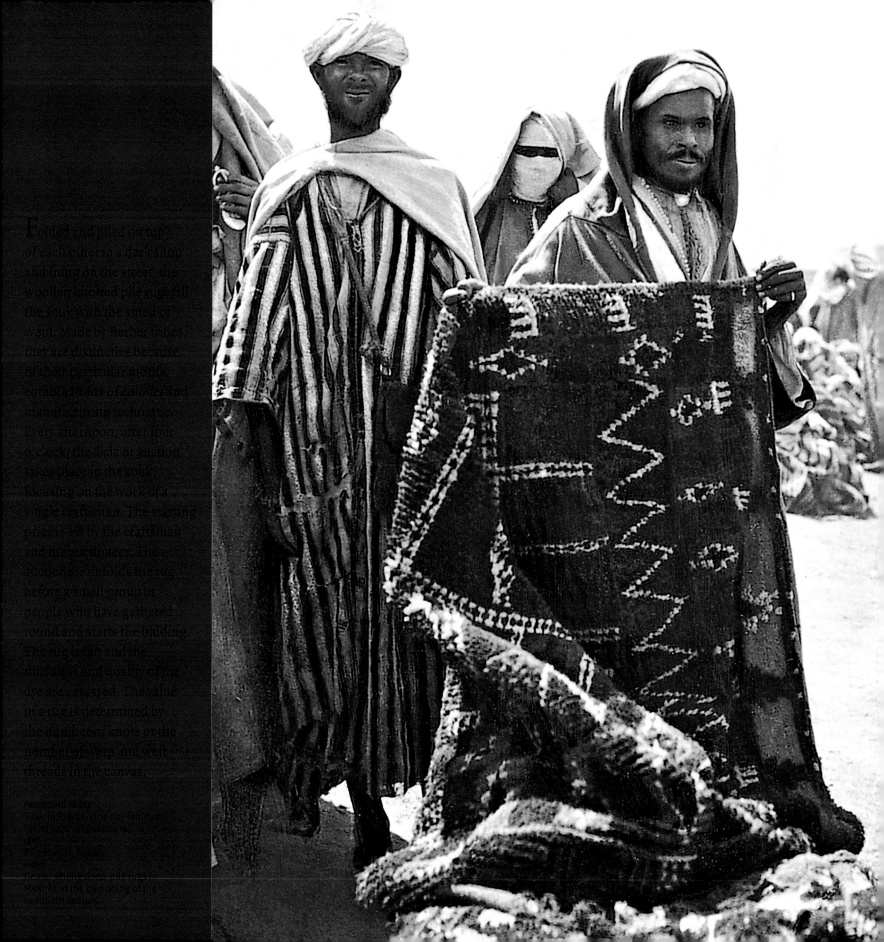

Folded and piled on top of each other in a dark shop and hung on the street, the woollen knotted pile rugs fill the souk with the smell of wool. Made by Berber tribes, they are distinctive because of their particular motifs, combinations of colours and manufacturing technique. Every afternoon, after four o'clock, the dlala or auction takes place in the souk, focusing on the work of a single craftsman. The starting price is set by the craftsman and the auctioneer. The auctioneer unfolds the rug before a small group of people who have gathered round and starts the bidding. The rug is felt and the thickness and quality of the dye are assessed. The value of a rug is determined by the number of knots or the number of warp and weft threads in the canvas.

PRECEDING PAGES:
Souk in Marrakesh (the rug famous for its rich ochre colour).
Left:
Rugs souk in Rabat.
Right:
Picture of the carpet souk in Meknes at the beginning of the twentieth century.

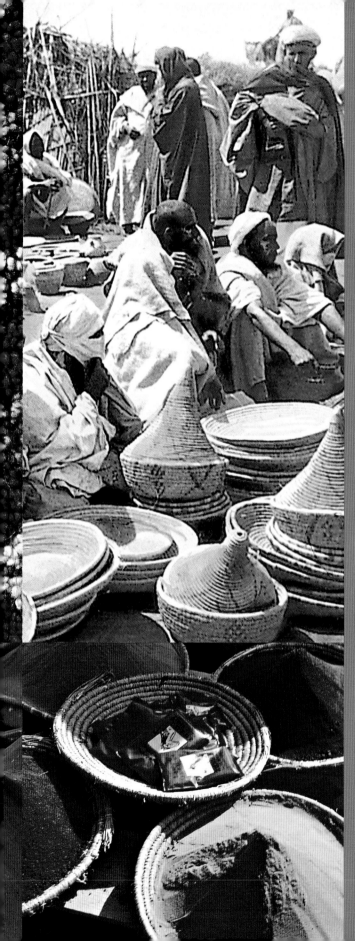

The abundance of fresh produce in the medina is made possible through the large number of small carriers, since methods of refrigeration are rare. In the souks and at home, the tagine pot – easily identifiable with its conical top – is the most widespread cooking utensil. Initially, the term 'tagine' referred to the container itself, but by extension it now also refers to the stew cooked in it. The round container, made of thick earthenware pottery, protects the food from the flames and enables it to simmer for a long time. The lid keeps the food hot. Made with meat, chicken, fish or vegetables, the tagine is the Moroccan dish *par excellence*.

**LEFT**
Tazenaght rugs. • Baskets sold on a market in Marrakesh at the beginning of the twentieth century. • Tagine pots. • Baskets filled with spices.
The old photographs show, clockwise from the top right, the souk in Marrakesh at the beginning of the twentieth century; people drinking tea in the Grand Socco district in Casablanca in about 1914; and one of the gates to the medina in Fès, Bab Mahrouk, in 1919.
**RIGHT**
A butcher in Fès.

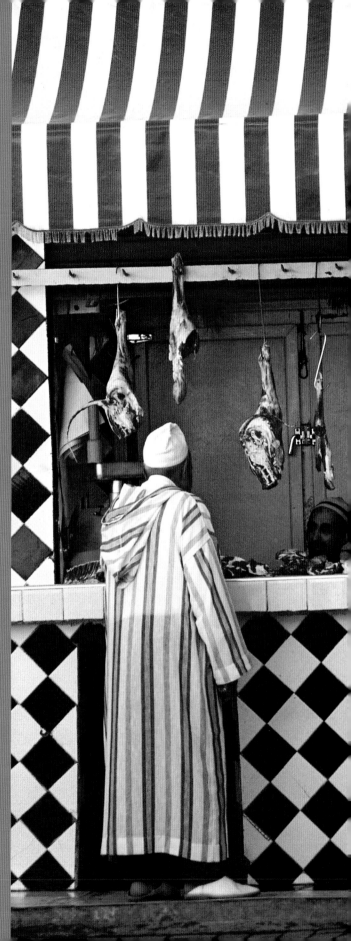

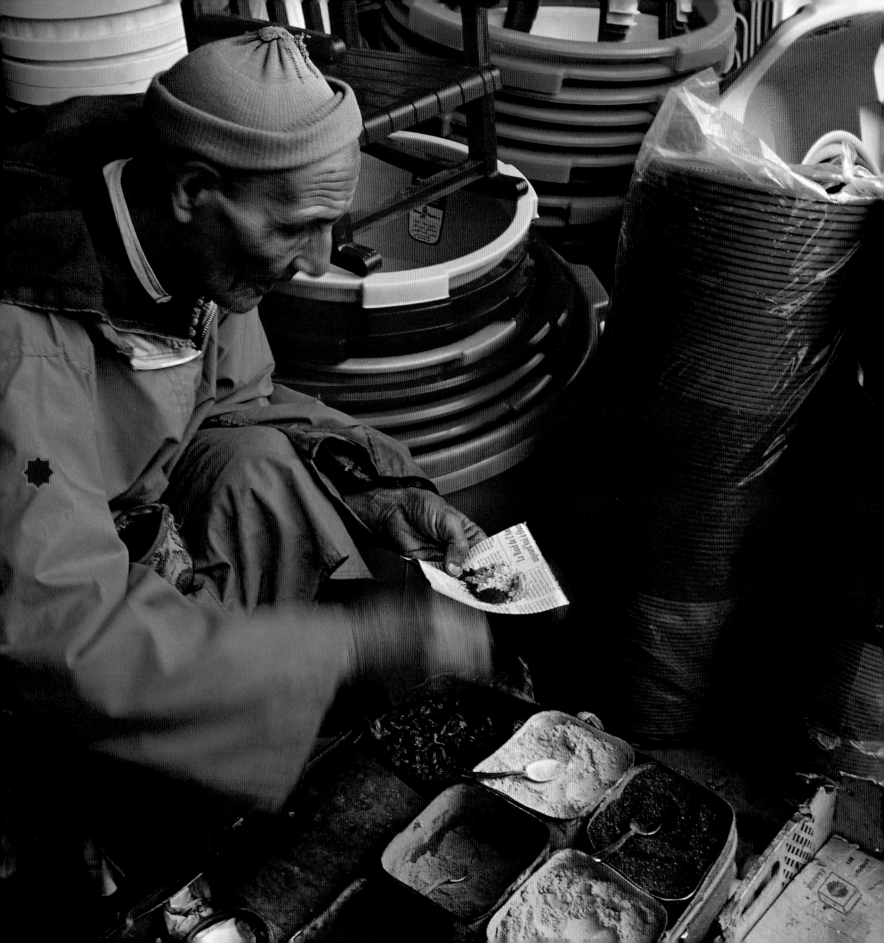

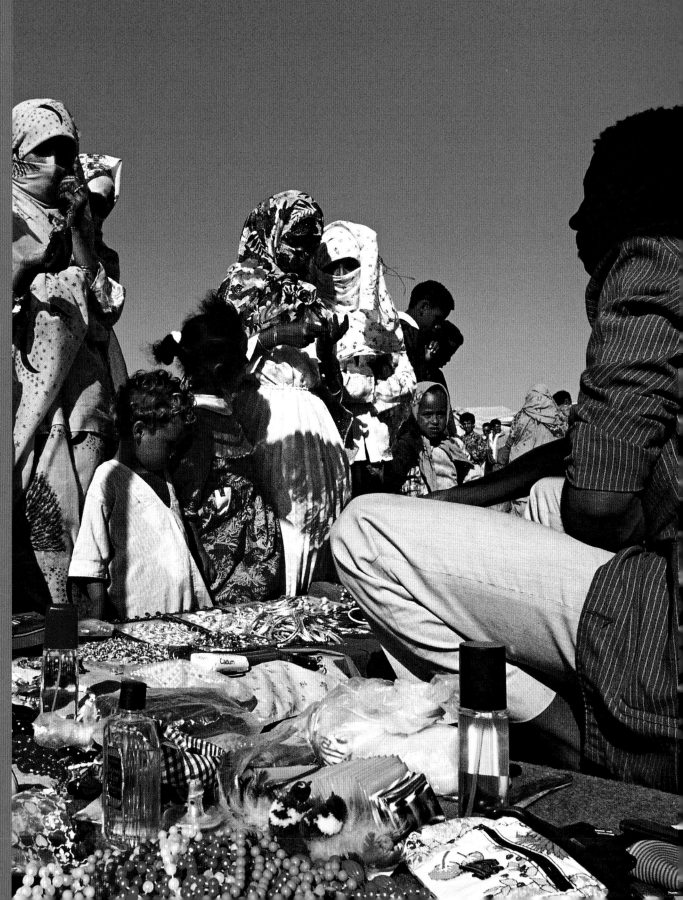

In rural souks, the stallholders are grouped according to what they sell. Some of them sell manufactured products: bags of green tea, plastic sandals, music cassettes, sugar loaves sold in lumps of 2 kg (about 4½ lb.) and wrapped in mauve paper, synthetic fabrics, plastic bowls and so on. On the butchers' stalls meat is cut up on the spot. The local craft products, such as wicker-work, pottery and rugs, are usually sold by the craftsmen themselves. As well as these traders, there are the omnipresent sellers of fritters and kebabs, cigarette vendors, barbers and cobblers.

**LEFT**
In the Ourika valley.
**RIGHT**
A rural souk near Agadir.

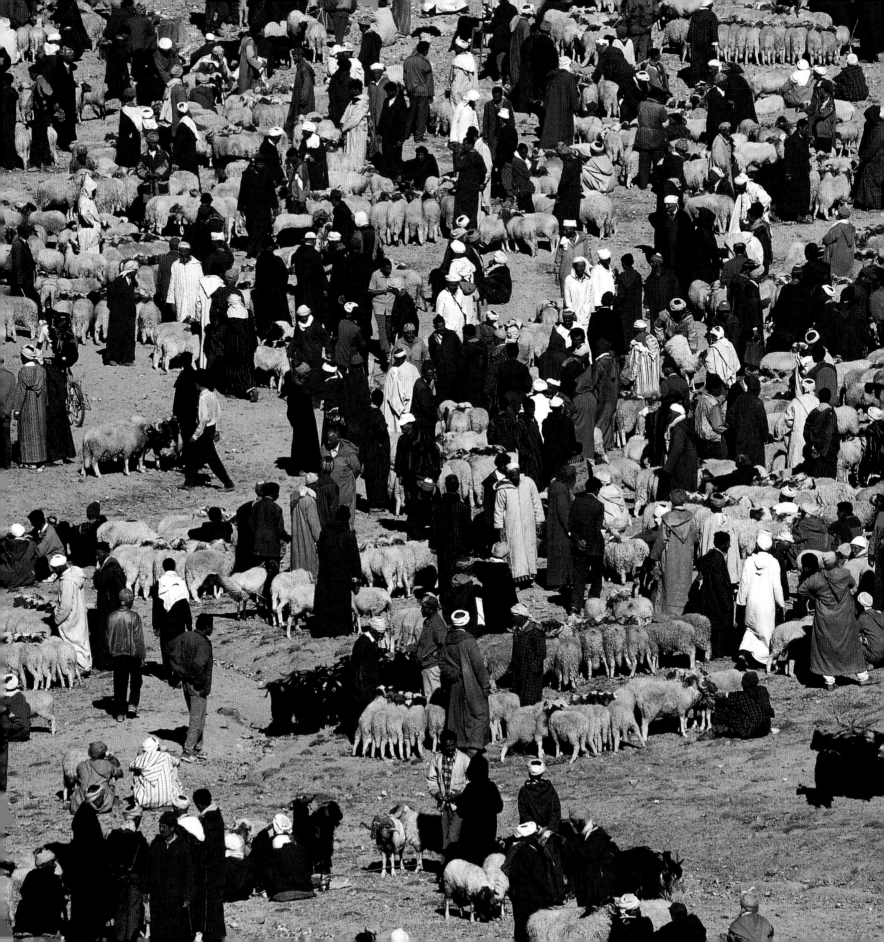

. . . in central Morocco, the souk is much more than a market. People go there without having to buy or sell anything; and to go there they do not mind walking a couple of days. In this country where the population is scattered, going to a souk is, with pilgrimages, the only way to meet people. In the past, the souk was the centre of political and social life *par excellence.*

Jean Robichez, *Maroc central (Central Morocco)*

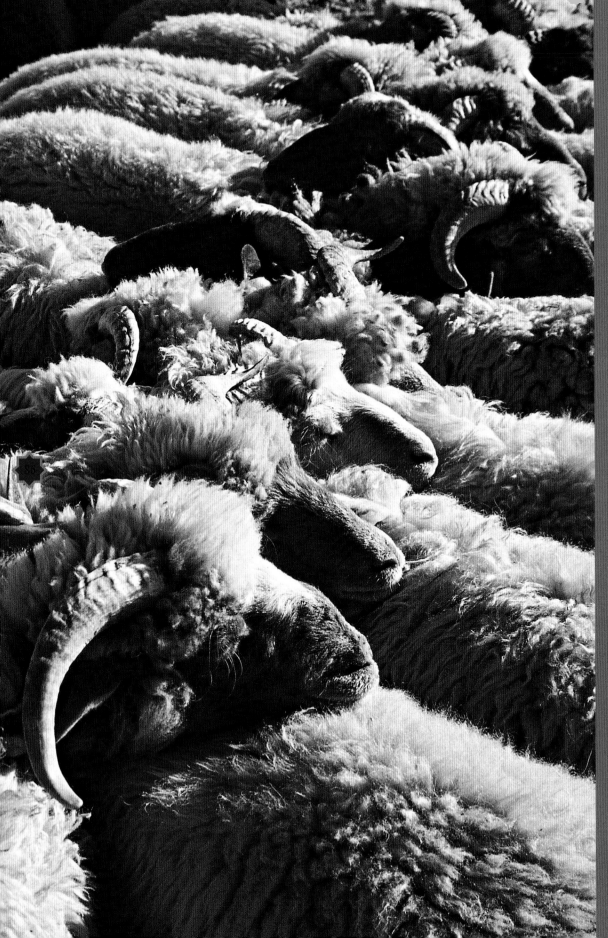

The large souks also have their own market for livestock where, depending on the region, donkeys, mules, cows, sheep and camels are bought and sold in the course of a day. In moussems such as that of Imilchil, in the High Atlas, the livestock are kept a little distance from the souk and the different herds do not mix: the dromedaries are tethered to one side while the mules and cows are at the other. Gathered in groups of twelve, the sheep form perfect squares of thick wool, their heads together and their horns locked so as to prevent any panicky movements. When an agreement has been reached between buyer and seller, both place their right hands palm to palm. This verbal agreement is always respected among honourable people.

**LEFT**
Sheep at the souk of Imilchil.
**RIGHT**
Endless discussions among merchants at the souk of Imilchil.

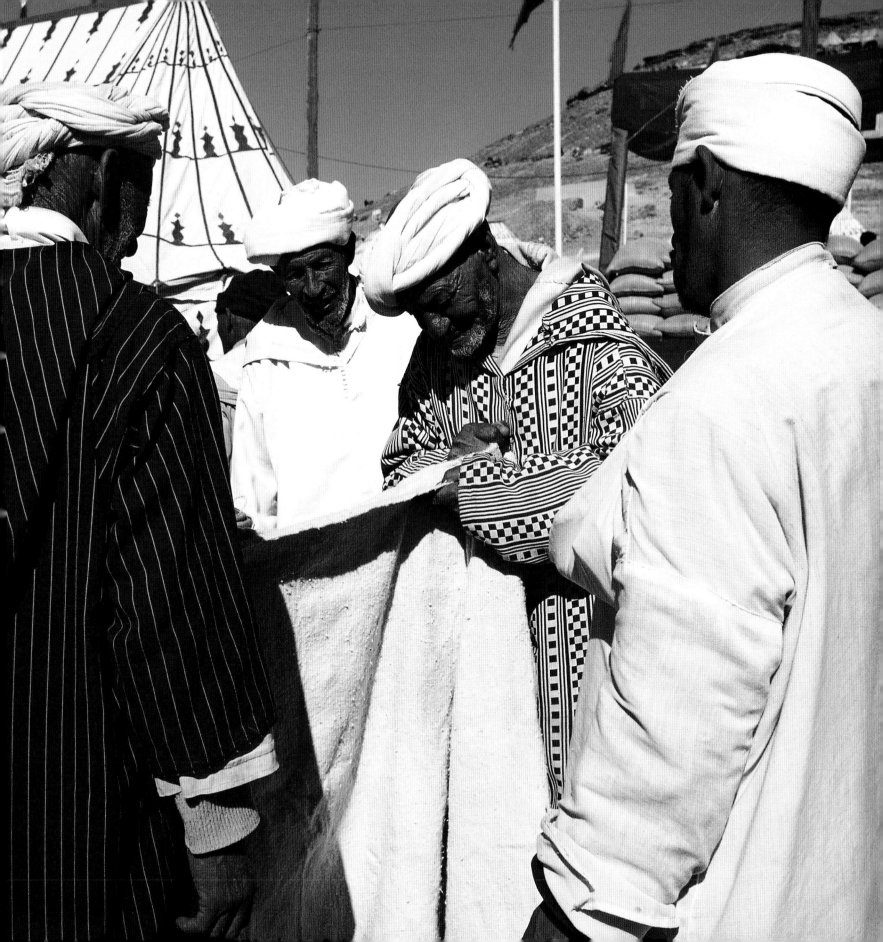

# THE CALL OF THE MUEZZIN

Five times a day, the muezzin's call to prayer from the top of the minaret reminds people of the importance of Islam as Morocco's official religion. The king, the direct descendant of the Prophet through his daughter Fatima, is the religious head and the commander of the faithful. Moroccan Islam is Sunni. The Sunna, the 'tradition', brings together the *hadith*, that is, the oral traditions of the actions and customs of the Prophet as reported by his family and friends. In Morocco the Malekite rite is practised, this being one of the four legal schools of Sunnite Islam.

Founded by Malik ibn Anas (who died in 795), Malekism accepts that to a certain extent the personal opinion of the doctors of the Law can be taken into account in their search to achieve the common good. Watching over the religion are the ulema, the theologians who are the guardians of sharia law, the Koranic law.

Every Friday at midday the faithful gather in the Great Mosque to pray together and to listen to the imam preaching.

From a historical point of view, the Prophet Muhammad's own house in Medina was the first mosque and its design inspired the master-builders of all other mosques. The architecture of mosques follows very precise rules: an open-air courtyard surrounded by covered arcades where the faithful carry out their ritual and codified ablutions in fountains supplied with fresh water.

One of the sides of the courtyard is occupied by the prayer hall (*haram*). This sacred place consists of an elongated rectangle, divided into several aisles where during prayers Muslims kneel down parallel to each other and prostrate themselves towards the qibla wall. In the middle of this wall is a highly decorated semi-circular niche, the mihrab, which symbolizes the direction of Mecca. On the right of the mihrab is the minbar, a wooden pulpit consisting of stairs surmounted by a throne. It is from there that the imam leads the prayers and preaches on Fridays. This sermon is often transmitted outside through loudspeakers. Inside, the floor of the mosque is covered with mats and its white walls are devoid of all decoration.

Nowadays the muezzin calling the faithful to prayer has been replaced by a recording conveyed by loudspeaker to the four points

> **"** *The king, the direct descendant of the Prophet, is the religious head"*

of the compass. A white flag can be raised at the top of the minaret to alert the hard of hearing that it is the hour for prayer.

Since the French Protectorate, access to mosques has been forbidden to non-Muslims. This measure was introduced by Maréchal Lyautey to avoid incidents between Muslims and Westerners.

In the imperial cities of Fès, Marrakesh, Meknès and Rabat, the madrasas, founded during the Marinid dynasty, are gems of Hispano-Moorish architecture. Before they became historical monuments, in Fès, Meknès or Marrakesh, these religious schools were small universities, religious foundations with an educational purpose. By means of these institutions the Marinids intended to secure the loyalty of the ulema, the doctors of the Law. It was in these madrasas that the future intellectual elite of the kingdom was educated. They provided a multidisciplinary education which included the study of the Koran and Muslim Law, arithmetic, astronomy, geography and sometimes also medicine. Today, the madrasas that are still active teach just the Koran.

The madrasas also provided lodgings for students from other cities, enabling them to receive a free higher education. These places of serenity and harmony all follow more or less the same plan: a way in that is bent at an angle, to shield the occupants from the prying eyes and noise of the outside world, a large square or rectangular courtyard open to the sky, surrounded by covered arcades, and a fountain for ritual ablutions or a basin where the students could cleanse themselves before entering the adjacent prayer room. The floor above housed the students' rooms, where privacy was ensured by an arcade protected by panels of moucharabieh (wooden lattice).

Moroccan Islam co-exists with other beliefs, for instance the cult of saints, inherited from the Berbers. Every year the cult's followers celebrate their revered master with processions to the various sanctuaries. The nature of the saints, their fame and their reputation reflect a certain hierarchy, because some great saints are direct descendants of the Prophet.

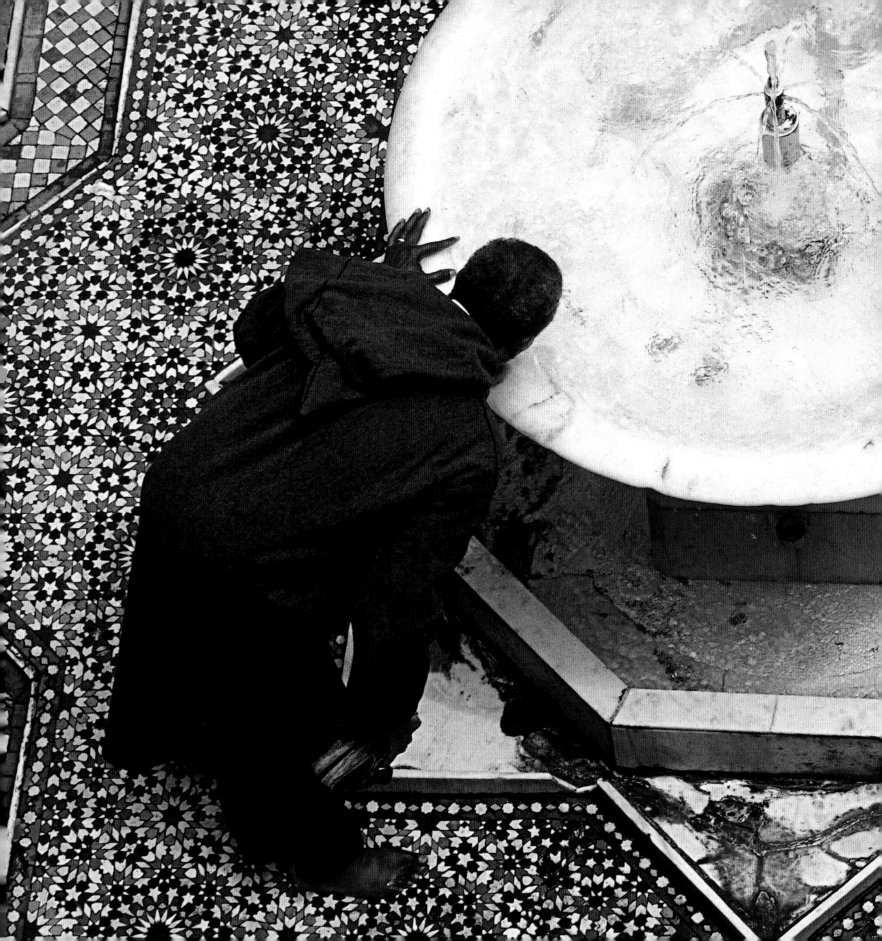

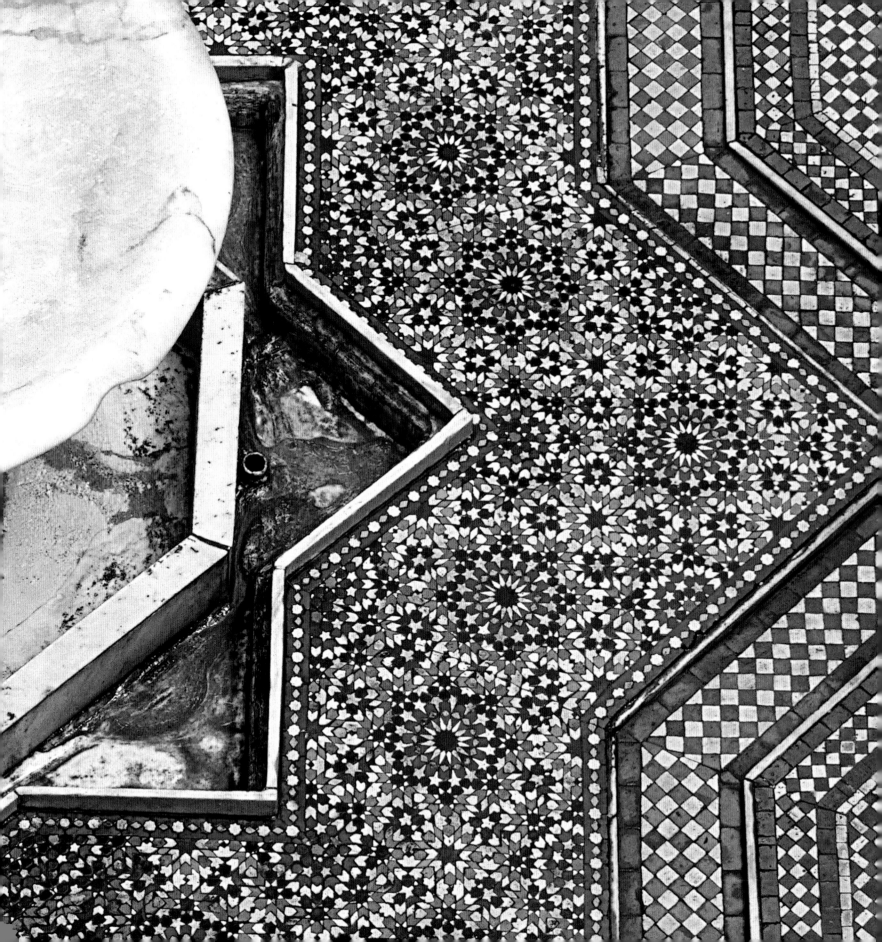

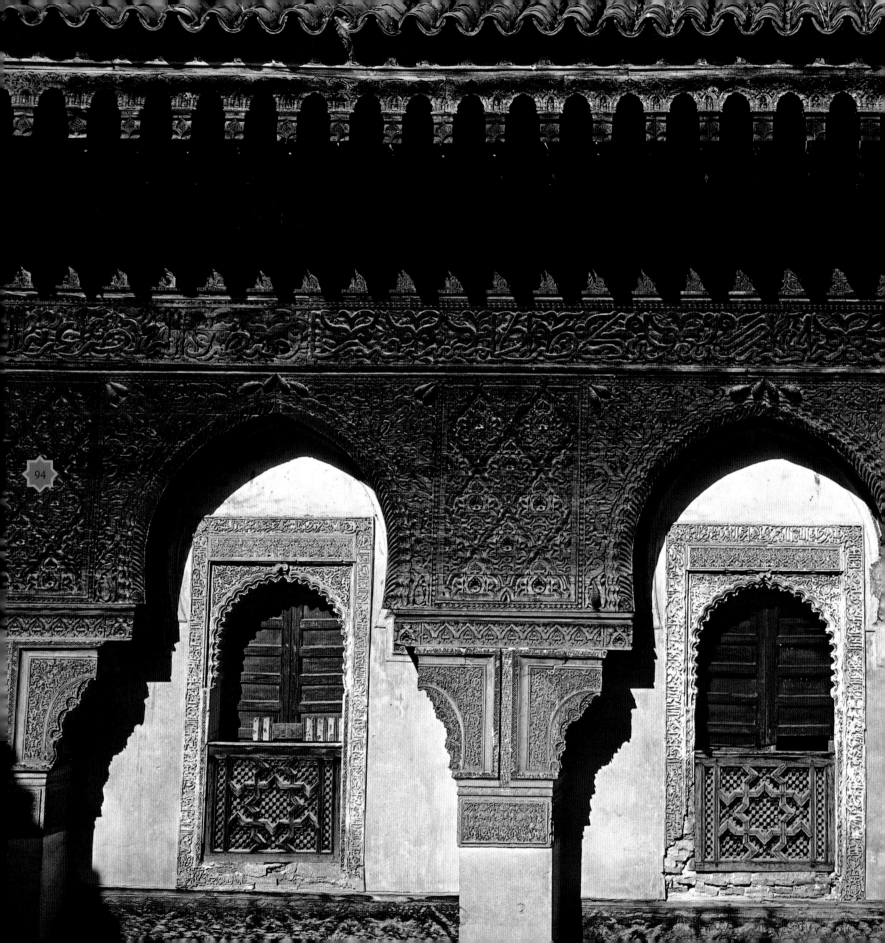

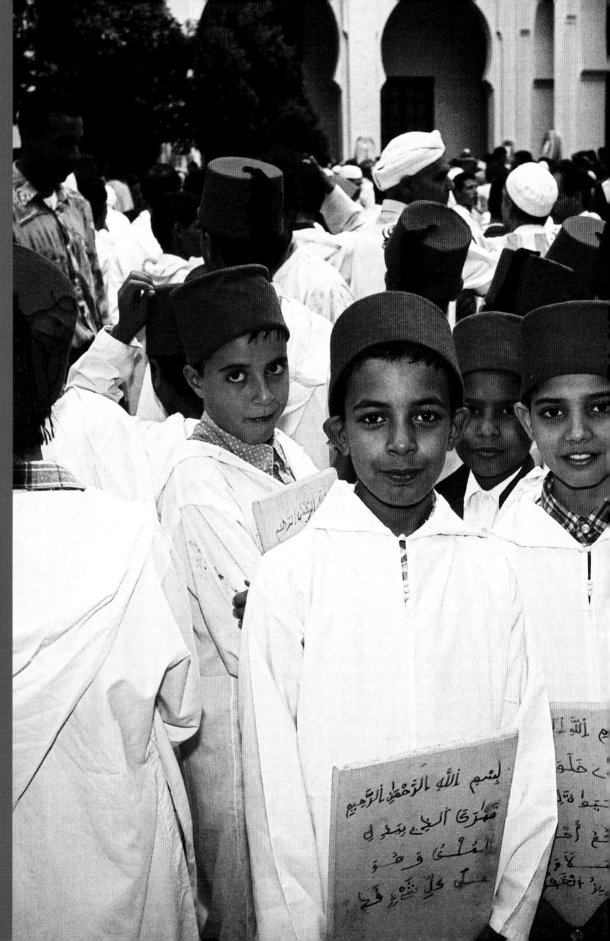

Conceived as prestige buildings by the Marinid dynasty, most of the madrasas were built in the first half of the fourteenth century. Elegant and sophisticated, they are embellished with rich decorations in the Andalusian style. The lower parts of the courtyard walls are covered with zellig mosaics. Halfway up the walls these small black, green and brown squares are replaced by chiselled stucco and *muqarnas*, stalactites of honeycombed plaster. The warm colours of sculpted cedar wood embellish the top of doors, arcades, canopies and moucharabiehs.

**PRECEDING PAGES**
Ablutions before prayer in the central courtyard of the sanctuary of Moulay Idriss in Fès.
**LEFT**
The madrasa Sahrij in Fès with a cedar-wood cornice and balustrades of carved wood.
**RIGHT**
Children in a Koranic school in the courtyard of the palace of Dar Batha in Fès.

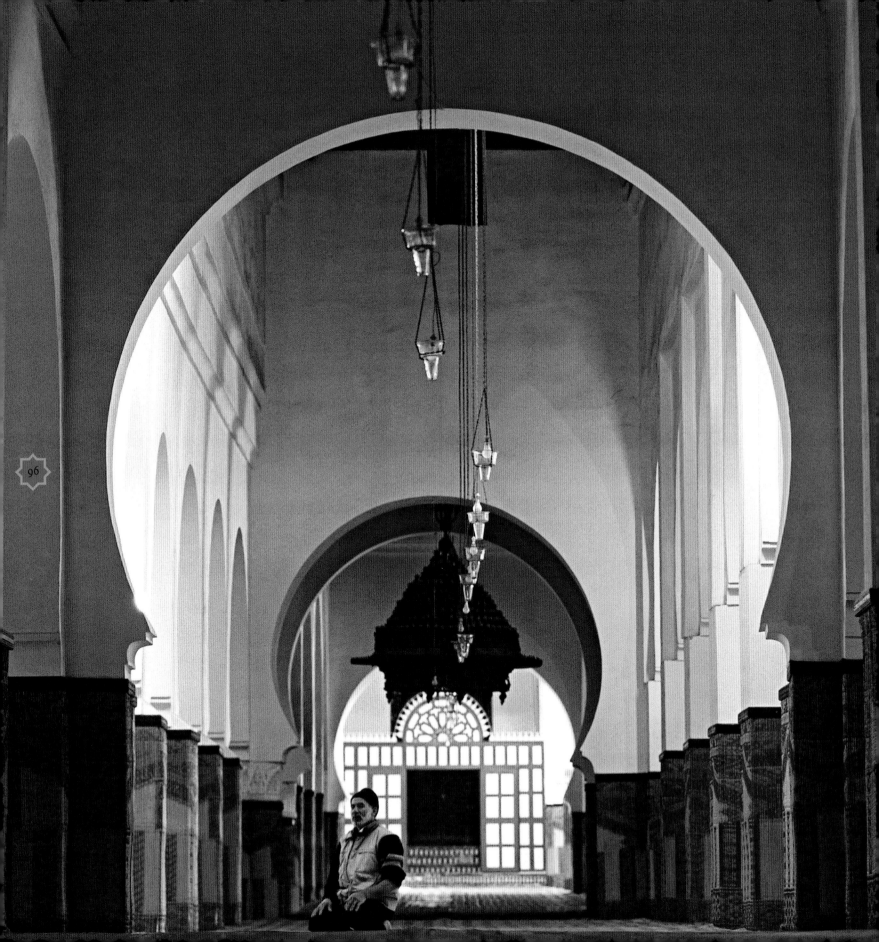

Suddenly came the call I had been waiting for: the last call of the muezzin, and immediately afterwards voices responded from all the mosques. They uncoil like a spring, creating vibrations in the air. Others take off, ethereal, dissolving into the sky, and deep voices break down into sobs.

Roland Dorgelès, *Le Dernier Moussem* (*The Last Moussem*)

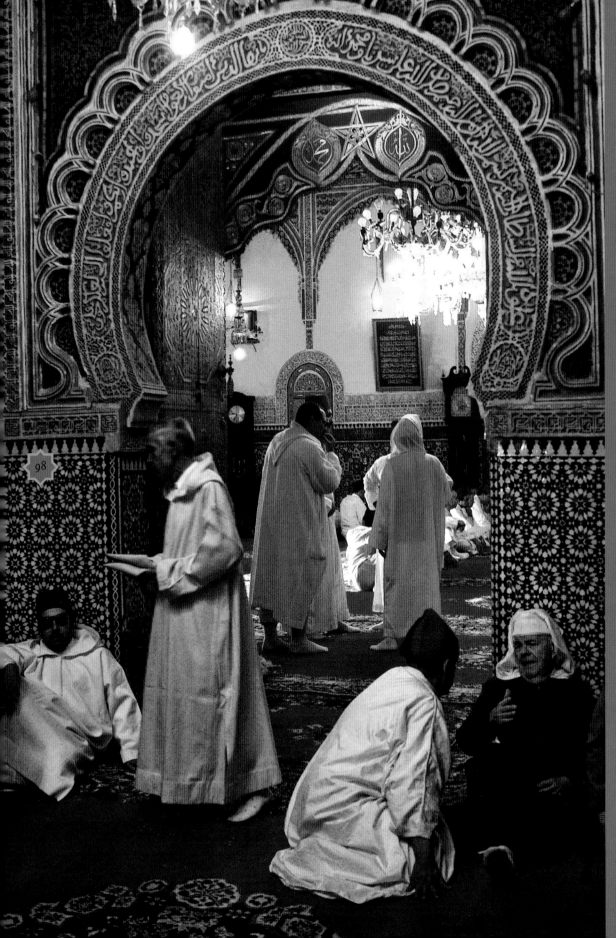

Introduced into Morocco in the seventh century, Islam governs the everyday life of all Muslims, who must respect the five Pillars of Islam: *shahadah*, the declaration of faith ('I testify that there is no god but Allah and I testify that Muhammad is his Prophet'); *salah*, the five daily prayers; *zakat*, ritual alms; the *sawm* or fast, particulary during the month of Ramadan; and the *hadj*, the pilgrimage to Mecca which must be made by all those who are in good health and who have the financial means to do so.

**LEFT**
Ceremony in the sanctuary of Moulay Idriss in Fès.
**RIGHT**
The entrance to the Sahrij madrasa in Fès; prayer in the sanctuary of Moulay Idriss in Fès.

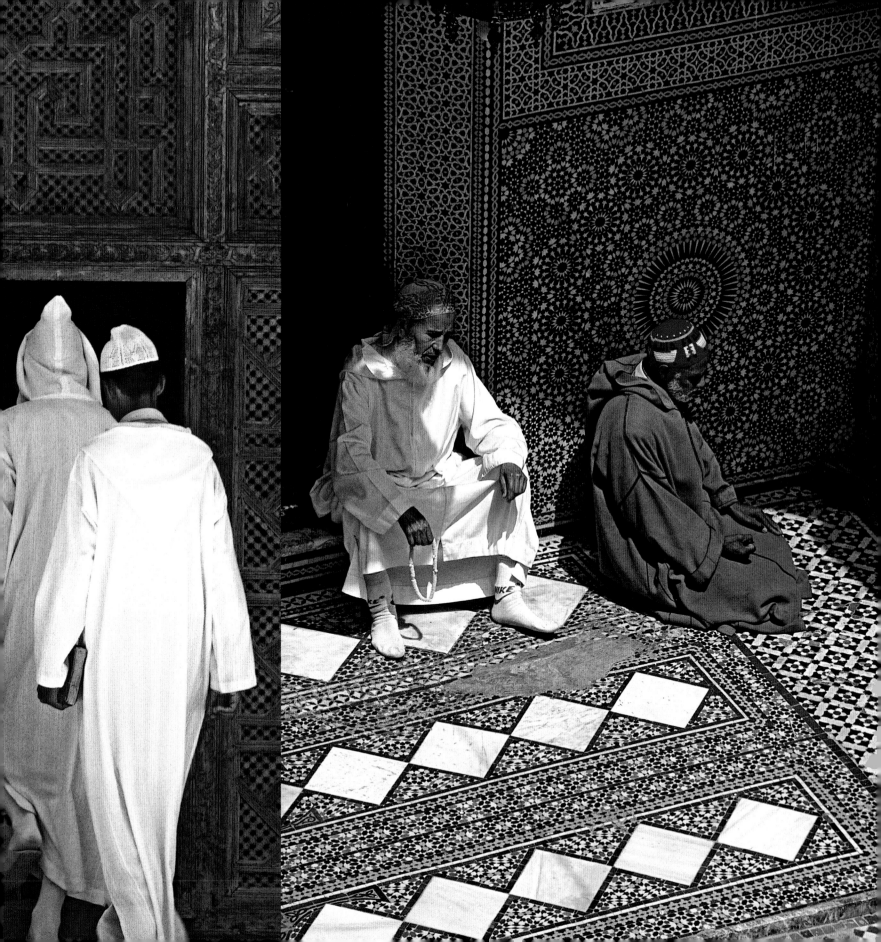

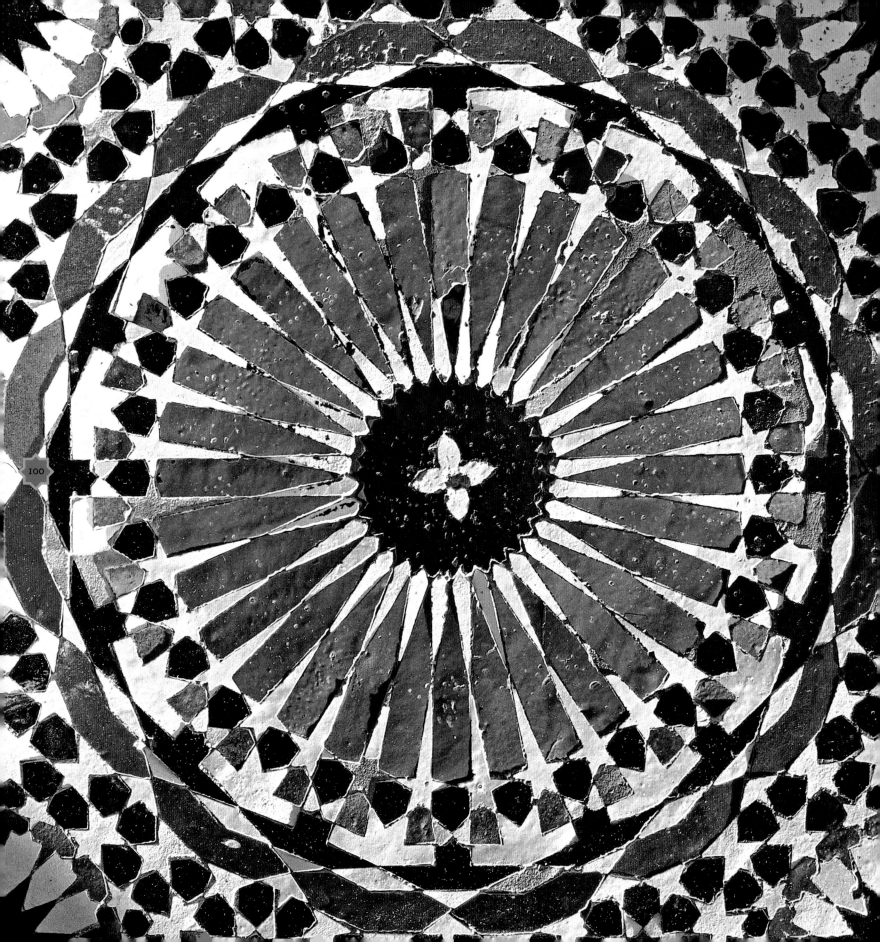

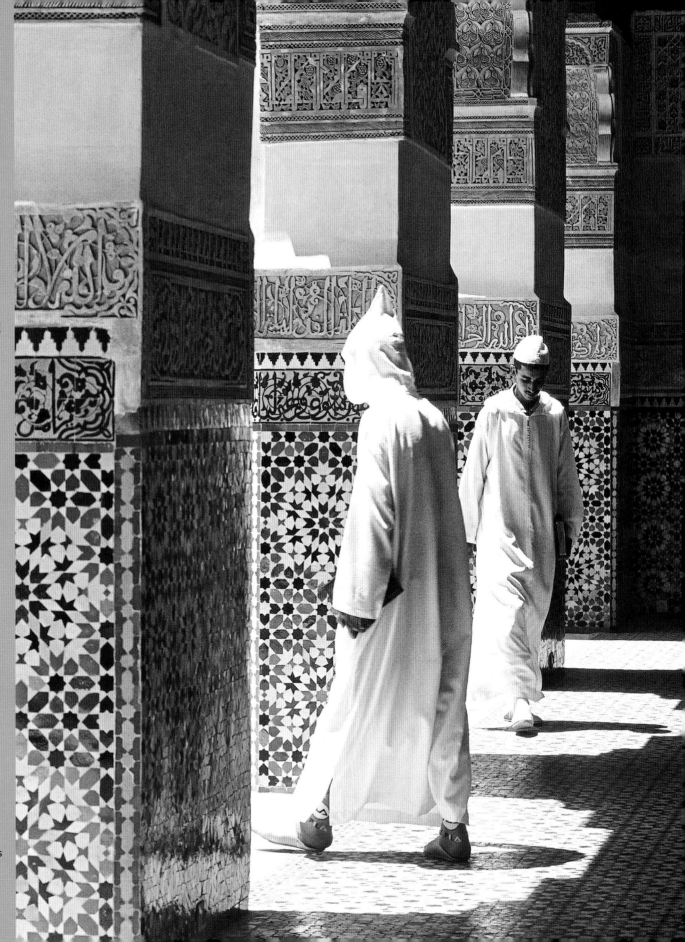

Zelligs, small multi-coloured pieces of ceramic, are used to cover the walls of palaces, mosques and madrasas. They pave the floors of courtyards, decorate the pillars and columns of courtyards and emphasize the edges of a fountain built against a wall. Zellig mosaics also protect the walls from damp and create a refreshing atmosphere in summer. With these square-, triangular- and diamond-shaped pieces, craftsmen create clever, complex, geometric compositions such as rosettes, semi-circles, entwined lines, star-shaped polygons, grid patterns and friezes of fleurons . . . These designs are based on symmetry and movement, creating optical illusions.

**LEFT**
Decoration of polychrome zellig mosaics in the Attarine madrasa in Fès.
**RIGHT**
The richly decorated arcades of the Ben Youssef madrasa in Marrakesh.

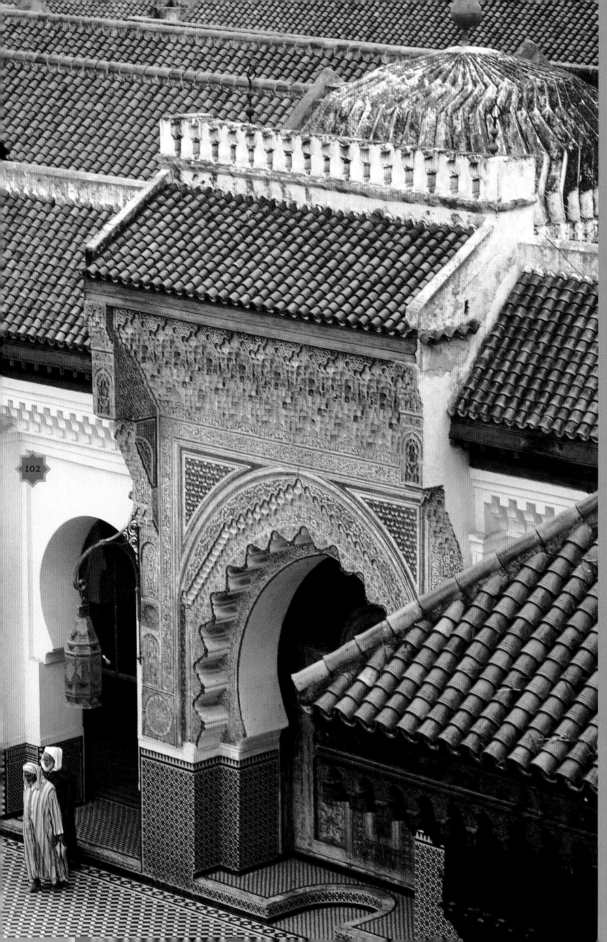

The Karaouine mosque in Fès is the most prestigious mosque in Morocco and for over a thousand years it has been one of the main intellectual centres in the country. Erected in the ninth century, it was originally a modest oratory in adobe and stone, built by a devout woman from Kairouan, Fatima al-Fihri. The master-builder sultans of successive dynasties have respected this building, enlarging and restoring it. The mosque-university is famous for its library containing almost 30,000 books, including 10,000 manuscripts and several famous incunabula.

**LEFT**
The Karaouine mosque. The door leading to the prayer hall is surmounted by stucco filigree, a canopy of green enamel tiles and a dome.
**RIGHT**
Zellig mosaics and stucco in the Bou Inaniya madrasa in Meknès. • Women visiting the sanctuary of Sidi Ouassai near Agadir.

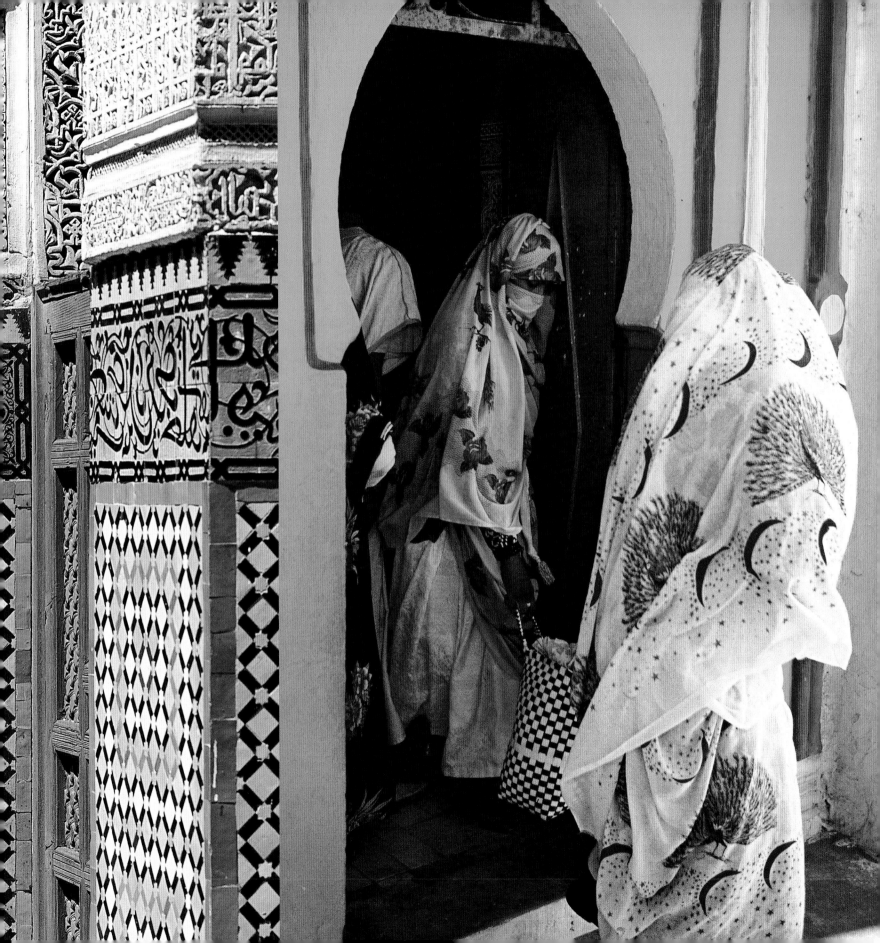

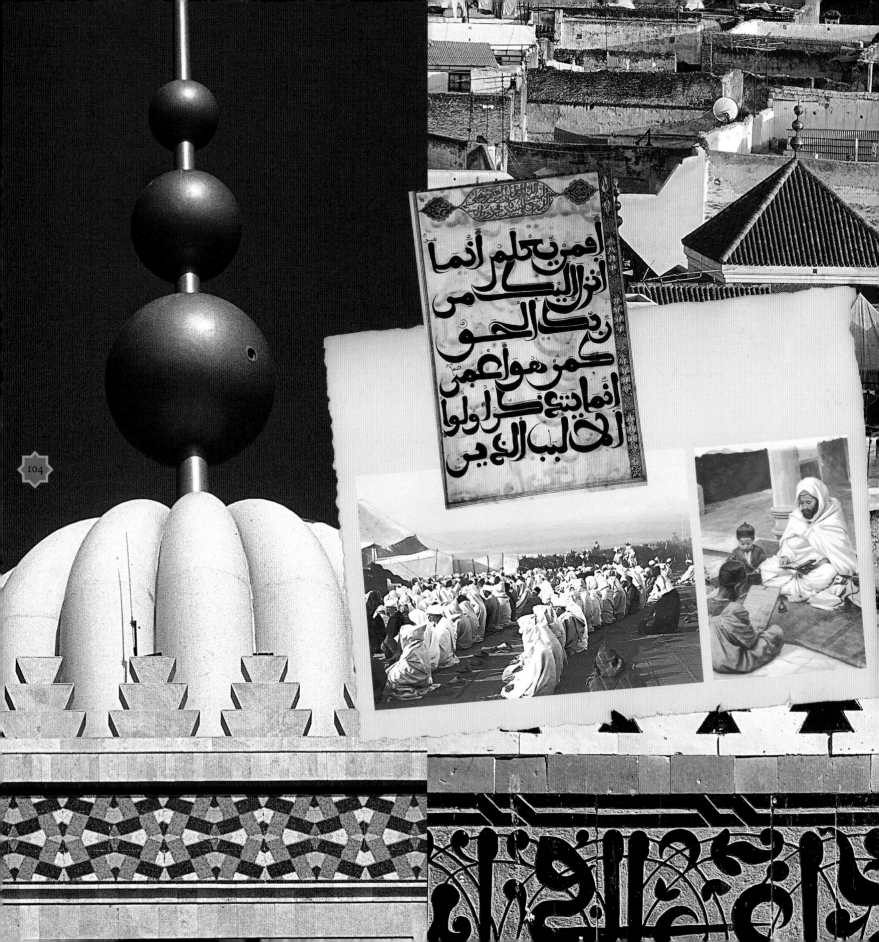

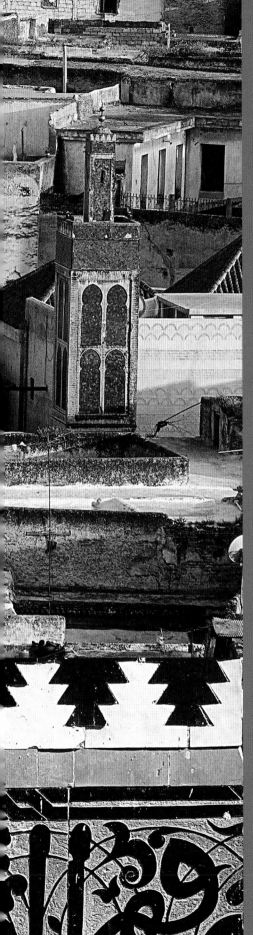

Calligraphy, with its emphasis on perfect legibility and on the harmony of upstrokes and downstrokes, is a major art in the Muslim world and the only graphic art tolerated by Islam. Consisting of straight lines, rigid, angular and thick, terminating at an angle, Kufic calligraphy is used to decorate the walls of some madrasas. Cursive script is more rounded, with alternating large upstrokes and downstrokes. In Muslim architecture these two types of script have been used in the glorification of Allah.

**LEFT**
The golden copper balls surmounting the minaret of the Koutoubia mosque in Marrakesh. • Details of the medina in Fès.
The old photographs show, left to right, at prayer during Aïd el-Kebir (religious festival) in Fès; a school at the beginning of the twentieth century.

**RIGHT**
A scholar from Fès at the beginning of the twentieth century.

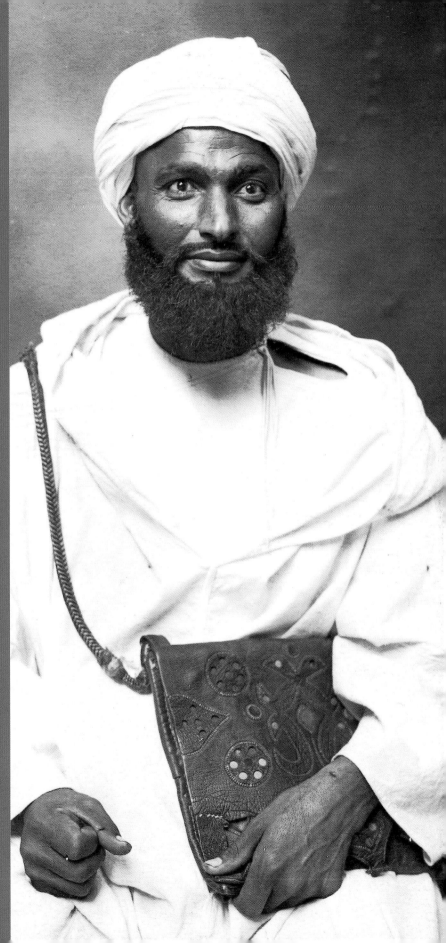

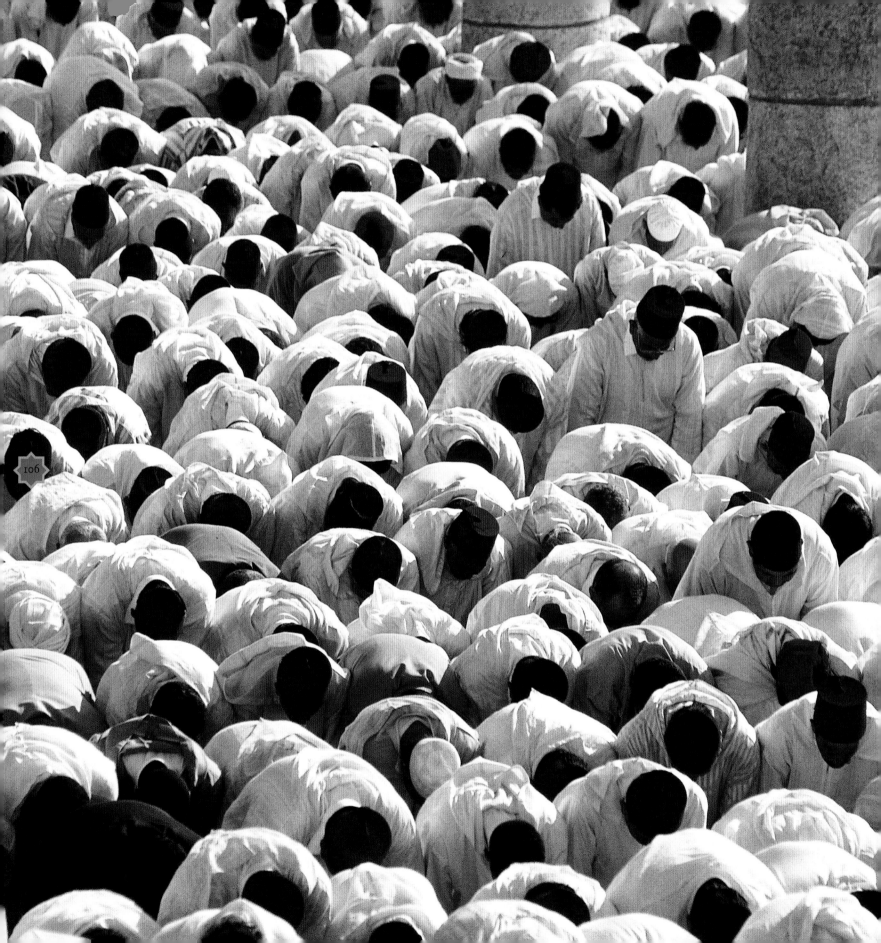

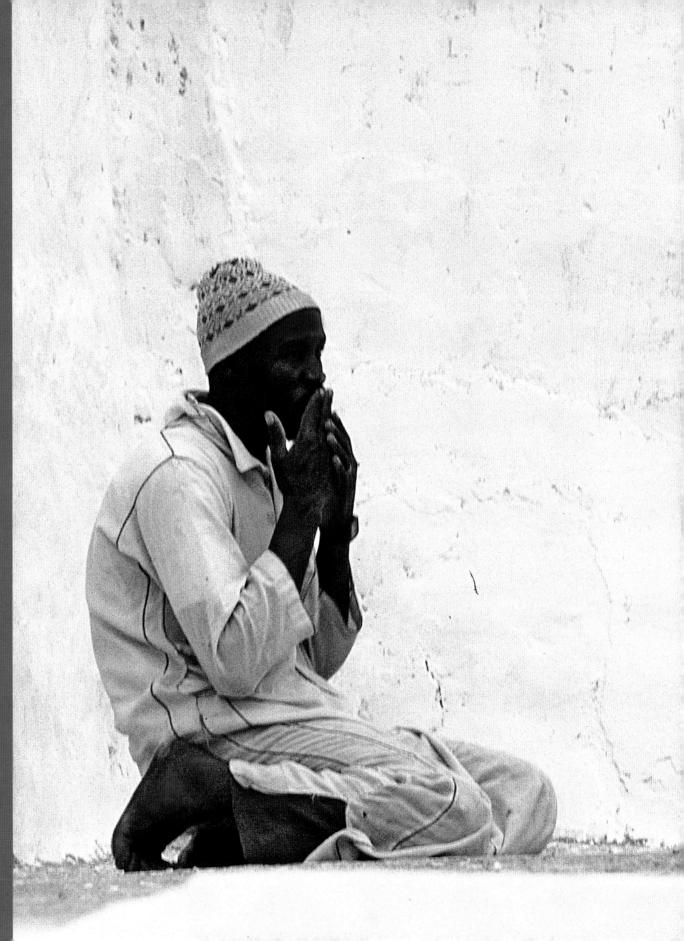

The Muslim calendar begins on 16 July 622 (of the Western calendar), the first day of the lunar year in which the Prophet left Mecca to settle in Medina. The Arabs call this event the Hegira. The Muslim year is made up of twelve months, each of which starts at the new moon. The Muslim religious feasts are celebrated at a fixed date according to the Hegira calendar but because the lunar year is shorter than the solar one they move forward in relation to the Western calendar by ten or eleven days each year.

**LEFT**
Leading citizens praying on the square in front of the mausoleum of Mohammed V in Rabat, on the occasion of the death of King Hassan II.
**RIGHT**
A man praying at the moussem (festival) of the former slaves of Illigh in the Tiznit region.

These arabesques, made of pieces of fabric that are cut up and then sewn together, always have the same design, going back many centuries: lacy crenellations following one another, the same motifs that the Arabs carve in the stone along the top of the walls of their religious buildings, the same ones that surround their earthenware mosaics.

Pierre Loti, *Au Maroc (In Morocco)*

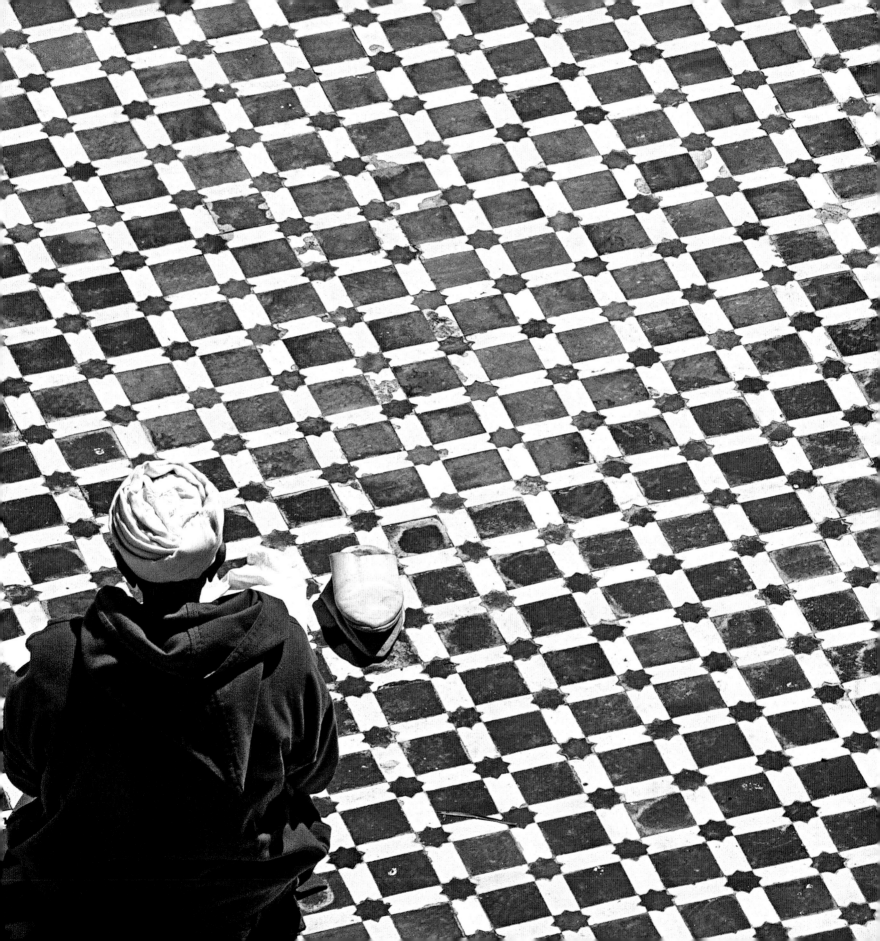

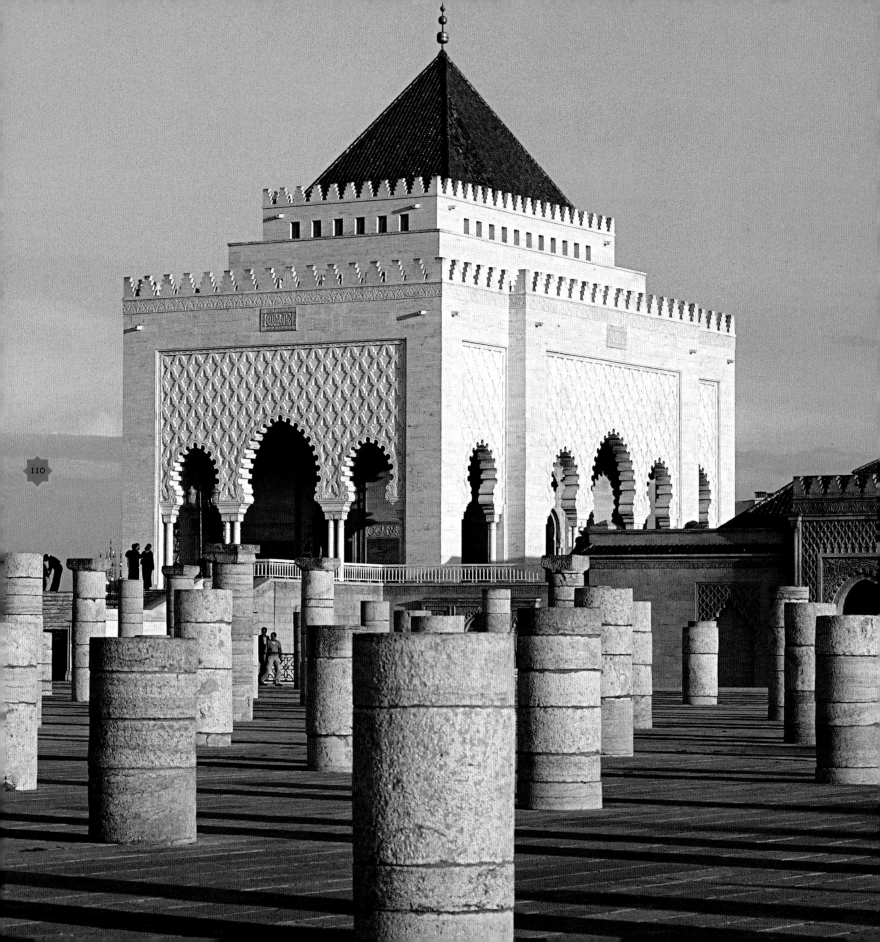

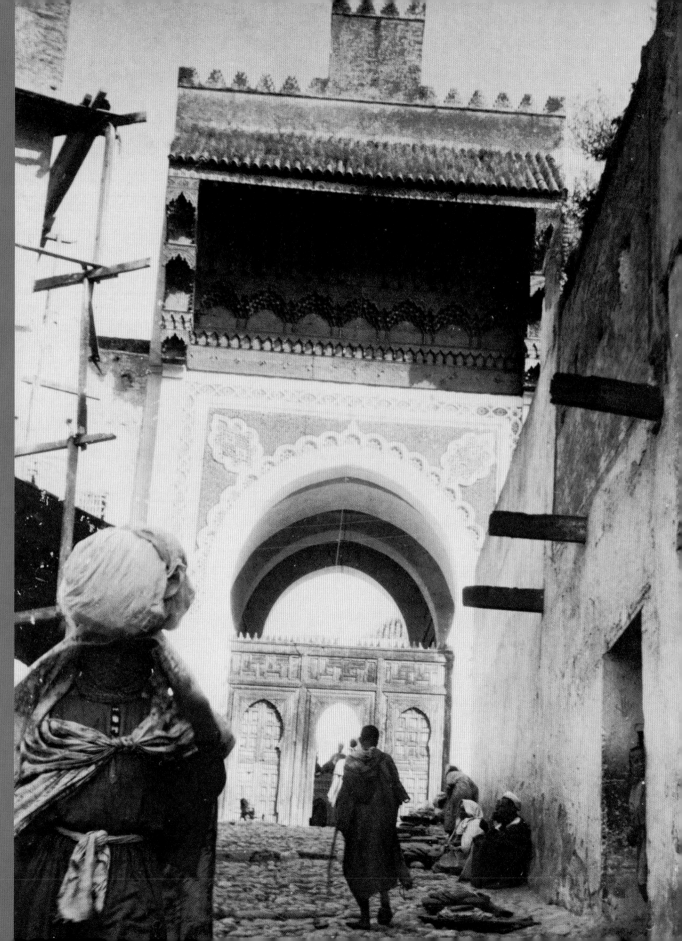

The rows of columns on the esplanade of the mausoleum of Mohammed V in Rabat bring to mind the gigantic but unfinished building project started by Sultan Yacoub el-Mansour at the end of the twelfth century. This sultan wanted to build the largest mosque in the Muslim world with 18 bays, 21 aisles and 400 pillars and columns. The mausoleum of Mohammed V, set on a plinth 3.50 metres (11 ft 6 in.) high and built of Italian white marble, is surmounted by a pyramidal roof covered with green tiles. Each of the four sides is pierced by multi-lobed arches. The pavilion contains the tomb of Mohammed V, the father of Moroccan independence, and those of his two sons Moulay Abdallah and Hassan II. The funerary hall is decorated in the purest Arab-Andalusian tradition.

**LEFT**
Mohammed V's mausoleum in Rabat.
**RIGHT**
The Spanish mosque in Fès in the early twentieth century.

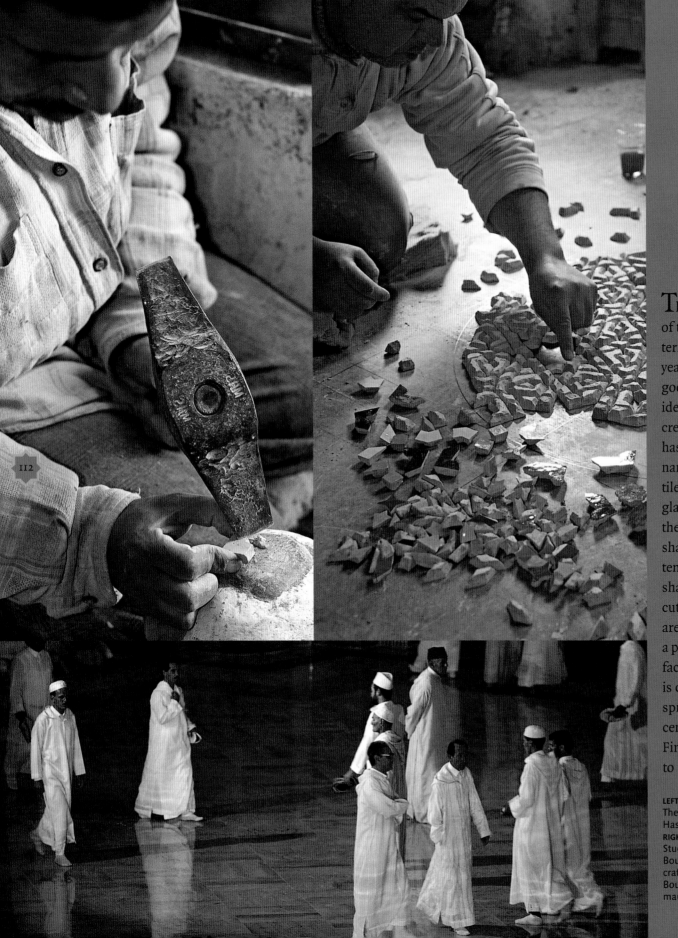

The meticulous assembly of the tiny pieces of glazed terracotta, the zelligs, requires years of apprenticeship, a good memory and a precise idea of the design to be created. Each zellig shape has a specific colour and name. After cutting square tiles that have already been glazed, the craftsman draws the outline of the desired shape on each of them with a template. Then with a hammer sharpened at both ends, he cuts all the shapes. The zelligs are arranged like the pieces of a puzzle, with the glazed side face down. Once the design is complete, the pieces are sprinkled with plaster and cement, then fixed together. Finally, the panel is attached to the wall.

**LEFT**
The meticulous work of artisans. · The Hassan II mosque in Casablanca.
**RIGHT**
Stucco decoration embellishes the Bou Inaniya madrasa in Fès. · A zellig craftsman. · Zelligs decorating the Bou Inaniya in Fès. · Women at the mausoleum of Moulay Idriss in Fès.

112

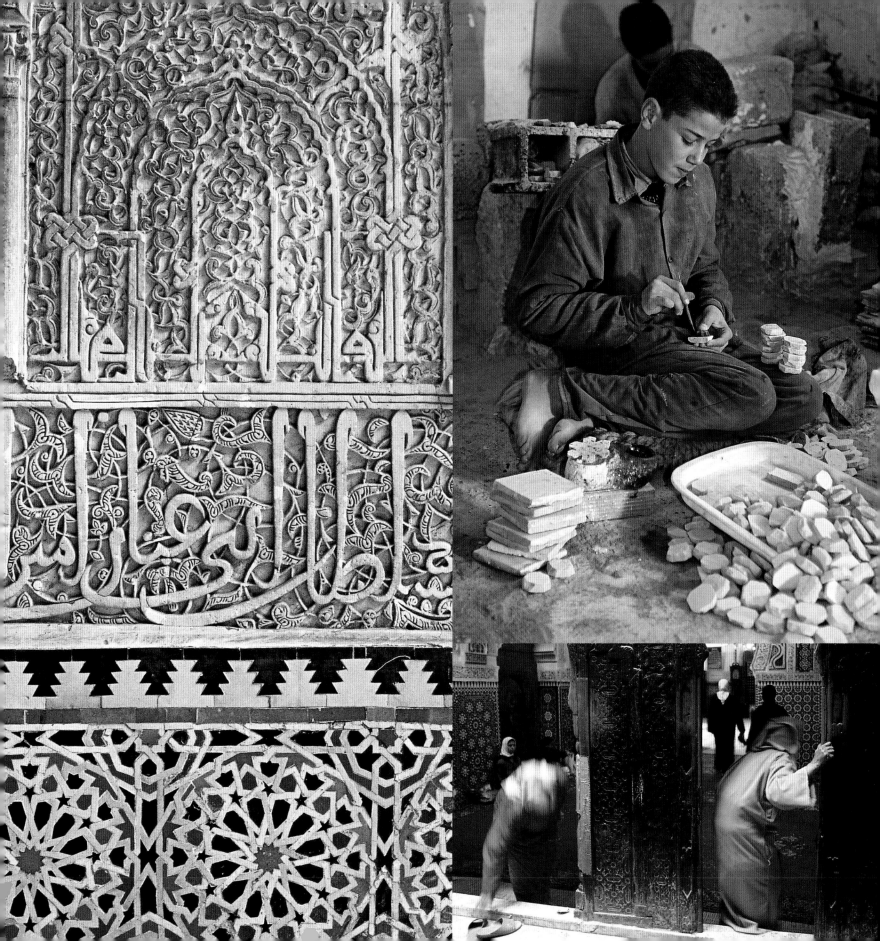

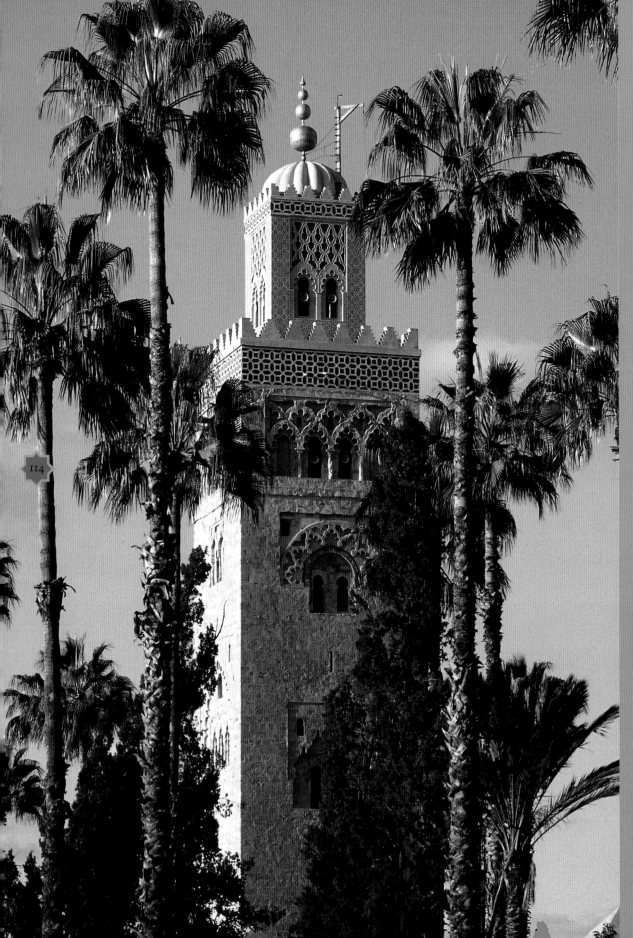

The word 'minaret' is derived from *manarat*, which means 'lamp' in Arabic. In Morocco the mosque has only one minaret, erected at one corner of the building. It is almost invariably square, the one exception is the cylindrical minaret erected in the holy town of Moulay Idriss. Covered in green ceramic mosaics, it is embellished with motifs reproducing the stylized calligraphy of the suras in the Koran.

**LEFT**
The minaret of the Koutoubia mosque in Marrakesh, built in pink stone, reaches a height of 77 metres (253 ft). This masterpiece of Almohad art inspired the builders of the Giralda tower in Seville and Hassan's tower in Rabat.
**RIGHT**
The delicate stucco tracery that decorates the walls of the mausoleum of Mohammed V. • The minaret of the Bou Inaniya madrasa dominates the old town of Fès.

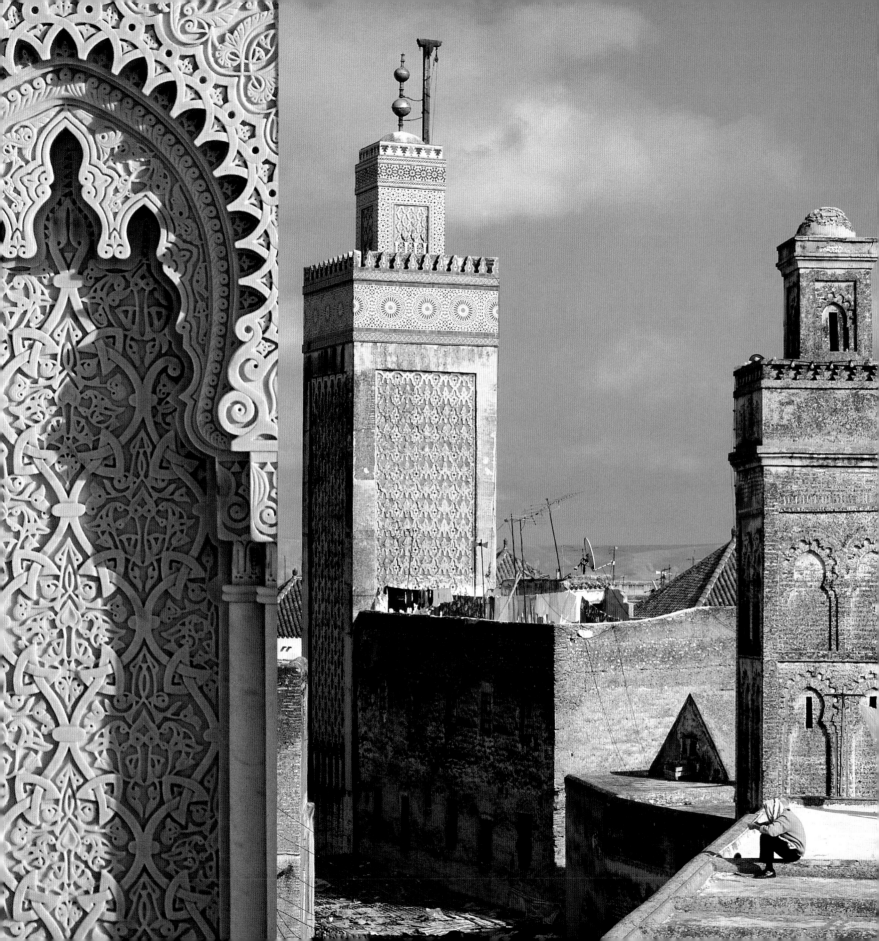

# THE GOLD OF
# THE DESERT

The austere and burning immensity of the Sahara, stony, bleak plateaux stretching as far as the eye can see, dried lakes or sandy dunes . . .

One-third of Morocco is covered by the desert that stretches from the foothills of the Atlas Mountains to Mauritania, from the Algerian border to the Atlantic Ocean. To merge with the background, animals have adopted the colours of sand and earth. The dromedary with its ochre coat, famed for its sobriety, the gold-coloured jackal, the pale, tawny Dorcas gazelles, the golden brown fennec fox and the uromastyx (spiny tailed lizard) whose skin changes from yellow to grey depending on the heat . . . these are all creatures of the desert.

A place of silence and solitude, Morocco's Great South is an ocean of dryness, punctuated by islands of life, the oases. Suddenly emerging in desert valleys, oases are havens of peace where the tall silhouettes of date palms conceal a world of refreshing coolness. Filled with pleasant muffled sounds, the gentle babbling of water running along narrow channels and the perfume of the lemon trees, oases are structured on three levels.

Market garden produce (carrots, onions, melons, marrows), cereals (lucerne, barley, wheat), dyes (henna) and fragrant herbs (mint, coriander)

are protected by the shade of the numerous fruit trees (apricots, figs, olives and pomegranates), which in turn are dominated and protected by the welcome shade of the date palms. Lords of the oases, these unfold their palms like a fan and rule over the crops. Native to Mesopotamia, between the Tigris and the Euphrates, the palm tree was introduced into North Africa many centuries ago by the Bedouins, who threw away their date stones near the watering holes where they set up their tents. With its feet in water, the date palm can reach a height of 30 metres (100 feet) thanks to its very deep roots. The tree of life, it produces not only the date, symbol of prosperity and happiness, but also supplies building material – its palms, stripped of their leaves, are dried in the sun and then intertwined.

The oases on the margins of the Sahara Desert owe their existence to proximity to a wadi or because they draw their water from deep down in the earth, below the water table. Tied to a rope, a donkey or camel pulls up a goatskin gourd from a rudimentary well, activated by a pulley system. The water is then immediately emptied into the small irrigation channels called *seguias*. The water may also come from sources further away and be

brought to where it is required through *khettaras*, subterranean channels, punctuated by wells.

Travelling to Zagora, Goulimine or Rissani, those great Saharan cities of the past that linked the African kingdoms to the Moroccan capitals, is to follow the trail of the ancient caravans that brought gold, ebony, ivory and gum arabic to the oases in return for salt, textiles, perfume and wheat. It is a journey back in time to the conquests of the numerous dynasties that succeeded one another in Morocco. It is also to evoke the 'blue men' of the Sahara, those nomadic cattle breeders whose skin was coloured blue by the indigo used to dye their clothes, who wandered through the desert in the Great South in search of watering places and pastures. Today, Moroccan oases are no longer the port of call for exhausted caravans but the priceless property of men and women who have settled in them, carefully and doggedly looking after this fragile world that is constantly threatened by the inexorable advance of the desert.

The Draa valley, the long ribbon winding its way through abrupt canyons to the south-western corner of Morocco, leads to an oasis almost 200 kilometres (125 miles) long. In Zagora, the last real town before the Sahara, a simple sign with a picture of a camel caravan announces that Timbuktu is fifty-two days away. In south-eastern Morocco, Tafilalet is still one of the country's most important palm groves. Cradle of the Alaouite dynasty – the mausoleum of Moulay Ali Chérif, founder of the dynasty, is in Rissani – Tafilalet was the site of the first Muslim city, the legendary Sijilmassa, founded in 757. Destroyed by successive waves of invaders, Sijilmassa perished and now only a few sections of wall remind the visitor of its existence. It was the most important port of call for the trans-Saharan caravans between the East, the Sudan and the Maghreb. Rissani was built near these ruins, a peaceful little town that comes to life three times a week because of the souk.

To the south, Rissani is bordered by desert and the breathtaking Erg Chebbi dunes. An enormous swell of sand shaped by the wind, they reach an impressive height of 150 metres (500 feet) and stretch as far as the eye can see. Blown by the sharqi (or chergui), the hot desert wind blowing from the Sahara, dunes appear and disappear in a perpetual motion. Hour by hour their colour changes, from pink to ochre, from red to orange, until they finally fade away when the sun sets.

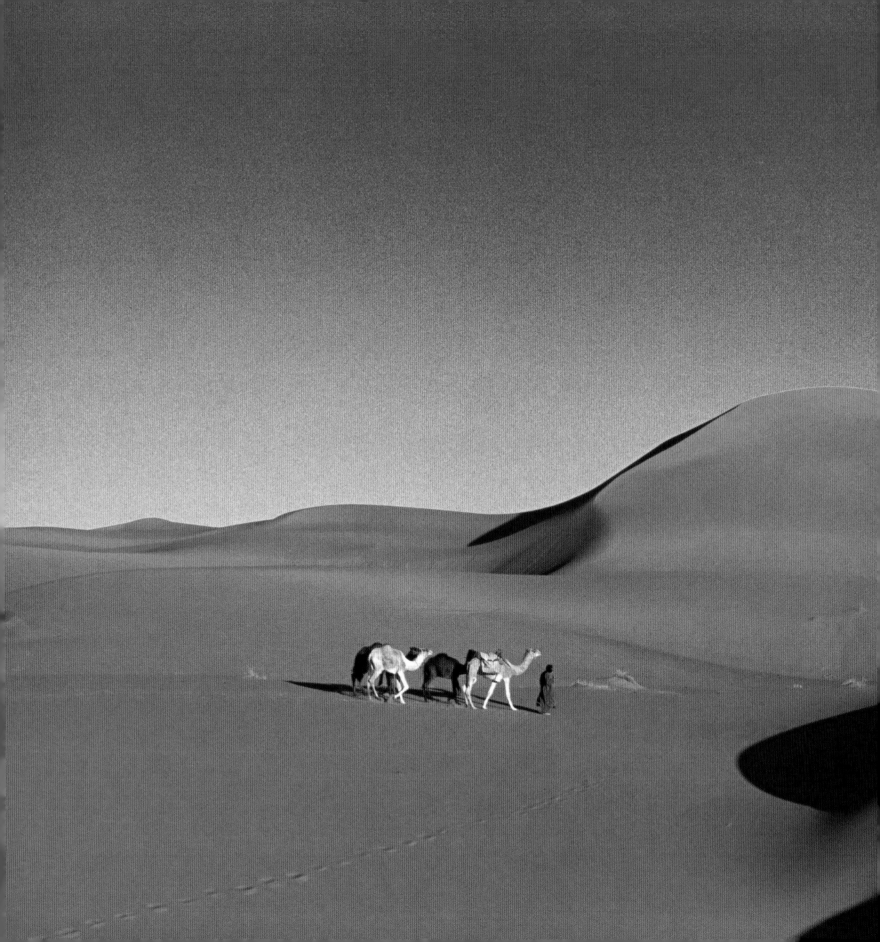

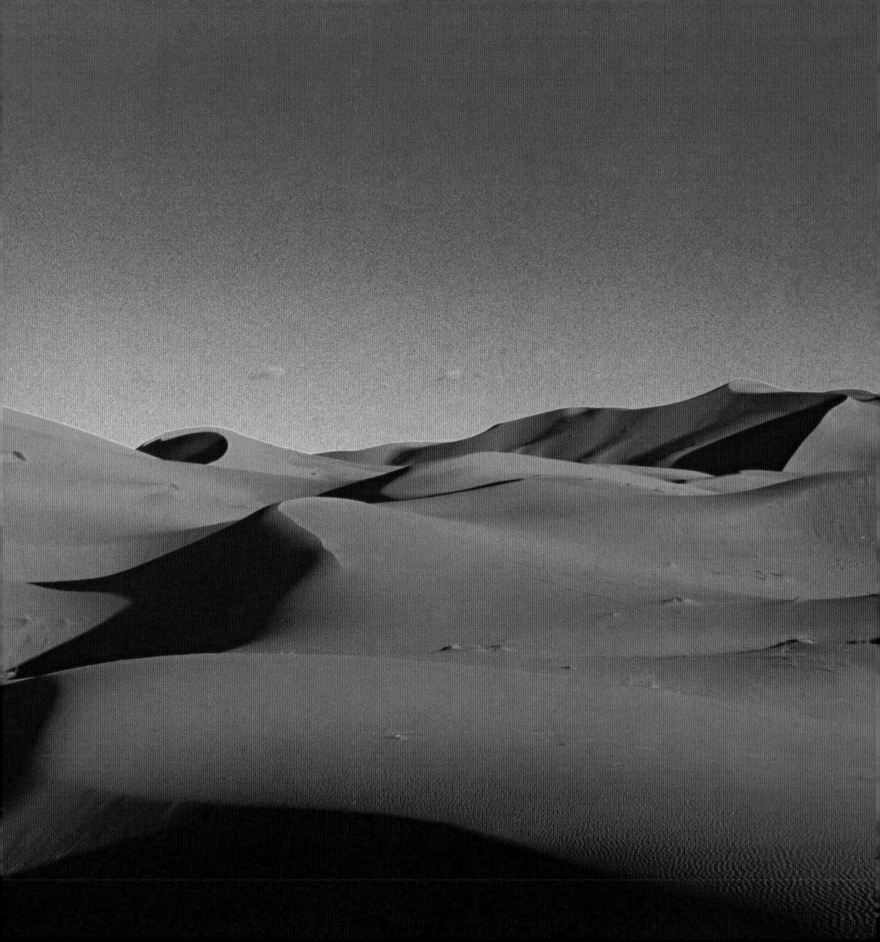

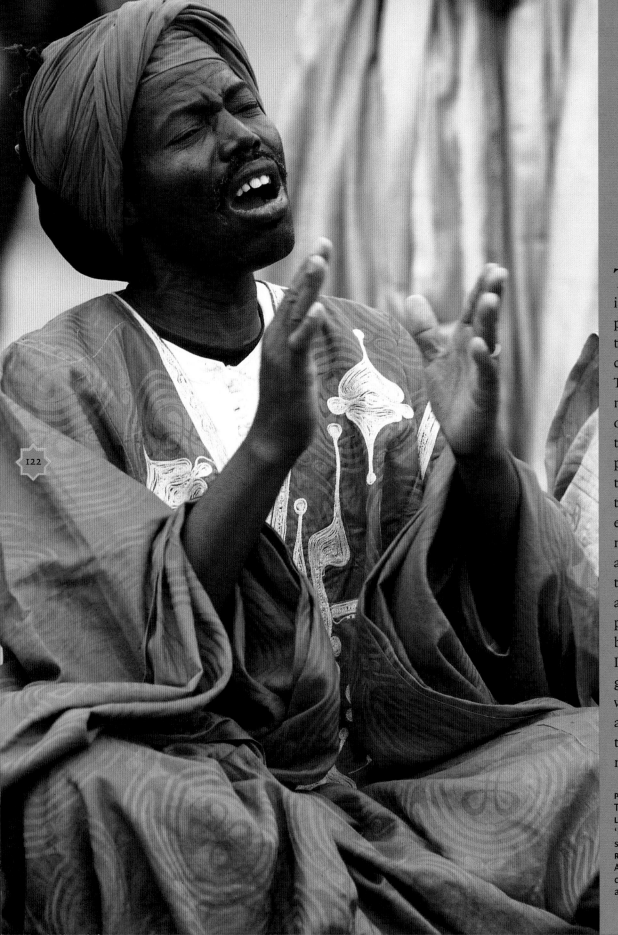

The 'blue men' – popular imagery evokes these noble princes of the desert, crossing the Sahara with their long caravans of dromedaries. The 'blue men' derive their name from the indigo dye of their clothes, which used to run from the effect of perspiration and coloured their skin. The ample tunics they wear, sometimes embroidered with white motifs, give them a proud appearance. The long blue turban skilfully wrapped around the head provides protection against the hot burning sun and sand storms. In the past, the indigo plant grew in oases, but cultivation was difficult and was gradually abandoned in Morocco; today, tunics and turbans are manufactured industrially.

**PRECEDING PAGES**
The dunes of Merzouga.
**LEFT**
'Blue man' in Laayoune,
southern Morocco.
**RIGHT**
A couple performing a ritual marriage
dance on the sand, surrounded by men
and women chanting and clapping.

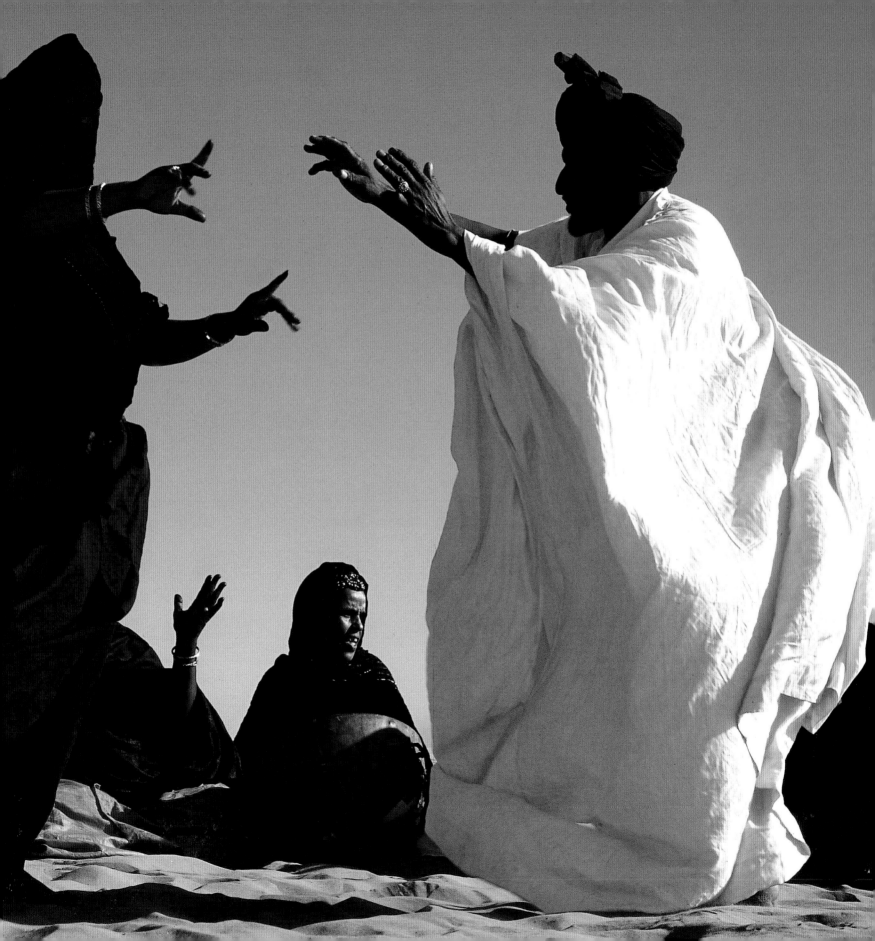

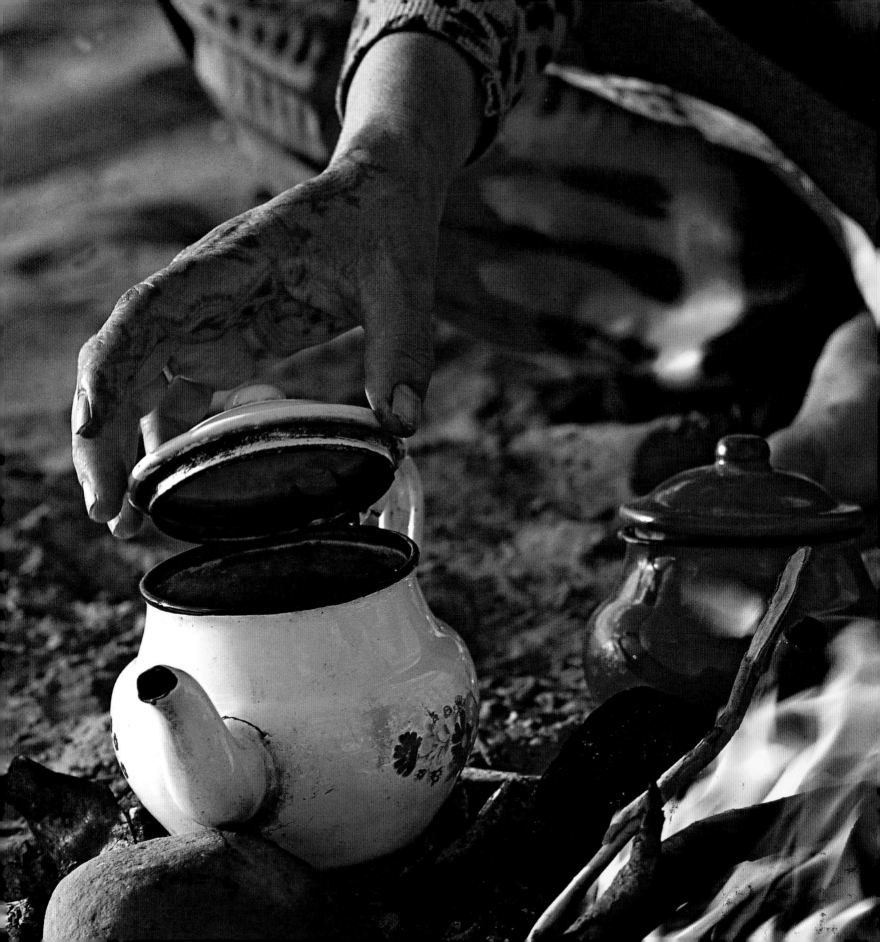

The whole universe is represented in the teapot.
More precisely, the sinia (round tray) represents
the earth, the teapot the sky and the glasses the rain;
the sky and the earth become united through
the rain.

Abdallah Zikra

**LEFT**
Even in the desert, the preparation
of mint-flavoured green tea is an
unchanging ritual.

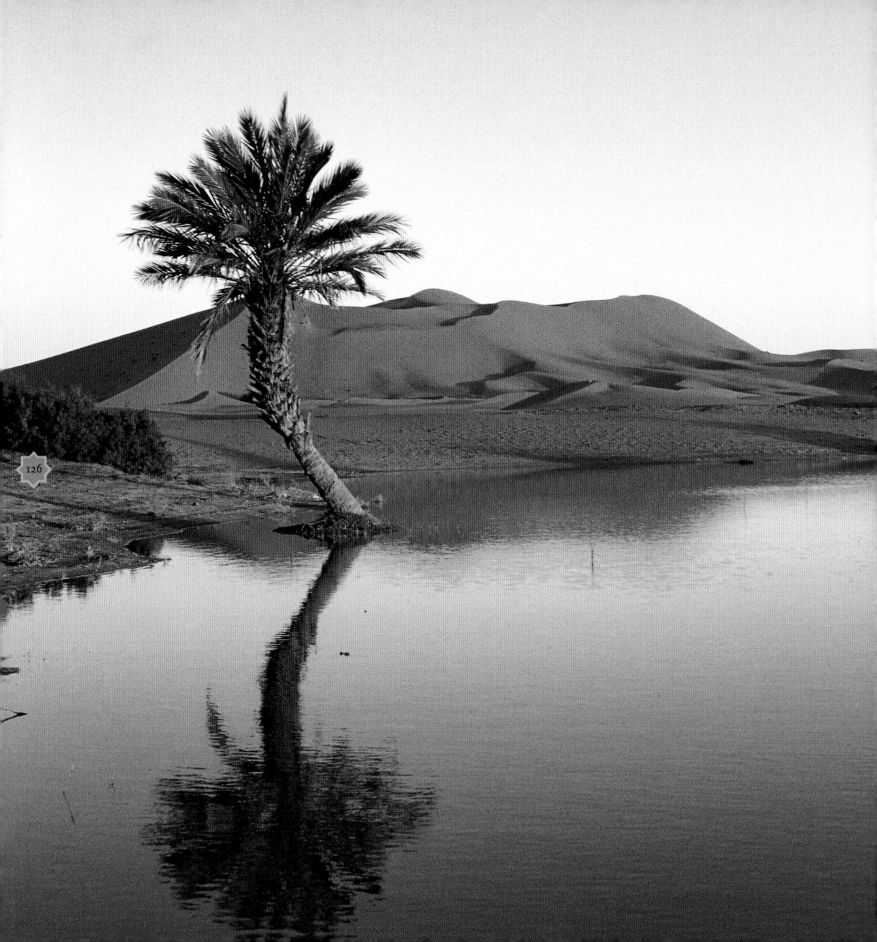

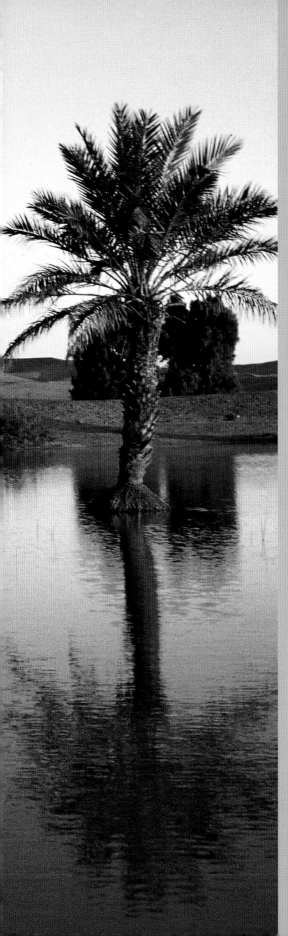

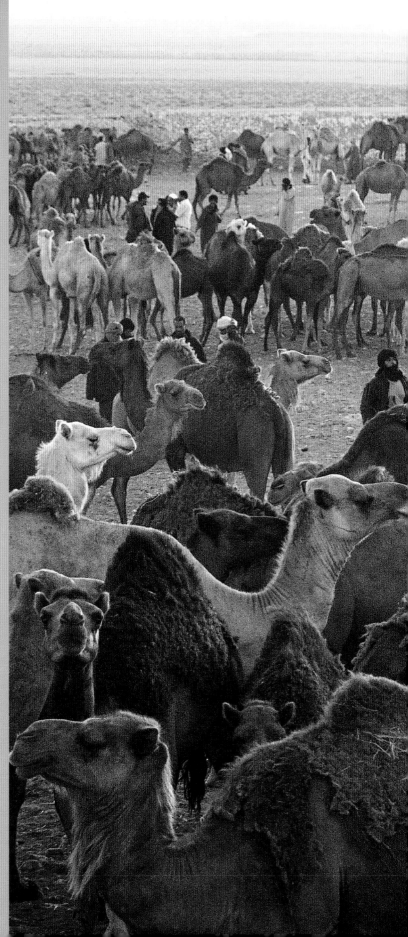

Native to Arabia, the dromedary is thought to have been introduced to North Africa during the third century. With its exceptional qualities, a legendary resistance to heat and especially thirst, the camel is still the 'ship of the desert'. A tireless traveller, the camel can live for twenty-five years. When dehydrated, the camel's hump becomes smaller as the animal draws upon its reserves of fat. After a week without water, it will need a hundred litres (about 25 gallons) to quench its thirst. In winter, the camel is happy to eat plants without worrying about the thorns. Camel hair is used to make burnouses (hooded cloaks) and the meat is very nutritious. The annual camelfair at Goulimine is the occasion for breeders to trade with one another.

**LEFT**
The Dayet Sjri, at the foot of the dunes of Merzouga, fills with water in some winters as a result of the sudden rains.
**RIGHT**
The camel fair at Goulimine.

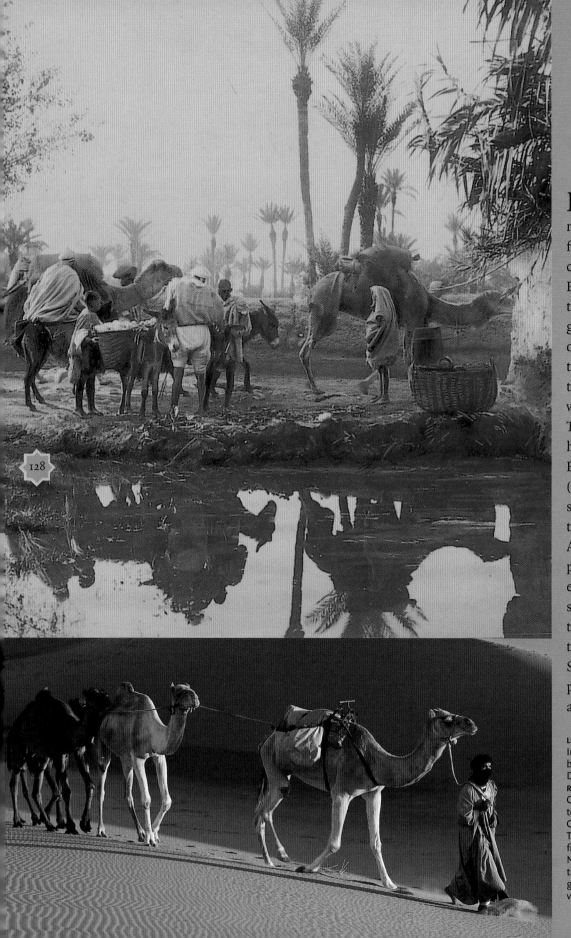

For centuries, precious merchandise was transported from the southern Sahara on caravans from Africa and the East: gold, from the ninth to the fifteenth century, slaves, gum arabic, ebony, ivory and ostrich feathers. In return, these caravans travelled back to Sub-Saharan Africa laden with dates, salt and fabrics. Today, the camel caravans have been replaced by trucks. But the goat's-hair *khaïma* (tent) of the migrant shepherds who move from the summer pastures in the Atlas Mountains to the winter pastures in the desert still exists. Consisting of strips sewn together by women, this round-shaped tent is easy to put up and to transport. Simple yet strong, it provides protection from both the sun and rain.

**LEFT**
In the palm grove of Marrakesh at the beginning of the twentieth century. • Dromedaries, the nomads' companions.
**RIGHT**
Cotton fabric dyed with indigo and hung to dry. • Erg Chebbi. • Dorcas gazelle. • Children in the dunes of Merzouga. The old photographs show, clockwise from top right, the ramparts of Marrakesh; anonymous riders at the beginning of last century; and grinding corn in a straw-roofed village in Mediouna in about 1913.

128

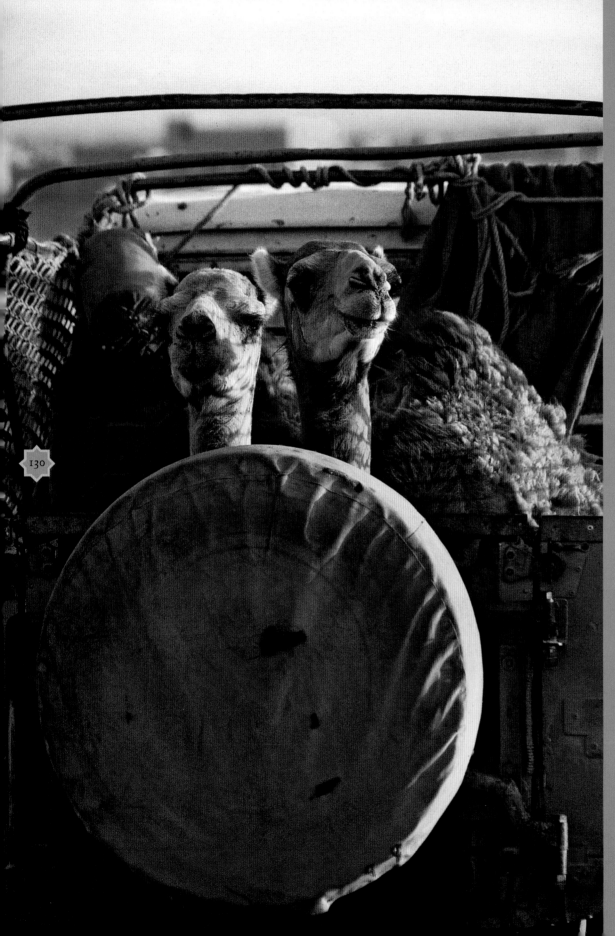

Most of the Sahara consists of regs, enormous plains covered with stones and rocks eroded by the wind, or of large barren rocky plateaux, the hamadas, cut by deep gorges that turn into valleys, which are often dry. They were created in the period when rivers flowed into the vast depressions carrying the sand that is now accumulated there. Dune seas or 'ergs' are fairly rare in Morocco; there are beautiful dunes at Erg Chebbi, near Merzouga, and in the region of Irriki.

**LEFT**
Dromedaries being transported to the nearest market in an off-road vehicle. The breeders will have great difficulty dragging them out of the vehicle.
**RIGHT**
A track linking Foum Zguid to the Draa valley across the Anti-Atlas.

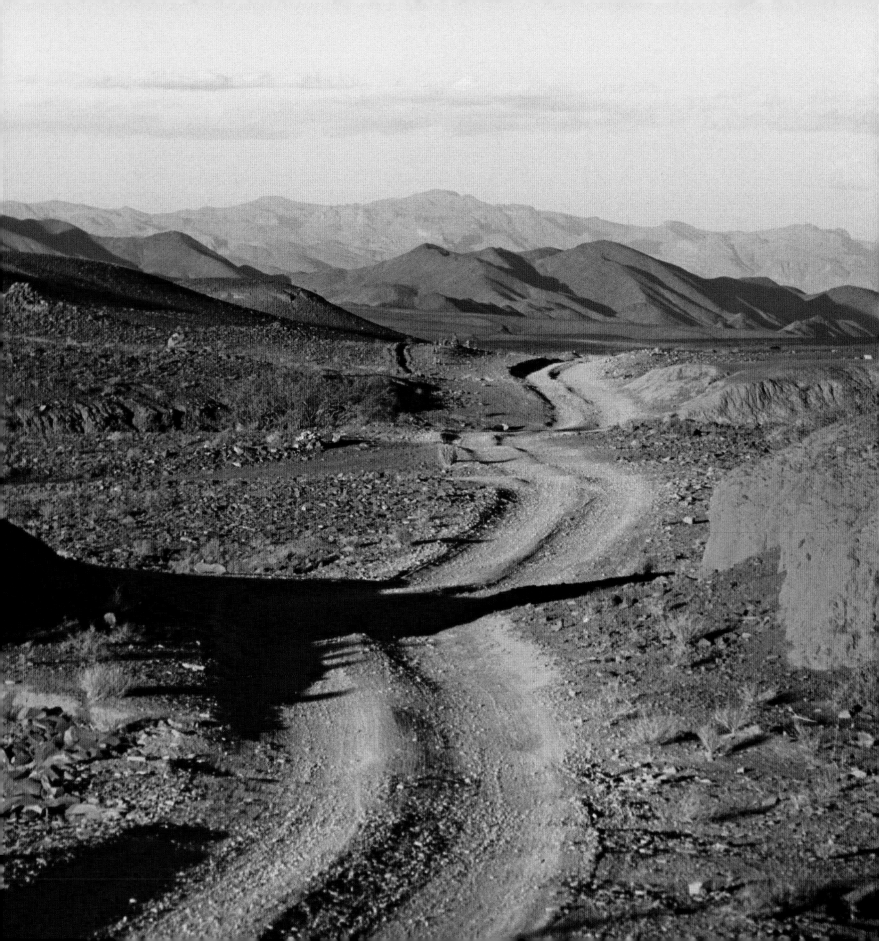

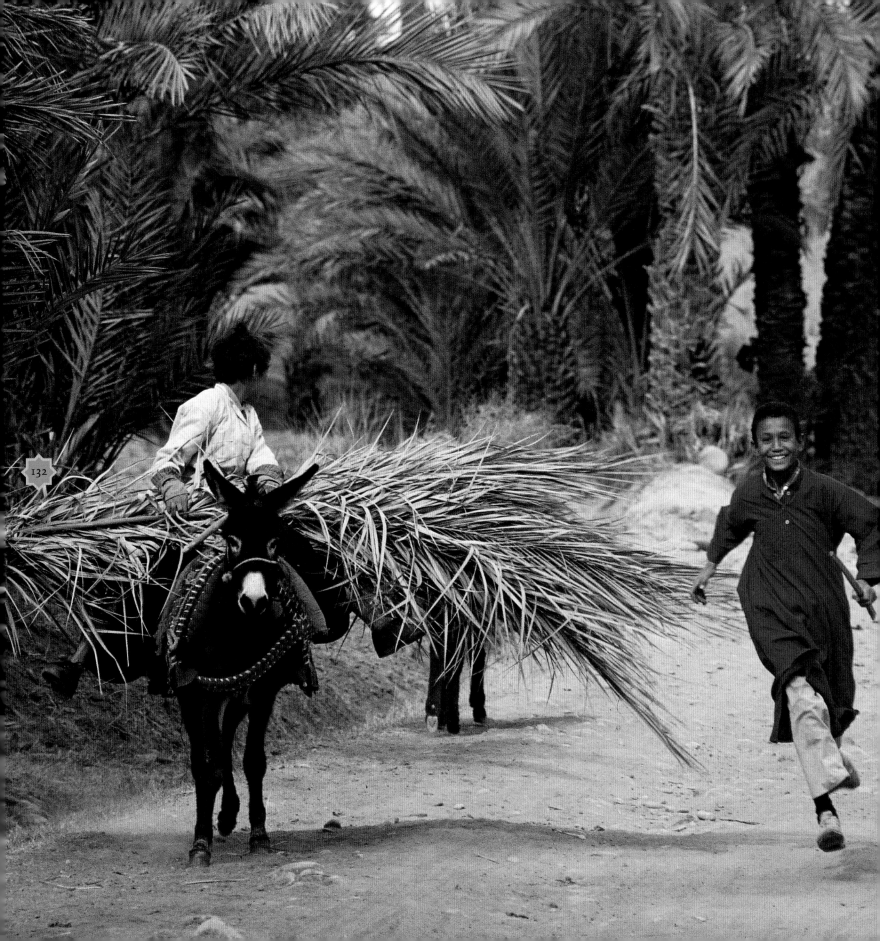

The date palm does not bear fruit naturally. Neither wind nor insects are sufficient to carry the pollen needed to fertilize it. So in oases, people use a form of artificial insemination. In late March or early April, a specialist gathers from the centre of the male palm the cone-shaped spathes that contain the pollen. He cuts them open one by one, slips them into a dozen spathes of the female date palm and secures them with a ribbon of palm to protect them from the wind. The ribbon will break once fertilization has taken place and the date harvest can begin at the end of the summer.

**LEFT AND RIGHT**
Everyday life on foot or on a donkey in the palm grove of Skoura.

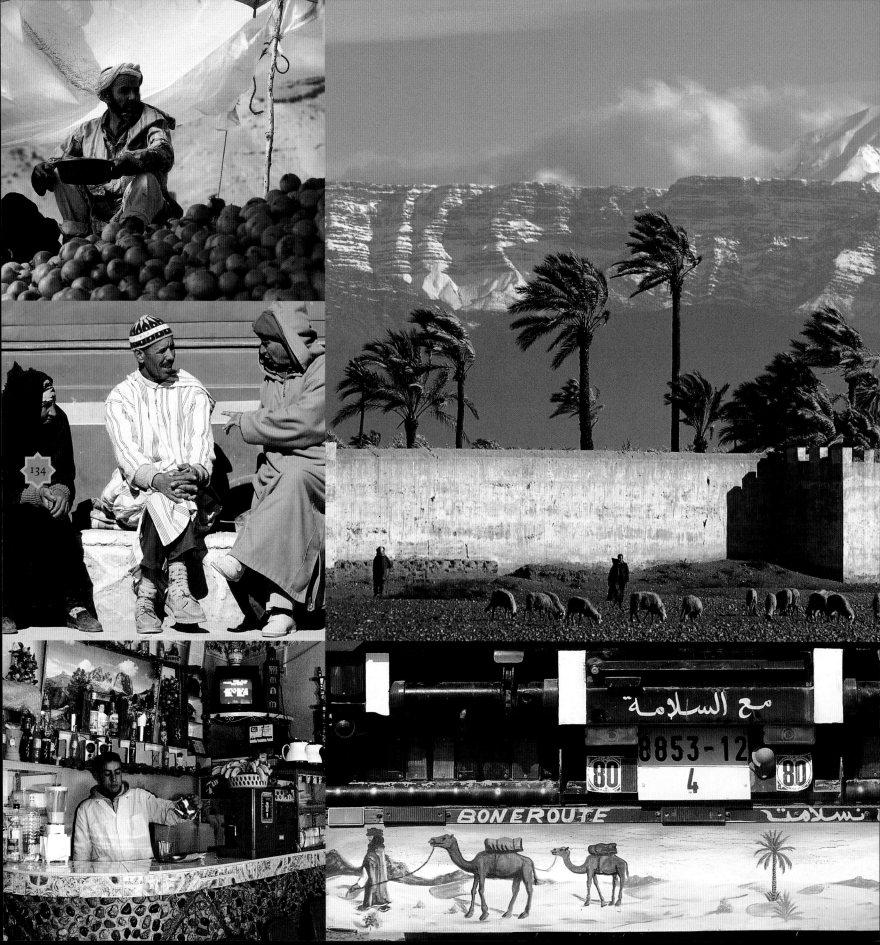

مع السلامة

8853-12

4

80   80

BONEROUTE   سلامت

The roads in southern Morocco, which are mostly in good condition, sometimes turn into tarmac tracks with soft verges. In the Atlas Mountains and the desert these moderately used tracks require a specially adapted vehicle and a good sense of direction. The sandy stretches, turned into 'corrugated sand' by the trucks, play havoc with the shock absorbers of cars, not to mention the lower backs of the passengers. While not particularly dangerous, traffic is fairly anarchic and a horn is indispensable. The roads are often cluttered with cars without lights, carts, apathetic cyclists and solitary donkeys, while buses and trucks compete to see who can go the fastest.

**LEFT**
A stall holder selling Barbary figs in the souk of Imilchil in the Atlas Mountains. • Men in conversation in Boulmane du Dades. • A café in the Ourika valley. • The ramparts of Marrakesh. • The painted back of a truck.
**RIGHT**
In the Ziz valley. • Returning home from the souk in Ouarzazate.

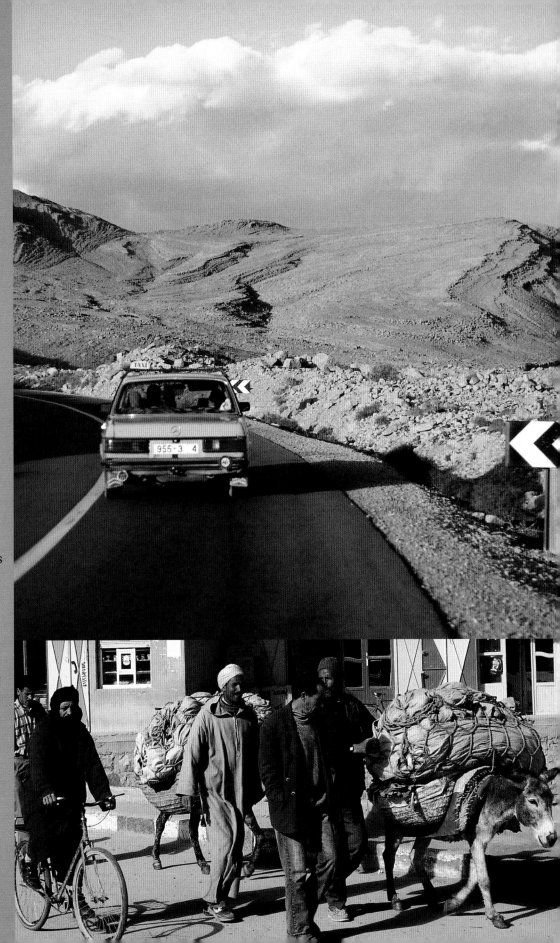

Oh! How lovely it is to stop finally in one of these delectable places, to slide off the burning saddle, to run and wash off in the water of the *seguia* that runs between the olive trees! Giant vines climb the trees or make a canopy of leaves and fruit supported by an architecture of reeds. Underneath are watermelons, squash, and tender, moist, green corn.

Jérôme and Jean Tharaud, *Marrakech ou les Seigneurs de l'Atlas* (*Marrakesh or the Masters of the Atlas*)

**RIGHT**
A palm grove in
the Draa valley.

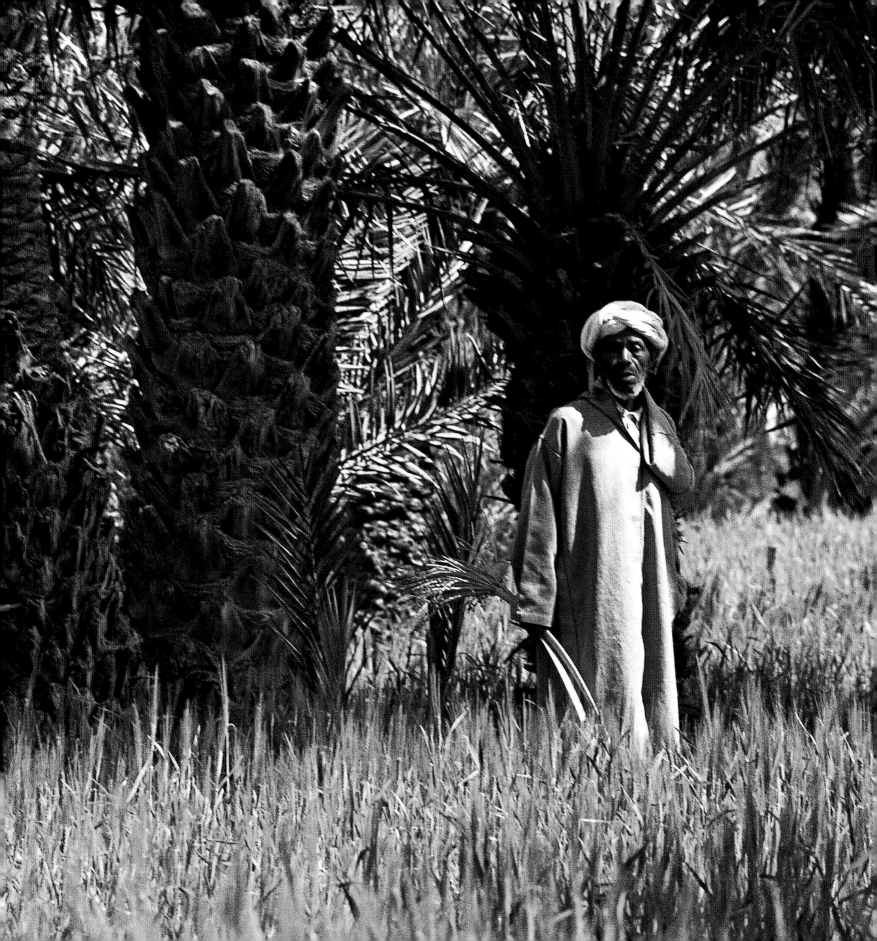

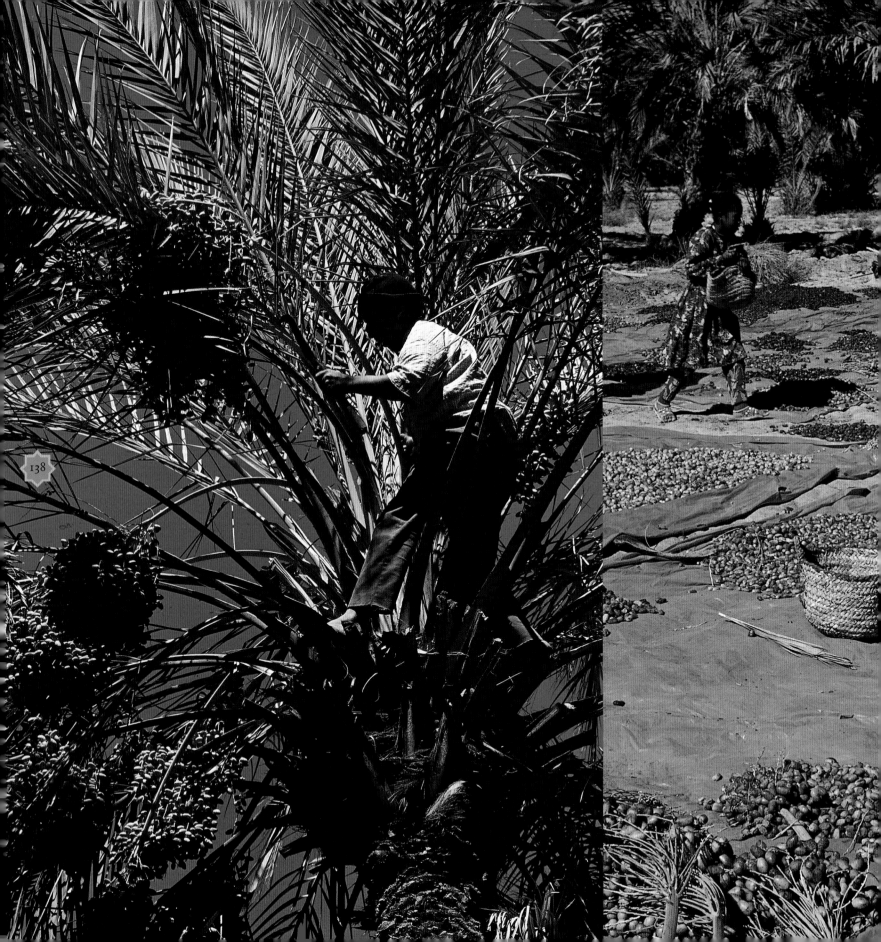

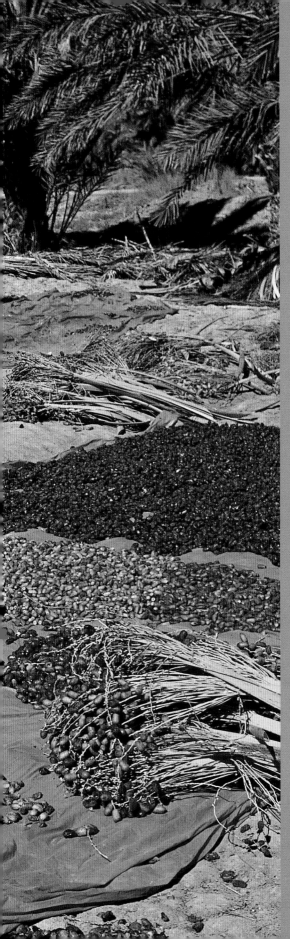

At the end of August, machete blows echo from tree to tree in all the palm groves. The bunches of dates, picked just before they are ripe, fall into heaps on large pieces of canvas laid out on the ground. A good palm tree can produce up to 50 kg (110 lb.) of dates, of which there are many varieties. In Morocco the most famous is the *medjoul* of Tafilalet, a very sweet, delicate, juicy date. Some dates are fragile and are consumed only locally. Dates of inferior quality as well as the stones, soaked in water and then crushed, are given to animals.

**LEFT**
Picking and drying dates in a palm grove in the Ziz valley.
**RIGHT**
Donkeys are often the only means of transport in oases.

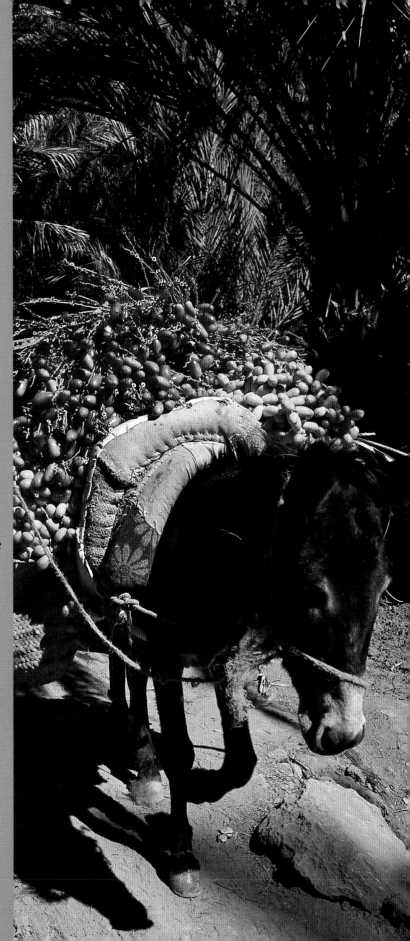

# FLAVOURS
# & FRAGRANCES

Refined, colourful and fragrant, Moroccan cuisine, whether popular or sophisticated, offers an endless variety of flavours.

A mixture of Berber, Arab, Andalusian, Ottoman and African traditions, Moroccan cuisine is above all about the art of living and . . . it is a woman's art. The pleasure of receiving guests and the pleasure of sharing a meal, hospitality and friendliness are no empty words in Morocco. Opportunities for family and friends to get together are numerous. Every important stage in life is celebrated by large family meals and culinary preparations. The low, round table is set, the air is fragrant with the scent of orange blossom, water is boiling in the samovar for tea, the embroidered tablecloths are sprinkled with rose petals, and a bowl and a ewer with a long spout are passed round the table so that guests can rinse their hands.

A pleasure for the eyes, the dishes are arranged artistically on the table, and when the master of the house has pronounced the time-honoured expression, 'Bismillah' ('In the name of God') the meal can start. It is usually substantial, reflecting the host's generosity.

Dishes follow one after the other: a series of colourful salads, pastillas (a kind of meat pie), grilled dishes, fish or a tagine. Made with meat, chicken or fish, combined with olives, prunes, preserved lemons and almonds, the tagine is cooked slowly in the thick earthenware dish from which it takes its name. Bread (kesra) is often used as a spoon. The meal ends with a sweet semolina, flavoured with cinnamon. Friday is the day for couscous. It is the most convivial dish for after prayer, served on traditional festive occasions such as a birth or a marriage, or after a funeral. Presented as a dome-shaped mound on a hollow dish and moistened with stock, it is covered with meat and vegetables, depending on the season and the region where it is prepared. Making it is a real art. Swollen in the steam of the cooking pot and then tossed by hand, the grains must melt in the mouth. Fish couscous on the coast, corn couscous in the High Atlas, couscous with mussels on the Sous plain and fig couscous in the Sahara . . . sharing couscous is always a festive experience.

In every house the visitor is greeted with a cup of tea and no meal is complete without the ritual of mint tea. Green tea made its appearance in Morocco in 1854 when it was introduced by English merchants who were no longer able to trade with Russia because the Crimean war led to a blockade of the Baltic Sea, cutting off the route to Russia. Green tea is always served with sprigs of mint that, washed and dried, are merely bent before being added to the teapot – they are never cut. The tea is brewed in front of the guests and it is stirred at great length, smelled and tasted by the person preparing it before being served in small, narrow glasses. The teapot is then raised high above the glass to pour this delicious drink in long, amber-coloured jets, sometimes flavoured with saffron, marjoram or orange flower water. Mint tea is always accompanied by home-made pastries: little cinnamon-flavoured shortbread biscuits, chebbakia, dripping with honey, almond-flavoured gazelle horns, or dates sweetened with honey . . .

Hot, stimulating or sweet, spices give Moroccan cuisine the indefinable flavour that makes it unique, so long as they are used in the right quantities. Bought loose at the markets, they enhance meat and vegetable dishes and add flavour to pastries and cakes. Each spice has its particular taste. Saffron, highly sought after and usually found in the form of whole filaments, is cultivated in Morocco in the area between Ouarzazate and Agadir. The flowers are carefully picked one by one by hand at the beginning of the winter. When the three stamens have been removed, they are dried in a dark place. You need about 100,000 flowers to make one kilo (2 lb. 2 oz.) of saffron. Turmeric colours food yellow and is often called 'poor man's saffron'; cumin is used to coat meat kebabs and to flavour eggs; ginger can be used to flavour both sweet or savoury dishes; cinnamon, imported from the east, enhances the flavour of oranges, pastilla and sweet semolina. Hot chilli pepper is used sparingly and is often replaced by the sweeter, milder paprika. Coriander (*kasbour*), used as a fresh herb, is omnipresent in Moroccan cuisine, as is flat-leaved parsley.

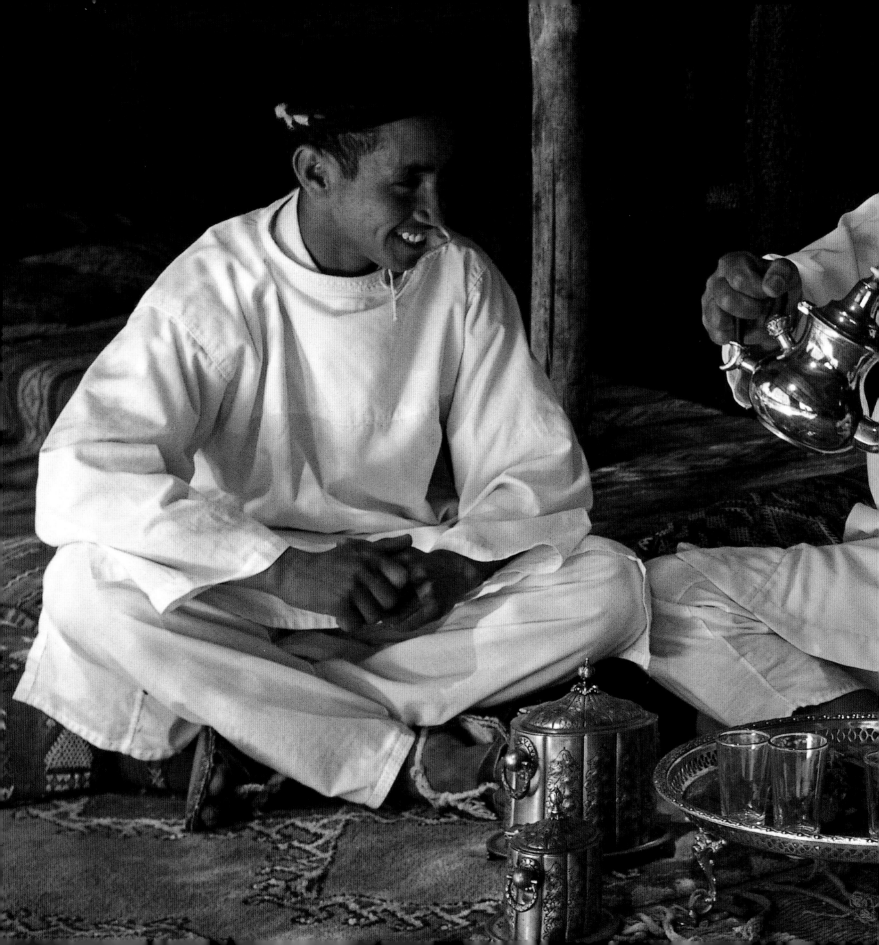

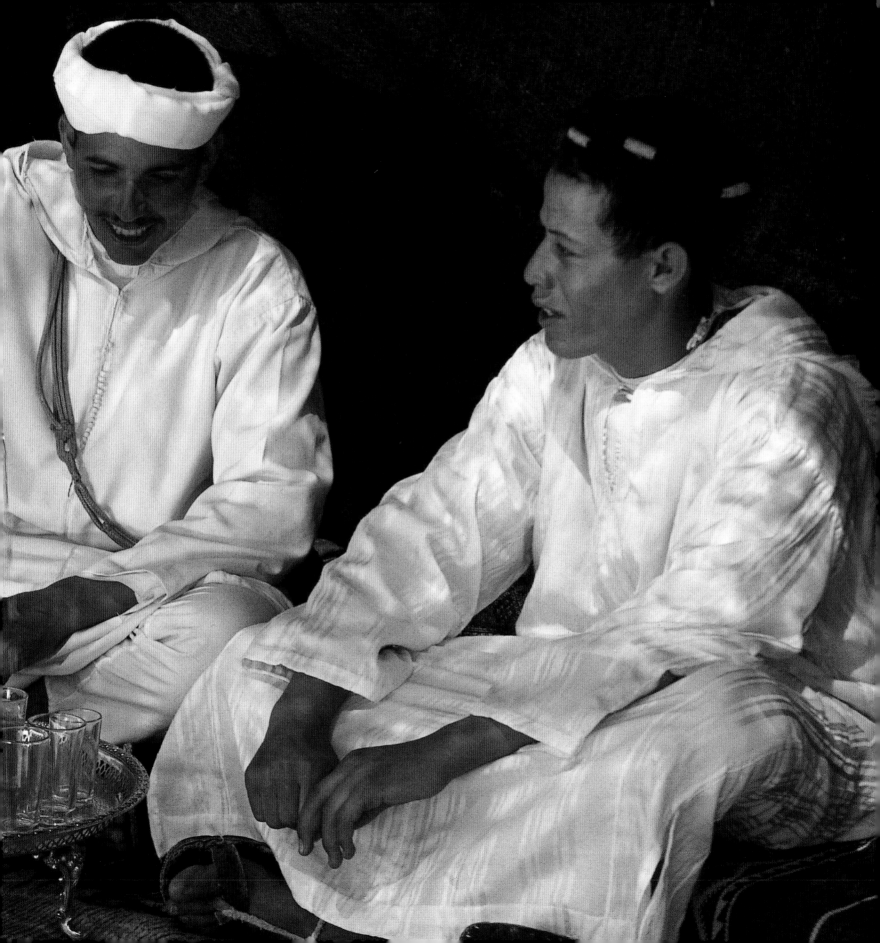

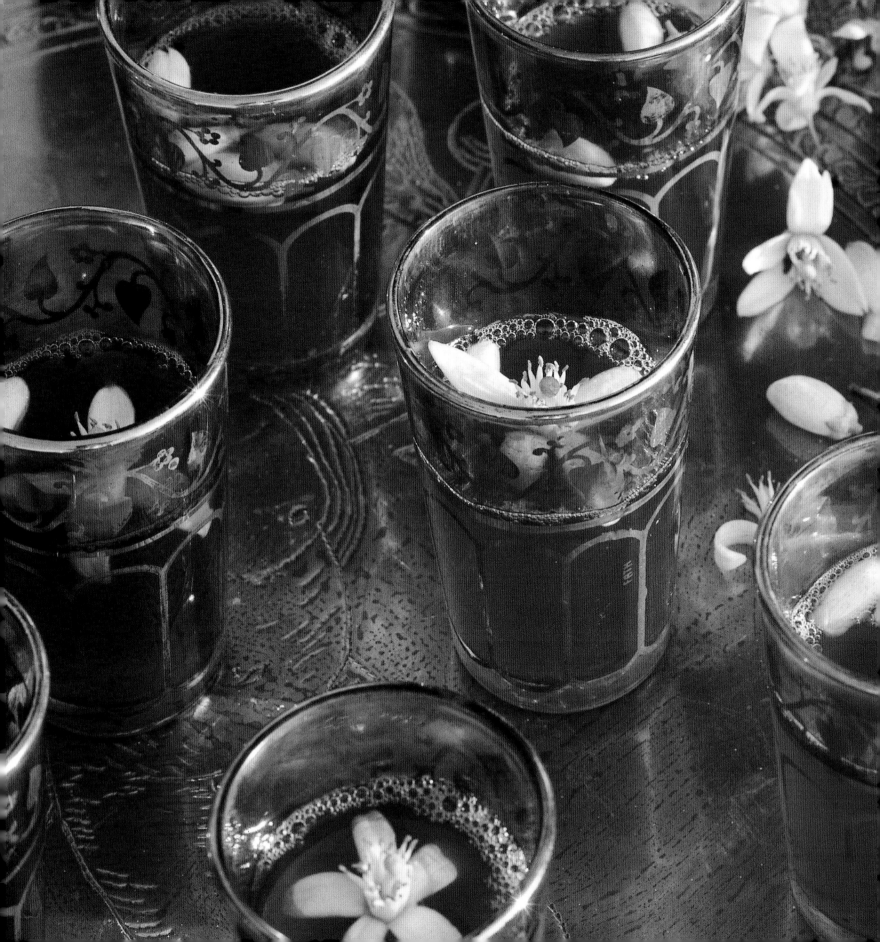

The father breaks the sugar with the bottom of a glass, crushes a handful of green tea in the palm of his hand and strips the leaves from the sprig of mint. The steam from the water that he pours from the copper kettle into the nickel teapot, which he then hands to the woman squatting down near him, almost conceals her. The brazier is flanked by two trays, one for the glasses and teapot, the other bearing three engraved copper boxes containing sugar, tea and mint. Without a single drop spilling onto the tray, the tea is poured from high up into the glasses. The man tastes the brew, clicks his tongue to express his satisfaction.

Driss Chraïbi, *Le Passé simple (The Simple Past)*

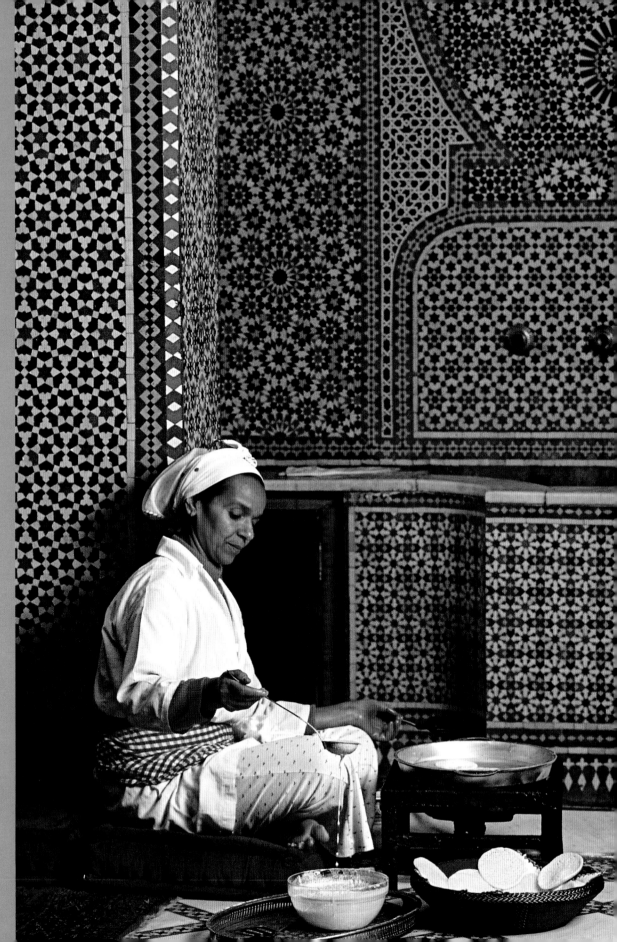

Cooking, whether for a modest meal or a festive occasion, continues to be the prerogative of women. The kitchen is exclusively the female domain where men never venture. In traditional families, women do the shopping and spend a large part of their day preparing meals, baking pastries and cakes and making preserves from jealously guarded secret recipes. Transmitted from mother to daughter through the generations, the art of cooking combines manual skills with a clever mixing of the proportions, relying more on hand and eye than on the scales. Meticulous, complex preparations and lengthy cooking processes are time consuming if done properly.

**LEFT**
Couscous semolina is traditionally worked by hand and steamed.
**RIGHT**
*Beghir* (pancakes 'with a thousand holes'), are eaten hot, coated in honey and butter.

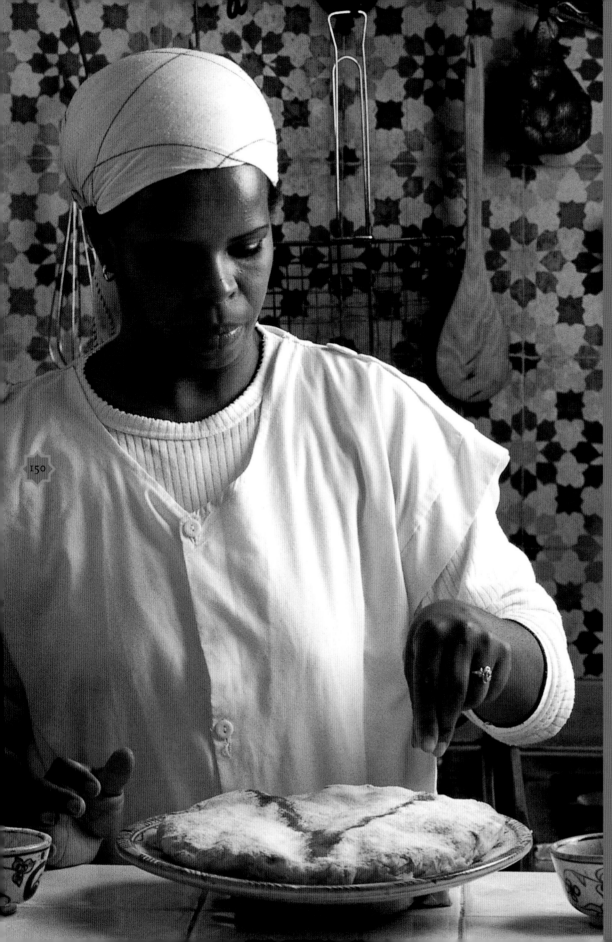

Paradoxically, Ramadan is the busiest period in the year for cooking. When the sun sets, the *iftar* meal marks the end of the fast, announced by sirens in every town. The steaming harira takes the place of honour at the centre of the table; this thick soup made with tomatoes, lentils, chickpeas, rice and spicy, lemon-flavoured meat is served with hard-boiled eggs, dates and pancakes. The traditional ramadan pastries are *chebbakia*, spirals of golden deep-fried dough, served with a thick sauce flavoured with honey and sprinkled with sesame seeds. The meal served before sunrise, *suhoor*, consists of dairy products, sweet semolina and pancakes.

**LEFT**
The pastilla: puff pastry stuffed with meat and powdered almonds, sprinkled with icing sugar and cinnamon.
**RIGHT**
Each spice has its own specific taste with beneficial and stimulating properties. • A table set for *iftar*.

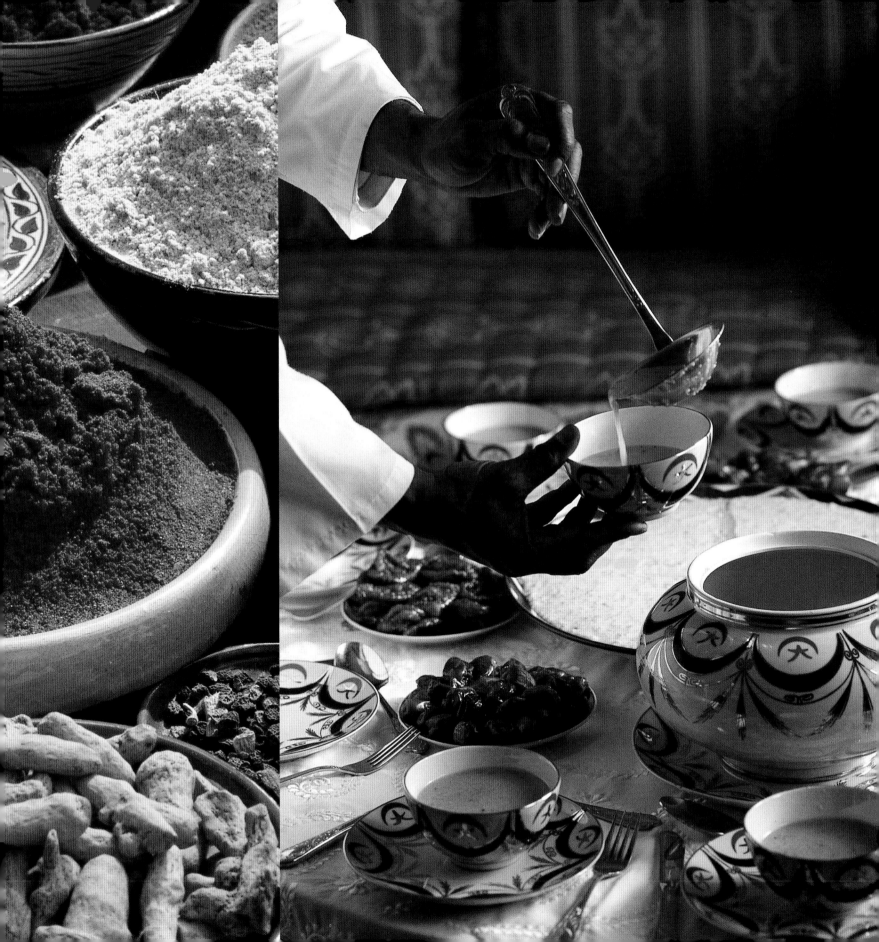

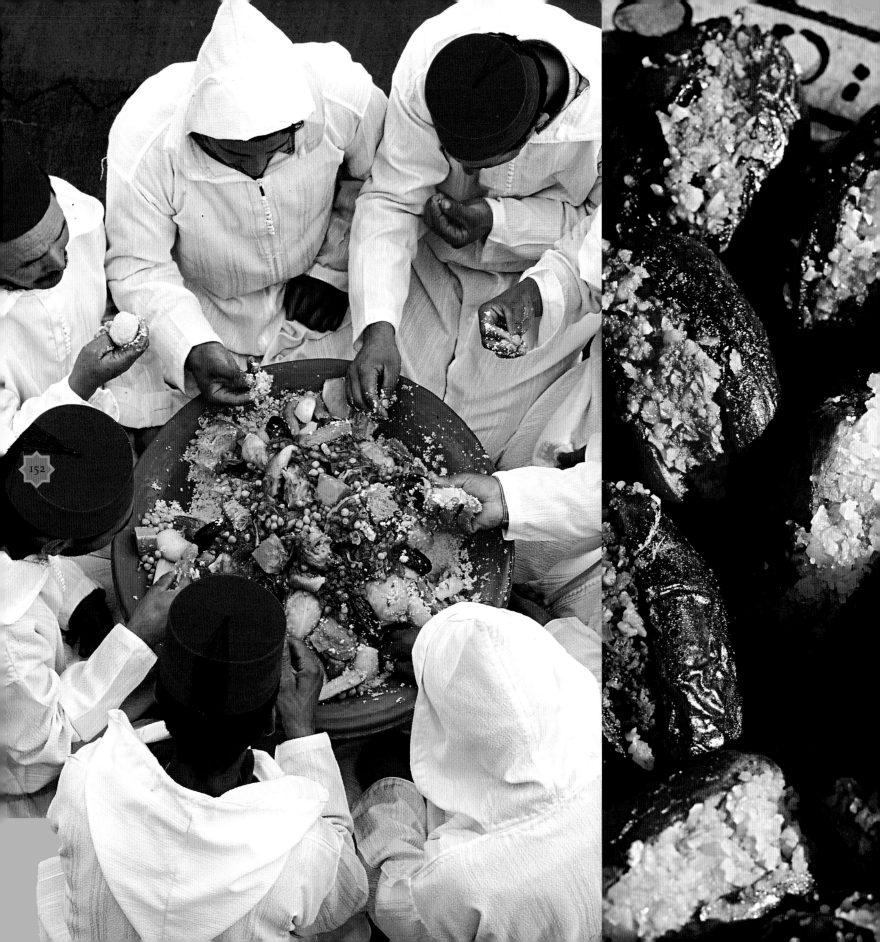

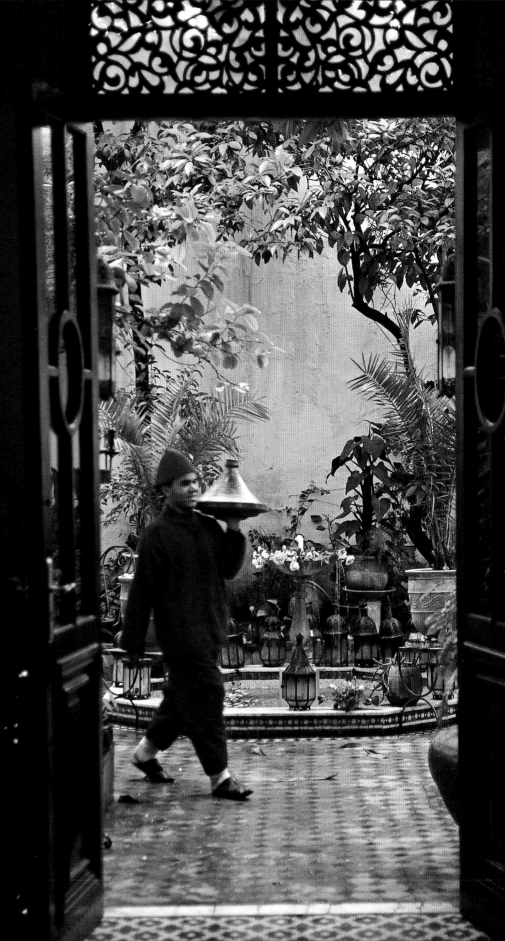

Famous throughout the world, Moroccan cuisine owes its richness to the mix of cultures that have existed in the kingdom over the centuries. From their Berber ancestors, Moroccans have inherited simple, country dishes, mainly based on wheat. The Arabs who arrived in Morocco in the seventh century to conquer North Africa brought with them the refinement of the East and the aromas of exotic spices. But Moroccan cuisine has largely been inspired by that of Andalusia, combining sweet and savoury, sweet and sour. Kebabs, mechoui and sweet pastries are borrowed from Ottoman cuisine and the omnipresent green tea was introduced by English merchants.

**LEFT**
Couscous, shaped into small balls, is eaten with the right hand. · Stuffed dates for dessert.
**RIGHT**
The arabesque riad in Fès.

They stop in front of our tents, set down a long line of covered dishes and wait, standing in front of us while we uncover in turn half a roast sheep, three chickens with lemon and olives, three more chickens with tomatoes and eggs on top, a mutton stew with aubergines, courgettes and chilli peppers . . . a couscous with meat and vegetables . . . and what else? I don't remember.

Jérôme and Jean Tharaud, *Marrakech ou les Seigneurs de l'Atlas (Marrakesh or the Masters of the Atlas)*

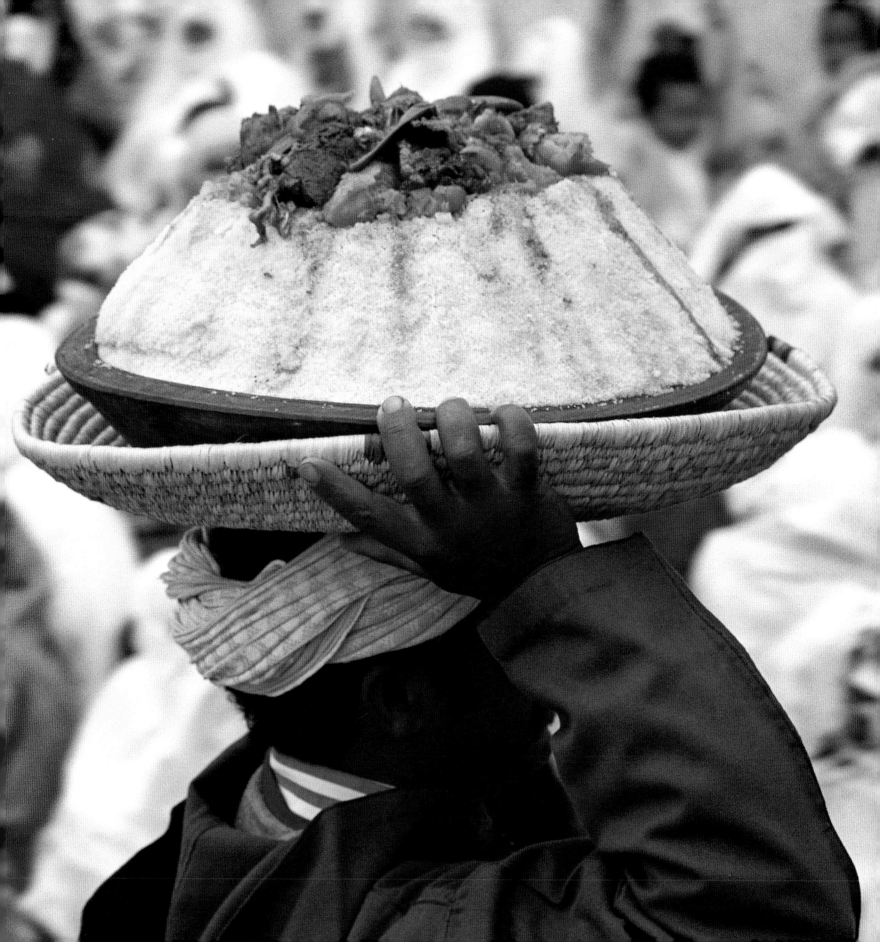

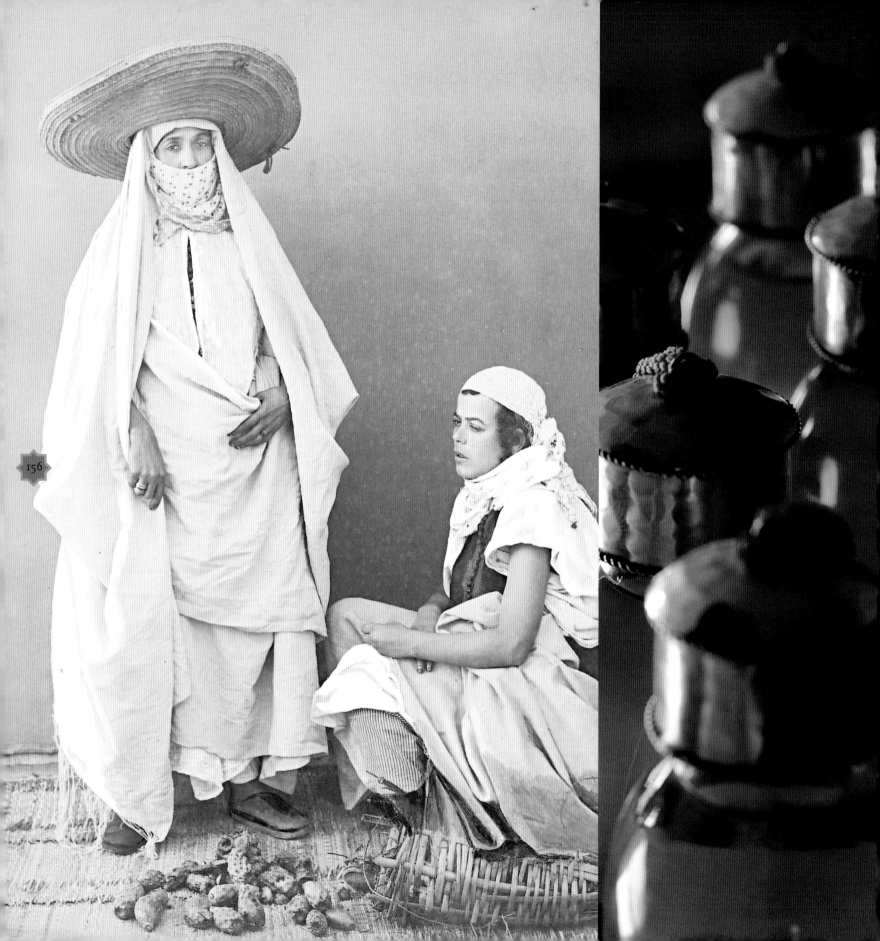

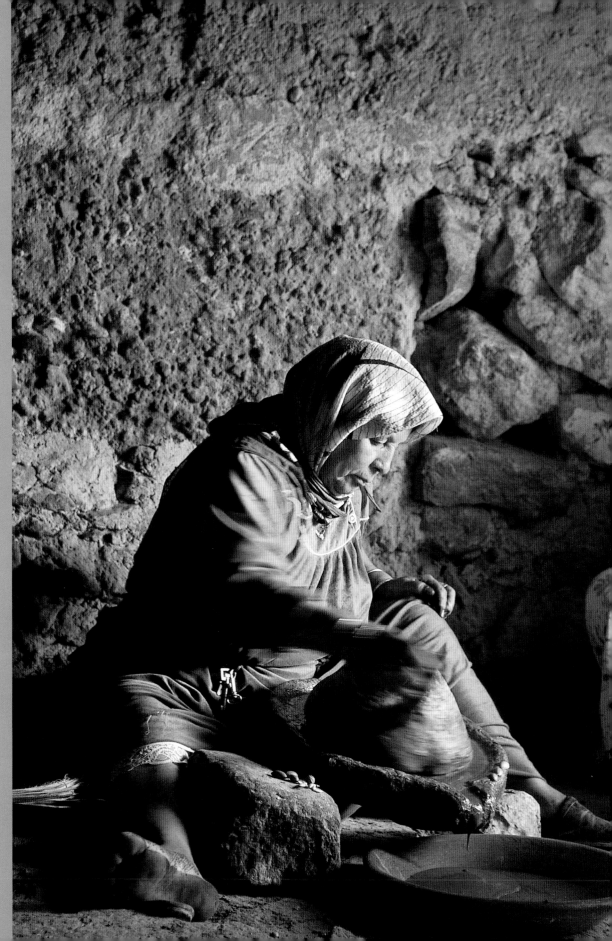

Argan oil, celebrated for its fruity taste, is extracted from the nuts of the argan, a tree with a gnarled trunk and branches covered in dry spiny thorns. This species is endemic to south-western Morocco and grows mainly on the Sous plain as well as near Agadir and Essaouira. Because of its deep roots the argan tree has nothing to fear from Moroccan heat and drought. Goats are particularly fond of it, climbing up its branches and balancing on their hooves as they eat the leaves and fruit.

**LEFT**
Women of Fès posing as fig sellers for a photographer in the early twentieth century. • Essential oils based on argan oil are much used in cosmetics.

**RIGHT**
Traditionally, removing the kernels of the argan nut has been women's work. After roasting, the kernels are ground and formed into a paste that is squeezed between the hands, so producing the oil. A total of 100 kg (220 lb.) of fruit produces about 30 kg (66 lb.) of nuts from which 1.5 litres (around 3 pints) of oil is extracted.

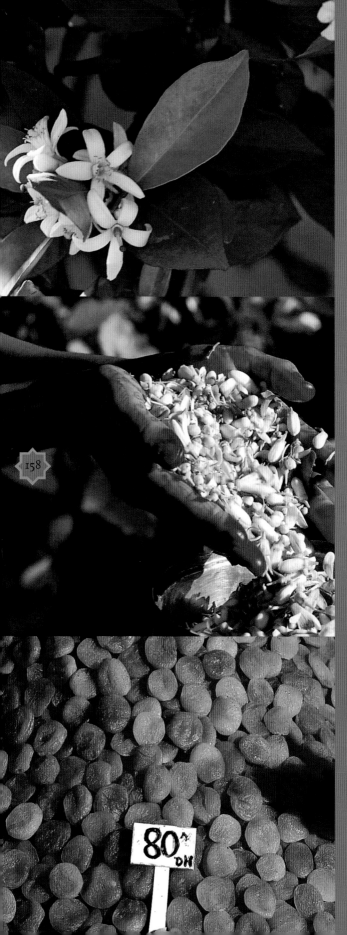

158

In Morocco eating somewhere other than at home is extremely rare, except from necessity. This is because few restaurants can compete with the quality of home cooking, whether it be in Fès, Marrakesh, Rabat or Safi. In the past, cooking varied from region to region but local dishes are gradually disappearing as a result of the movement of population. Only family traditions survive in the secrecy of the kitchen. The cuisine of Fès, the imperial city, has spread throughout Morocco and is the inspiration of numerous recipes. It is a cuisine characterized by dishes that have simmered for hours on end and have sophisticated flavours.

**LEFT**
Picking orange blossom in the spring. •
Dried apricots sold by weight.
**RIGHT**
Pastries. • Precious saffron from
Talioune. • Mint leaves. • 1 kg (2.2 lb.)
of saffron represents 100,000 flowers. •
Jasmine flowers. • Cone-shaped sugar
loaves weighing about 2 kg (4.4 lb.),
wrapped in their traditional thick,
mauve paper.

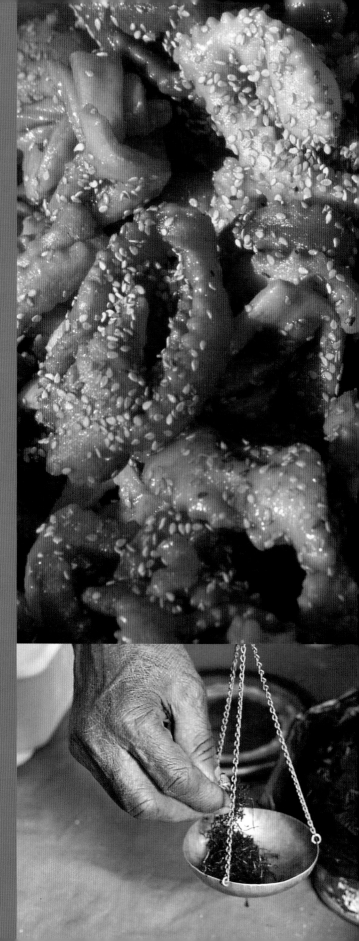

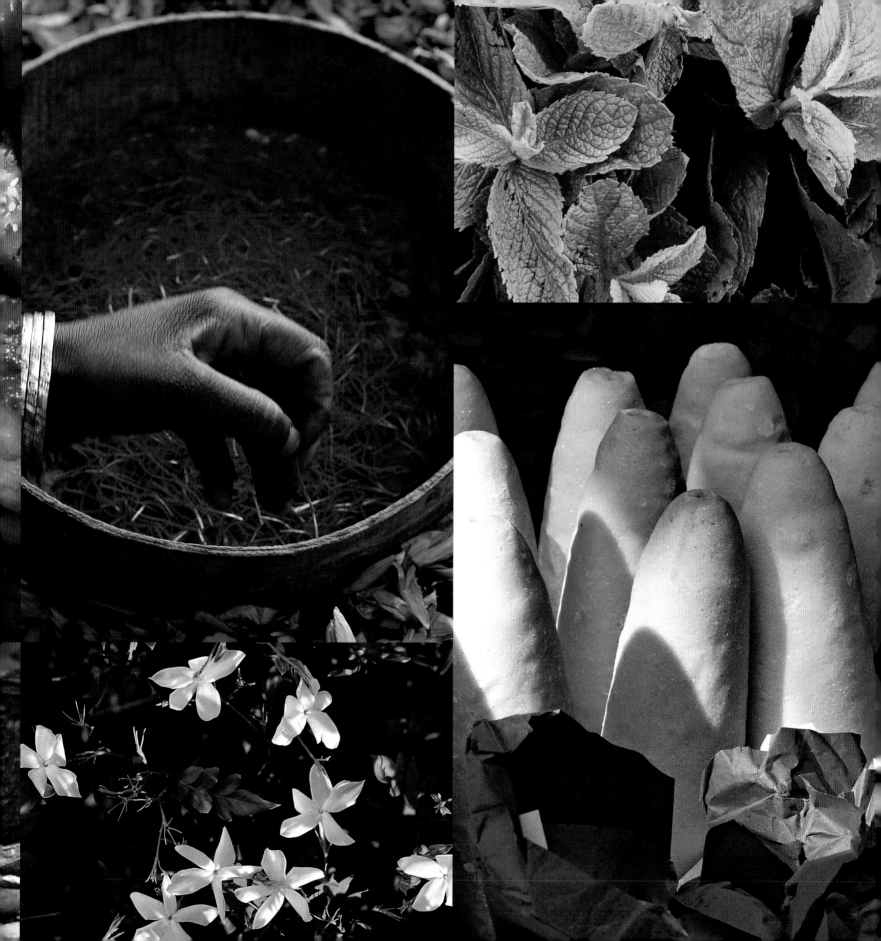

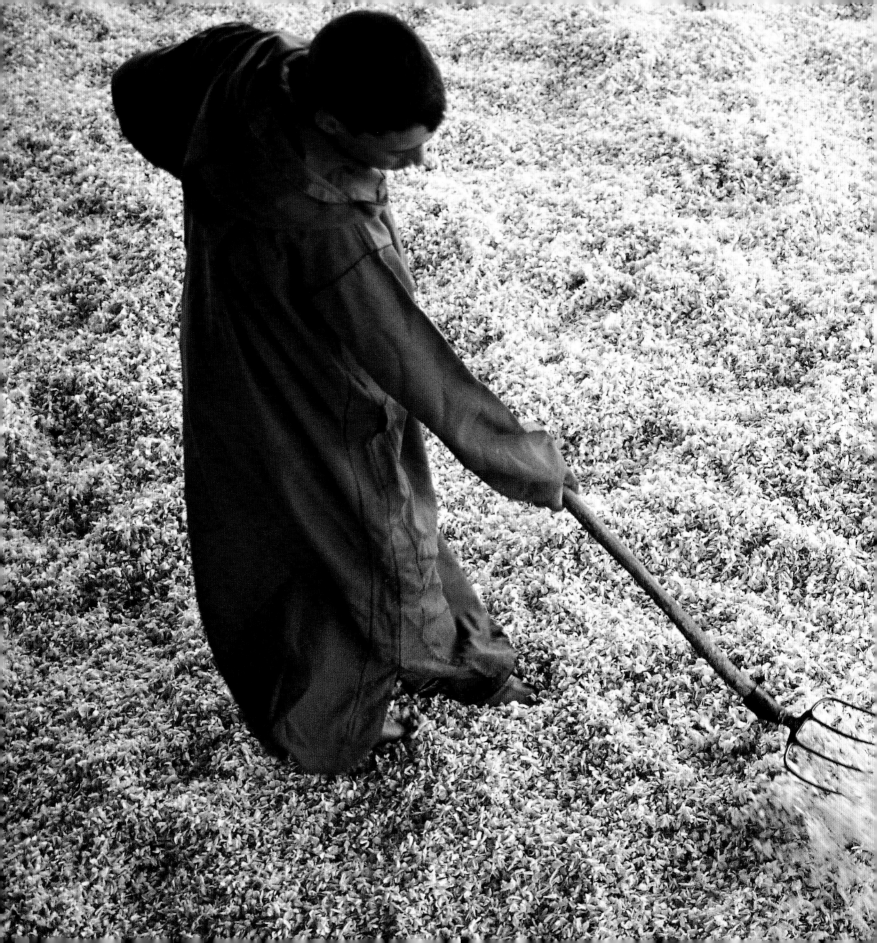

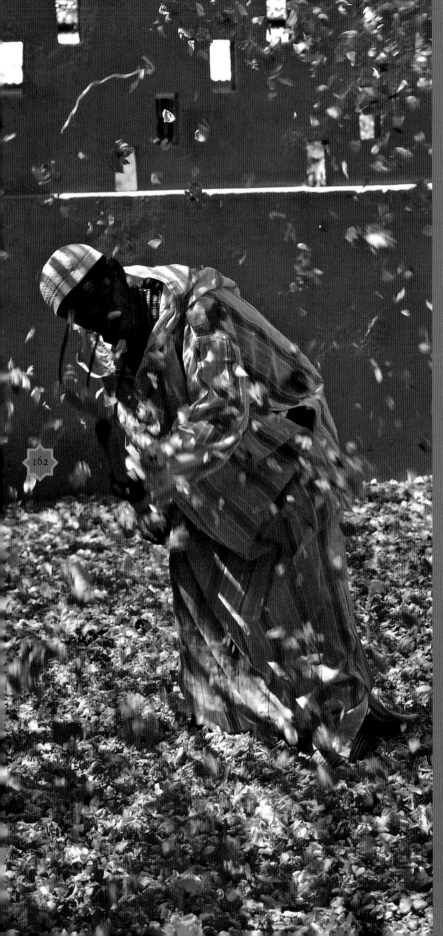

162

Every morning in spring, starting at dawn, the inhabitants of the Kelaa M'Gouna region pick roses by the thousands. The flowers are then spread on shaded terraces to dry. Some of the roses are for the herbalist's shop while the rest are sold to the two distillation factories in Kelaa M'Gouna. Spread out on a thick rug in an open hangar, the roses are carefully turned over every day to prevent them from rotting. The petals are then transferred to enormous copper vats before being distilled to produce rose oil and rosewater. The festival of roses, held every year at the beginning of May, celebrates the end of the harvest.

**PRECEDING PAGES**
Harvesting jasmine flowers.
**LEFT**
Rose petals before distillation.
**RIGHT**
In all, 5 kg (11 lb.) of fresh roses are needed to obtain 1 kg (2.2 lb.) of dried flowers. • Morocco produces about 3 tons of rose oil per year, one-third of which is exported to France.
The old photograph shows Cherha-Fasia in Fès in about 1919.

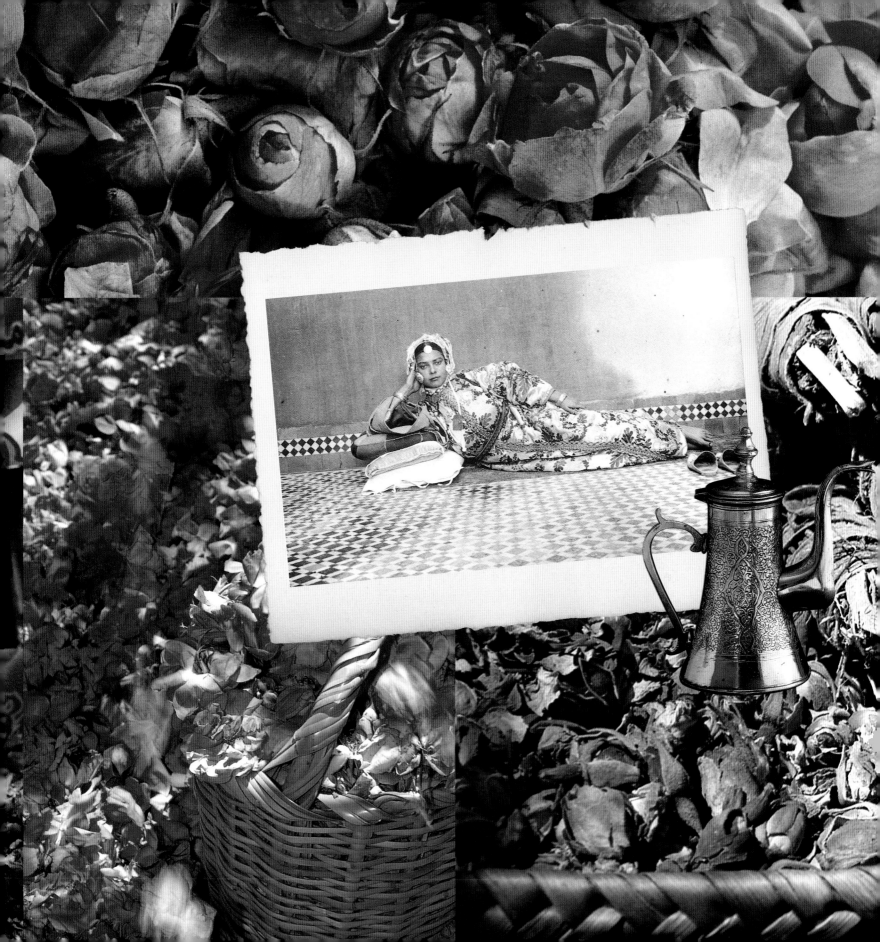

Herbalists' shops sell frankincense, myrrh and benzoin, which are burned for their fragrance, in their natural state. Frankincense is the resin produced by a small tree, *Boswellia sacra*. To release its fragrance, incense must be placed on a slow-burning source of heat such as coals. Some types of incense have a stimulating effect while others have calming properties. Myrrh is a gum resin obtained by making incisions in the trunk of *Commiphora myrrha*, a tree that grows in Arabia and East Africa. Reddish-brown in appearance, it exudes its fragrance only when it is warmed or moistened. Benzoin is produced by a tree that grows in Jordan, Palestine, Nubia, Somalia and Ethiopia. The resin that oozes from the trunk is collected in vases; these are buried underground and later exposed to the sun. An oil then forms that sits on the surface, the balm itself, pure and liquid.

**LEFT**
Pink incense stones.
**RIGHT**
Incense burning in an earthenware *kanoun* (movable brazier).

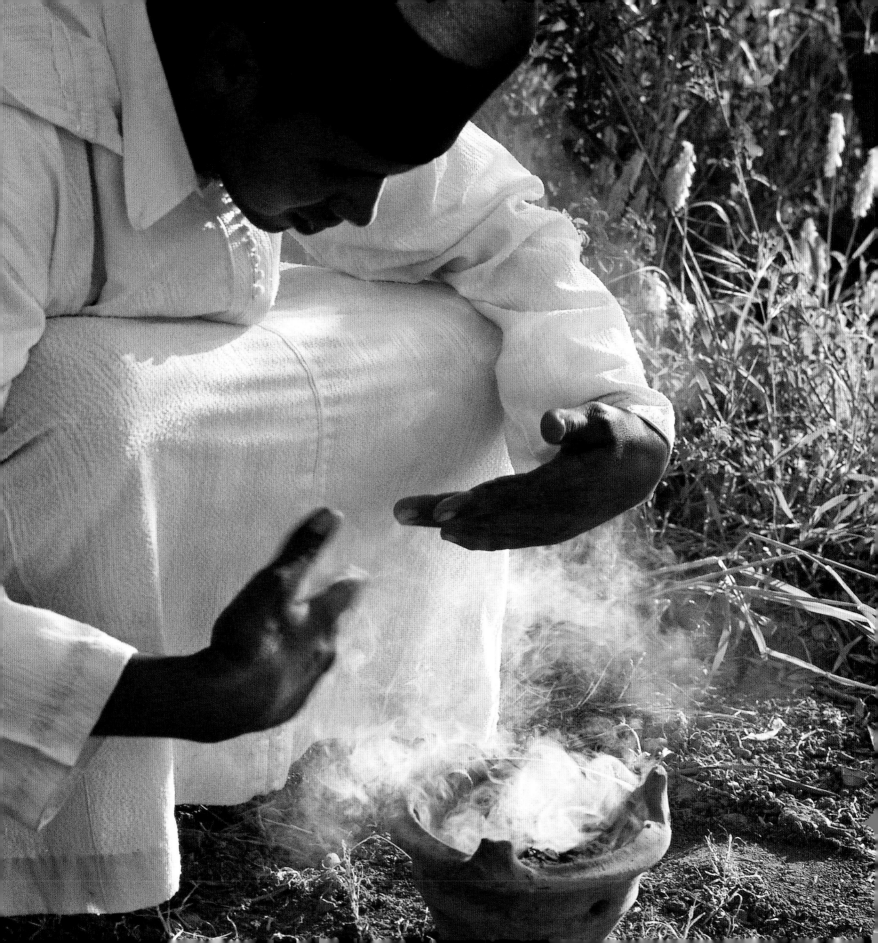

# THE BLUE OF THE SEAS

Morocco is bordered by two seas, one to the north, the Mediterranean, and the other to the west, the Atlantic, in other words 3,600 kilometres (2,240 miles) of coastline. The two seas meet at Cape Spartel near Tangier where their turquoise, blue-green and green waters mingle. The sea has been the means of conquest since antiquity. The Phoenicians were the first invaders of Morocco, reaching the Atlantic coast in the ninth century BC and they built ports at Lixus, not far from present-day Larache, at Salé (Rabat) and on the island of Mogador, facing Essaouira. In about 450 BC the Carthaginians left traces of their passage at Tetouan, Larache and Salé. In 146 BC the Romans arrived in Morocco and established trading posts at the ports. Lixus became a fishing and commercial centre. It had about a hundred vats for salting the fish and manufacturing garum, a condiment made from fish intestines that was highly prized in Rome.

The Portuguese established themselves in Morocco by force in the early fifteenth century. Their aim was to build towns all along the Atlantic coast to secure the sea route to western Africa and so control the gold trade. They captured Ceuta, then Ksar-es-Seghir, before landing in Asilah with a fleet of 480 vessels. They then sailed to Azzemour and on to Mazagan (El Jadida), also settling in Safi, Essaouira and Agadir in 1505. The age of Portuguese conquests ended in 1578 with the Battle of the Three Kings in which King Sebastian of Portugal died, as did Abd al-Malik, chief of the Saadi dynasty, and his nephew Mohammed al-Mouttaouakil, an ally of the Portuguese. Vestigesof the Portuguese occupation survive in Morocco, including several fortified cities protected by walls and bastions facing the ocean. El Jadida in particular has some beautiful Portuguese architecture and a magnificent cistern: an underground hall with vaults supported by five rows of stone columns reflected in the water.

In the seventeenth century, taking advantage of the political conflicts and anarchy that marked the end of the Saadi regime, the Spanish captured the coastal cities of Larache and Mehdia while the Portuguese occupied Tangier again and Mazagan. At the same time, the Atlantic Ocean became the scene of a holy war. The last Muslims expelled from Spain by the Catholic kings took refuge in Rabat,

> *" The Phoenicians were the first invaders of the Atlantic coast of Morocco"*

from where they attacked Christian ships on the high seas as a jihad and seized their goods. These new pirates founded an independent republic, spreading fear and terror among European powers.

Essaouira, the former Mogador, was founded in about 1760 on the order of the Alouite Sultan Sidi Mohammed Ben Abdallah. The architect Théodore Cornut, commissioned by the sultan, drew the plans and built the walls surrounding the town, which followed the same design as Vauban's Saint Malo. On the seaward side, square-crenellated ramparts defended the town from maritime attacks. Essaouira was named 'the port of Timbuktu'.

The seas off Morocco form one of the largest natural marine resources in the world and fish are a vital economic asset for the kingdom. The ocean depths supply the ports of Casablanca, Agadir, Safi and Essaouira. Morocco is the largest supplier of fish in Africa and the largest exporter of tinned sardines of the species *Sardina pilchardus*. The types of fish captured in Moroccan waters are extremely varied and are classed in two large groups: the

benthic species that are found near the coast (gilt-head bream, smelt, gurnard, hake, ombrine and sole) and the pelagic species that live in the open seas (sardine, mackerel, tuna, anchovy and horse mackerel).

The most beautiful beaches are found along the Atlantic coast: between Rabat and Mohammedia; between El Jadida and Safi; in Oualidia, where it is protected by a lagoon famous for its oysters; in Essaouira, popular with surfers and windsurfers; in the bay of Agadir; and near Tiznit and Sidi Ifni for lovers of large, wild beaches. But they can all be dangerous when the strength of the wind transforms the swell into violent waves and treacherous breakers. The Atlantic coast is also ideal for bird watching, for instance in the lagoon of Moulay-Bousselham, south of Larache or in the nature park of Sous-Massa, south of Agadir. On the Mediterranean coast from Ceuta to Cabo Negro or near Al Hoceima, long beaches with golden sand alternate with rocky coves and little creeks. Some of these creeks are sought after by divers and underwater fishermen.

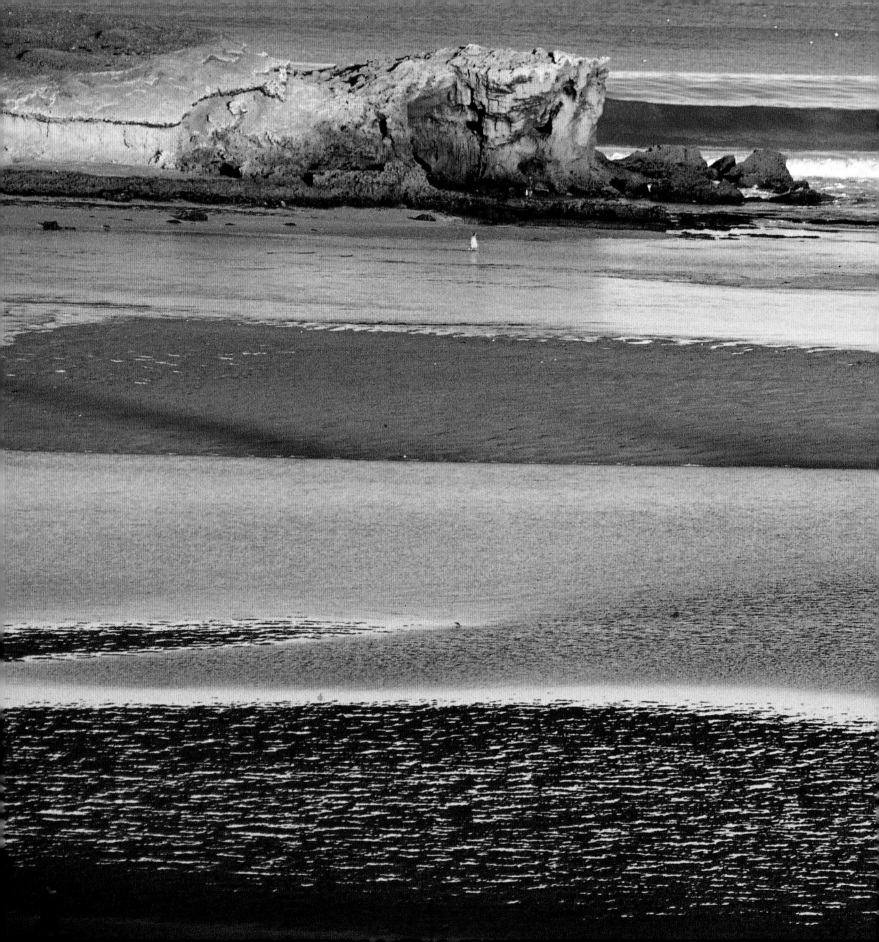

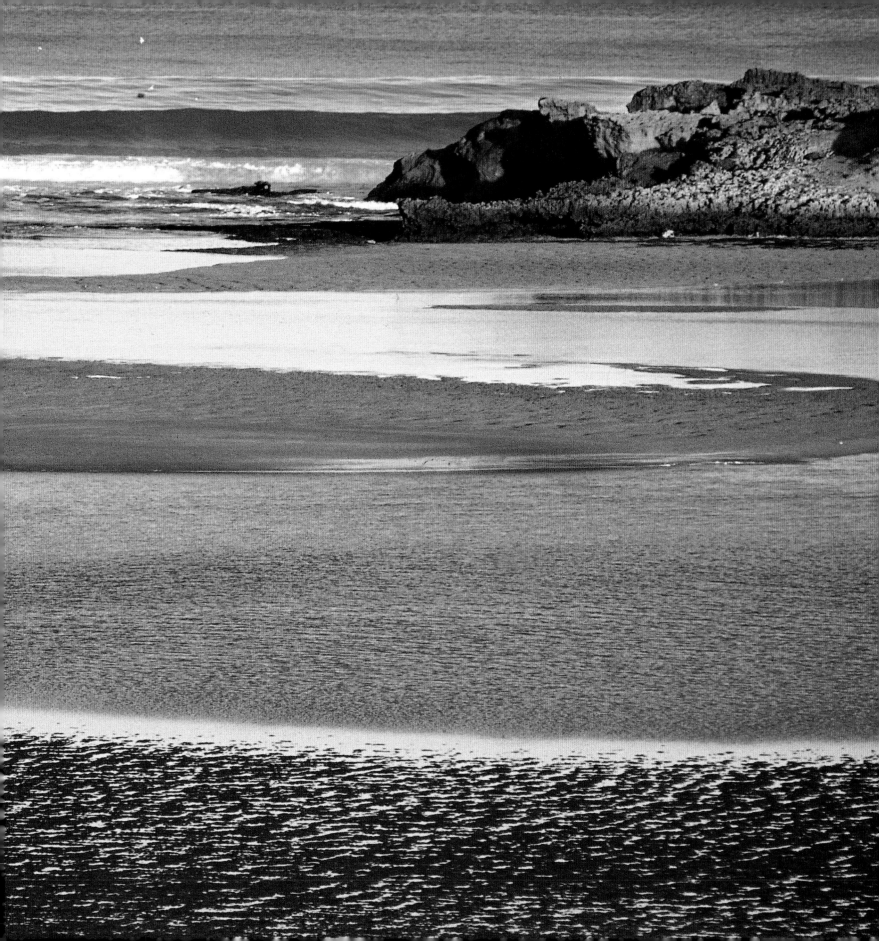

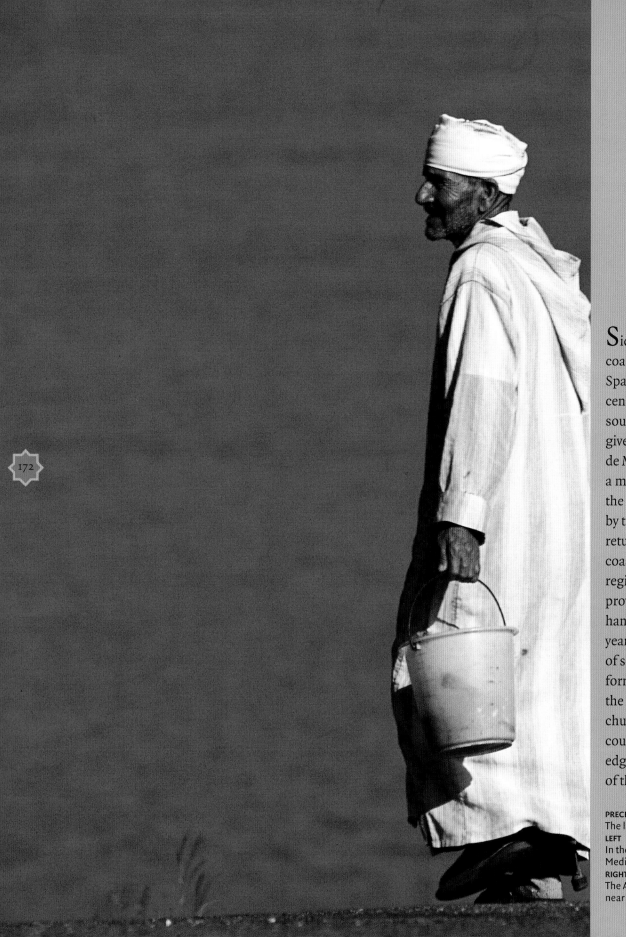

Sidi Ifni, on the Atlantic coast, was occupied by the Spanish in the fifteenth century. The small fort erected south of the town in 1476, given the name of Santa Cruz de Mar Pequeña, was used as a military base on the route to the Canaries. Expelled in 1524 by the Saadians, the Spanish returned and settled on the coast in 1934. In 1959 the region was declared a 'Spanish province of Africa'. It was handed back to Morocco ten years later. The colonial style of some buildings, such as the former Spanish consulate or the Art Deco Hispano-Berber church converted into law courts, and the *paseo* on the edge of the cliff, are reminders of this occupation.

**PRECEDING PAGES**
The lagoon of Oualidia.
**LEFT**
In the Oued-Laou region on the Mediterranean coast.
**RIGHT**
The Atlantic coast north of Sidi Ifni, near Mirleft.

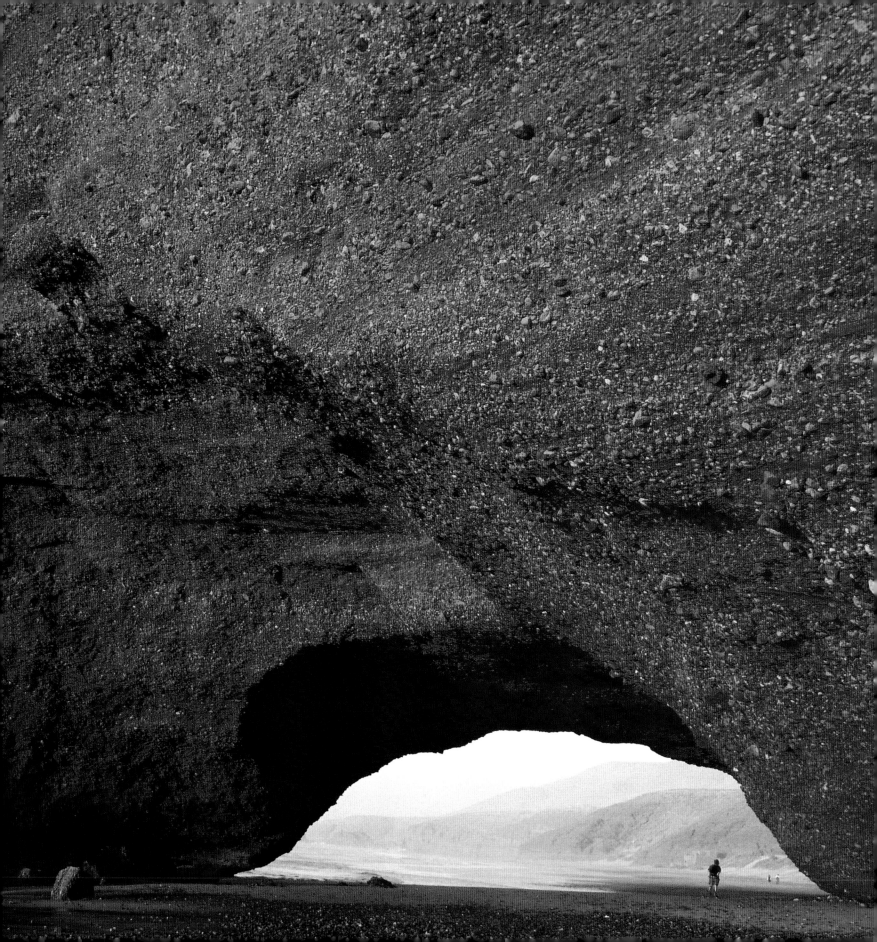

... Cliffs that defy the Atlantic. A scrubland shrivelled
by wind and salt.
Seagulls.
Seagulls.
Seagulls ...

The obsolete memory of the Phoenicians, the outdated
nostalgia of the Romans and the lost memory of
adventurers of all kinds, in a frightening solitude ...

Rachid Haloui, *Essaouira: A vol de mouette* (*Essaouira: As the Seagull Flies*)

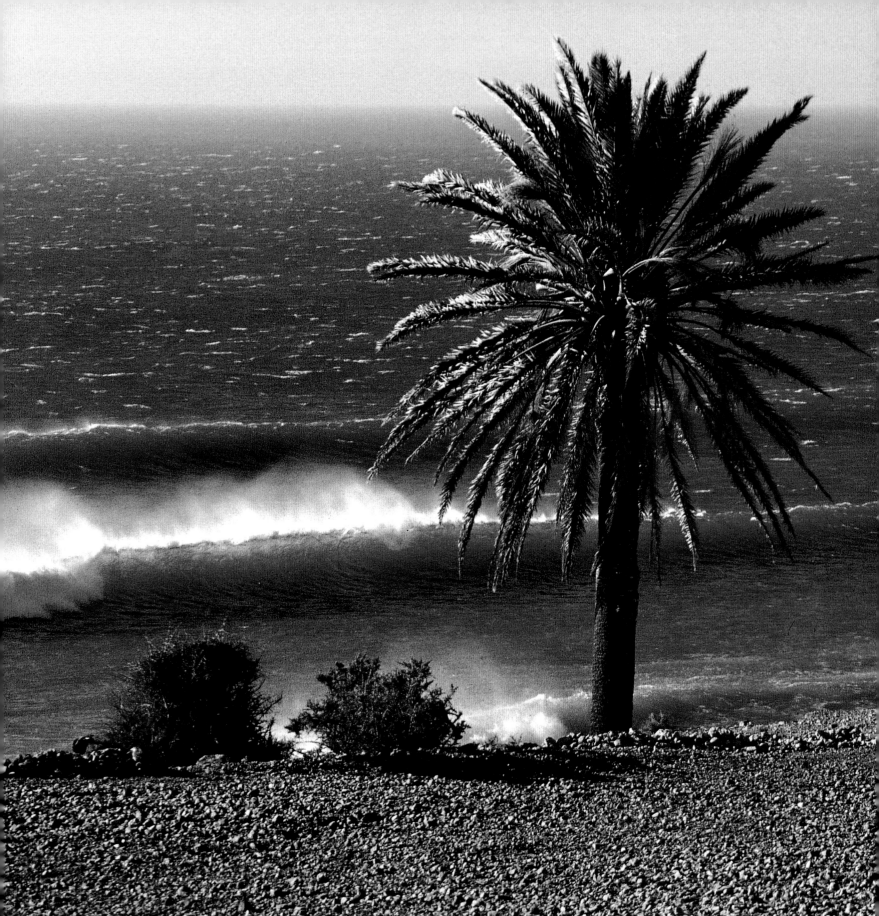

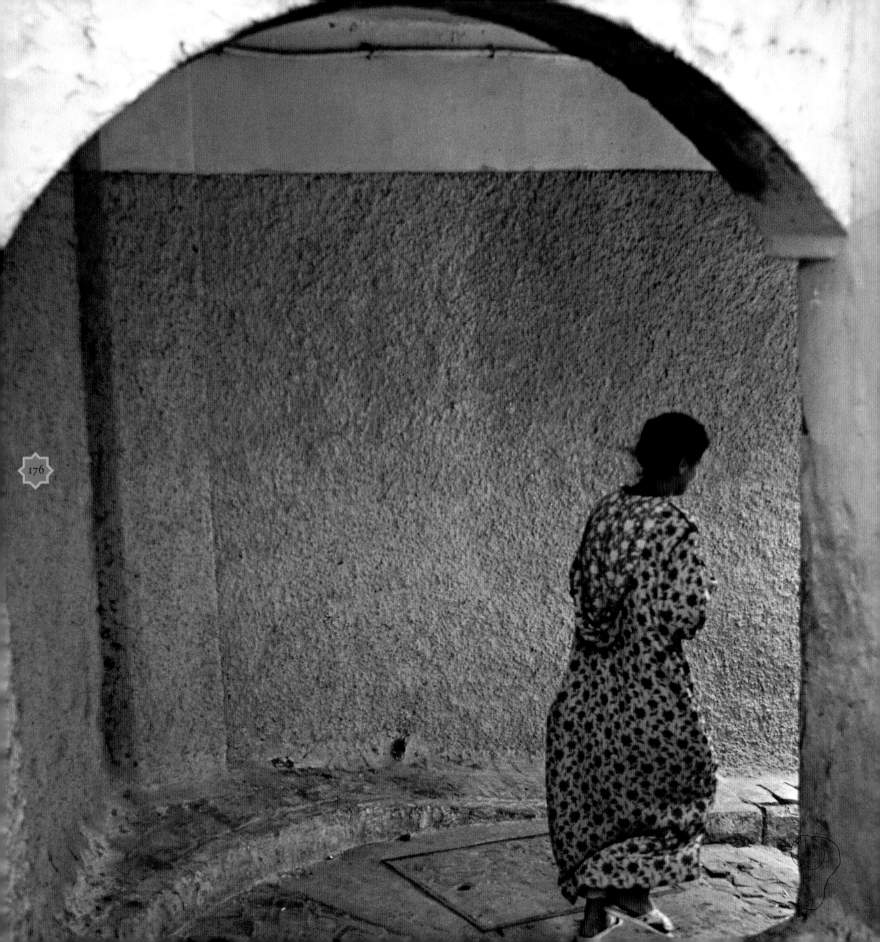

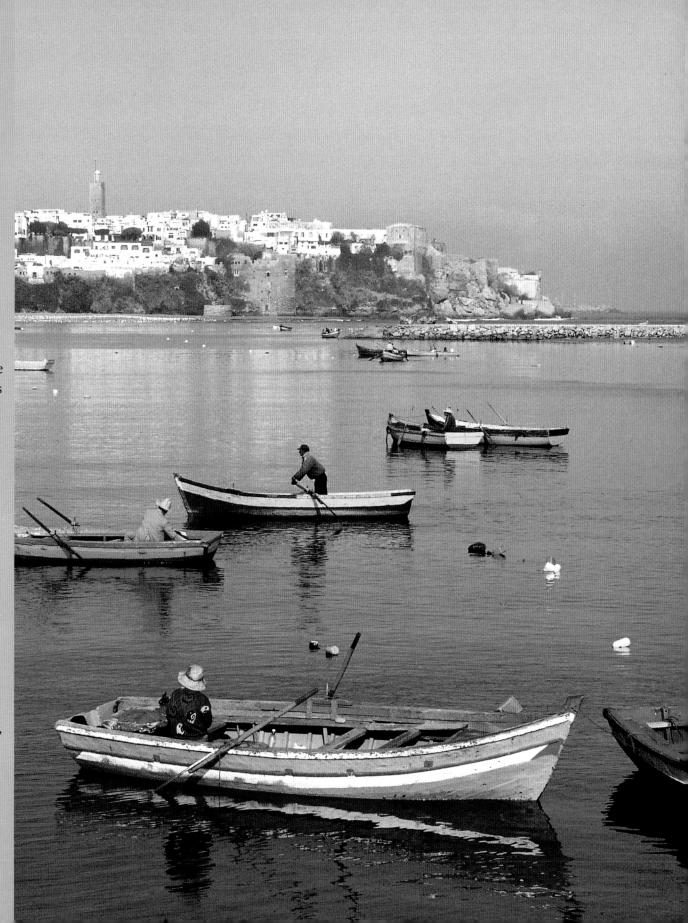

Situated between the Bou Regreg river and the ocean, the Oudaias kasbah in Rabat looks like a fortress. A protected harbour and advance post, in the Middle Ages it provided a base for warriors setting out on expeditions to Spain. The kasbah is criss-crossed by narrow alleyways and lined with houses painted in blue and white. In the fifteenth and sixteenth centuries it was the refuge of the last Muslims expelled from Spain who gave it its Andalusian flavour. The palace of the kasbah, erected in the seventeenth century, is surrounded by a magnificent garden in the Andalusian style, embellished with fountains, fruit trees, oleanders and orange trees.

**LEFT**
A narrow alleyway in the Oudaias kasbah.
**RIGHT**
The Bou Regreg river with the Oudaias kasbah in the background.

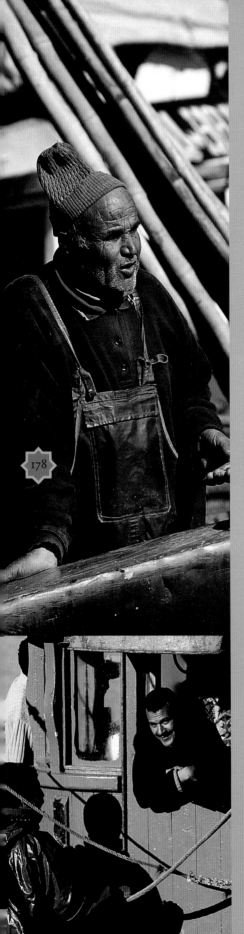

178

With 75 per cent of the total catch, coastal fishing plays a major part in Morocco's economy. The coastal fleet consists of 2,500 vessels, including 400 trawlers, 400 sardine boats, 100 long-line fishing boats, 700 lobster boats and various other boats. The trawlers catch mostly 'white' fish while the sardine boats catch mostly 'blue' fish. The lobster boats catch their prey with the help of lobster pots while the long-line fishing boats operate mainly in rocky areas.

**LEFT**
Fishermen of Essaouira.
**RIGHT**
Fishing boats in the Agadir region. •
The sea walls at Tangier. • Oyster
fishermen. • The famous oysters of
Oualidia. • Fishermen returning with
their catch.

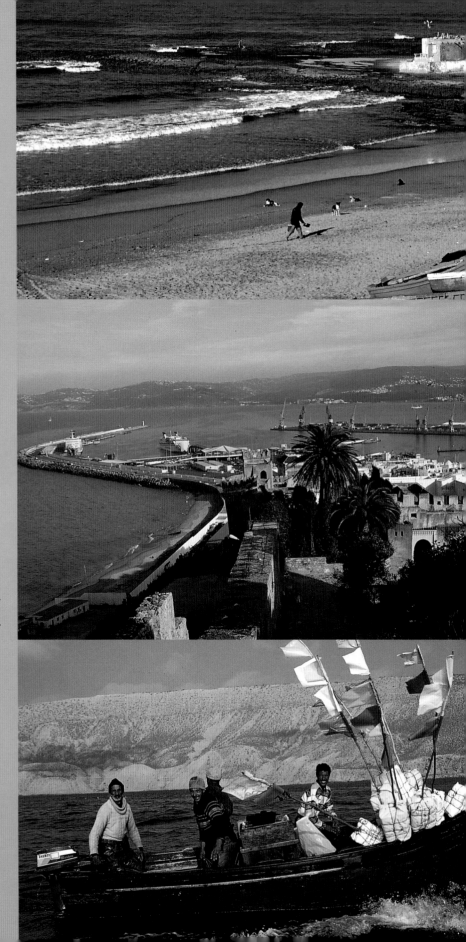

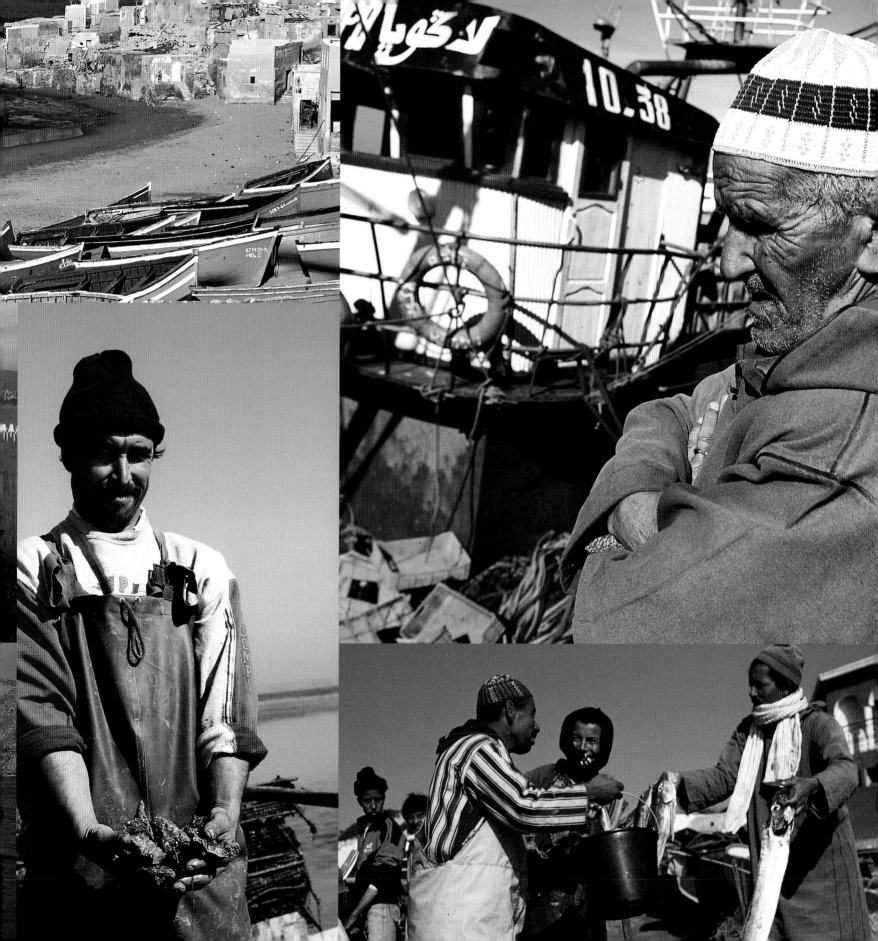

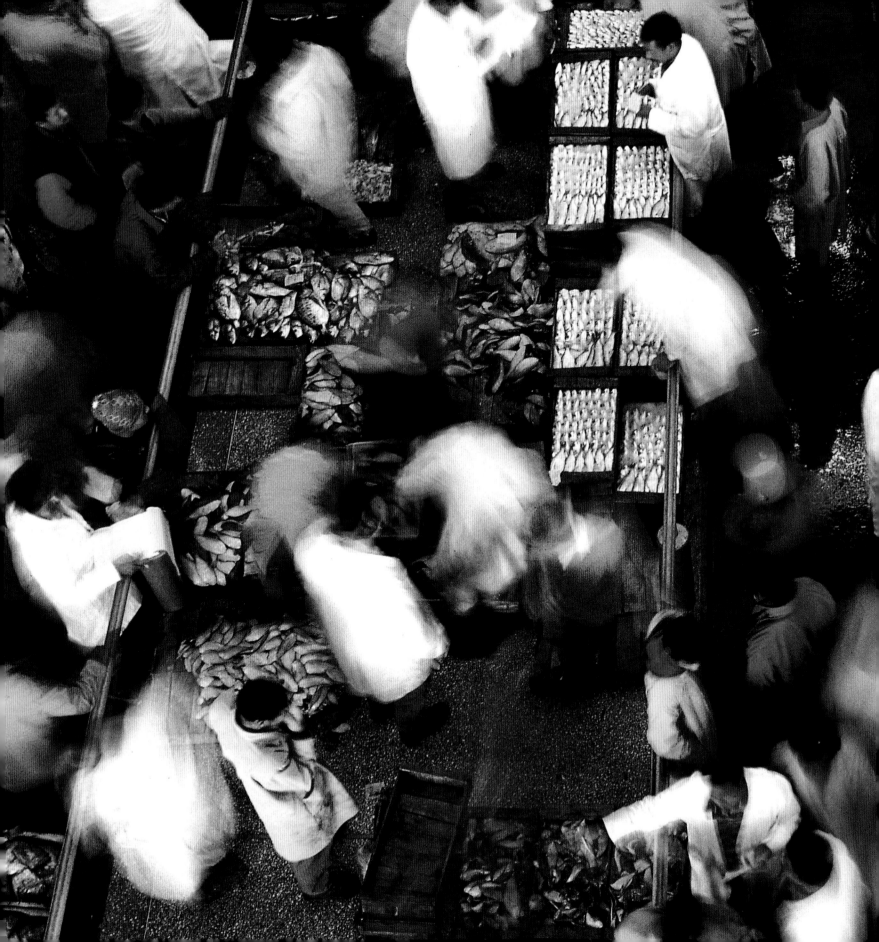

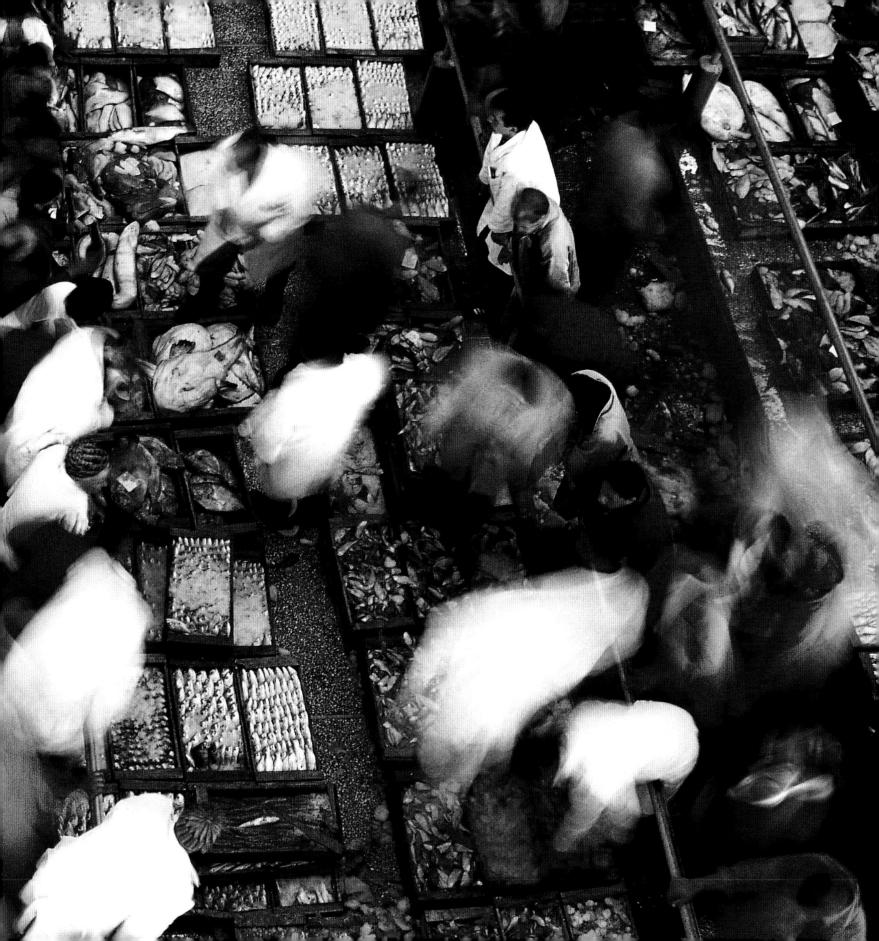

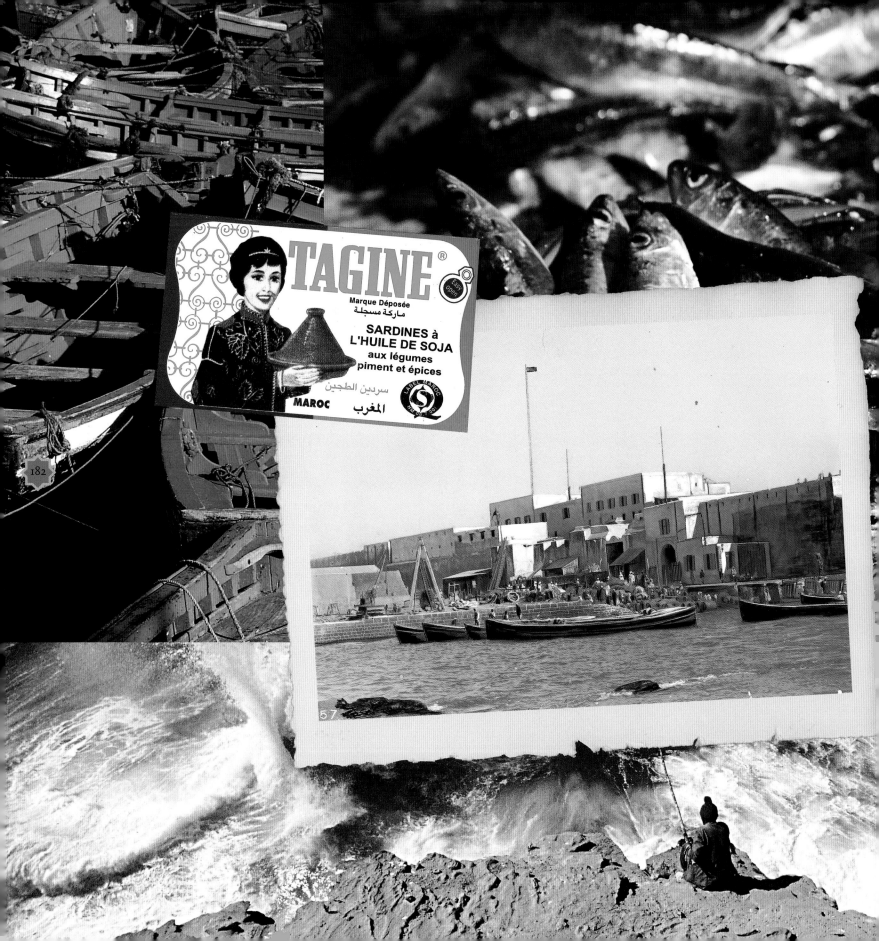

TAGINE ®

Marque Déposée
ماركة مسجلة

SARDINES à
L'HUILE DE SOJA
aux légumes
piment et épices

سردين الطجين

MAROC    المغرب

Easy
open

LABEL MAROC

182

57

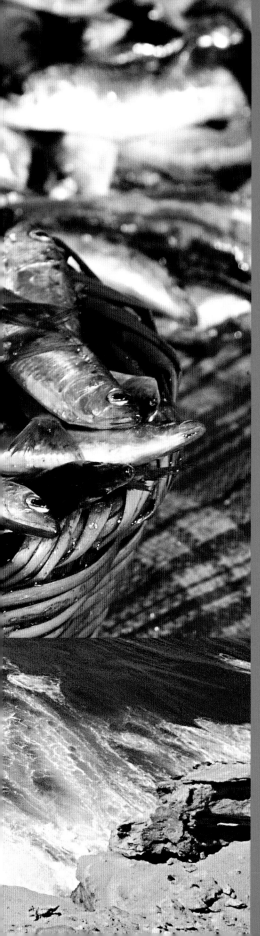

The fish processing industry accounts for 50 per cent of Morocco's food exports and 12 per cent of the country's total exports. The fish caught near the coast make up three-quarters of the catch. One-third of this haul is destined for the canning industry and the rest is used in the manufacture of fish meal and fish oil. In Morocco the revenue brought in by fishing is four billion dirhams and 90 per cent of its fish exports go to Japan. Home consumption remains very low at an average of 6 kg (13.2 lb.) per person per year.

**PRECEDING PAGES**
The fish market in Agadir.
**LEFT**
The blue-painted fishing boats in the port of Essaouira. • Sardines on display in the market. • Fishermen on the cliffs of Tan-Tan.
The old photograph shows the customs house in Casablanca in 1911.
**RIGHT**
Seagulls flying over Essaouira. • A solitary *koubba* housing the tomb of a *marabout* (holy man) in the region of Safi.

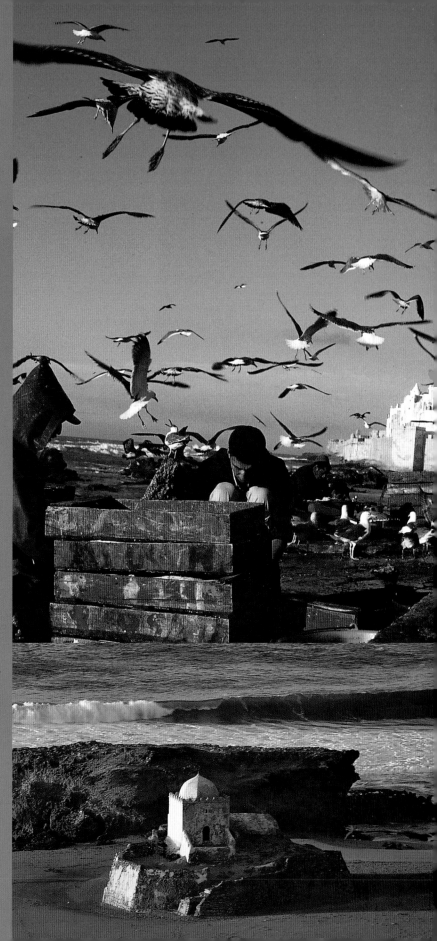

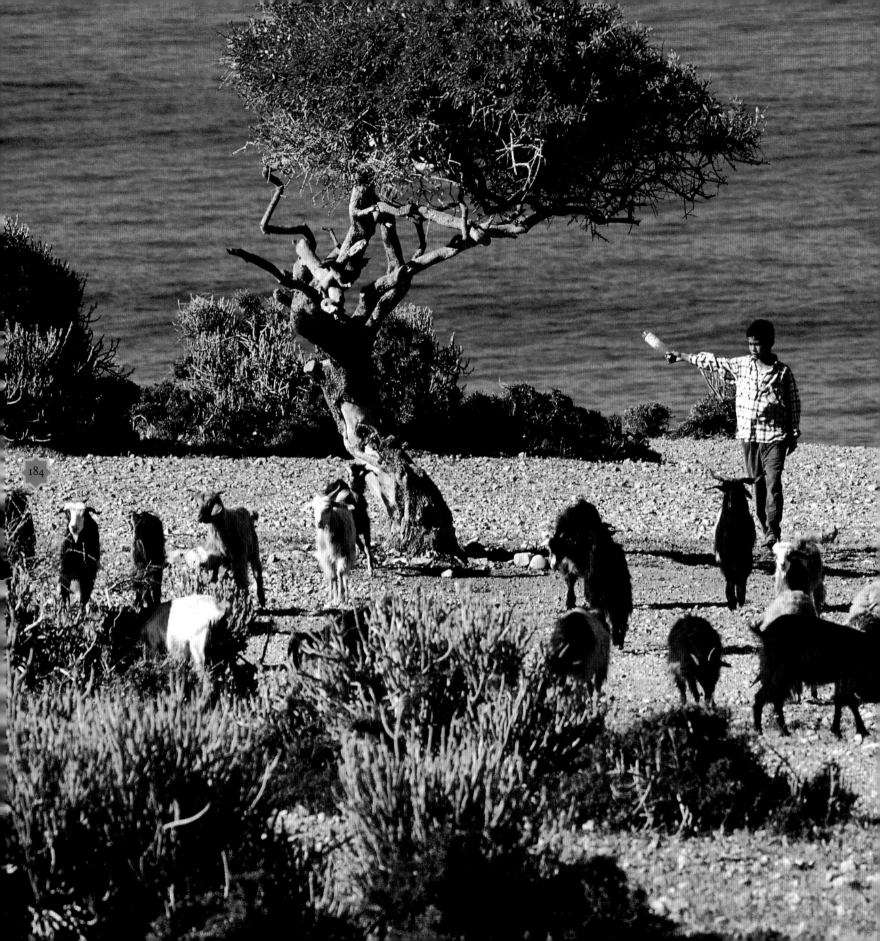

It is a house in which we have received in profusion the
flavour and odour of beings
the tactile colours of elements
the discreet beauty of trees
We have preferred to eat with the stranger
drunk with the most desperate table companion
and kept watch by night and by day with our wise ghosts
There we welcomed the free children of our dreams
All this while keeping an ear glued to the door to capture
the hesitant steps of the unexpected.

Abdellatif Laâbi, *Ecris la vie (Tell Life)*

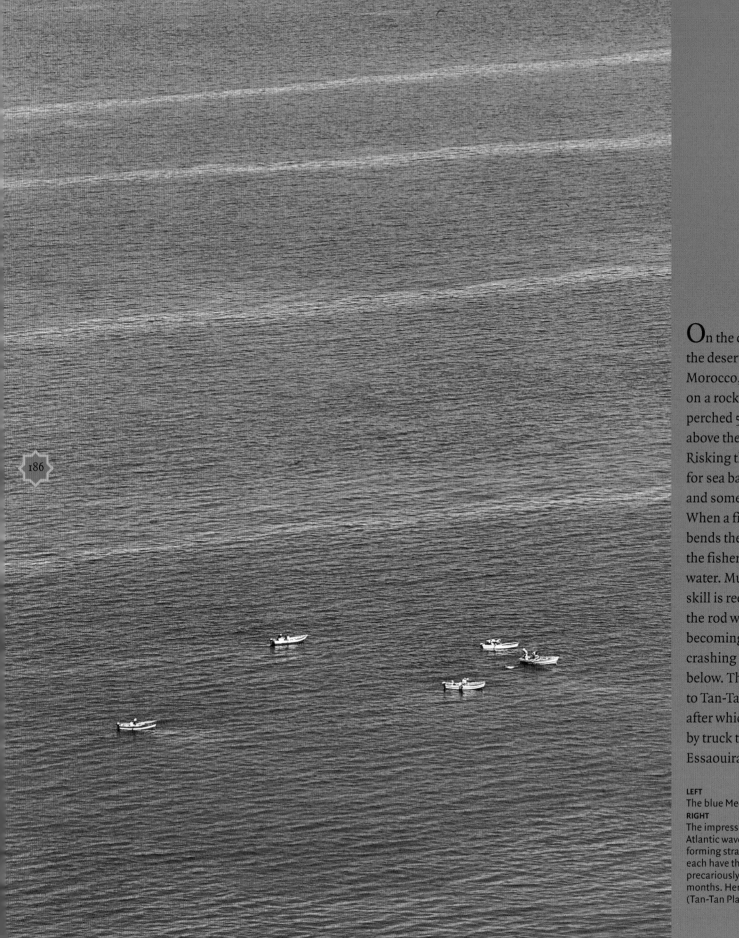

186

On the cliffs of Tan-Tan in the desert region of southern Morocco, fishermen stand on a rock above the ocean, perched 50 metres (165 ft) above the booming waves. Risking their life, they fish for sea bass, gilt-head bream and sometimes croaker. When a fish bites, its weight bends the fishing rod, pulling the fisherman towards the water. Much experience and skill is required to recover the rod without the fish becoming unhooked or crashing against the rocks below. The catch will be taken to Tan-Tan and sold there, after which it is transported by truck to Agadir and Essaouira.

**LEFT**
The blue Mediterranean near Tetouan.
**RIGHT**
The impressive rocky cliffs, swept by the Atlantic waves, crumble and collapse, forming strange shapes. The fishermen each have their own 'stone' and camp precariously on the cliffs for several months. Here, the cliffs near El Ouatia (Tan-Tan Plage).

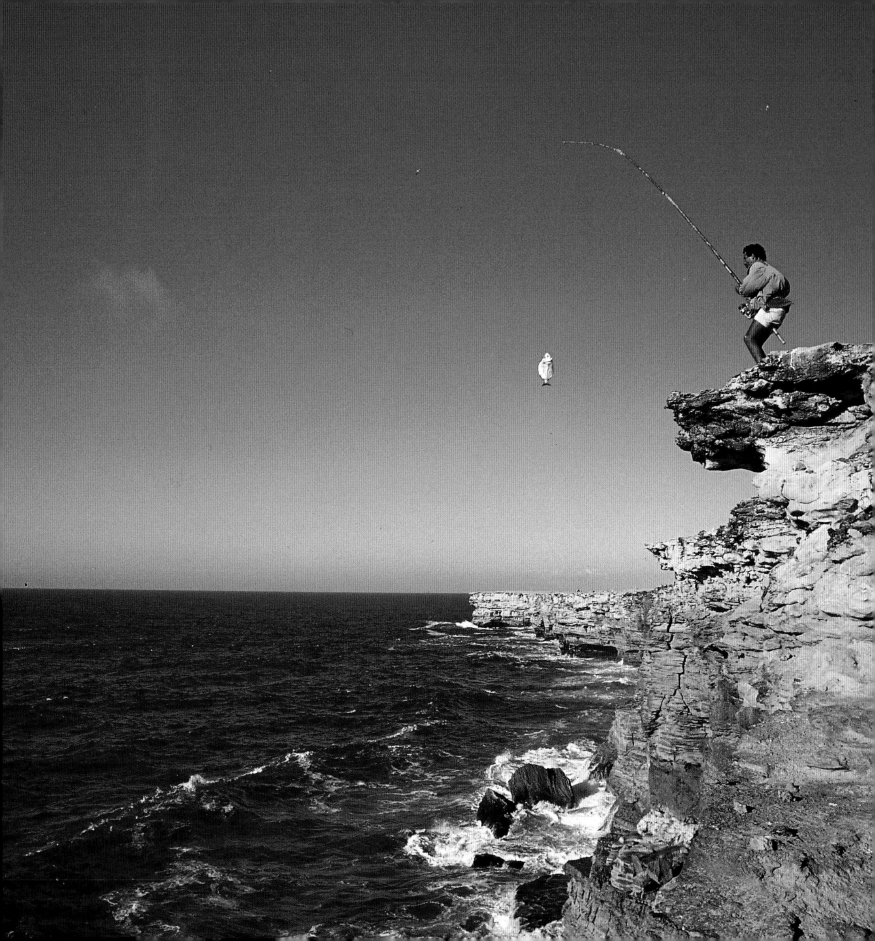

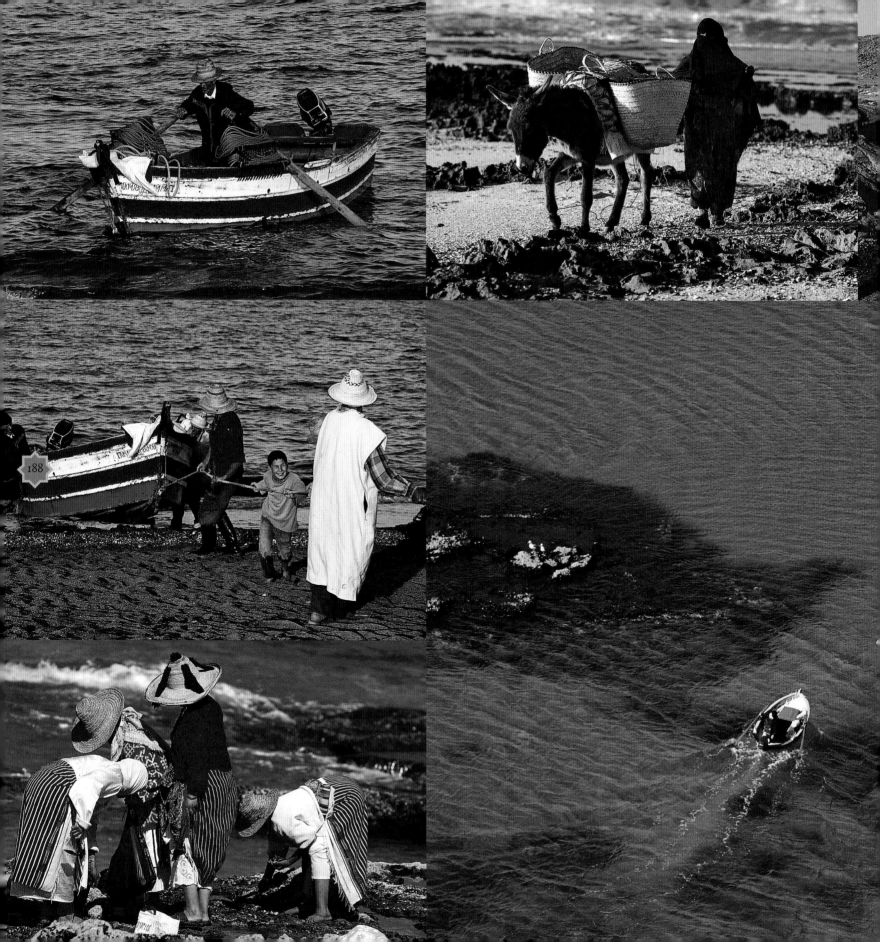

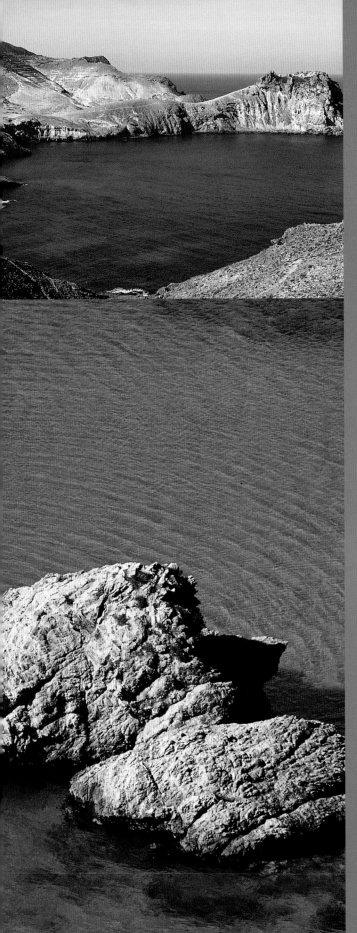

The Rif is a region in north Morocco, running along the Mediterranean from Tangier and Ceuta as far as the estuary of the Moulouya, just before the border with Algeria. The coast is punctuated by magnificent natural sites: promontories, gorges and arid mountains with sheer cliffs thrusting down into the sea, little peaceful creeks, fishing ports, caves, natural grottoes where the sea penetrates at high tide, beaches lined with holiday villages, and lagoons (Bou Areg, to the south of Melilla). In the Rif, women wear a *fouta* (a rectangular piece of fabric with blue and white stripes), wrapped round their hips topped with a wide-brimmed straw hat.

**LEFT**
A fishing boat landing on the beach at Oued Laou on the Mediterranean coast. • Women of the Rif near Cape Spartel. • Beach in the region of Essaouira. • Rocky formations in the region of Al Hoceima.
**RIGHT**
Shepherdess watching goats on the Mediterranean coast.

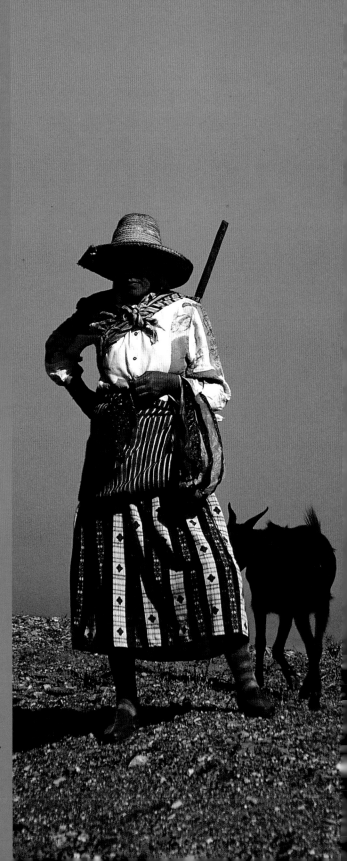

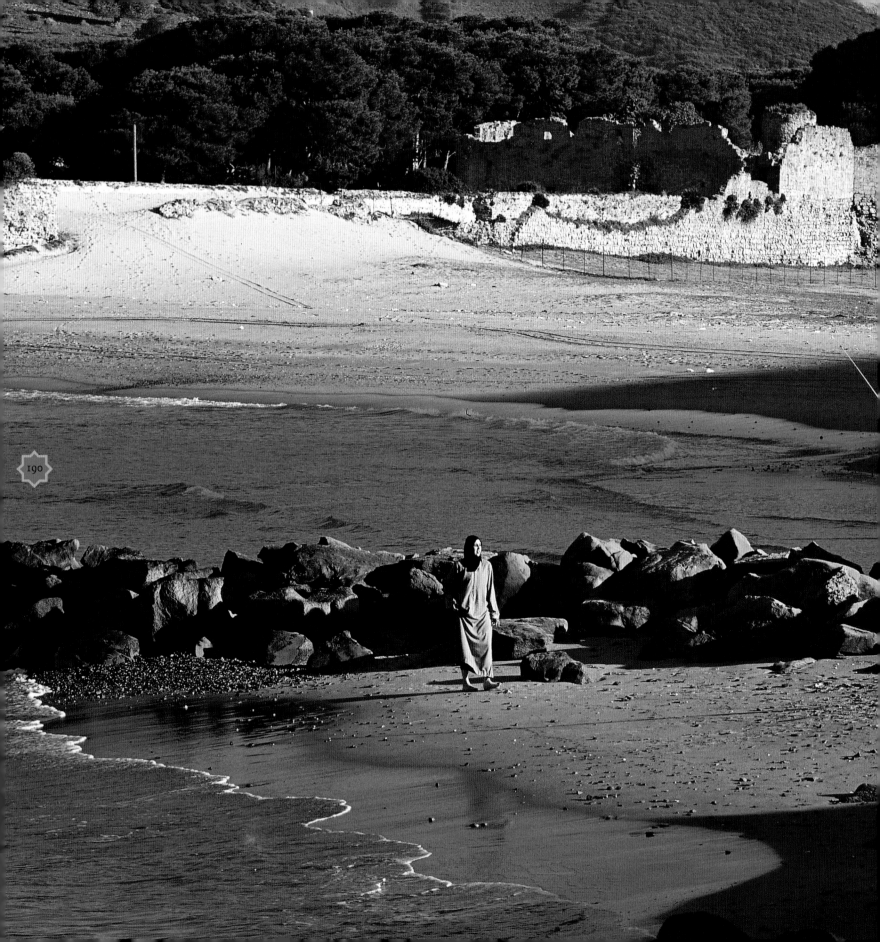

Between Tangier and Ceuta, Ksar es-Seghir, a small fishing village with a beautiful beach, faces the Spanish town of Tarifa. In the eighth century, this small town was used as a port by armed troops setting out on their holy war against Spain. Fortified during the reign of Yacoub el Mansour (1192), Ksar es-Seghir was occupied by the Portuguese between 1458 and 1549. Surviving remnants of their period of domination are sections of the crenellated town walls and a path round the battlements. The ruins are those of the city built by the Marinids in the fourteenth century.

**LEFT**
Ksar es-Seghir on the Mediterranean coast.
**RIGHT**
An old man deep in thought on the beach of Essaouira.

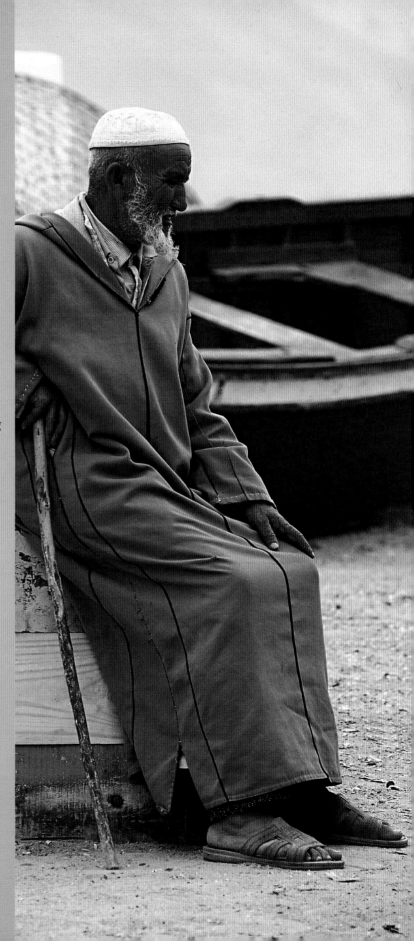

# PALACES, GARDENS
# & RIADS

In the last ten years, the riads built among the narrow alleyways of the medinas have been rediscovered by Moroccans and foreigners alike. These vast, traditional houses, sometimes several centuries old, have been gradually abandoned by whole families who preferred modern European-style villas, outside the medina.

The riad was originally an enclosed garden of Andalusian origin, divided into four parts, with a decorative fountain in the centre from which water endlessly flowed. A form of reconstituted oasis, in the Muslim tradition it prefigures the celestial paradise. In Islam, paradise or the garden of Eden is described as the source of four rivers, the most famous of which is Al-Kawthar, mentioned in the Koran.

In a riad, water is always present in the form of a fountain or basin with a jet fed by a system of pipes, either underground or on the surface. By extension, the riad has given its name to the whole house surrounding this enclosed garden with its straight paths. The largest number of these traditional houses is to be found in Marrakesh.

A welcoming, friendly place, the riad was designed to receive a large number of people. Paved with marble or zellig mosaics, the courtyard is sometimes surrounded by a beautiful covered arcade offering protection against the hot sun or bad weather and flanked by several long, rectangular rooms. Drawing rooms and bedrooms are lit by low windows, decorated with ornamental wrought-iron work. In the wealthier residences, each room is entered through a double-door made of carved cedar wood. Kitchen, hammam, bathrooms, cellars and the stairs leading to the floors above are situated at the corners of the riad. The size of the riad, the number of loggias and the richness of the decoration depend on the wealth of the owner. Some riads are princely residences indeed. In Marrakesh, the Al Bahia palace, erected at the end of the nineteenth century by the Grand Vizir, spreads over 8 hectares (20 acres) and has several courtyards, a riad, a courtyard surrounded by a covered arcade and numerous apartments. Similarly in Fès, the El Mokri palace is a harmonious blend of sumptuous Hispano-Moorish architecture and Ottoman and Italian touches.

In Fès there are about 500 palaces in the medina, some of which have been restored while others are ruins. These palaces open onto courtyards, gardens and a real labyrinth of rooms. The inner space is an architectural and ornamental unity: the floors are

paved with marble, the walls are covered with polychrome zelligs up to a man's height, above which the walls are covered with delicate grey-white lacy stucco motifs; the cedar-wood ceilings are painted in flamboyant colours with geometric and floral motifs. Some of the most sumptuous residences have fallen into disrepair, such as the Glaoui Palace in Fès, built at the end of the nineteenth century as a secondary residence for the Pasha of Marrakesh, Hadj Thami el-Glaoui; it consists of seventeen houses and almost a thousand rooms, all richly decorated. Some have been converted into hotels or restaurants, such as the Djamaï and Dar Mnebbi palaces in Fès. Others have become museums, such as the Dar el-Batha palace, also in Fès, which contains masterpieces of Moroccan art, or the Dar Si Said palace in Marrakesh which is a museum of Moroccan art.

The ruins of these palaces clearly reflect their colossal size. The El-Badi palace in Marrakesh, built by Sultan Ahmed el-Mansour, was a sumptuous palace designed for large receptions and solemn audiences. With its 360 rooms, most of which were covered in gold, marble, ceramic or onyx, it was intended to reflect the grandeur of the reigning dynasty. Unfortunately it was demolished a century later by the Alouite Sultan Moulay Ismail. Closed to the outside world, the royal palaces, surrounded by high walls, were entered through monumental, richly decorated doors. They retained the structure of the Hispano-Moorish palaces with their three interconnected parts: the *mechouar* (the place for swearing allegiance), the throne room and the harem.

The art of Arab-Islamic gardens was born in the East, in Baghdad, Damascus and Kairouan, and these places have been the inspiration for Moroccan gardens. The vast royal or imperial gardens were surrounded by ramparts, filled with fragrant trees, olive trees, palm trees and basins for irrigation. In Marrakesh, the gardens of the Agdal, which are 3 kilometres (nearly 2 miles) long, form a vast orchard divided into different enclosed areas, planted with different kinds of tree – palm, fig, olive and walnut; there are two large ornamental lakes. Still in Marrakesh, the gardens of Menara, surrounded by adobe walls, contain an olive grove and a large pool in which the delightful Saadian pavilion is reflected. During the French Protectorate, gardens were created in the new town, such as the Majorelle Gardens in Marrakesh where some of the rarest species are grown.

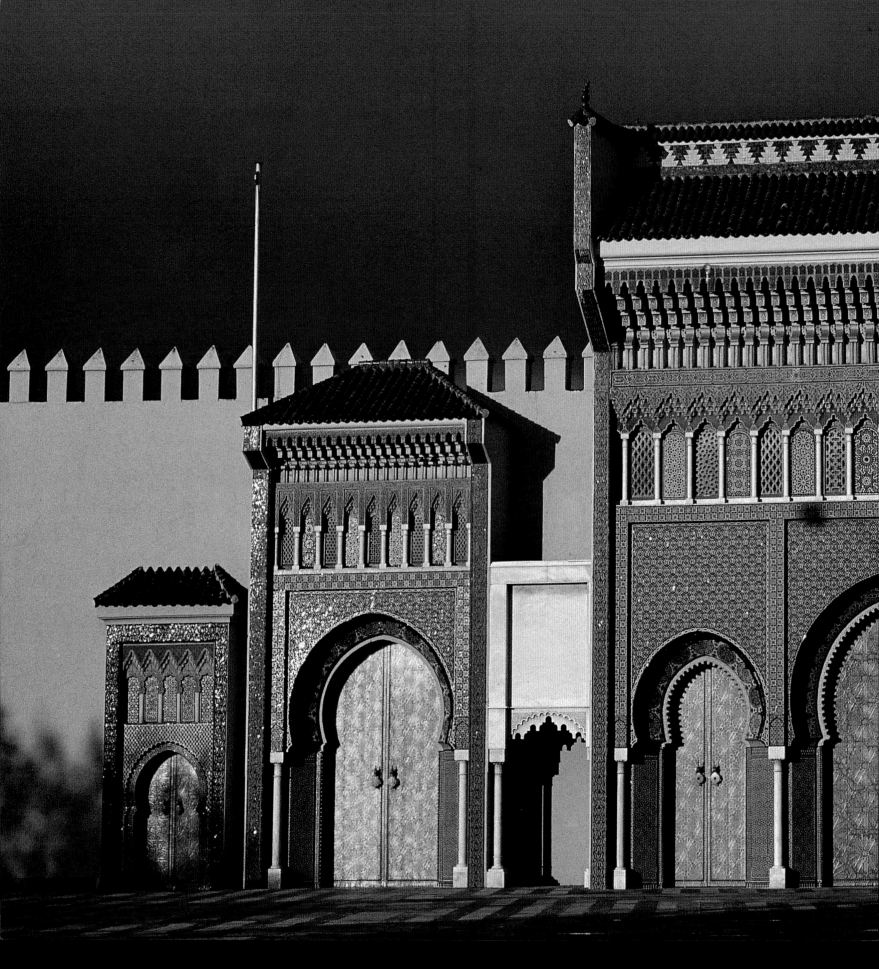

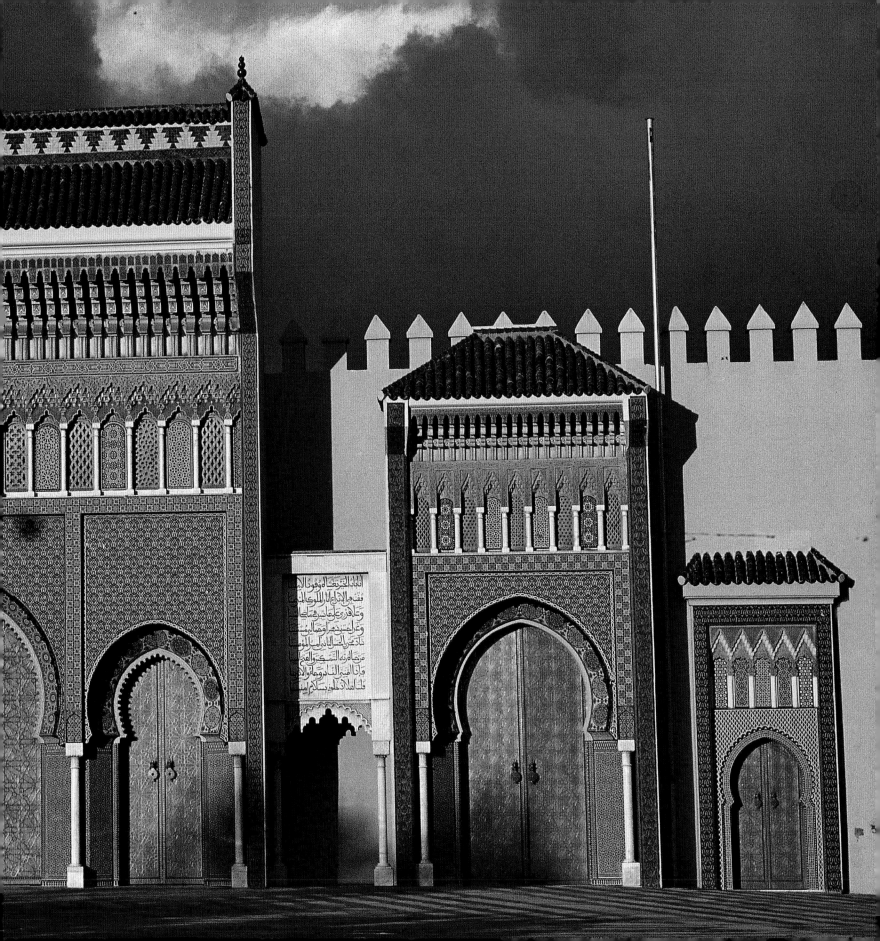

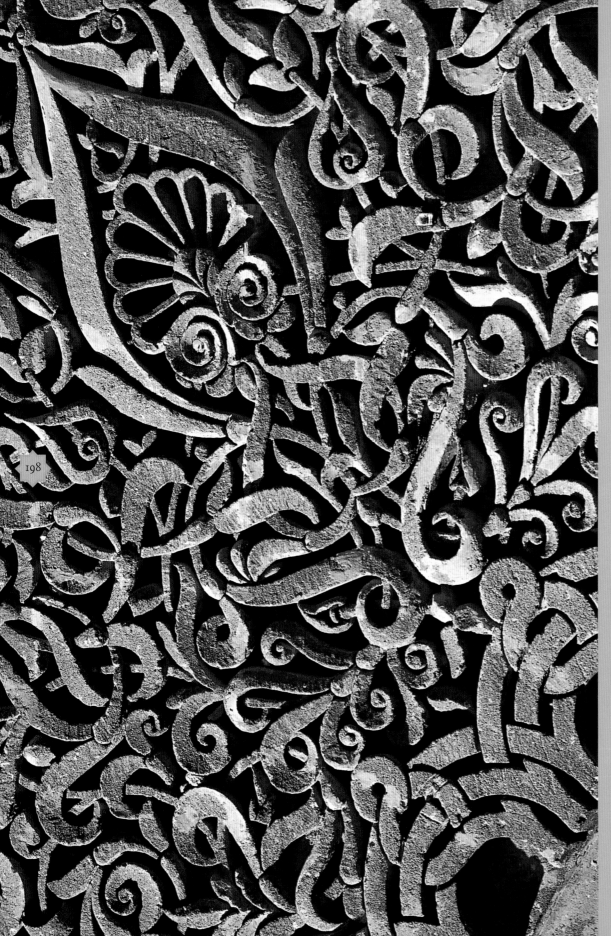

198

The decoration in palaces and riads is a heritage of Arab-Andalusian art. Stucco is present in all the more prestigious buildings. This type of plaster, which is found in the regions of Safi, Fès and Asni, is spread in a thick layer on the walls, then directly carved and engraved with a fine chisel. Perched on scaffolding and with the help of a pair of compasses, a ruler and stencils, the artist draws lines, friezes of tracery and carvings, creating a lacy motif that is repeated indefinitely, leaving no area untouched. Soft, easy to work with and slow to dry, carved plaster can be adjusted after it has been applied.

**PRECEDING PAGES**
The monumental doors of the
royal palace at Fès.
**LEFT**
Stucco tracery.
**RIGHT**
The sumptuous decor of
the Glaoui palace in Fès.
The old photograph shows the entrance
to the large drawing room in the Al Bahia
palace in Marrakesh at the beginning of
the twentieth century.

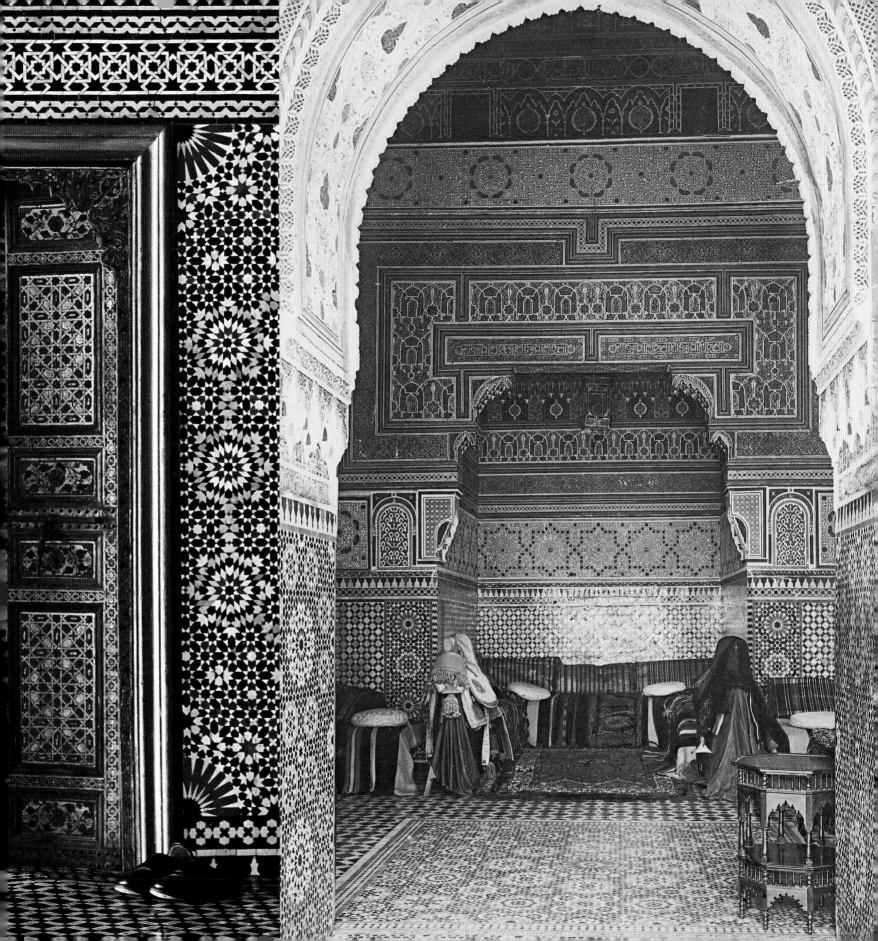

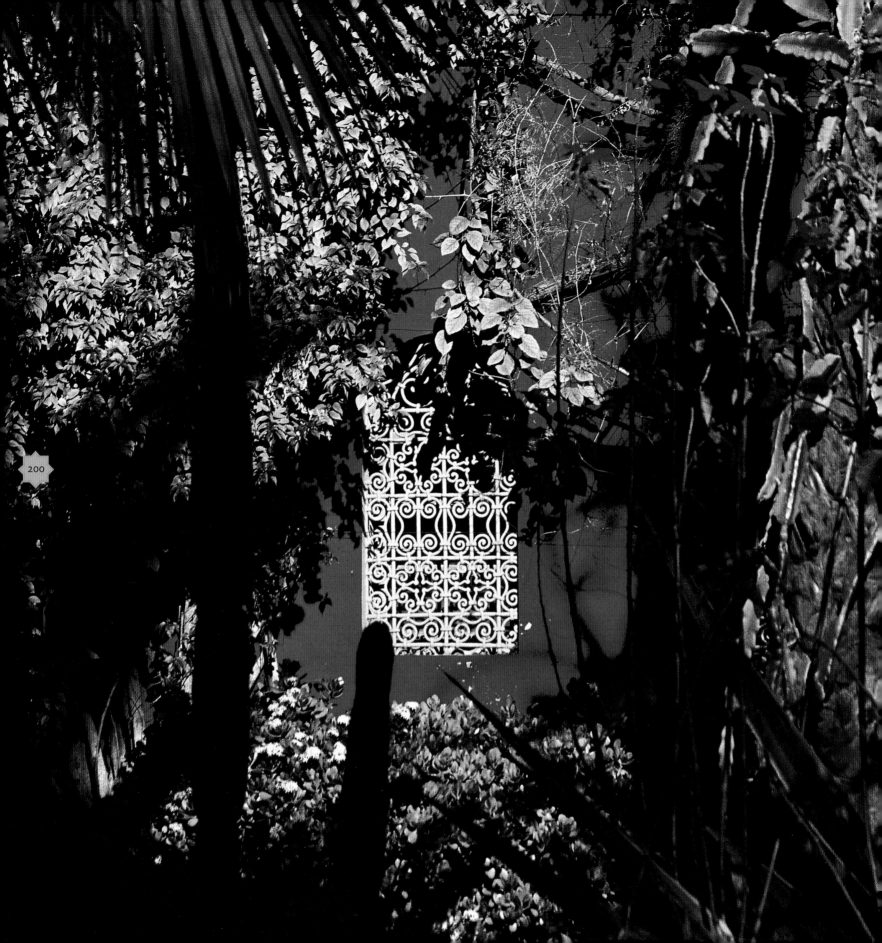

An eternal spring ensures the greenery of its gardens where all kinds of streams murmur and flow . . . streams of delicious water, streams of milk, streams of wine, streams of honey, gliding in the deep shade of the trees . . .

Extract from the *Koran*

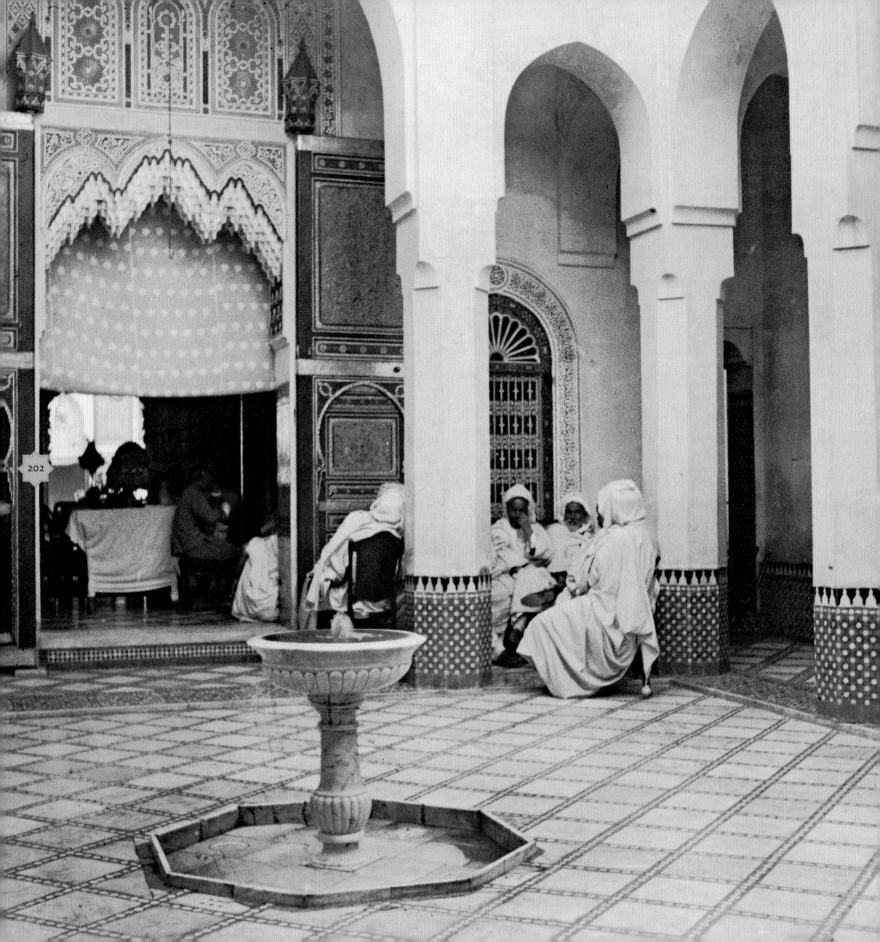

A basin for ablutions or merely an essential decorative element in a riad, the Andalusian-style fountain – built in marble with wide flat edges from which water gushes continually – has pride of place in the centre of every courtyard. The white marble, imported from Carrara in Tuscany, is difficult to carve but very resistant. It is quarried in large blocks, then cut with primitive machines. The fountains are cut from a single block that is shaped and carved by a craftsman before it is polished. White marble is also used to cover the floors and for the capitals of columns and pillars.

**LEFT**
Interior of the Pasha's house in Meknès in about 1921.
**RIGHT**
Roses floating in the central basin of a riad.

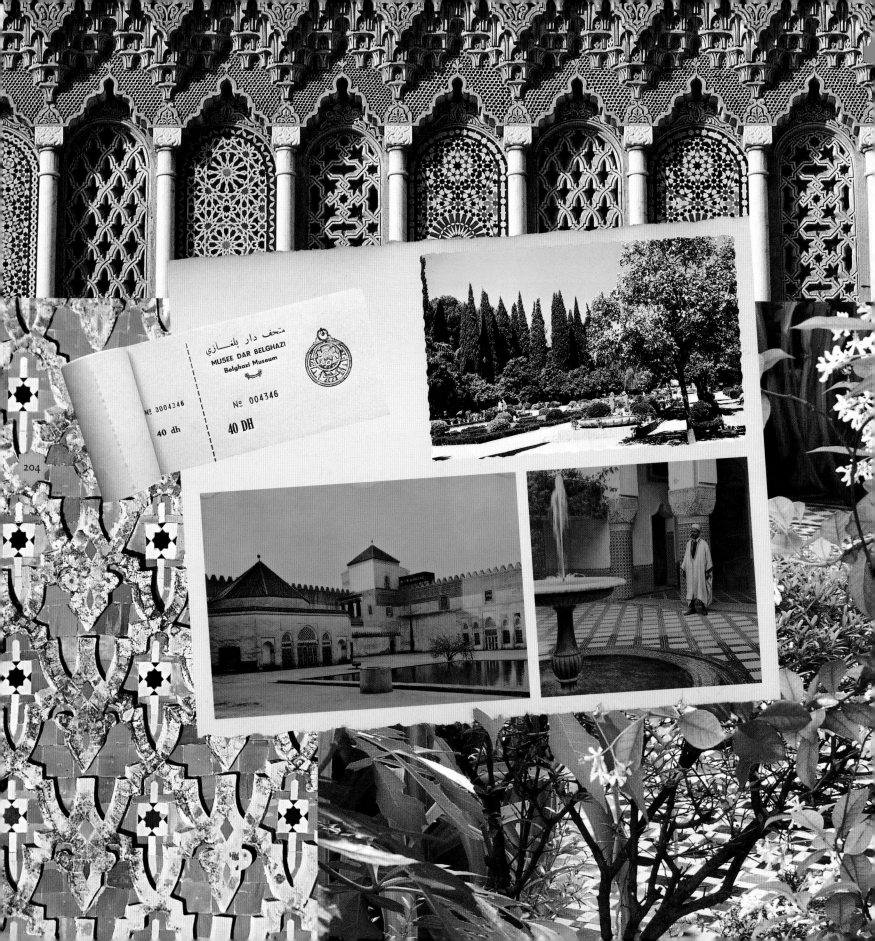

MUSEE DAR BELGHAZI
Belghazi Museum

Nᵒ 0004346    Nᵒ 004346

40 dh    40 DH

204

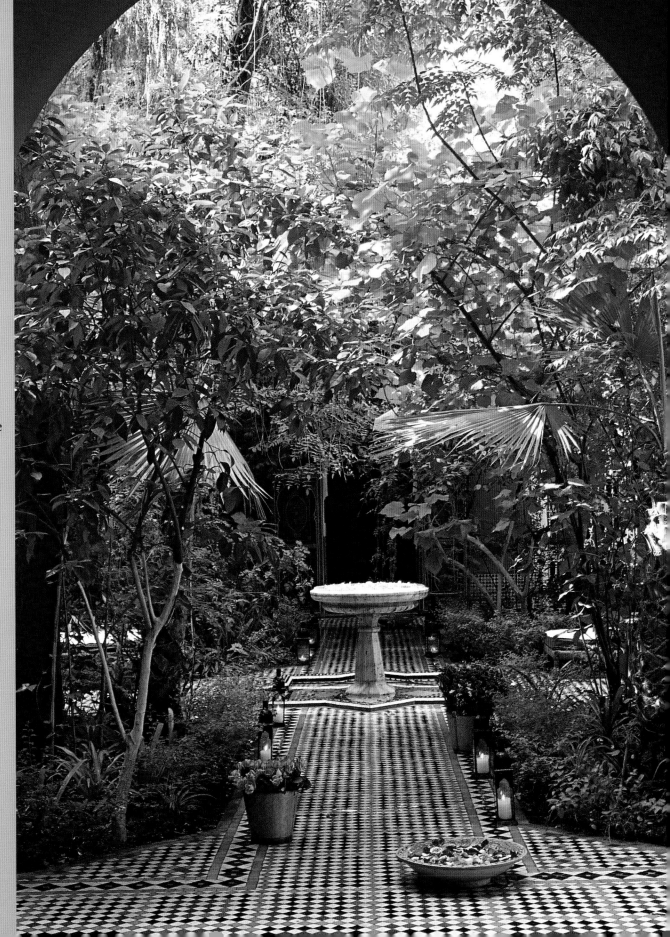

In the riad gardens, the beds laid out between the straight paths are crammed full of plants and trees: citrus fruits (oranges, lemons, pomegranates, bitter or Seville oranges), cypresses, Judas trees, climbing plants (vines and ivy), date palms and banana trees. The fragrance of orange blossom, jasmine flowers, datura, carnations, hyacinths, narcissi, mint and rosemary is released at nightfall and mingles with the coolness of the fountain and the irrigation channels. Places of tranquillity and calm, these gardens are a reflection of paradise on earth.

**LEFT**
Detail of the doors of the Royal palace at Fès. • The zelligs and tracery on the minaret of the Bou Inania madrasa in Fès. • Riad in Marrakesh.
The old photographs show, clockwise from top left, the Boujeloud garden in Fès; the courtyard of the Dar Tazi palace in Fès at the beginning of the twentieth century; and the Dar el-Beida palace in Marrakesh at the beginning of the twentieth century.
**RIGHT**
The Kaiss riad in Marrakesh.

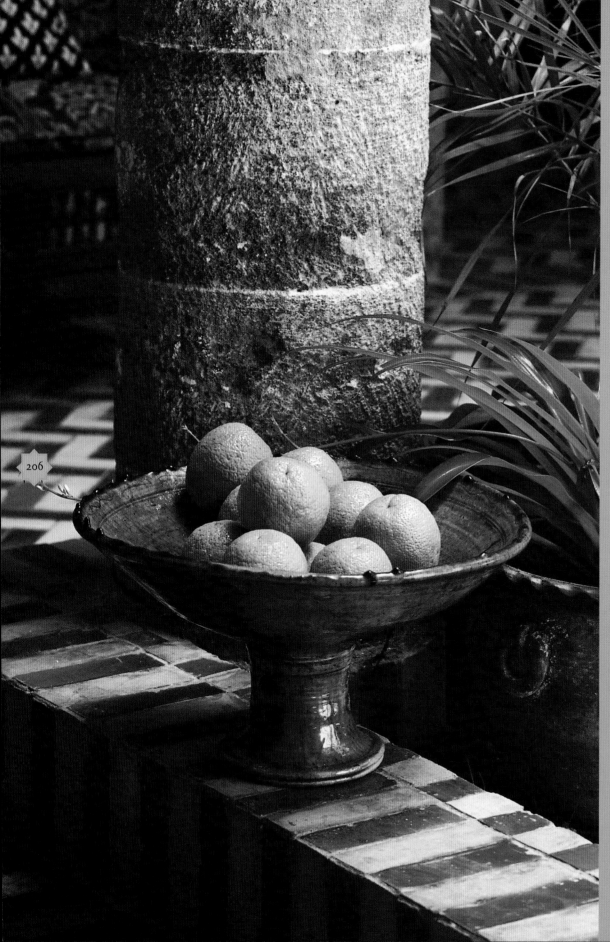

The bitter orange and sweet orange trees bear their fruit and flowers at the same time every year. The thorns, dark foliage and highly scented flowers of the bitter orange tree distinguish it from the sweet orange tree. The flower buds of the bitter orange tree are picked in May. They are used to make the orange flower water that is poured over the hands of guests on special occasions. The fruit is picked at the beginning of November and lasts six months. The fresh fruit of the sweet orange tree is exported or squeezed to extract the juice; the bitter orange fruit is squeezed and produces an acid juice that is used to flavour olives. Neroli oil is extracted from the highly scented blossom of the bitter orange tree.

**LEFT**
A riad in Essaouira.
**RIGHT**
Orange blossom and Kaffir lily.

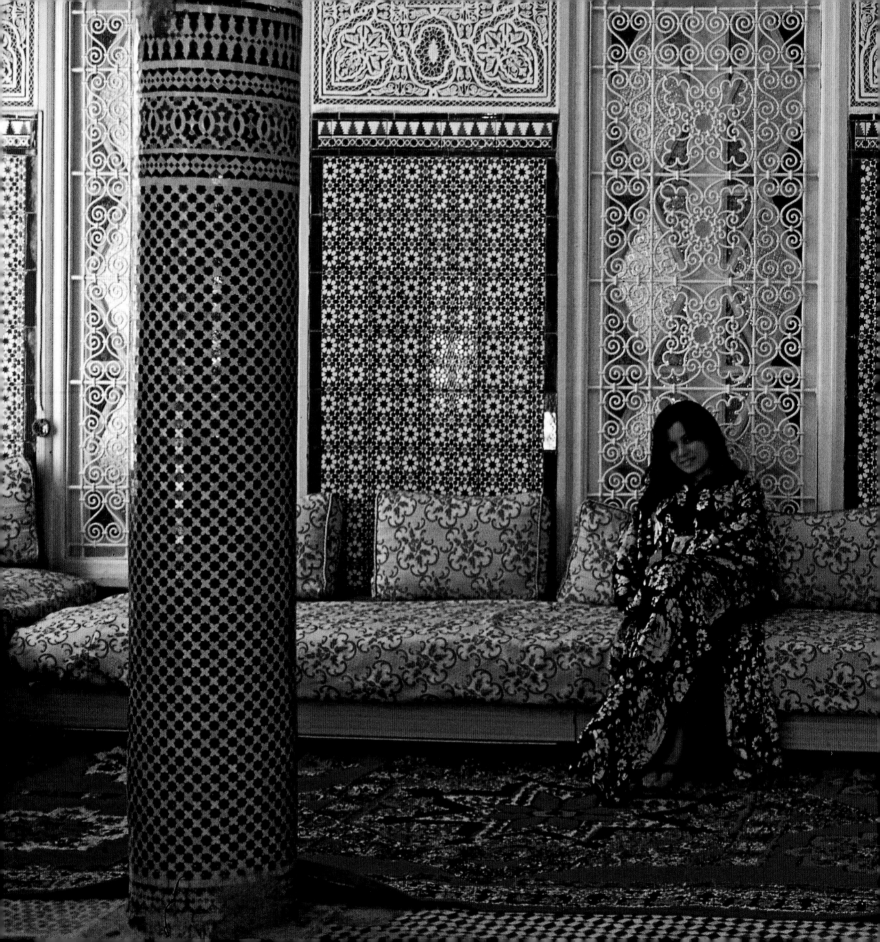

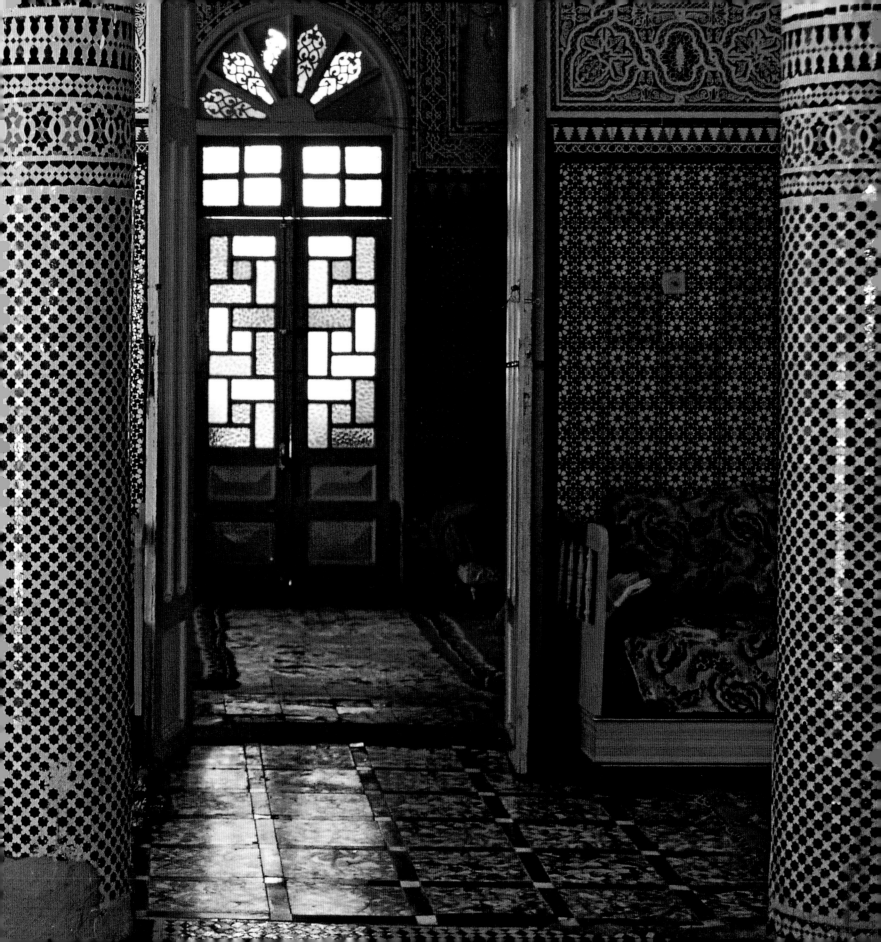

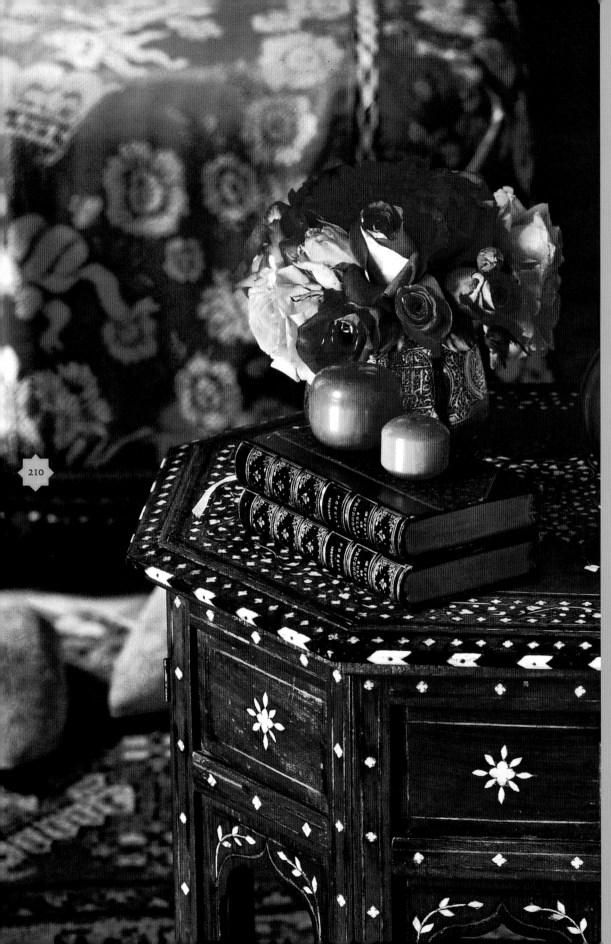

The Moroccan drawing room is the place for hospitality above all others. The choice of furnishings, fabrics and their frequent replacement are the responsibility of the women of the house. Divans are arranged along all the walls of the drawing room to accommodate as many people as possible at the same time. Covered with ordinary cretonne or sumptuous velvet, they are brightened up with cushions covered in the same fabric and perfectly aligned. Although synthetic fabrics are becoming more widespread, cotton, silk and muslin are still the most popular choices. These rich fabrics are embellished with big patterns and colourful embroidery.

**PRECEDING PAGES**
A riad in Meknès.
**LEFT**
A riad in Essaouira.
**RIGHT**
A riad in Essaouira. • The Lamrani riad in Marrakesh.

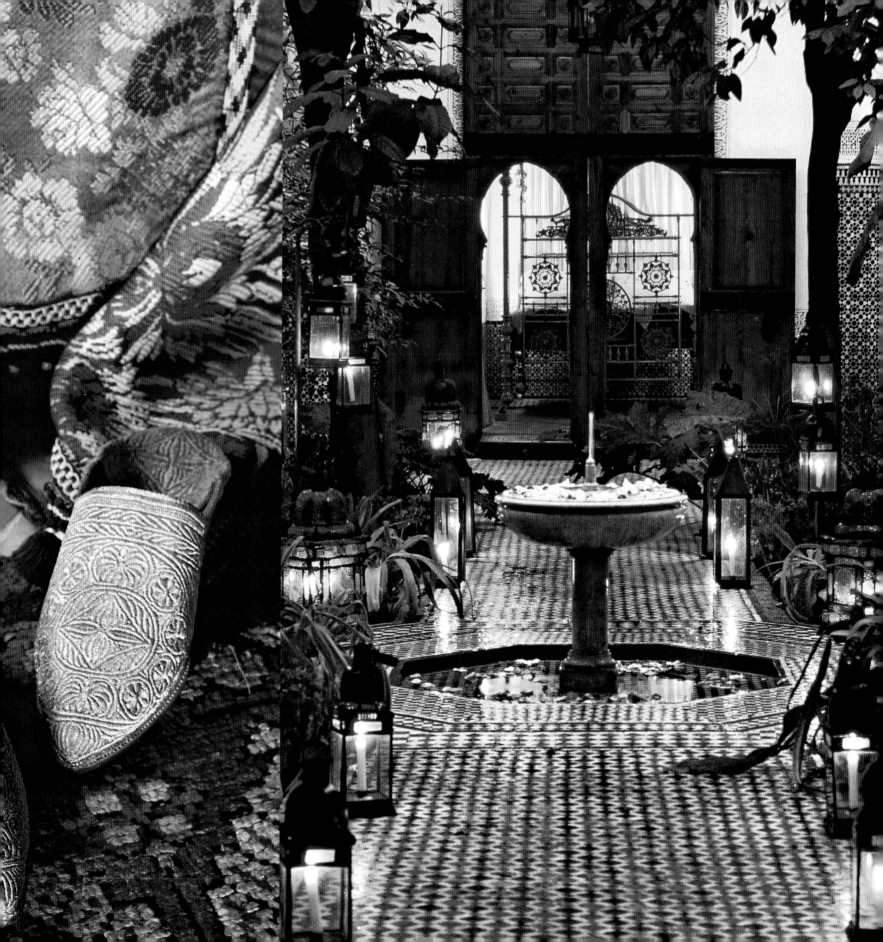

Applying henna to your feet, even for no special reason, is always an excuse for a party, a reason to gather your female friends. Henna is attractive for the colour of baked bread that it leaves on your skin and the sheen similar to that of precious stone, of ruby, that it leaves on the nails; and most of all, since one risks brushing against the spirits of air and water, it is both prudent and polite to touch it only with feet and hands whose appearance and smell are equally pleasant.

Jérôme and Jean Tharaud, *Fèz ou les Bourgeois de l'Islam (Fès or the Bourgeois of Islam)*

**RIGHT**
Festive make-up

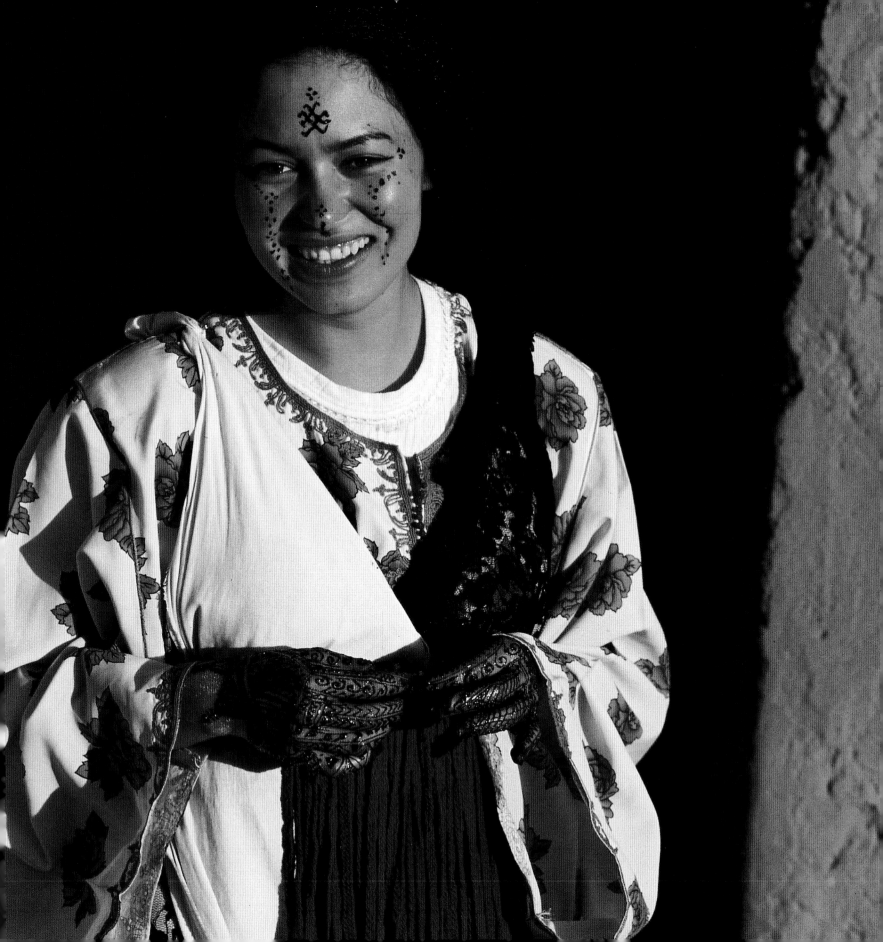

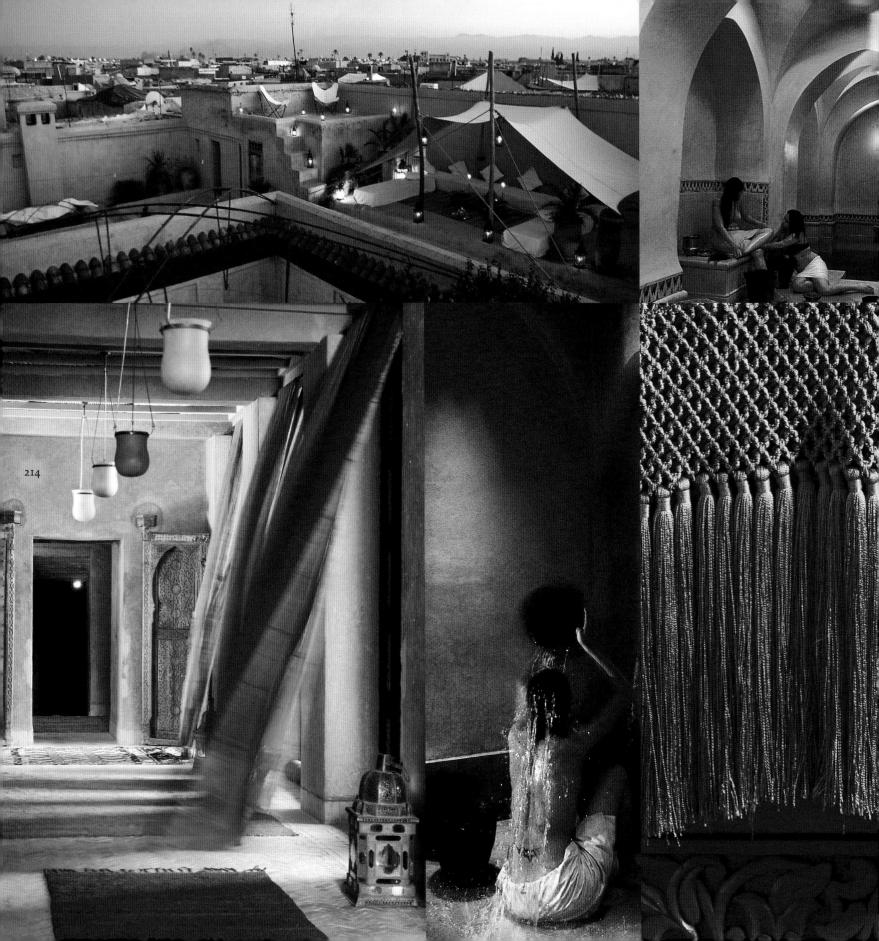

214

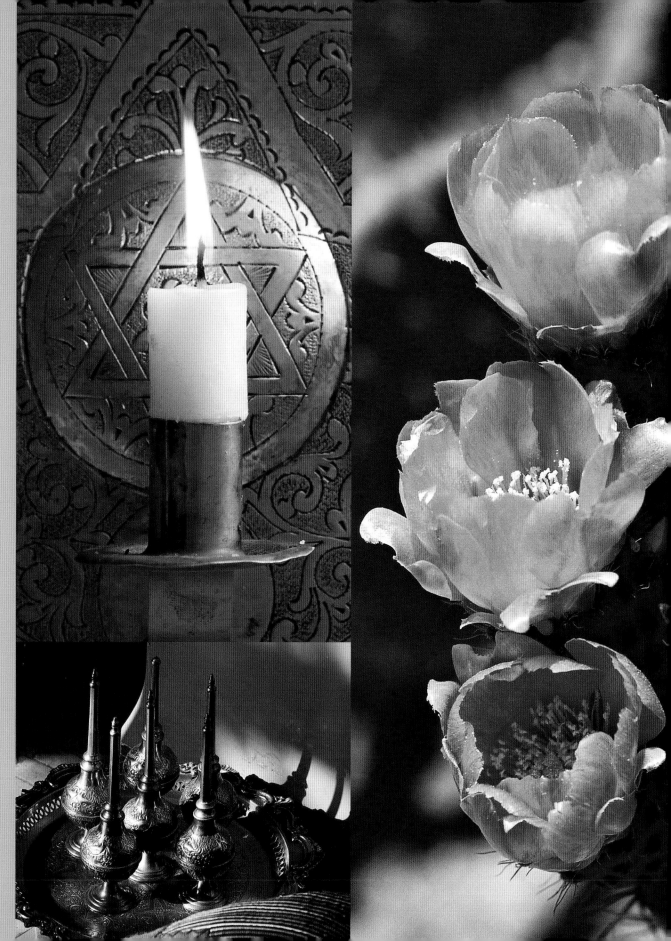

The hammam or public bath plays an important part in the art of living in Morocco. From the early years of Islamization, this building in the medina has had an essential role in ritual purification and for its social function. Depending on the time of day, it is reserved either for men or for women. For women, the weekly visit to the hammam enables them to gather together regardless of social status. Dimly lit, the hammam has two or three rooms, heated to different temperatures, ranging from 38 to 45 °C (100 to 113 °F). Softened by the heat and humidity, the skin is cleansed, scrubbed and massaged. The mint tea served in the resting room tastes divine.

**LEFT**
Roof terrace in Marrakesh. • Dar Ahlam in Skoura. • Hammam scenes in Marrakesh.
**RIGHT**
The art of metalwork at the service of beauty and perfume. • Prickly pear flowers.

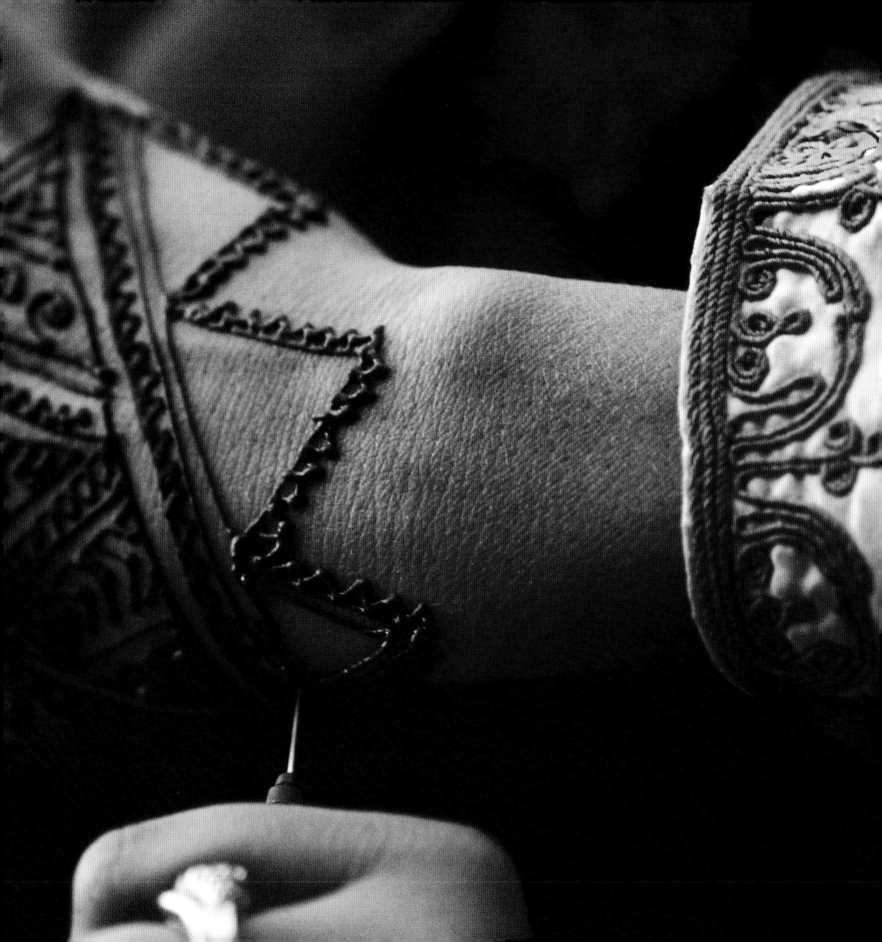

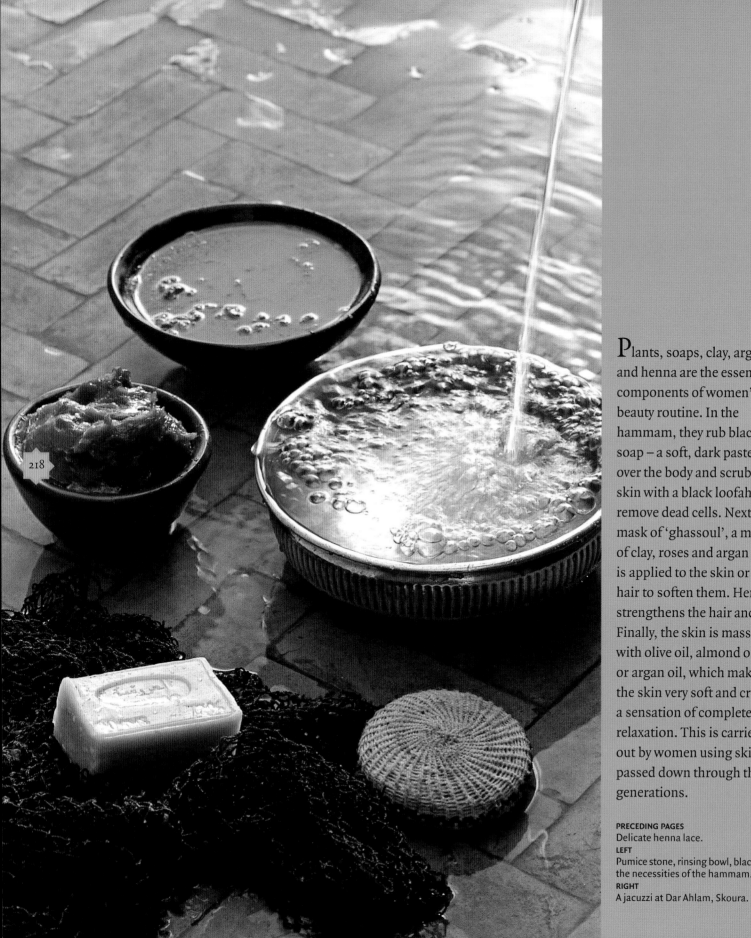

Plants, soaps, clay, argan oil and henna are the essential components of women's beauty routine. In the hammam, they rub black soap – a soft, dark paste – all over the body and scrub their skin with a black loofah to remove dead cells. Next a mask of 'ghassoul', a mixture of clay, roses and argan oil, is applied to the skin or hair to soften them. Henna strengthens the hair and skin. Finally, the skin is massaged with olive oil, almond oil or argan oil, which makes the skin very soft and creates a sensation of complete relaxation. This is carried out by women using skills passed down through the generations.

**PRECEDING PAGES**
Delicate henna lace.
**LEFT**
Pumice stone, rinsing bowl, black soap . . . the necessities of the hammam.
**RIGHT**
A jacuzzi at Dar Ahlam, Skoura.

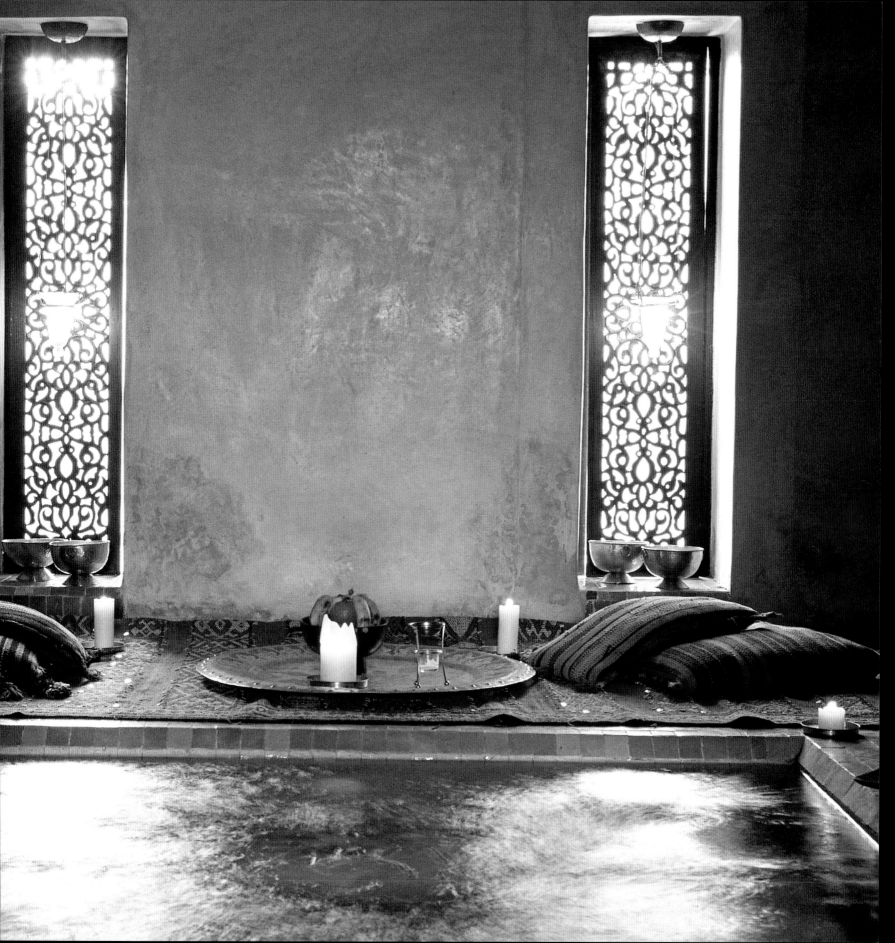

# JEWELS OF THE EARTH

With its opulent kasbahs, slender and richly decorated, and its fortified ksour flanked by square bastions and crenellated towers, adobe architecture fascinates and defies time with its mysterious ochre silhouettes. In the High Atlas mountains, in the valleys of the Dades, Draa and Tafilalet, the Berbers have built fortresses in the middle of oases and cultivated fields. The origin and age of these castles made of mud remain a mystery. This fortified architecture evokes a tumultuous past when peasants sought refuge from the enemy behind thick walls. For centuries the *ksours* of the Great South of Morocco, a region of passage and transition, have met the need of rural communities to pool economic resources and to share a means of defence .

Blending into the ochre or purple rock, the ksar ('ksour' in the plural) is built against the folds of a sheer rock face or stands on a plateau overlooking a fertile valley. Surrounded by a continuous, windowless wall, it is flanked by corner towers. A single door, placed in the middle of one of the walls, leads into the ksar where the mud houses huddle together. The inhabitants circulate along a central street that crosses narrow alleyways, sheltered from the heat or cold.

The kasbah is the ancient patriarchal dwelling. It was the residence of the great Berber caids who lived there between military expeditions. Its walls tilt slightly inwards and have no windows; there are just a few small, soberly decorated openings along the upper part. Harmonious in its design, each corner of the kasbah has an elegant tower made of unbaked bricks, embellished with arcades and punctuated by niches, honeycombs, diamond-shaped motifs and chevrons.

To the north-west of Ouarzazate, the village of Aït Benhaddou, built against a hillside of pinkish sandstone, has several majestic kasbahs. The harmony and beauty of this ensemble lie in the very tangle of houses and kasbahs made of red and ochre adobe, topped with crenellations and embedded in the hillside of the same colour. Classed as a World Heritage Site, the kasbahs of Aït Benhaddou are one of the most poetic sites in Morocco. The sumptuous palm grove of Skoura,

at the foot of the High Atlas mountains, is criss-crossed by a maze of narrow tracks and small luxuriant gardens, linking together unusual structures of elegant adobe.

In the mountain villages, the collective granary, known as the *igherm* or *agadir*, was the foundation of the communal organization that was so vital during the period of intertribal conflicts. Built in adobe, it contained the harvest of each family and also weapons, ammunition, jewels and other valuables. Each family had its own box and key, and the *igherm* was guarded by a caretaker.

Built against the hillside, the mud houses of the High Atlas mountains seem to emerge from the ground. They fit into each other, forming an ensemble of roof terraces turned towards the rising sun. Adapted to the rigours of the climate, they are maintained with great care. Adobe is the most widespread building material on the hillsides of the High Atlas and the Dades river valley. A mixture of more or less clayey unbaked earth, water and sometimes straw and gravel, adobe is used to build the walls and roofs of houses. The foundation is constructed from large blocks cut out of limestone. Then the adobe is poured into a rectangular wooden form made of thick planks, held together by bolts.

Inside this form or mould, a workman presses the earth down by trampling on it, then the rammer presses it down again with a heavy wooden pestle. When the earth has dried, the mould is removed and repositioned next to the block of adobe just produced. The operation is repeated, row after row.

The roof, always flat, is the most carefully built part of the house. It is used as a terrace, for drying maize or walnuts, as a courtyard and as a kitchen. When the adobe walls have been constructed to the required height, heavy rough-hewn oak or poplar beams are arranged horizontally lengthways.

Next juniper branches are placed on top, at right angles and arranged in serried rows, and these are then covered with a carpet of thick grass. This in turn is covered with a layer of clayey packed earth that ensures the water-resistance of the roof. Rain water and snow, the worst enemies of adobe, are regularly swept or scraped off. The roof is usually renewed every four or five years.

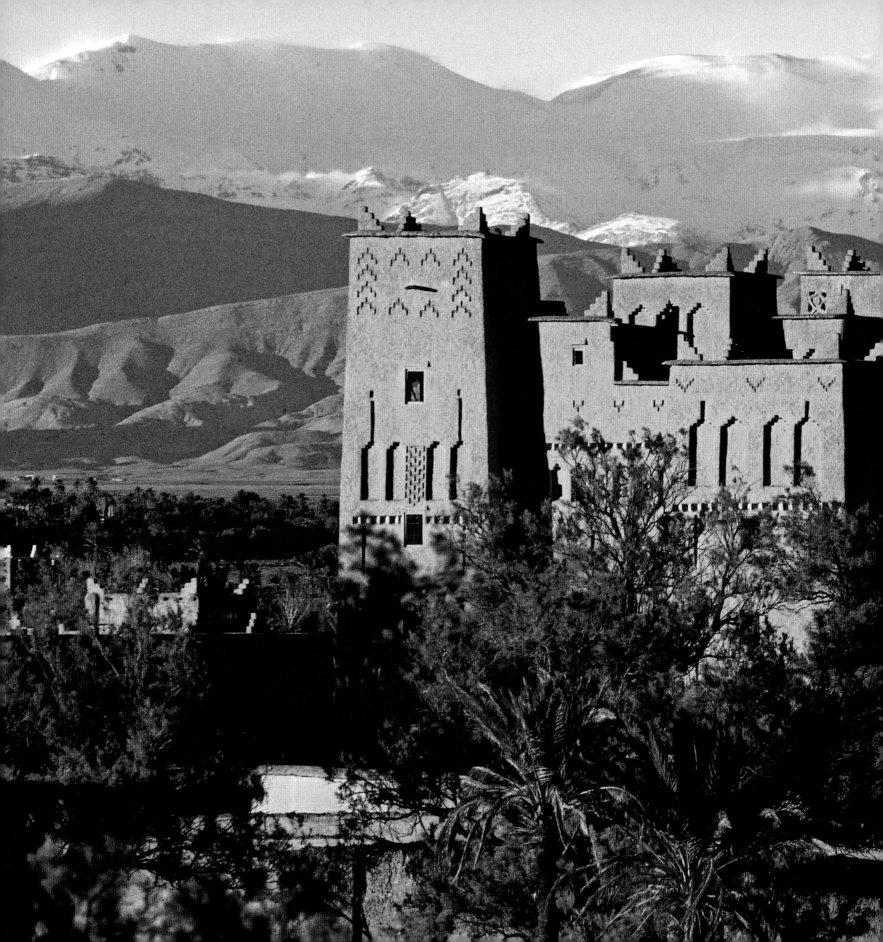

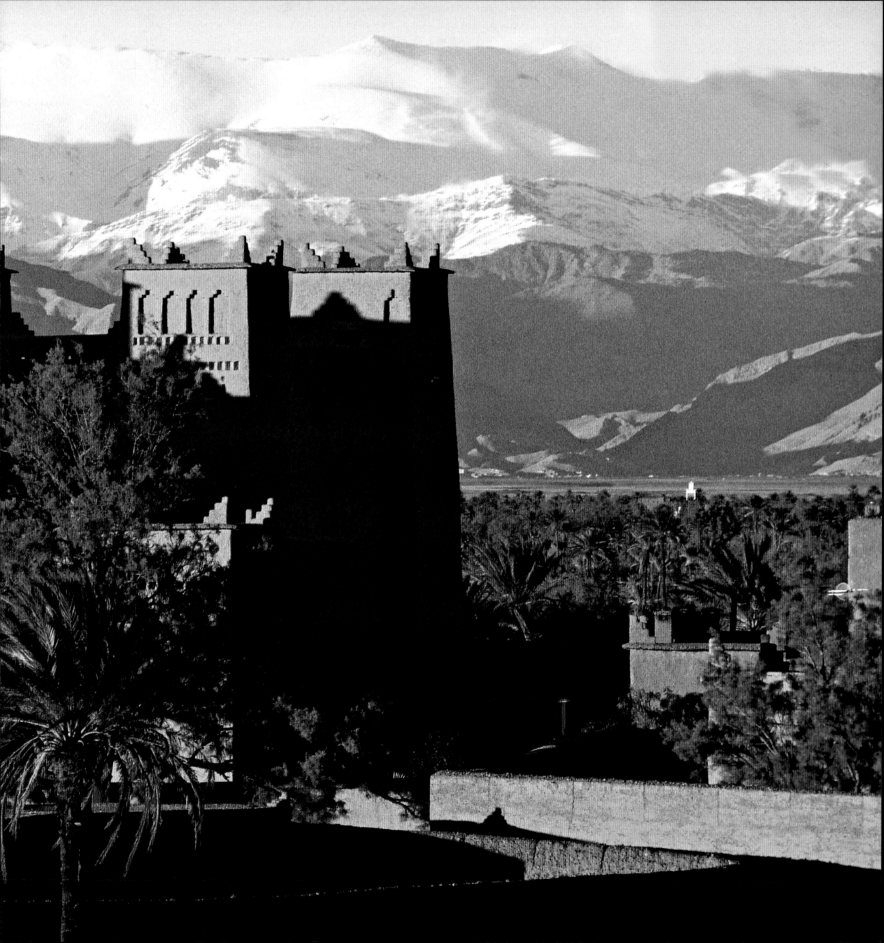

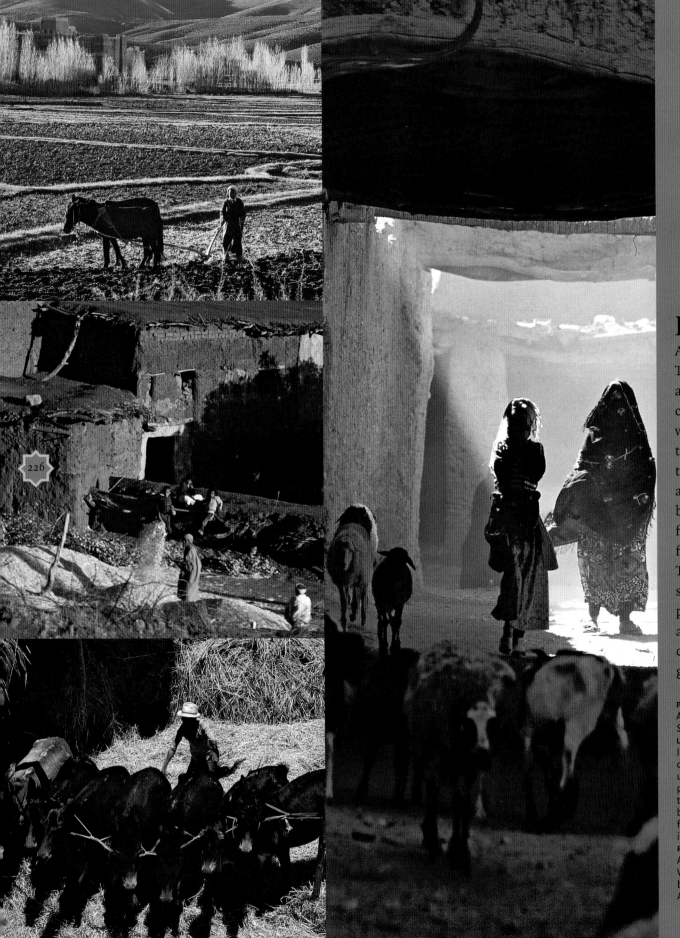

Everyday life in the High Atlas is harsh and precious. The men cultivate the fields and are responsible for cutting the wood needed for winter, as well as for selling their produce and cattle in the souk. The women look after the children, make bread, prepare and cook the food, look after the cattle, fetch water, spin and weave. They are responsible for the seasonal chores: the harvest, picking olives, almonds and walnuts, shucking corn, carrying water and gathering twigs.

**PRECEDING PAGES**
A kasbah in the palm grove of Skoura, at the foot of the High Atlas.
**LEFT**
In the Aït Bou Gmez valley, men cultivate their small plots of land using wooden ploughs with metal ploughshares, then help the mules to thresh the ears of wheat or corn before removing the grains with a fork. • Women driving a herd of goats in Mhamid, in the Draa valley.
**RIGHT**
A mud village in the Dades valley. • Women washing clothes on the banks of a wadi. • Young woman of the Aït Atta tribe, living in the High Atlas.

226

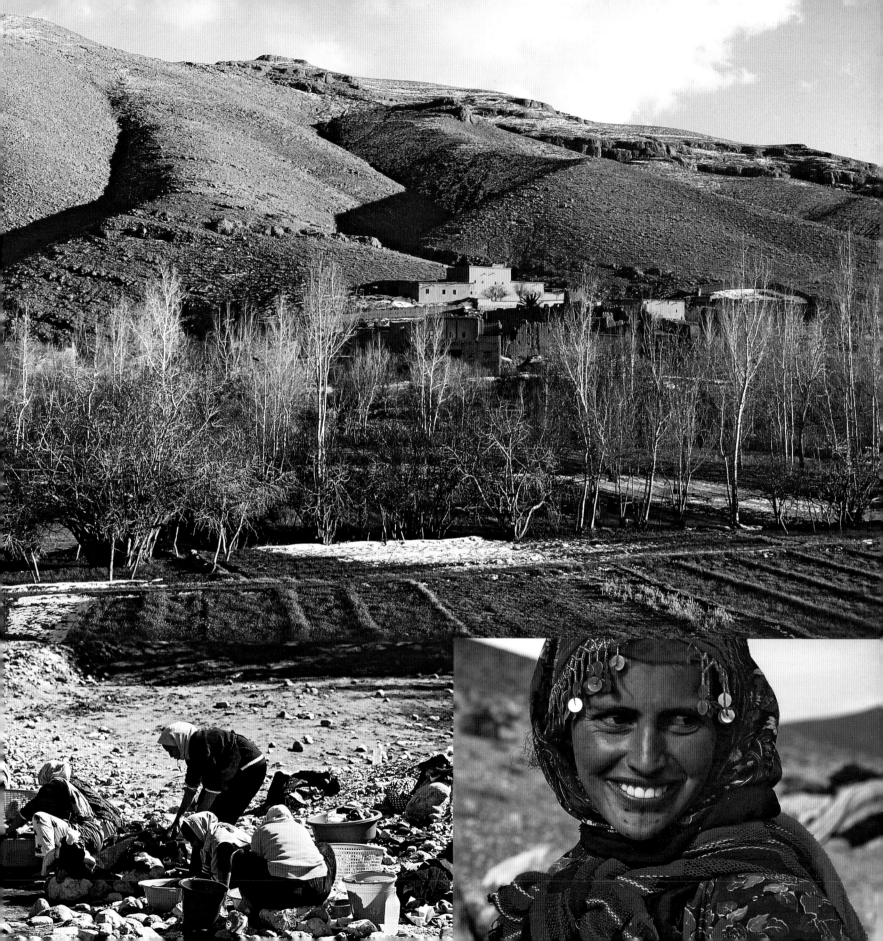

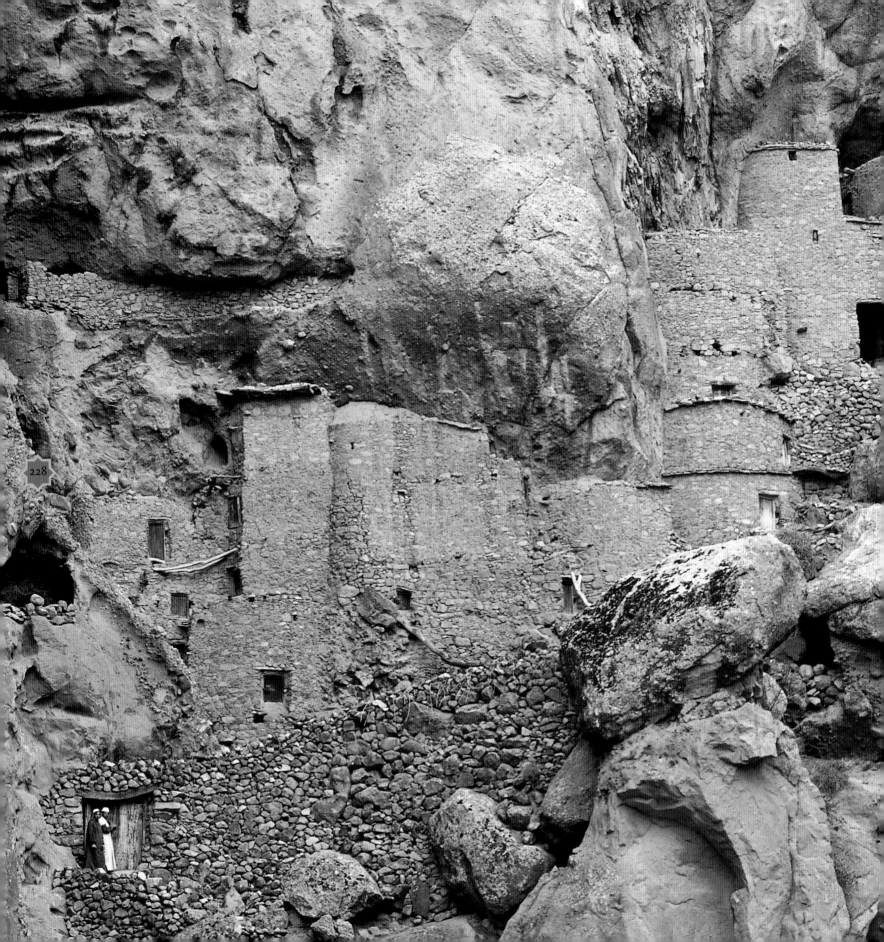

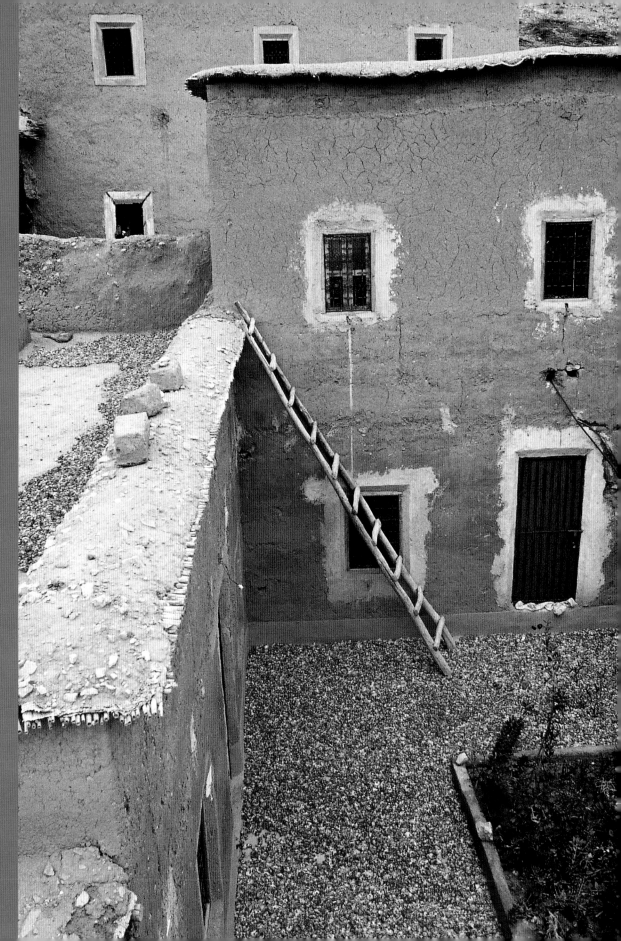

The earth used to construct the houses in the south of Morocco is dug up on the site where the houses are built. In the past, windows were rare and closed from inside with wooden shutters, or cut out behind the wooden lattice work of moucharabiehs. In more recent houses, the openings are larger and glazed windows with wooden frames are common.

The front doors, small and low, are always closed to preserve the privacy of the home. Old, solid wooden doors are rare.

**LEFT**
Communal granary in the Jbel Siroua. It can be entered only through the door at the bottom.

**RIGHT**
Rose petals drying on the terraces in a village in the M'Goun valley in the High Atlas.

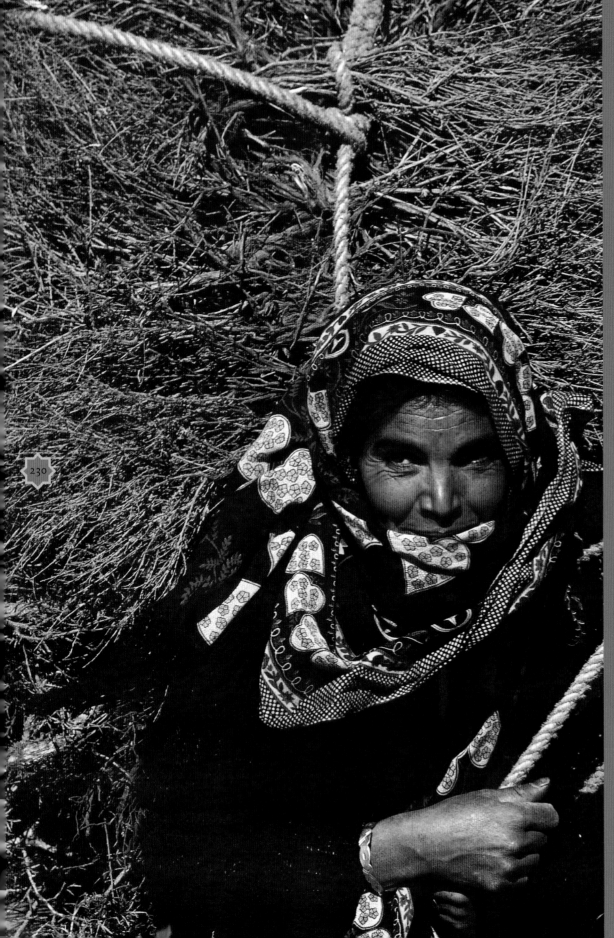

Women are responsible for chores such as gathering twigs and fodder. Young or old, they set off early in the morning with billhooks and climb up steep hillsides to the forest. They carry heavy loads of oak twigs and bunches of artemisia on their back, secured with ropes and a wooden fork-shaped wedge. In the evening they return home exhausted, weighed down by their heavy load.

**LEFT**
The women in the Atlas Mountains carry loads three times as large as themselves.
**RIGHT**
For two weeks in February, the almond trees of the Anti-Atlas Mountains in the Tafraoute region are covered with thousands of white flowers.

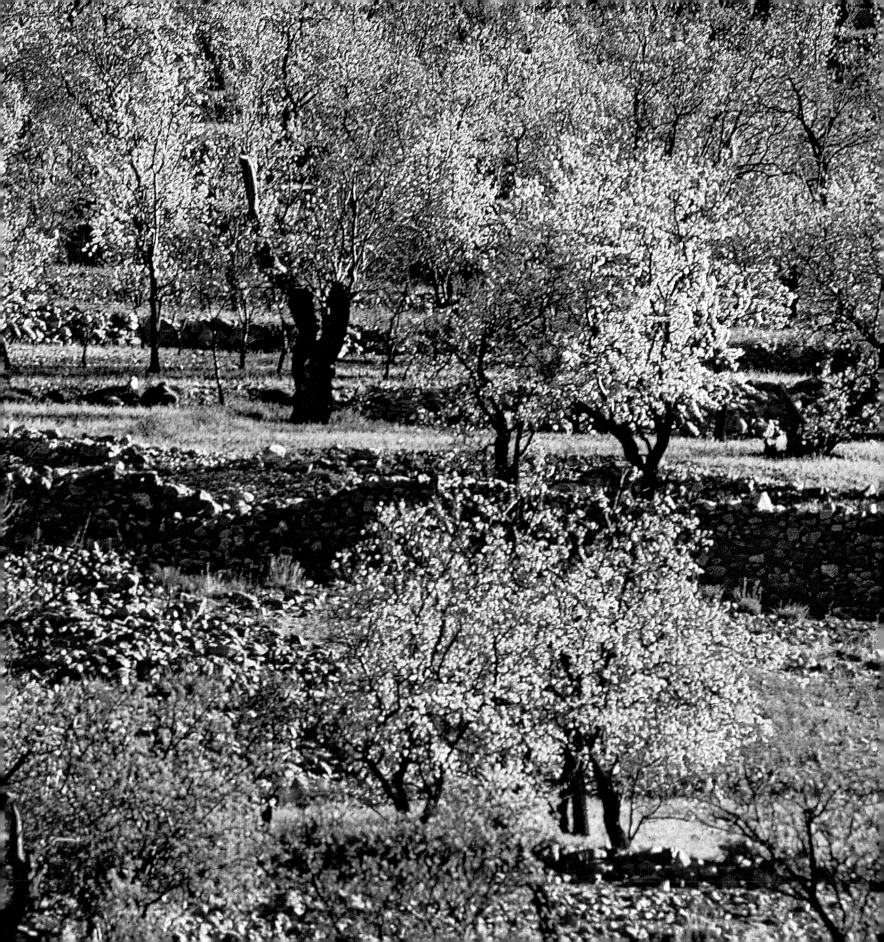

. . . in the south, it is the desert, yellow, black, like the sea when the wind whips up clouds of sand; but in the north, there are palm groves; around fruit trees with their flowery heads, pink almond trees, red pomegranate trees, white apple trees; in the middle of greenery, villages or rather kasbahs, very tall, surrounded by tall walls of orange adobe.

Paul Odinot, 'The first communion of Abd-el-Kader', from *Maroc, les villes impériales* (*Morocco, the Imperial Cities*)

**RIGHT**
Old fortified dwellings in the Dades valley.

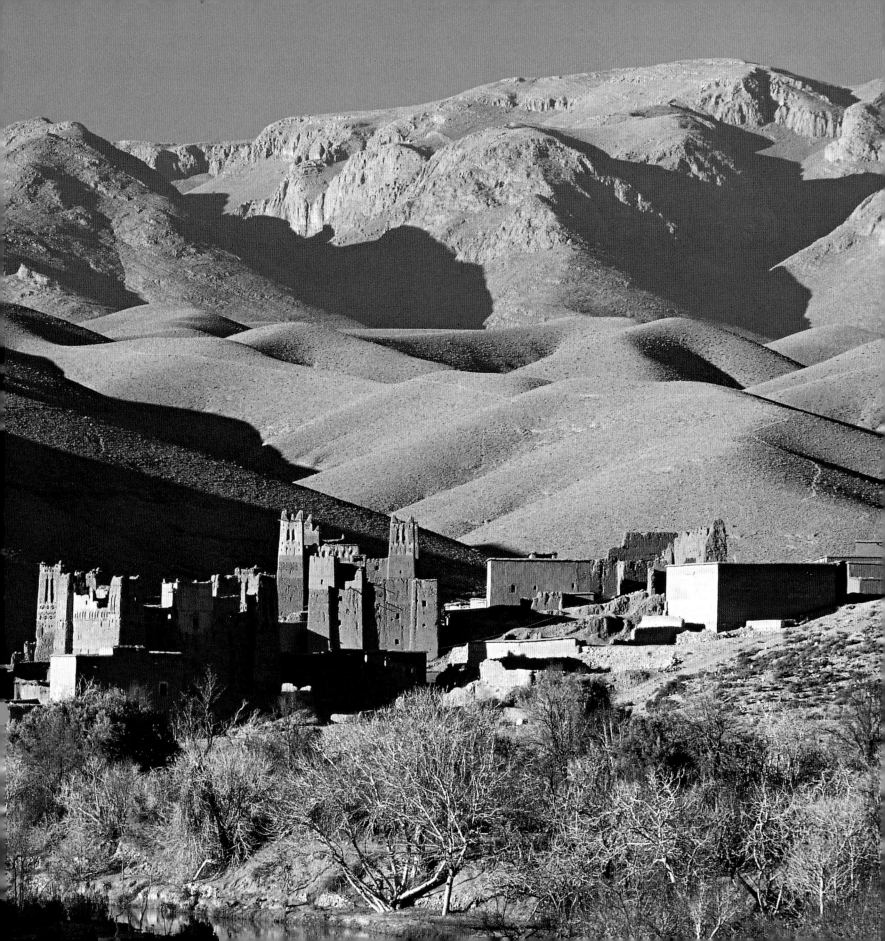

234

Among the Berbers of the Atlas, from an early age girls are required to imitate their mother and help looking after the younger children, including carrying the youngest child on their back supported by large coloured scarves. They go and fetch water from the river, sift the grain, wash up and help with the housework. By the age of twelve, they can make bread, roll couscous grains in the large dish, wash clothes in the wadi, cut the grass in the fields and weave. These future Berber women will not wear the veil like their Arab sisters, but simply a headscarf.

**LEFT AND RIGHT**
Smiling little girls in Djebel Sagho in winter.

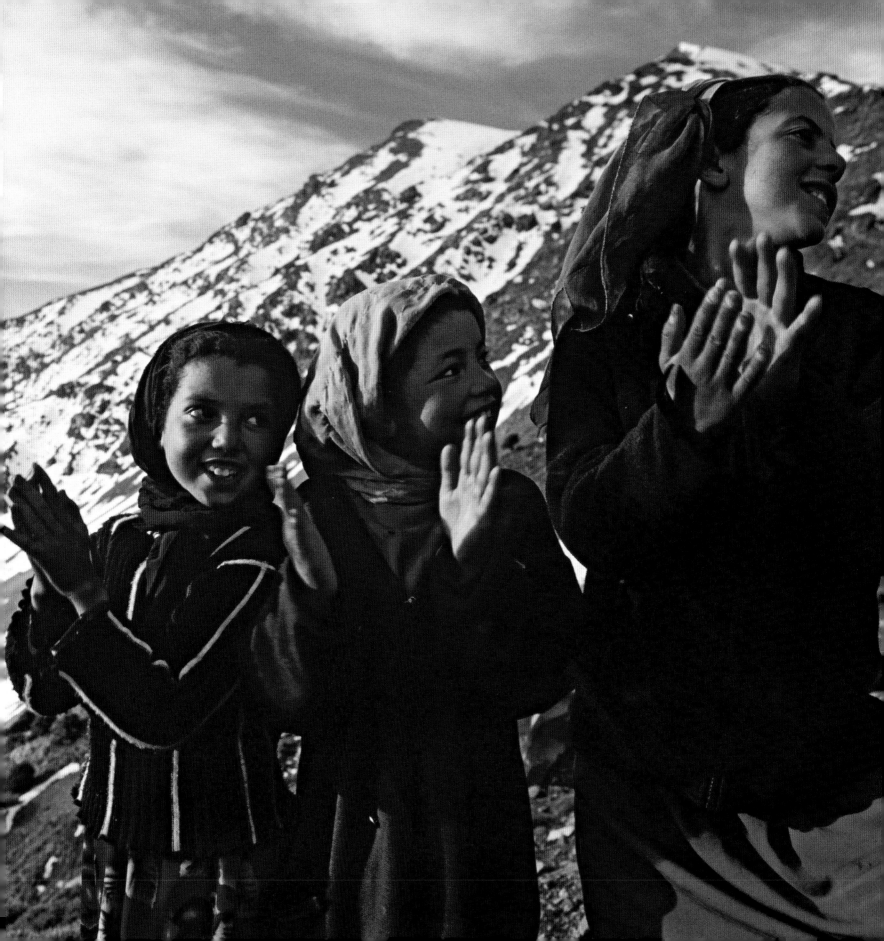

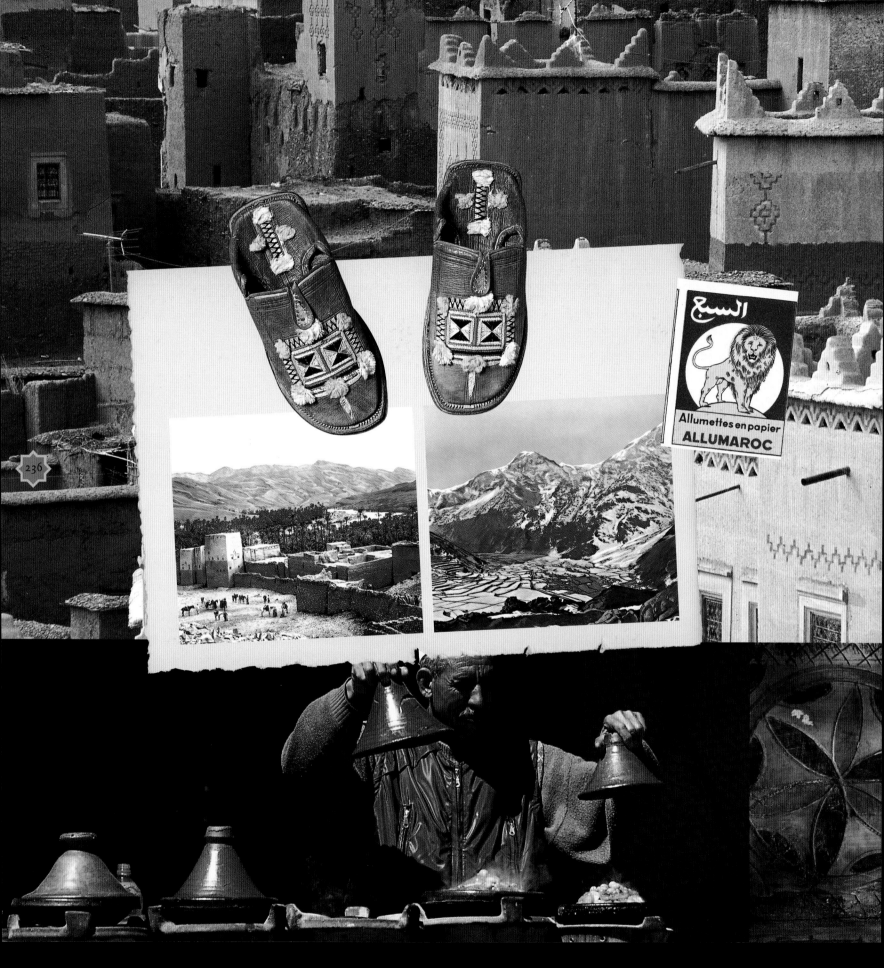

السبع

Allumettes en papier
**ALLUMAROC**

Friezes of miniature arcades, delicate repeated carvings and honeycomb brickwork embellish the upper part of the façades and the slender towers of the kasbahs. They use all kinds of geometric motifs: dots, broken lines, check patterns and squares. Although the unbaked brick is delicate and precludes excessive carving, the decoration is elaborate. The merlons decorating the tops of terraces and protecting the path around the battlements reflect the taste of the craftsman: rounded, prismatic, saw-toothed or stepped.

**LEFT**
The kasbahs of Toundout, situated on the southern slopes of the High Atlas, are richly decorated and well preserved.
• Tagines simmer on terracotta *kanouns*.
• Detail of a hand-painted wooden ceiling in the Aït Bou Gmez valley.
The old photographs show, left to right, the town of Taza, between the Rif and the Middle Atlas, as it appeared at the beginning of the twentieth century; Mount Toubkal, 4,167 metres (13,671 ft) above sea level, is the highest peak in North Africa.
**RIGHT**
In a ksar of the Draa valley. • A woman and her baby in the Aït Bou Gmez valley.

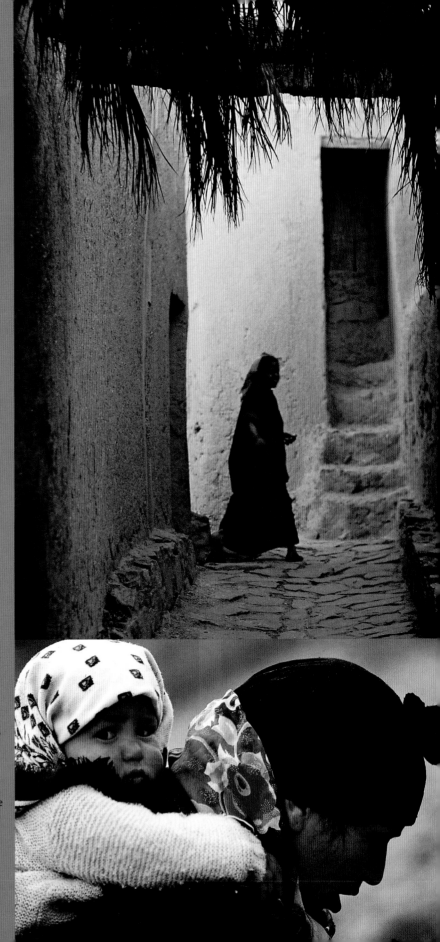

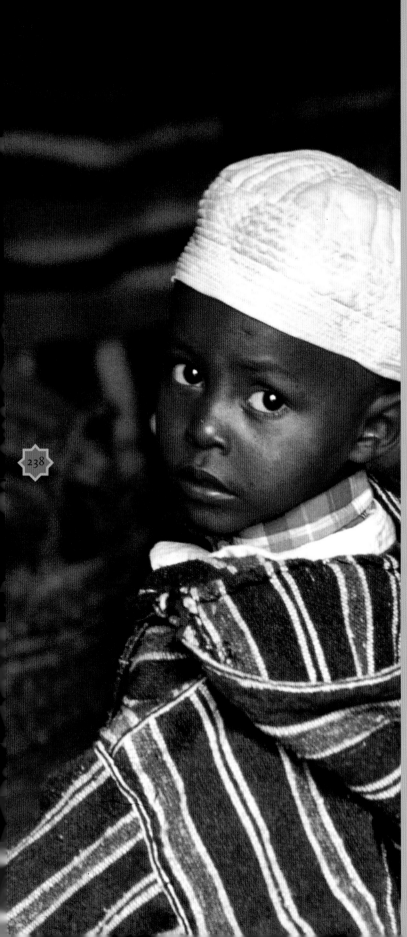

Primary school is usually obligatory for children between seven and thirteen years of age. But Morocco does not have enough secondary schools and teachers to meet the country's requirements. In rural regions, children who have to walk several miles to go to school also find it difficult to get a place, and priority is given to boys. But today, almost a quarter of the country's budget is spent on education and the percentage of children at school rose from 55 per cent to 87 per cent between 1997 and 2004. Teaching is in Arabic in the early years, then in Arabic and French for the rest of the child's education.

**LEFT**
A little nomad boy in the Merzouga region.
**RIGHT**
A rudimentary 'school' in the Tessaout valley of the High Atlas.
**OVERLEAF**
A ksar in the Draa valley.

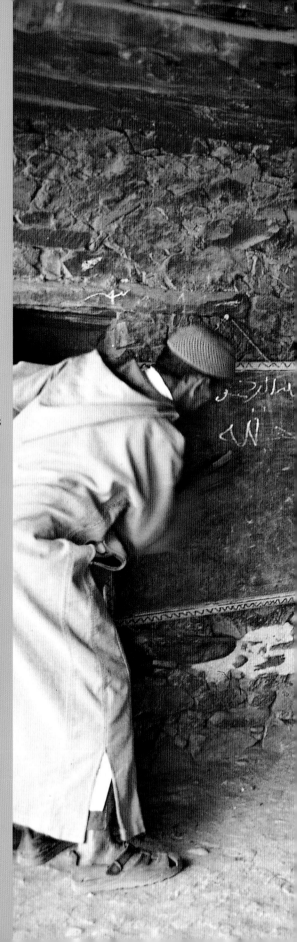

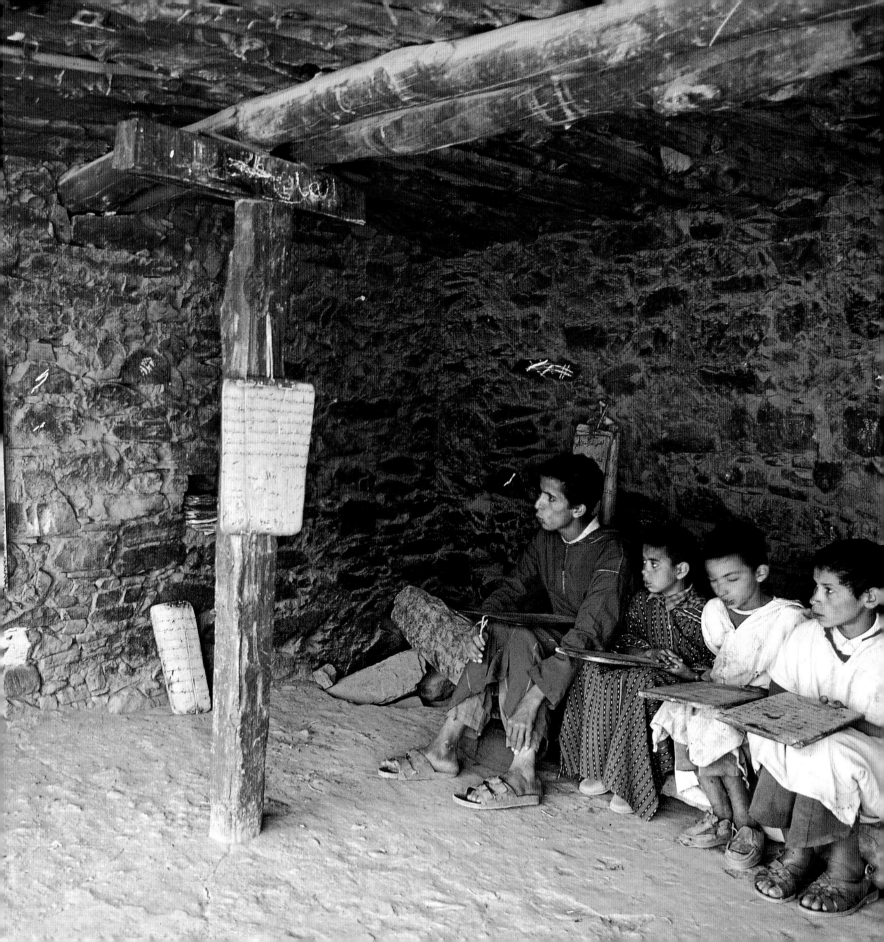

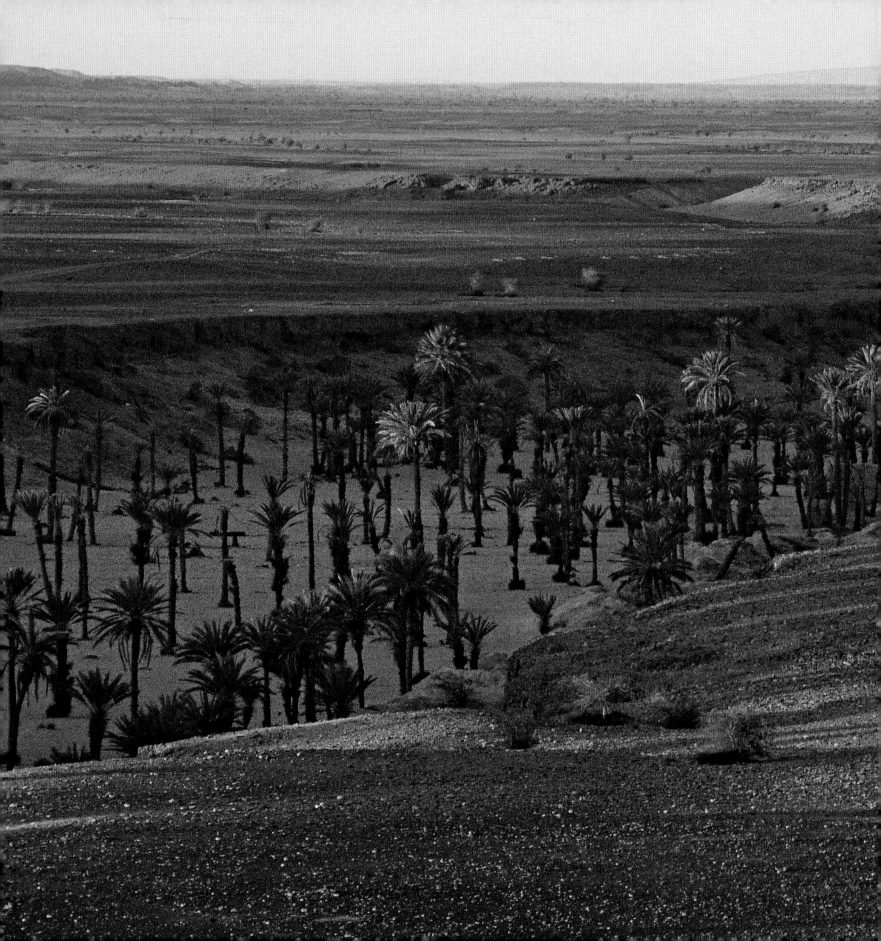

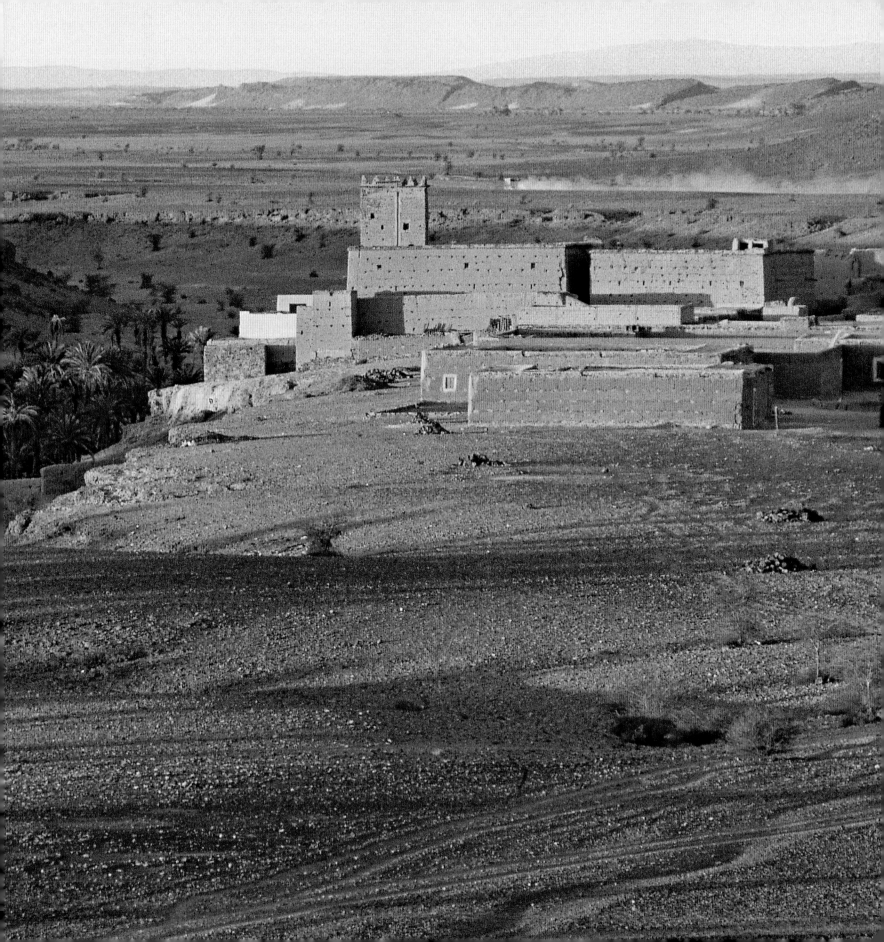

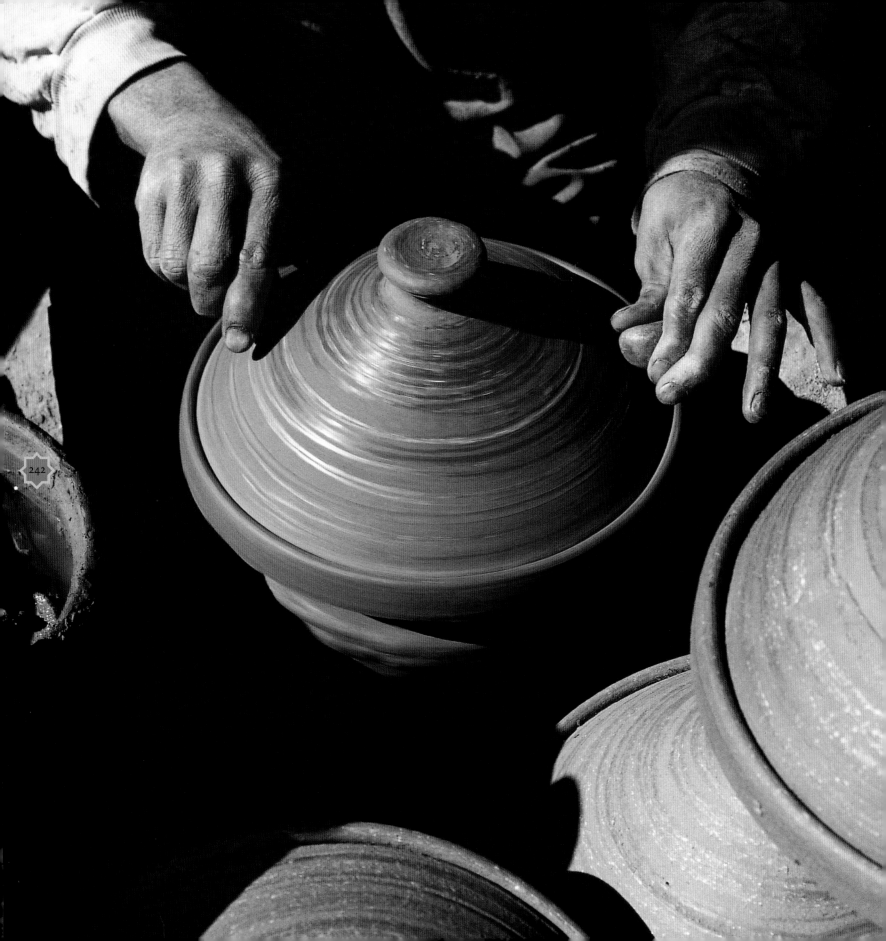

With such care he chooses his earth, with such love he sprays it with pure water, with such respect he kneads this primeval clay. You can only create in joy. This joy mixed with pain, from which life emerges, makes the potter's hands tremble with a sensual delight that is almost sacred. These pots are living beings, they are born from earth, water, air and fire.

Ahmed Sefrioui, *Le Chapelet d'ambre (The Amber Rosary)*

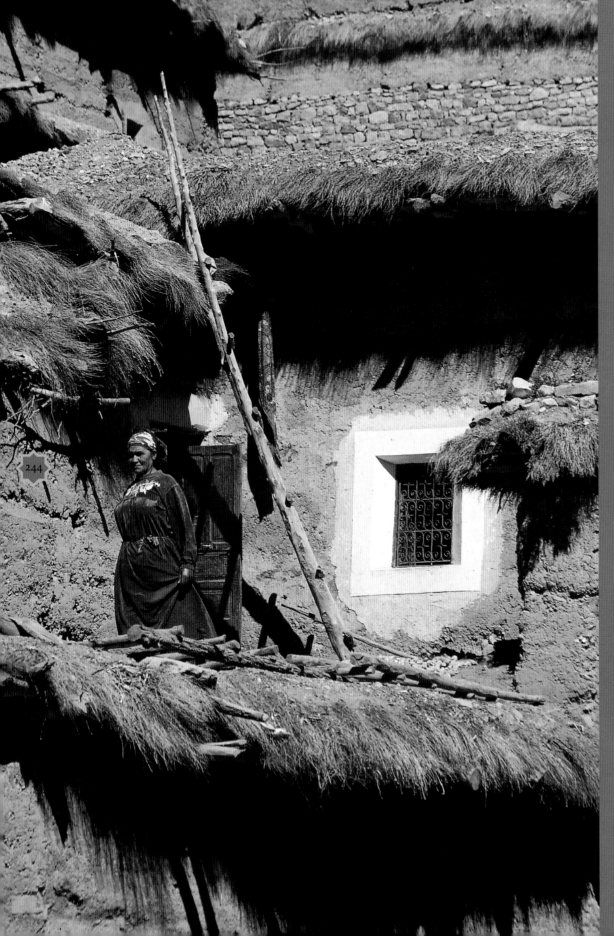

In mountainous areas, the adobe houses huddle together to form compact villages on hillsides, sometimes built right against the mountain. Their flat roofs are often used as terraces by the inhabitants of the house below. Mud buildings require a lot of maintenance. As long as the base of the walls is regularly strengthened and the coating is renewed, the technique is reliable. But, being fragile, adobe is not very resistant to the rain and snow in the mountains. The roofs are covered by a thick layer of long grasses that projects far beyond the walls and prevents the rain running down the adobe.

**LEFT**
A rudimentary ladder links the various terraces together in a village in the Aït Bou Gmez valley.
**RIGHT**
An arcaded house in the Atlas Mountains.

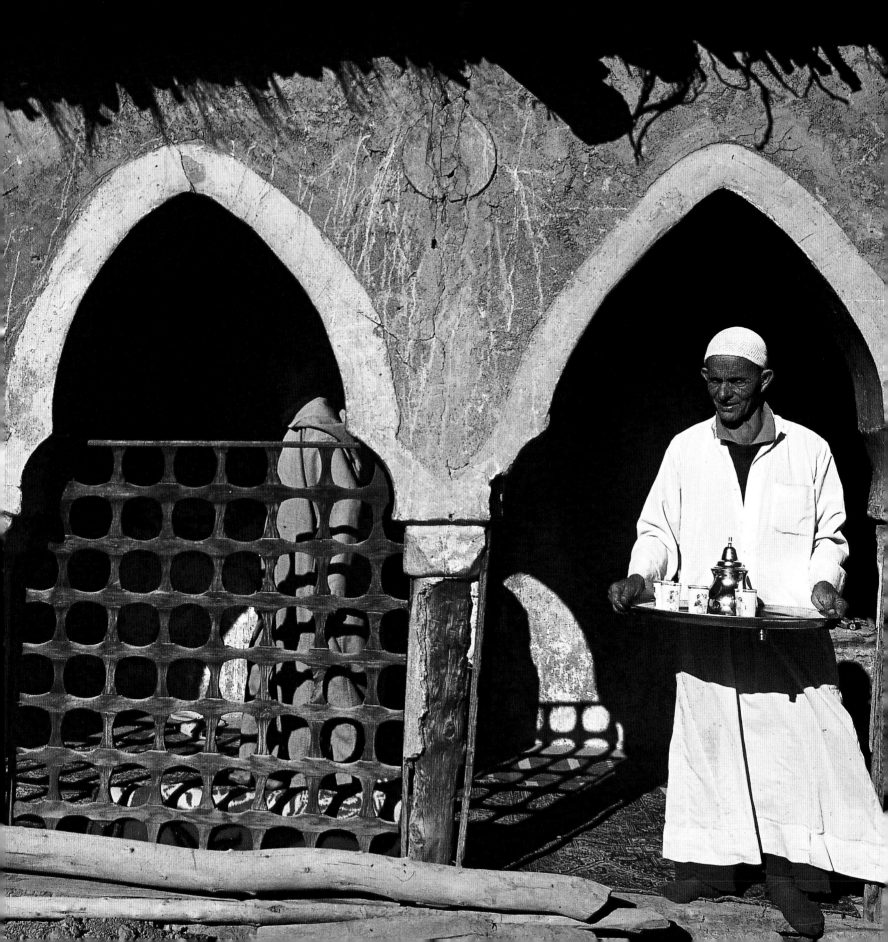

# MOROCCO CELEBRATES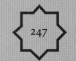

Fragrant mint tea, dizzying 'fantasias', women dressed in sumptuous clothes, strange dances, bewitching chants . . . In Morocco, festivals and moussems take place throughout the seasons. From north to south, six or seven hundred moussems are celebrated each year when tent villages suddenly emerge, attracting large crowds of passers-by and pilgrims. It is a seasonal folk festival that is at once a pilgrimage to the tomb of a saint, a commercial fair and a place to go to have fun. A moussem may last a week, three days or sometimes just one day. Some retain a purely religious character while others are more famous for their souk, their 'fantasia' or their entertainments. Each region likes to celebrate its local resources, traditionally at the end of the harvest. In spring, the Rose Festival celebrates the picking of the wild rose blooms that are abundant in the region of Kelaa M'Gouna. Young girls with plaits intertwined with woollen yarn of many colours dance to the tune of the *bendir* on colourful rugs, decorated with giant paper roses.

The summer Cherry Festival in Sefrou, the date festival in Erfoud each autumn, the Almond Festival in Tafraoute and the Honey Festival in Immouzer des Ida Outanane are all an excuse for bringing together musicians and dancers, dressed in their most beautiful traditional clothes. A survival from fairs of days gone by, usually taking place at the crossroads of several caravan routes, moussems traditionally provided an annual opportunity for exchanges between regions.

Today, the Moussem of the Betrothed that takes place not far from Imilchil brings together all the tribes of the Aït Haddidou, scattered on the high plateaus of the Atlas Mountains. 'Betrothal certificates', promises of marriage, are signed by young couples who have met at the moussem. The enormous souk of colourful tents enables the tribes to replenish their supplies and to buy more cattle and tools before the winter sets in, when the snows cut off the valley from the rest of the world for many months.

In Goulimine, Saharawi sellers and buyers gather together at a gigantic camel market while

> ❝ The riders, all dressed in white, whirl their rifles in the air ❞

*guedra* dancing girls, on their knees and wrapped entirely in drapes, undulate to a syncopated rhythm until they are completely exhausted. These colourful festivities reflect a popular culture that is both mystical and joyful.

The dizzying 'fantasias' take place on a stretch of ground about 200 metres (220 yards) long: teams of riders set off amid clouds of dust and the deafening sound of hooves, first at a rising trot, then at a gallop. The riders, all dressed in white, whirl their rifles in the air above their heads, each one holding it with one hand only. Shortly before reaching the finish, on a brief command from the chief, all the riders fire their guns at one go, then rein in their horses while the clouds of dust mingle with the wafting smoke. The success of a 'fantasia' lies in the perfect sequence and synchronization of events.

Family celebrations and religious festivals mark each important stage in life, namely birth, circumcision and marriage. The arrival of a child is celebrated on the seventh day after its birth. A sheep is sacrificed if the family can afford it and the new-born is officially given a first name. Circumcision is a ritual that is required by the Muslim religion. While it is no more than a matter of hygiene in urban surroundings, it is still a very important event in traditional circles; the child, dressed in a little green waistcoat and wearing a green fez embroidered in gold, is fêted by the whole family.

A social event as well as a religious one, marriage is a festive occasion *par excellence*, marking the alliance between two families. However, costly ceremonies are less and less compatible with the demands of modern life. In cities and towns, marriage celebrations have been reduced from seven to two or three days. But the spirit survives.

Aïd el-Kebir, one of the religious festivals in the Muslim calendar, commemorates the day when Abraham was prepared to sacrifice his son Ismael because God had ordered him to do so. Seeing his submission, God replaced the child with a ram. So during this festival every home sacrifices a sheep and the meat is shared at meals with family and friends.

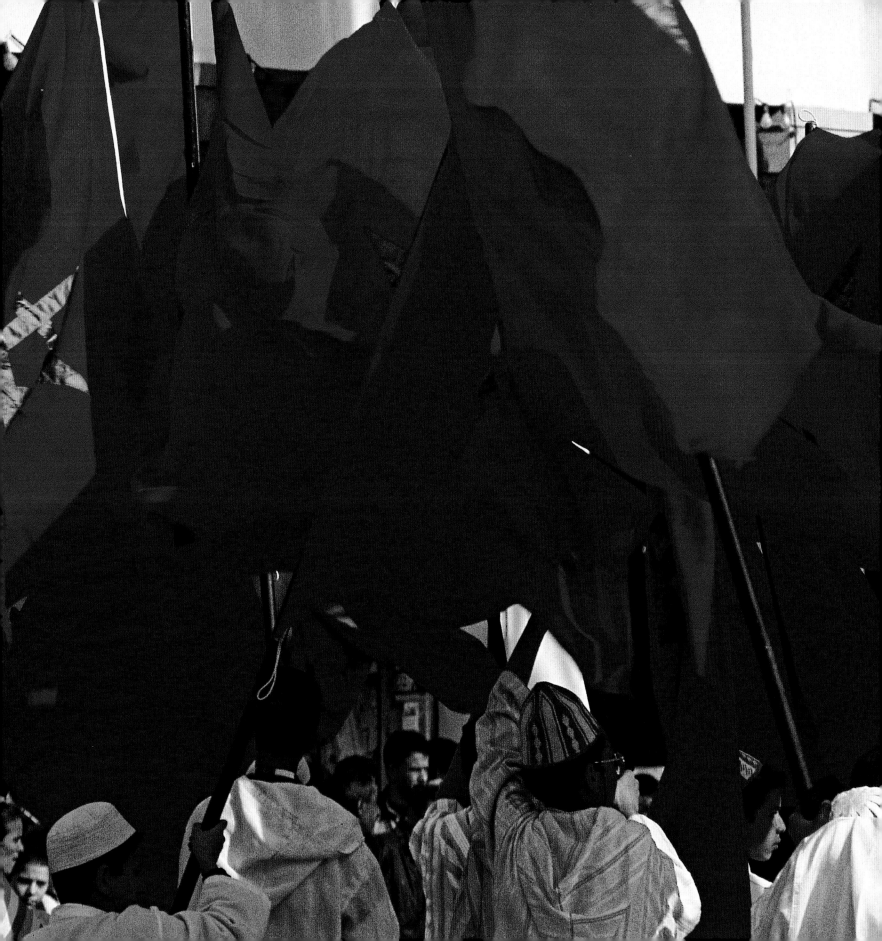

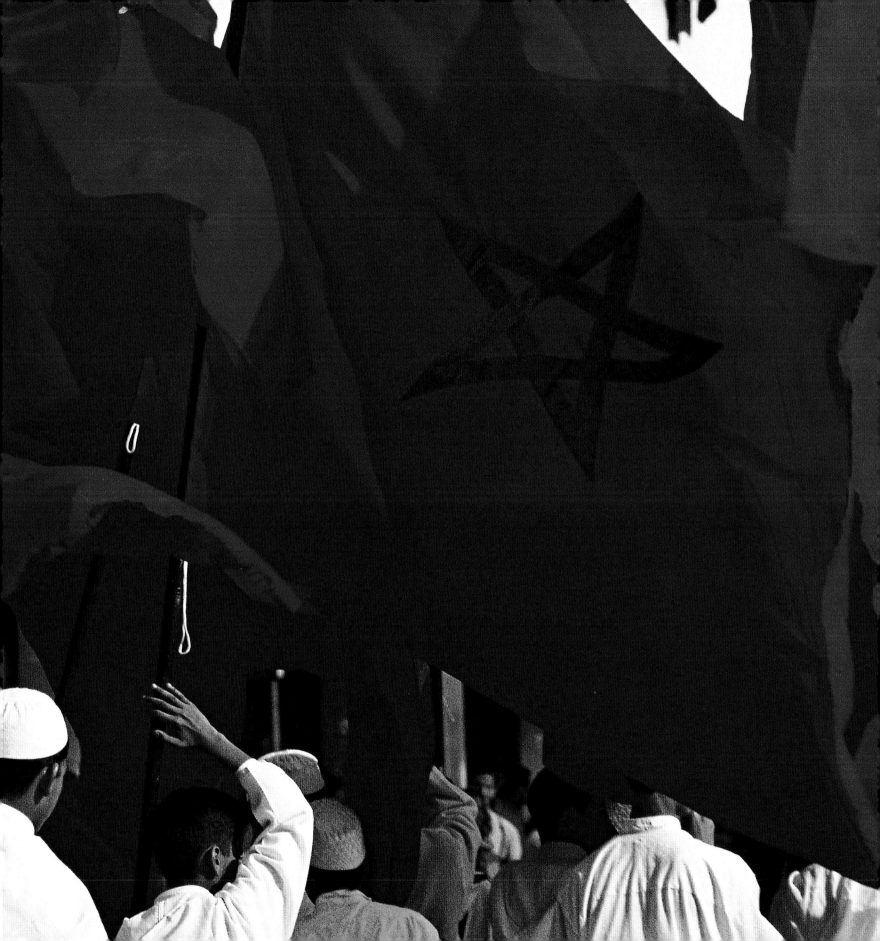

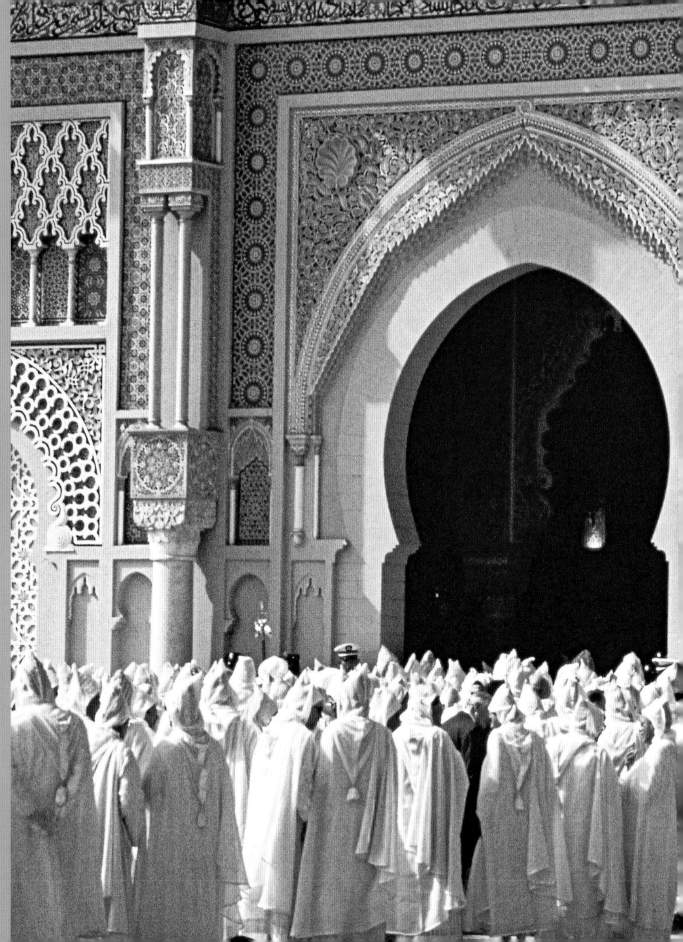

The Festival of the Throne is the most important secular festival in Morocco. It is celebrated each year on 30 July, the anniversary of the enthronement of King Mohammed VI. The Festival of the Throne gives the king the opportunity to survey the past year and present the prospects for the future. The festival was created during the reign of Mohammed V, when the Moroccan people euphorically celebrated their new-found independence. Today, it involves parades, fireworks, dancing and receptions throughout the country.

**PRECEDING PAGES**
The national emblem, the Moroccan flag fills the streets of Rabat on the day of the Festival of the Throne.
**LEFT AND RIGHT**
On the large esplanade in front of the royal palace in Rabat, leading citizens prepare to enter the compound to present their good wishes to King Hassan II.

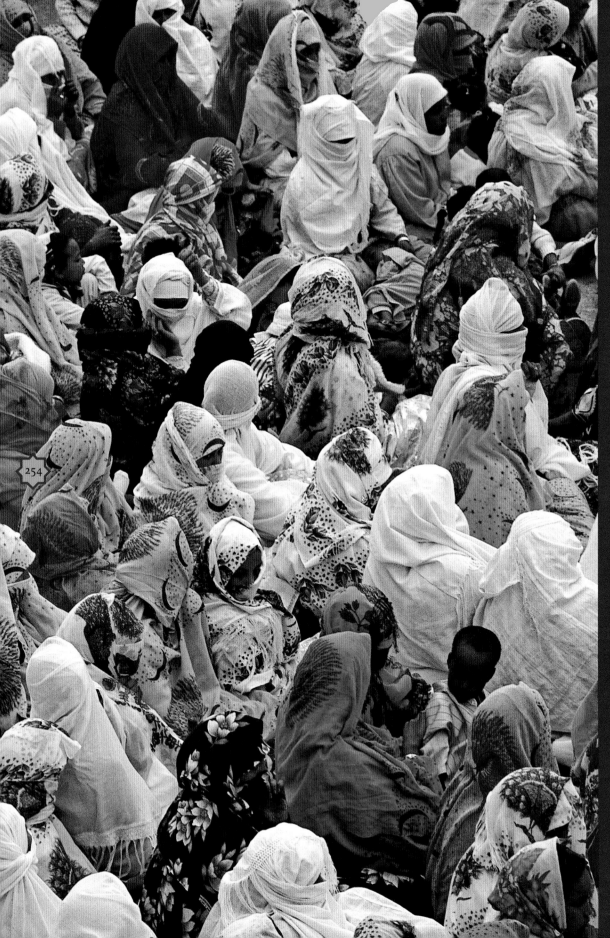

Every moussem is an opportunity to bring musicians and dancers together from all over the country, dressed in their beautiful traditional costumes. Before the twentieth century, none of the Moroccan musical repertory had been written down. The most popular instruments for accompanying dancers are the *bendir*, a frame drum made from wood and covered with animal hide, with a hole in the frame where the musician inserts his thumb; the *r'bel*, a large drum with a double membrane played with drumsticks; the *gumbri*, a primitive lute with two or three strings; the *gasba*, a reed flute; the *ghaita*, a kind of oboe with double reed; and the *derbouka*, a single-headed clay drum made of clay.

LEFT
Women wearing multi-coloured veils at the Moussem of the Gnaouas in Tazerwalt.
RIGHT
Dancers and musicians at the Rose Festival, Kelaa M'Gouna.

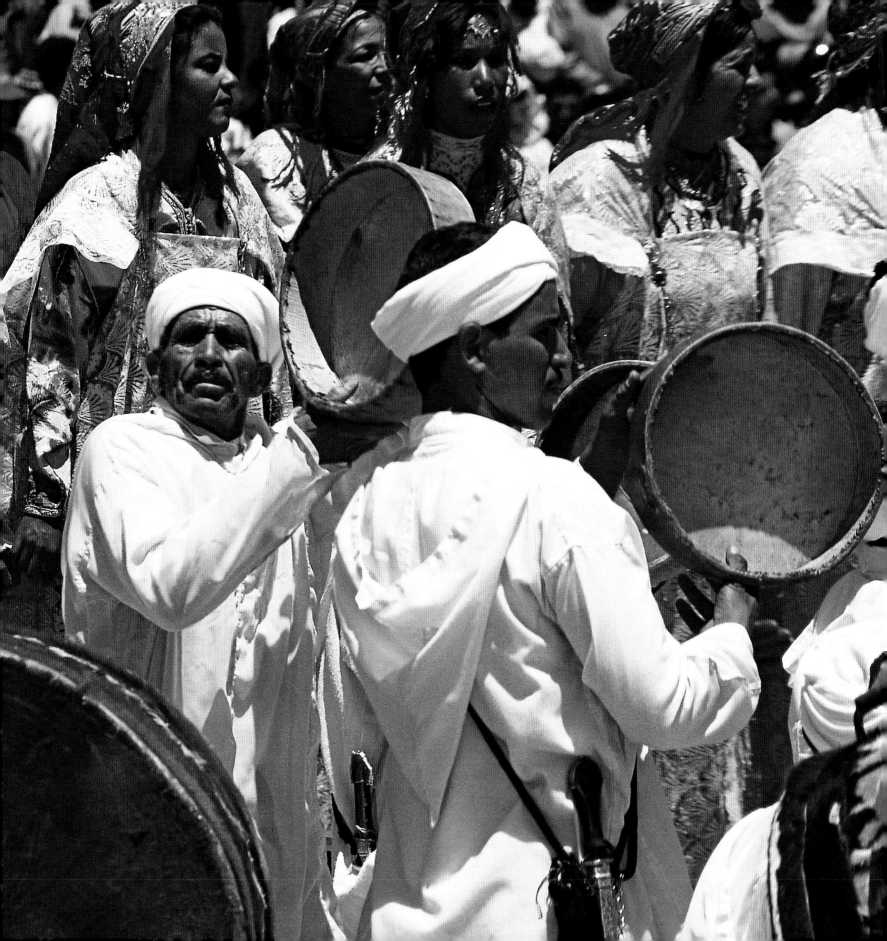

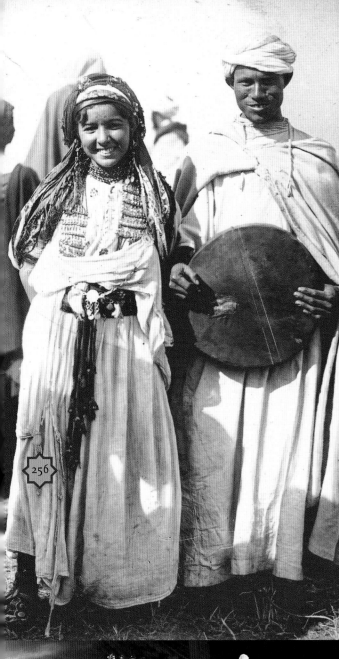

A marriage ceremony can vary in all kinds of ways and follow different customs, depending on the region. Usually, on the first day the bride is accompanied to the hammam by her sisters and girl friends. The following day is devoted to the henna ceremony, supervised by professional organizers who look after the rituals involved in the marriage ceremony. That same evening or on the third day, the groom and his family call at the home of the bride-to-be. In the presence of two adouls (a kind of notary public), the assembled guests recite the Fattha (the first sura of the Koran) which consecrates the marriage from the religious point of view. This is followed by a sumptuous meal that takes place at the house of the bride or the groom.

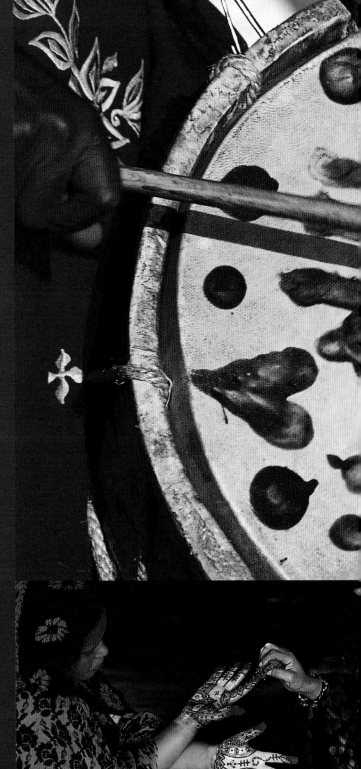

LEFT
A party in Azrou in the Middle Atlas. • During the marriage ceremony in Fès the bride is lifted onto a mida, a high chair of painted wood, covered with a piece of velvet embroidered with gold thread.
RIGHT
The t'bel; the henna ceremony. • The jewelry and make-up worn at wedding celebrations. • At some weddings the tradition of the 'seven dresses', worn by the bride one after the other throughout the afternoon, still survives. The old photographs show, clockwise from top right, moussem among the M'Tir, about 1921; a group of children dressed up for the Ramadan festival in Meknès, about 1921; and the twenty-seventh day of the Ramadan festival in Meknès, about 1921.

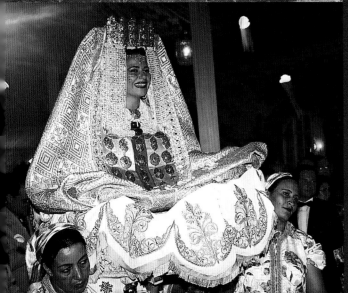

Silk scarves decorated with flowers enclosed the head, gold and pearl necklaces wrapped round smooth necks like ivory; earrings adorned with cabochons framing their delicate faces and the eyebrows, painted with a single stroke, were the bows of love that shot bewitching arrows into the hearts of men.

Tahar Essafi, 'The coriander amulet', from *Maroc, les villes impériales* (Morocco, the Imperial Cities)

**RIGHT**
Young Berber girl at the
Imilchil moussem.

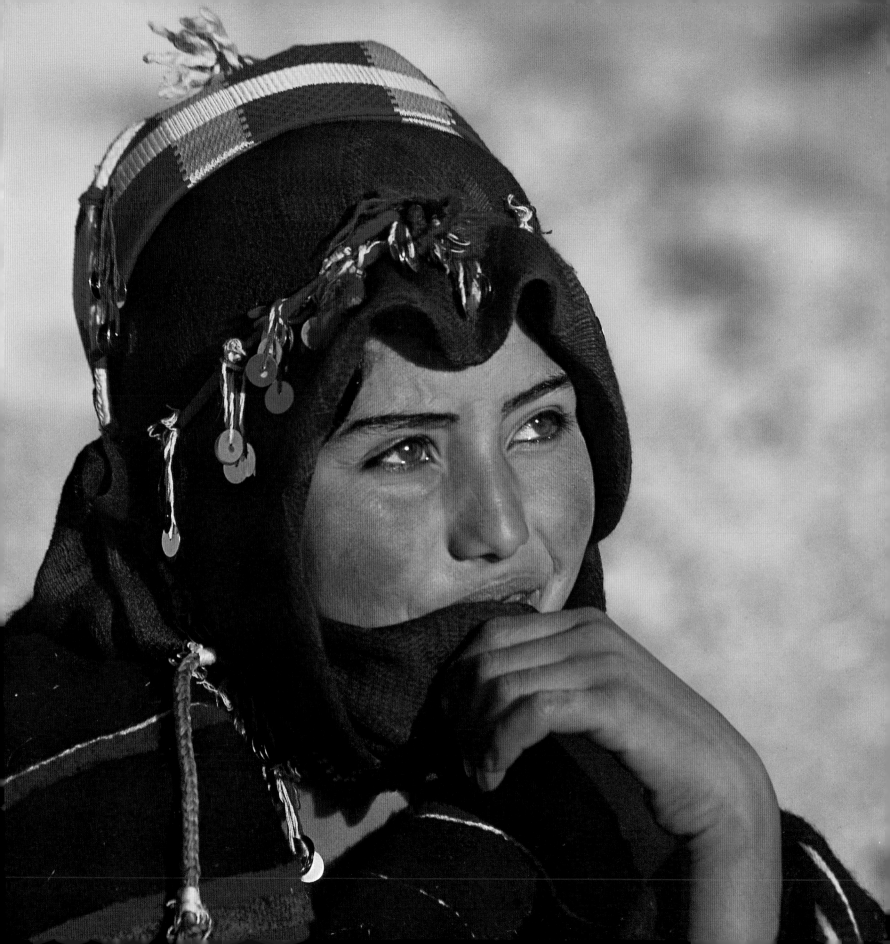

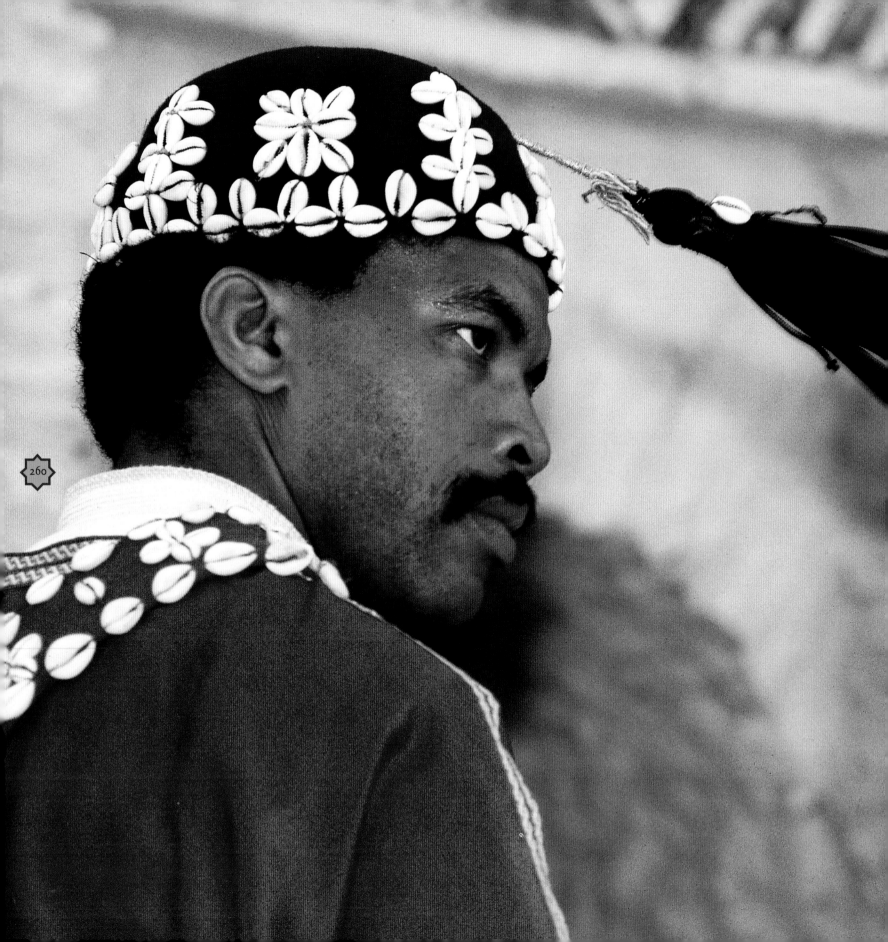

Musicians, dancers and singers, the Gnaouas are present at all celebrations. Capable of astonishing physical prowess, they leap into the air, whirl around themselves and pound the ground to the rhythm of the *qarqabeb*, metal castanets. But these displays conceal the complexity of their religious rituals. Descendants of former slaves from the Sudan, Mali and Niger, the Gnaouas heal souls in distress during the *lila*, nights of ritual chanting and dancing reserved for initiates. The women, veiled in a material the colour of the spirit invoked, gradually become possessed as they fall into a trance and collapse, healed.

LEFT AND RIGHT
Gnaouas in the medina at Agadir.

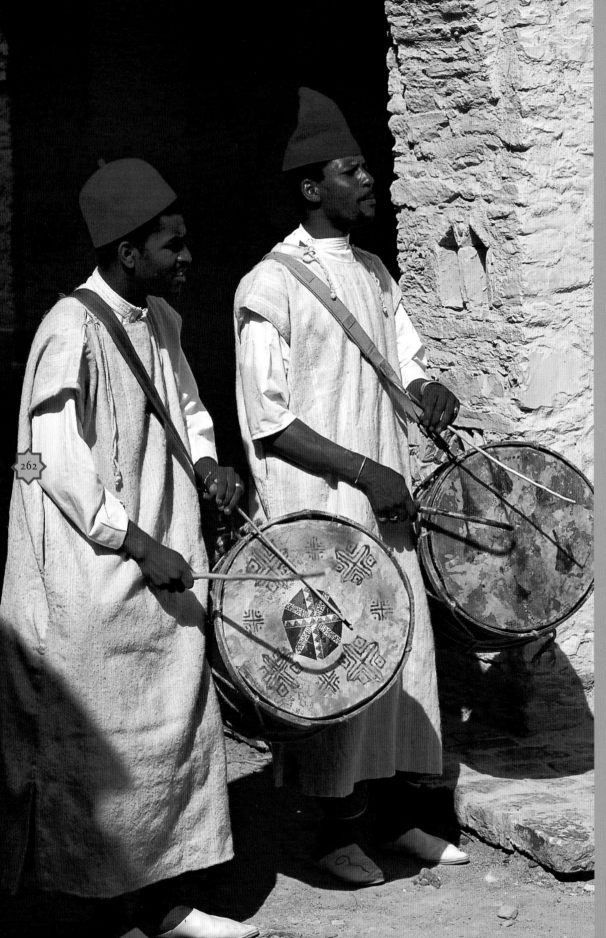

Although often 'folkloricized' and deprived of some their essence, the traditional dances form an integral part of the Moroccan heritage. They accompany all of life's important moments and vary from one region to the other. Originally, these dances were intended to express the link between mankind and the earth, to obtain its fertility, beg for rain or honour a divinity so as to be granted its protection and favours. As well as dances associated with poetry and music (*ahidous, ahouach*), there are also warrior dances (*taskioune* or Sabre dance) and betrothal dances such as the *tissint* in the south of the country.

**LEFT**
Gnaouas wearing the red pointed *chechia*.
**RIGHT**
Acrobats of Sidi Ahmed Ou Moussa.

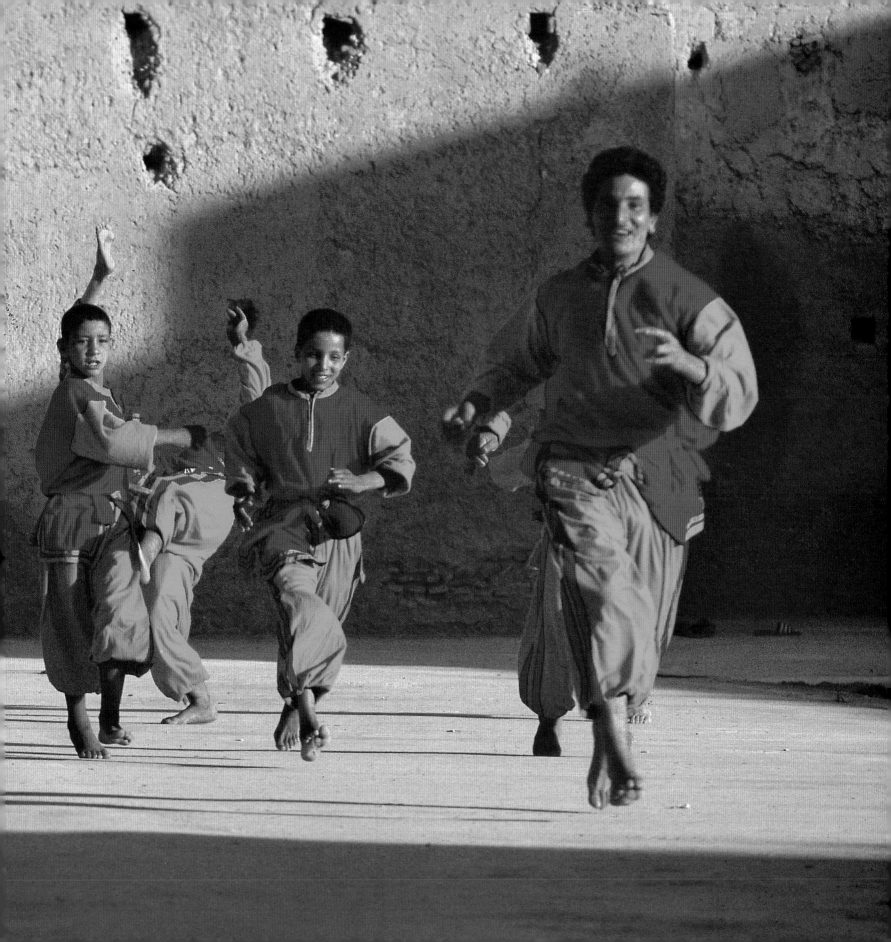

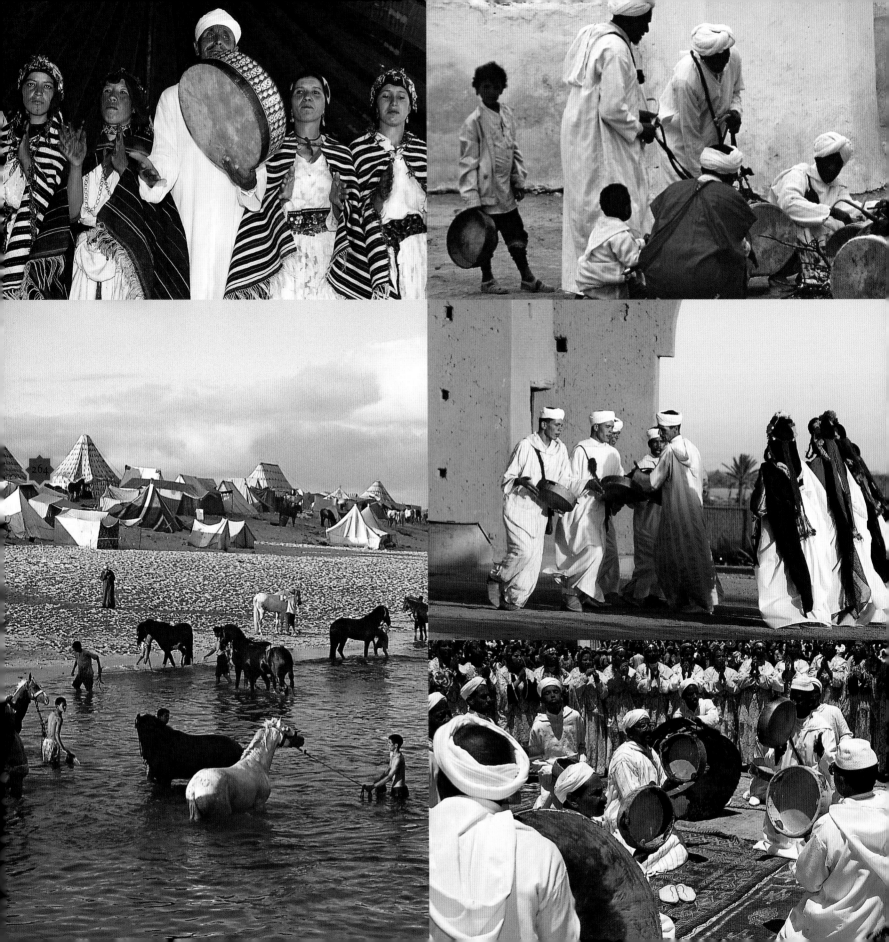

Their heads covered with multicoloured scarves or small silver coins, their hair braided with silver thread, adorned with necklaces of brown amber or coral, carefully made up with henna, the women dance, alternating with the men, to the sound of timeless chants, passed down from generation to generation.

**LEFT**
Traditional dance of the Aït Haddidou in the High Atlas. • The 'fantasia' horses cooling down in the Atlantic ocean during the moussem of Moulay Abdallah Amghar. • The Illigh moussem, in the Tiznit region. • Dancers and musicians of Kelaa M'Gouna in the kasbah of Marrakesh. • Dance of the Ahouach by a troupe from Ouarzazate – the musicians in the centre play the *bendir* while the dancers slowly move round in a circle .
**RIGHT**
Women cheering during the Festival of the Throne in Rabat. • Dromedary race in which some of the riders are barely ten years old.

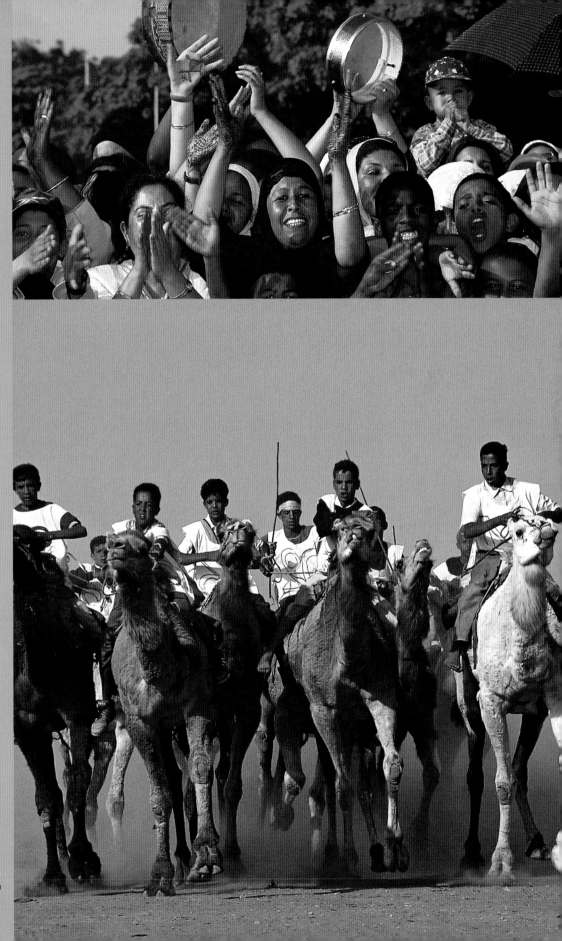

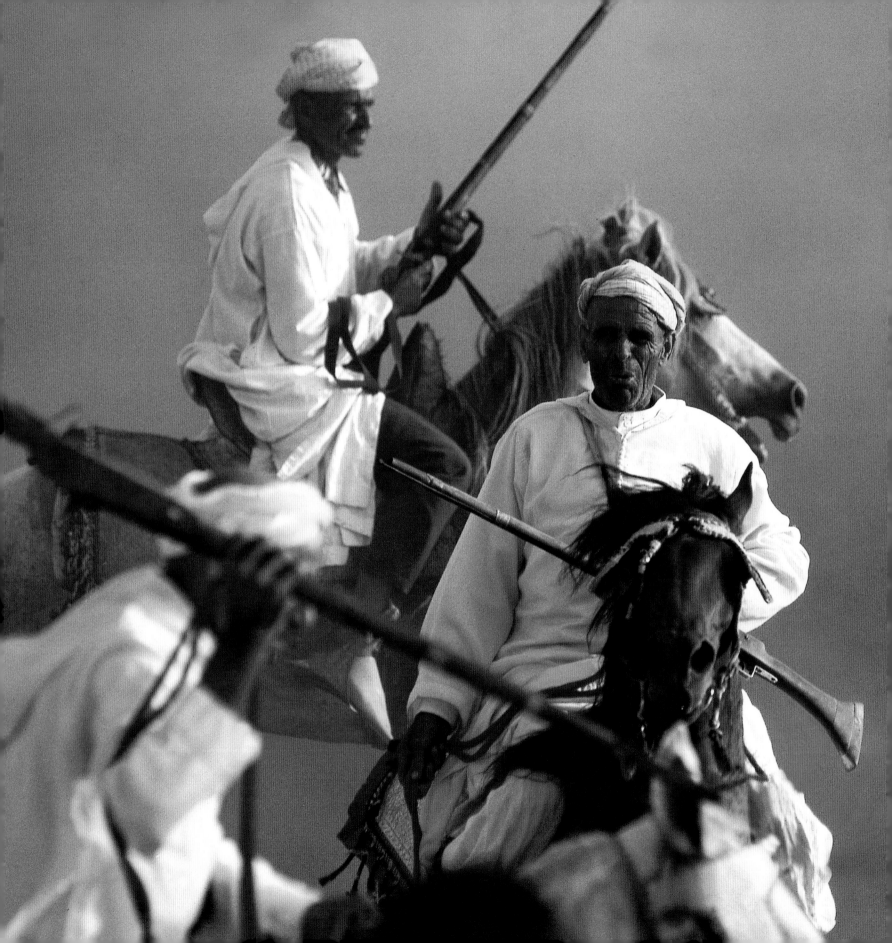

Oh, the strange riders, seen at rest and in the distance!
On their small scrawny horses, on their high armchair
saddles, they look like old women wrapped in white
veils . . . Their heads are all wrapped in muslin and their
burnouses trail like scarves over the hindquarters of their
horses. We approach and, suddenly at a signal, a command
given in a raucous voice, everyone scatters, swarming
like bees . . . And all the white burnouses in which they were
wrapped flew away, now floating with exquisite grace . . .

Pierre Loti, *Au Maroc (In Morocco)*

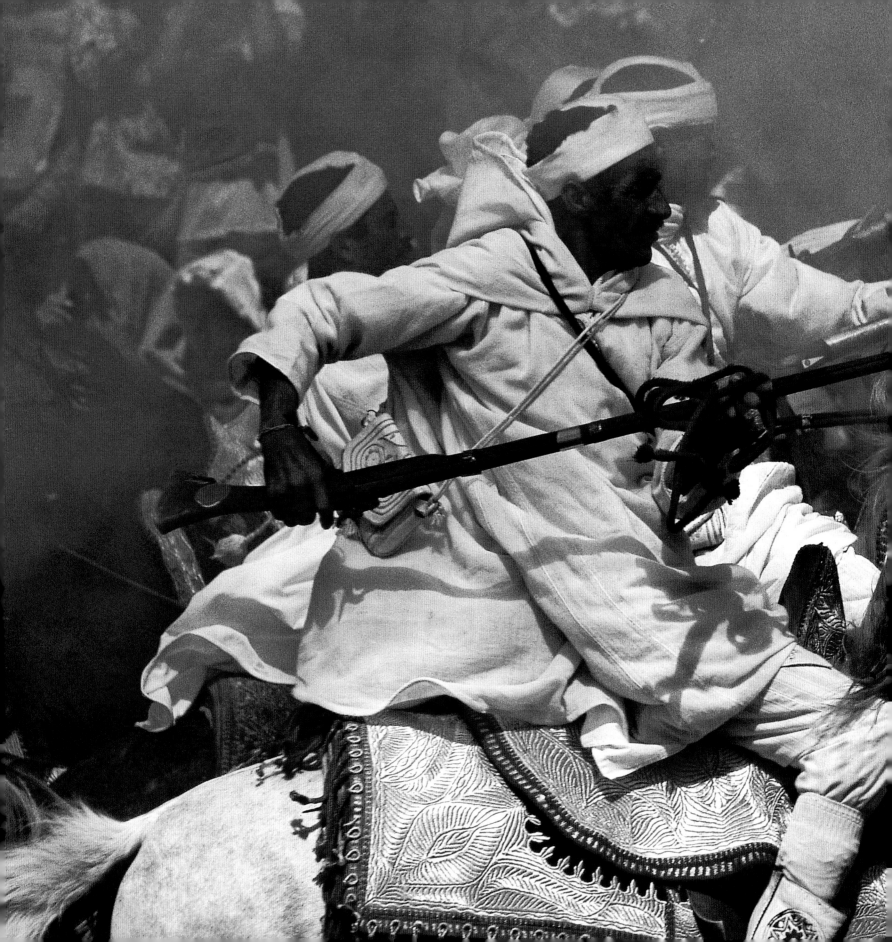

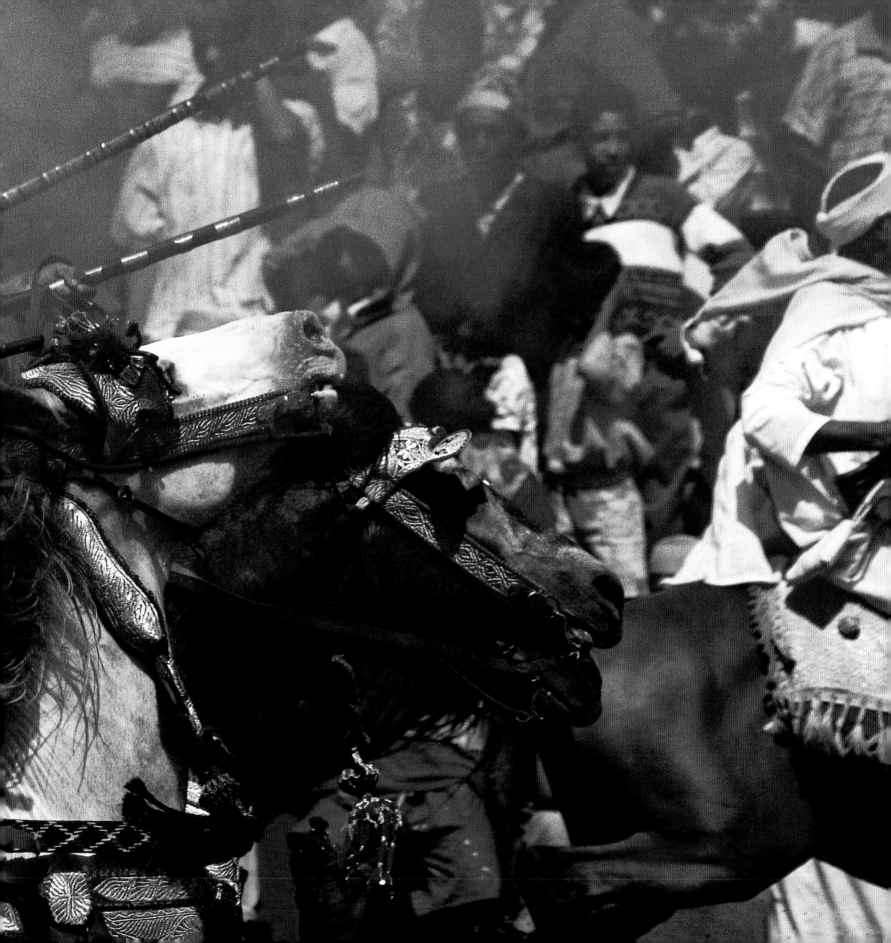

## WORKS QUOTED

p. 23 Karin Huet and Titouan Lamazou, *Sous les toits de terre du Haut Atlas*, Editions Belvisi, 1988.

p. 30 Jacques Chegaray, *Au Maroc à l'aventure*, Presses de la Cité, 1964.

p. 48 Amjad Nasser, extract from *Impressions du Maroc*, trad. Paul Henri.

p. 57, p. 136 and p. 154 Jérôme and Jean Tharaud, *Marrakech ou les Seigneurs de l'Atlas*, Plon, 1920.

p. 74 Ahmed Sefrioui, *La Boîte à merveilles*, Le Seuil, 1954.

p. 85 Jean Robichez, *Maroc central*, Arthaud, 1946.

p. 97 Roland Dorgelès, *Le Dernier Moussem*, Les Laboratoires Deglande, 1938.

p. 108 and p. 267 Pierre Loti, *Au Maroc*, Christian Pirot, 2000.

p. 147 Driss Chraïbi, *Le Passé simple*, Denoël, 1954.

p. 174 Rachid Haloui, *Essaouira à vol de mouette*, Publiday-multidia, 2003.

p. 185 Abdellatif Laâbi, *Écris la vie*, La Différence, 2005.

p. 212 Jérôme and Jean Tharaud, *Fèz ou les Bourgeois de l'Islam*, Plon, 1930.

p. 232 Paul Odinot, 'La première communion d'Abd el-Kader', in *Maroc, les villes impériales*, Omnibus, 1996.

p. 243 Ahmed Sefrioui, *Le Chapelet d'ambre*, Le Seuil, 1964.

p. 258 Tahar Essafi, 'L'Amulette de coriandre', in *Maroc, les villes impériales*, Omnibus, 1996.

## OLD PHOTOGRAPHS

© Photothèque Hachette:
p. 25 above left, below left and right; p. 52 above left and below left; p. 53; p. 79; p. 80 above right and below left / Moreau; p. 81; p. 104 below left and below right; p. 105; p. 111; p. 128; p. 129 above right and below right; p. 156; p. 182; p. 199; p. 204 above right, below left and right; p. 236 left / G.Courtellement et right; p. 256.

© Vérascopes Richard-Photothèque Hachette:
p. 52 / Moreau; p. 80 below right / Goenner; p. 129 below left / Brunet; p. 163 / de Perigny; p. 202 / Commandant Arnaud; p. 257 above right / Commandant Arnaud, below left / Commandant Arnaud and below right / Commandant Arnaud

SPAIN

MEDITERRANEAN SEA

Tangier
Ceuta
Tetouan
Al Hoceima
Melilla
Nador
Larache
Chefchaouen
*Rif*
Oujda
Ouazzane
Taourirt
Taza
Guercif
Kenitra
Fès
Rabat
Meknès

ATLANTIC OCEAN

Casablanca
Azrou
*Middle Atlas*
Tendrara
El Jadida
Khenifra
Settat
Khouribga
Midelt
Bouarfa
Figuig
Beni Mellal
Ben Guerir
Er-Rachidia
Boudnib
Safi
*High Atlas*
Erfoud
Marrakesh
Tineghir
Essaouira
Merzouga
Toubkal
Ouarzazate
Tazzarine
Taliouine
Zagora
Taroudannt
ALGERIA
Agadir
*Anti-Atlas*
Tata
Tiznit
Tafraoute
Sidi Ifni
Guelmim
Tan-Tan

| 0 | 100 | 200 | 300 | 400 | 500 km |

| 0 | 50 | 100 | 150 | 200 | 250 | 300 miles |

Translated from the French Maroc originally published by
Editions du Chêne - Hachette Livre, 2007

Text: Marie-Pascale Rauzier

Photographs: Cécile Tréal, Jean-Michel Ruiz

English translations by Rosetta Translations

Published in the U.S. in 2008 by Putumayo World Culture.

ISBN 9781587592188
PWC 790248320557

Printed and bound in Hong Kong